GRAPHIC DESIGN USA: 13

The Annual of the American Institute of Graphic Arts

Written by Hugh Aldersey-Williams, Ralph Caplan, Steven Heller,
Joel Katz, Judith Nasatir, Veronique Viénne
Designed by Beth A. Crowell, Cheung/Crowell Design
Computer composition by Mark F. Cheung, Cheung/Crowell Design
Judith Fletcher Getman, Production Assistant
Philip F. Clark, Managing Editor

CONTENTS

1991 Medalist Colin Forbes: A Citizen of Design 10

1991 Lifetime Achievement Award E. McKnight Kauffer: The Essential Modernist 26

George Nelson: Articulating the Eye 38

1991 Graphic Design Leadership Award MTV: Visual Rock 'n Roll 50

Olivetti: Designing a World 58

Award Shows Communicating With Children 66

Issues and Causes 94

Communication Graphics 130

The Book Show 294

Index 348

The American Institute of Graphic Arts

The American Institute of Graphic Arts is the national non-profit organization which promotes excellence in graphic design. Founded in 1914, the AIGA advances graphic design through competitions, exhibitions, publications, professional seminars, educational activities, and projects in the public interest.

Members of the Institute are involved in the design and production of books, magazines, and periodicals as well as corporate, environmental, and promotional graphics. Their contributions of specialized skills and expertise provide the foundation for the Institute's programs. Through the Institute, members form an effective, informal network of professional assistance that is a resource to the profession and the public.

Separately incorporated, the 35 AIGA chapters enable designers to represent their profession collectively on a local level. Drawing upon the resources of the national organization, chapters sponsor a wide variety of programs dealing with all areas of graphic design.

By being a part of a national network, bringing in speakers and exhibitions from other parts of the country and abroad, focusing on new ideas and technical advances, and discussing business practice issues, the chapters place the profession of graphic design in an integrated and national context.

The competitive exhibition schedule at the Institute's national gallery in New York includes the annual Book Show and Communication Graphics. Other exhibitions include Illustration, Photography, Covers (book jackets, record albums and compact discs, magazines, and periodicals), Posters, Signage and Packaging. The exhibitions travel nationally and are reproduced in *Graphic Design USA*. Acquisitions have been made from AIGA exhibitions by the Popular and Applied Arts Division of the Library of Congress. Each year The Book Show is donated to the Rare Book and Manuscript Library of Columbia University, which houses the AIGA collection of award-winning books dating back to the 1920s. For the past nine years, The Book Show has also been exhibited at the Frankfurt Book Fair.

The AIGA sponsors a biennial national conference covering topics including professional practice, education, technology, the creative process, and design history. The 1993 conference will be held in Miami, Florida.

The AIGA also sponsors an active and comprehensive publications program. Publications include *Graphic Design USA*, the annual of the Institute; the *AIGA Journal of Graphic Design*, published quarterly; the *AIGA Salary and Benefits Survey*, *Graphic Design For Non-Profit Organizations, 2nd Edition*; *Symbol Signs, 2nd Edition* and the *Symbol Signs Repro Kit*, the book and accompanying portfolio containing 50 passenger/pedestrian symbols originally designed for the U.S. Department of Transportation and guidelines for their use; the *AIGA Membership Directory*, the AIGA Standard Form of Agreement (Contract); a Graphic Design Education Statement; and a voluntary Code of Ethics and Professional Conduct for AIGA Members.

Founding Patrons

*Under the leadership of Ivan Chermayeff,
Milton Glaser, and Massimo Vignelli, a
Founding Patrons Program was established.
Contributions from 29 individuals created
an endowment — the AIGA's first — to
be used for pro-active and educational
programs, and programs that respond to
contemporary issues.*

Primo Angeli
Saul Bass
Bruce Blackburn
Kenneth Carbone
Roger Cook
Ivan Chermayeff
Bart Crosby
James Cross
Richard Danne
Paul Davis
Michael P. Donovan
Lou Dorfsman
Thomas Geismar
Milton Glaser
Nancye Green
Robert M. Greenberg
Cheryl Heller
Jerry Herring
Kit Hinrichs
Miho
Clement Mok
Paul Rand
Stan Richards
Robert Miles Runyan
Anthony Russell
Paula Scher
Deborah Sussman
Michael Vanderbyl
Massimo Vignelli

1991 Patrons

*We wish to thank the following individuals
for becoming Patrons this year:*

Charles Spencer Anderson
Michael Cronan
Peter Good
Leo Lionni
Robert B. Ott, Jr.
Arthur Paul
David Rhodes
Silas Rhodes
Arnold Saks
James Sebastian
Dugald Stermer
Bradbury Thompson
Henry Wolf
Richard Saul Wurman
Lois Ehlert

Past AIGA Presidents

1914-1915 William B. Howland
1915-1916 John Clyde Oswald
1917-1919 Arthur S. Allen
1920-1921 Walter Gilliss
1921-1922 Frederic W. Goudy
1922-1923 J. Thompson Willing
1924-1925 Burton Emmett
1926-1927 W. Arthur Cole
1927-1928 Frederic G. Melcher
1928-1929 Frank Altshul
1930-1931 Henry A. Groesbeck, Jr.
1932-1934 Harry L. Gage
1935-1936 Charles Chester Lane
1936-1938 Henry Watson Kent
1939-1940 Melbert B. Carey, Jr.
1941-1942 Arthur R. Thompson
1943-1944 George T. Bailey
1945-1946 Walter Frese
1947-1948 Joseph A. Brandt
1948-1950 Donald S. Klopfer
1951-1952 Merle Armitage
1952-1953 Walter Dorwin Teague
1953-1955 Dr. M.F. Agha
1955-1957 Leo Lionni
1957-1958 Sidney R. Jacobs
1958-1960 Edna Beilenson
1960-1963 Alvin Eisenman
1963-1966 Ivan Chermayeff
1966-1968 George Tscherny
1968-1970 Allen Hurlburt
1970-1972 Henry Wolf
1972-1974 Robert O. Bach
1974-1976 Karl Fink
1976-1977 Massimo Vignelli
1977-1979 Richard Danne
1979-1981 James Fogleman
1981-1984 David R. Brown
1984-1986 Colin Forbes
1986-1988 Bruce Blackburn
1988-1991 Nancye Green

DIRECTOR'S LETTER

Each year this book provides an annual report on the state of the art of graphic design. The jurors — designers taking the pulse of design — selected the work recorded here from over *7,000* entries to represent excellence in the field. It's a lively and interesting process which provides an up-to-date and selective take on what is being done *now*. It also provides an archive of original work (as well as slides) and traveling exhibitions that opened in 36 locations this year, from Melbourne, Australia to Saratoga Springs, New York. All bring attention to the primary focus of the AIGA: graphic design. This year we included a special five-year retrospective of design as propaganda in the public interest, "Issues and Causes," an exhibition of graphics that confront us with the social issues of our time.

Issues specific to design were covered in the *AIGA Journal of Graphic Design*, including "Smart Machines, Dumb Ideas," "Can We Overprotect Our Rights?," and "How I Lost My Faith in Rational Functionalism," to name a few from an impressive lot. Issues were also addressed through national and chapter programming, sometimes interrelated. *ECO*, a newsletter on ecology, was distributed as a special insert in the *AIGA Journal*; AIGA National adopted its first environmental policy; AIGA/Boston published *Recycled Papers: The Essential Guide* with MIT Press, which was distributed by National free of charge to all members; and AIGA/New York held two ecology events, "What, No Varnish?" and "It's Green, But is it Gorgeous?," as well as addressing the issue of safety in the office environment in the publication *Terminal Health*, which discusses the risks of new technology. The ethics game, "Where Do You Draw the Line?," initiated at the 1989 AIGA Conference, will be distributed this spring; and ethics was also the subject of sessions held in San Diego, Birmingham, Richmond and Chicago. In all, 35 chapters held over 350 events ranging in subject matter from a two-day seminar on "The Creative Spirit" in Birmingham to "The Designer as Entrepreneur" in San Francisco, and Minnesota's popular Design Camp. Chapter programs reached out to help the community at large including an AIGA/Atlanta art auction to support the efforts of The Atlanta Project for affordable housing, a project conceived by Jimmy Carter; an AIGA/Washington art auction to establish a scholarship at the Duke Ellington School for the Arts; an AIGA/Boston exhibition of African-American graphic designers to raise consciousness and heighten sensitivity in the representation of racial groups; AIGA/Los Angeles' Project Angel Food, which supports Meals on Wheels for people with AIDS; and an AIGA/Wichita art auction which donated a portion of the proceeds to The Wichita Children's Home.

AIGA National covened a conference in Chicago, "Love, Money and Power: The Human Equation," which sold out during a recession year and proved through its provocative programming that tough financial times can also be productive and exciting. We published a second edition of *Graphic Design For Non-Profit Organizations*, co-sponsored "Bit by Bit: Infringement on the Arts," a copyright symposium on intellectual property that was held at the Smithsonian Institution, and started a Patrons Program that established our first endowment. In addition we developed an ambitious long-range plan of AIGA initiatives based on issues identi-fied at a national/chapter retreat—initiatives which will take us into the next five years with the sure sense that we are advancing graphic design as a discipline, profession, and cultural force.

Caroline Hightower

Spring 1992

The AIGA Medal

For 72 years, the medal of the AIGA has been awarded to individuals in recognition of their distinguished achievement, services, or other contributions within the field of the graphic arts. Medalists are chosen by a committee, subject to approval by the Board of Directors.

1991 Awards Committee

Joel Katz, Chairman
Principal, Joel Katz Design

Ralph Caplan
Author, By Design

Nancye Green
Principal, Donovan and Green

April Greiman
Principal, April Greiman Incorporated

Kit Hinrichs
Partner, Pentagram San Francisco

Henry Wolf
Principal, Henry Wolf Productions

Past Recipients

Norman T. A. Munder, 1920
Daniel Berkeley Updike, 1922
John C. Agar, 1924
Stephen H. Horgan, 1924
Bruce Rogers, 1925
Burton Emmett, 1926
Timothy Cole, 1927
Frederic W. Goudy, 1927
William A. Dwiggins, 1929
Henry Watson Kent, 1930
Dard Hunter, 1931
Porter Garnett, 1932
Henry Lewis Bullen, 1934
J. Thompson Willing, 1935
Rudolph Ruzicka, 1936
William A. Kittredge, 1939
Thomas M. Cleland, 1940

Carl Purington Rollins, 1941
Edwin and Robert Grabhorn, 1942
Edward Epstean, 1944
Frederic G. Melcher, 1945
Stanley Morison, 1946
Elmer Adler, 1947
Lawrence C. Wroth, 1948
Earnest Elmo Calkins, 1950
Alfred A. Knopf, 1950
Harry L. Gage, 1951
Joseph Blumenthal, 1952
George Macy, 1953
Will Bradley, 1954
Jan Tschichold, 1954
P. J. Conkwright, 1955
Ray Nash, 1956
Dr. M. F. Agha, 1957
Ben Shahn, 1958
May Massee, 1959
Walter Paepcke, 1960
Paul A. Bennett, 1962
William Sandberg, 1963
Saul Steinberg, 1963
Josef Albers, 1964
Leonard Baskin, 1965
Paul Rand, 1966
Romana Javitz, 1967
Dr. Giovanni Mardersteig, 1968
Dr. Robert R. Leslie, 1969
Herbert Bayer, 1970
Will Burtin, 1971
Milton Glaser, 1972
Richard Avedon, 1973
Allen Hurlburt, 1973
Philip Johnson, 1973
Robert Rauschenberg, 1974
Bradbury Thompson, 1975
Henry Wolf, 1976
Jerome Snyder, 1976
Charles and Ray Eames, 1977
Lou Dorfsman, 1978
Ivan Chermayeff and
Thomas Geismar, 1979
Herb Lubalin, 1980
Saul Bass, 1981
Massimo and Lella Vignelli, 1982
Herbert Matter, 1983
Leo Lionni, 1984
Seymour Chwast, 1985
Walter Herdeg, 1986
Alexey Brodovitch, 1987
Gene Federico, 1987
William Golden, 1988
George Tscherny, 1988
Paul Davis, 1989
Bea Feitler, 1989
Alvin Eisenman, 1990
Frank Zachary, 1990

The Design Leadership Award

The Design Leadership Award has been established to recognize the role of the perceptive and forward-thinking organization which has been instrumental in the advancement of design by application of the highest standards, as a matter of policy. Recipients are chosen by the awards committee, subject to approval by the Board of Directors.

Past Recipients

IBM Corporation, 1980
Massachusetts Institute of Technology, 1981
Container Corporation of America, 1982
Cummins Engine Company, Inc., 1983
Herman Miller, Inc., 1984
WGBH Educational Foundation, 1985
Esprit, 1986
Walker Art Center, 1987
The New York Times, 1988
Apple and Adobe Systems, 1989
The National Park Service, 1990

The Lifetime Achievement Award

The Lifetime Achievement Award, presented this year for the first time, is posthumously awarded to individuals in recognition of their distinguished achievements, services or other contributions within the field of graphic arts. This award is conclusive and is for special and historical recognition. This award has been created to ensure that history, past and present, is integral to the awards process, is part of the awards presentation and is documented in the Annual. Recipients are chosen by the awards committe, subject to approval by the Board of Directors.

The AIGA Awards 1991-92: A Continuum of Excellance

The special satisfaction of serving on the awards committe, of all the committees and juries on which I have served, is the opportunity it provides of being able to look backward as well as forward, to look at our profession, or "art," or "craft," as a continuum stretching across time and space.

The committee was grateful to the Board for adding a Lifetime Achievement award this year. It permitted us to break the four-year pattern of selecting two gold medalists, and we responded by choosing two Lifetime Achievement recipients and two Design Leadership medalists.

Marty Fox wrote about the selection process a year ago, and with such eloquence that there is nothing to add about the process. But what I have noticed about the last two committees on which I have served is an unanticipated quality of thematic symmetry to complement the serendipity of the process. Last year the awards went to three great *catalysts* for design. This year, I feel, the medalists share a quality of the *integration* of great design with other, critically important elements — business, information, broad audience, architecture, interior space, products, popular culture, and geographic diversity.

I think that, unconsciously, as the committee sifted through past nominees, current year nominees, and new nominees that individual committee members brought with them, this theme magically emerged, developed, and finally struck us with its inherent appropriateness and logic.

Colin Forbes's achievements include not only his design but his success as the architect of a multinational practice, with offices on two continents, now with a full second generation of brilliant, mature design professionals. E. McKnight Kauffer, much of whose significant work was done in Britain, applied wit, sensitivity, and intelligence to the design of routine information for an enormous public, introducing it to the conventions of modern painting. George Nelson's practice bridged space design, products and architecture, a keen sense of design history and human factors, and the written word. MTV has integrated design with contemporary popular culture in a new medium, unifying young and old, professional and lay audiences. And Olivetti has applied the highest principles of taste and function to all the products — two- and three-dimensional — of an enormous multinational corporation, disseminating the value of design around the world through products and projects both elevated and humble.

It was a pleasure to work with such a dedicated committee, an honor to bestow these awards on such worthy recipients, and a cause for optimism that there are so many more to select in coming years.

Joel Katz, Chairman
1991-92 Awards Committee

COLIN FORBES

A CITIZEN OF DESIGN

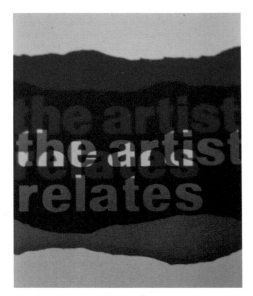

Exhibition catalogue cover,
1956 (top); magazine cover
featuring new design of garden
shears, 1959 (above).

By Ralph Caplan

It may be a violation of confidentiality to say so, but when Colin
Forbes was proposed for the AIGA Medal there was very little
discussion among the jurors. That did not seem curious until
afterwards, when I discovered that I could not think of my favor-
ite Colin Forbes designs. Other medalists have been strongly
associated with particular works — Milton Glaser with his Dylan
poster or *New York* Magazine; Paul Rand with his logos for IBM
and Westinghouse; Bill Golden with the CBS eye. Forbes's
portfolio contains no counterparts to those icons. Other medal-
ists, such as Lester Beall, Gene Federico, and Allen Hurlburt,
have each been described as a "designer's designer," whatever
that means. But whatever it means, I doubt that Colin Forbes has
been called that very often.

He has been called something else though. In introducing
him to a meeting of Art Center College of Design's faculty and
trustees, president David Brown said, "Colin Forbes is unique as
a designer of things that are not normally thought of as being
designed." That, I think, is the heart of the matter. Throughout
most of a long and spectacularly successful career in graphic
design, Forbes has concentrated his splendid energies on nothing
less than designing the practice of design itself. That makes him a
designer's designer in quite a special sense.

When the brilliant film designer Anton Furst committed
suicide last year, his son offered an insight into the cause: "He
always told me the tools of his trade were a 6B pencil and a store
of putty. He was in control with his pencil; but suddenly he was
dealing with unknown things. He worried about the fact that he
wasn't producing anything. He needed to be drawing."

Colin Forbes does not need to be drawing. Graphic
designers once used an archaic commercial art term, "on the
board," to describe what was misleadingly thought of as "actual
designing." Even more misleading, time on the board was
sometimes equated with billable time. When I asked Colin how

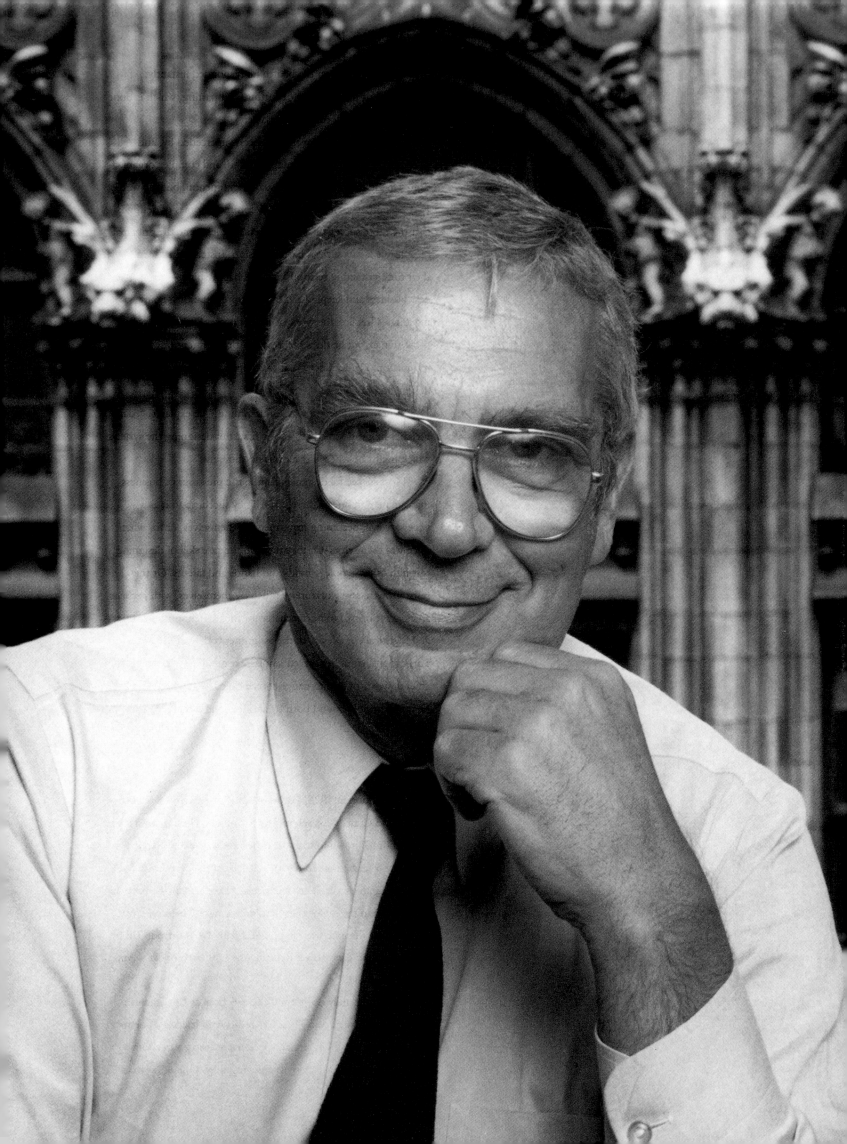

Christmas card for photographer, 1957 (top); cover for leaflet on readership figures, (above).

much time he spent on the board, he responded instantly: "None." (But he does a lot of cutting-and-pasting, which is done on desk, table, or floor for that matter.)

In Forbes's case, drawing has been superceded by, and subordinate to, running a large, scattered, and complex organization. That in itself is not an unusual phenomenon, but the way Forbes approaches it is. One of the common ironies of design is that the more successful an office gets, the less time the principals responsible for its success have to design. Instead, they spend their time sustaining relationships and happy ships — getting new business and keeping old, making presentations, going to meetings, directing the work of other people. Forbes does all of those things, but he does them without resentment or even resignation. He does not see it as compromise; he sees it as design, and he likes it.

"There are different ways of designing," he explains. "Alan Fletcher might doodle with a logo first, but designing the system, which might be where I'd start, is no different."

Most successful designers handle the pressures of business management in one of three ways. They succumb to it as a necessary evil, becoming front men for themselves, or for what once was themselves. Or they develop the rare skill of designing through other people's minds and hands and talents. Or they resist growth, and work pretty much by themselves, with perhaps an assistant or two to do mechanicals, thereby limiting the scale and logistical complexity of the assignments they can undertake. Forbes took, or rather carved, another route. He became the chief designer of an alternative choice called Pentagram, to which he is inextricably bound both by accident and design.

•

Born in London in 1928, Forbes studied at the Central School of Arts and Crafts. "Art school was for misfits," he says with some satisfaction. Thrown in with the other misfits, he discovered generally what he wanted to do, and specifically how far he was from being able to do it competitively. "I could draw better than anyone else in the senior class in middle school," he recalls; but in art school the ante was raised: "Suddenly I was surrounded by people who *all* drew better than anyone in the senior class. And better than I did."

Forbes gleefully describes Central School as "an organizational disaster," a circumstance he credits with leaving students free to learn. It also left students free *not* to learn, a freedom Forbes came perilously close to enjoying fully. One of his treas-

Symbol for the
Designer's & Art
Directors Club,
1963.

Personal Christmas
card, 1958.

Advertisement announcing pre-cut wrapped building boards, 1962.

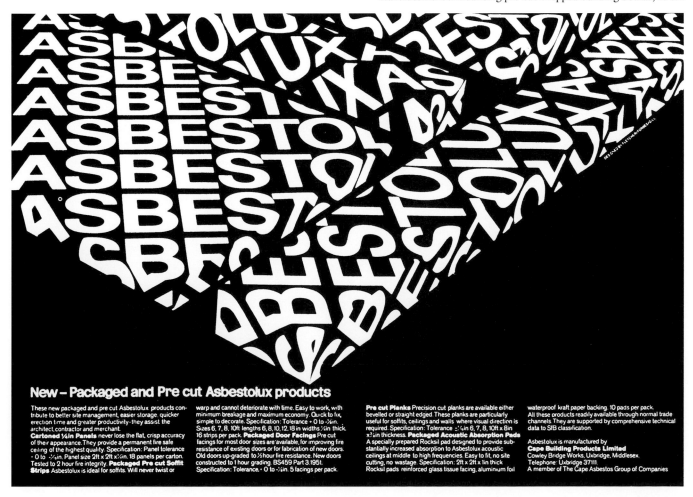

New – Packaged and Pre cut Asbestolux products

These new packaged and pre cut Asbestolux products contribute to better site management, easier storage, quicker erection time and greater productivity - they assist the architect, contractor and merchant.
Cartoned ¼in Panels never lose the flat, crisp accuracy of their appearance. They provide a permanent fire safe ceiling of the highest quality. Specification: Panel tolerance · 0 to -⅛in. Panel size 2ft x 2ft x¼in. 18 panels per carton. Tested to 2 hour fire integrity. **Packaged Pre cut Soffit Strips** Asbestolux is ideal for soffits. Will never twist or

warp and cannot deteriorate with time. Easy to work, with minimum breakage and maximum economy. Quick to fix, simple to decorate. Specification: Tolerance · 0 to -⅛in. Sizes 6, 7, 8, 10ft lengths 6, 8, 10, 12, 18 in widths ¼in thick. 16 strips per pack. **Packaged Door Facings** Pre cut facings for most door sizes are available, for improving fire resistance of existing doors or for fabrication of new doors. Old doors up-graded to ½hour fire resistance. New doors constructed to 1 hour grading. BS459 Part 3.1951. Specification: Tolerance · 0 to -⅛in. 5 facings per pack.

Pre cut Planks Precision cut planks are available either bevelled or straight edged. These planks are particularly useful for soffits, ceilings and walls where visual direction is required. Specification: Tolerance · ⅛in 6, 7, 8, 10ft x 8in x⅜in thickness. **Packaged Acoustic Absorption Pads** A specially prepared Rocksil pad designed to provide substantially increased absorption to Asbestolux acoustic ceilings at middle to high frequencies. Easy to fit, no site cutting, no wastage. Specification: 2ft x 2ft x 1in thick Rocksil pads reinforced glass tissue facing, aluminium foil

waterproof kraft paper backing. 10 pads per pack.
All these products readily available through normal trade channels. They are supported by comprehensive technical data to SfB classification.

Asbestolux is manufactured by
Cape Building Products Limited
Cowley Bridge Works, Uxbridge, Middlesex.
Telephone: Uxbridge 37111.
A member of The Cape Asbestos Group of Companies

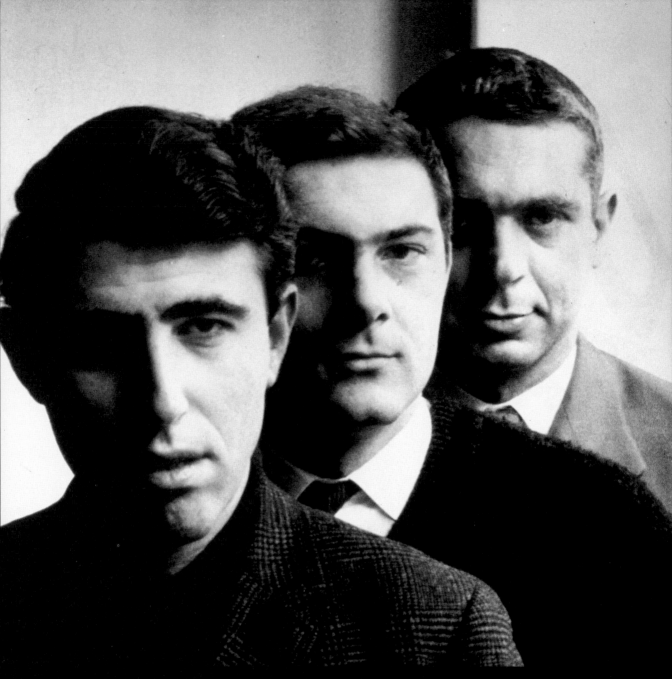

Fletcher, Forbes and Gill. Photograph © Robert Freeman, 1962.

Zinc Die Casting
Conference, 1966.

Designs for Pirelli, 1960, 1965.

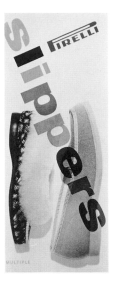
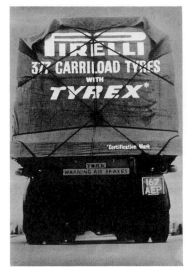

ured teachers was a wood engraver named John Farleigh, who said to him one day, "Colin, I can't teach you anything because you haven't read anything." Farleigh gave him a list of a dozen books to read, most of which Forbes can no longer name, although he remembers that it included Huxley's *Brave New World* and Hardy's *Tess of the D'Urbervilles*, and that others were by Dos Passos, Waugh, and Dostoyevski. Although none of the books were about art or design, he regards the reading list as intrinsic to his learning to be a designer.

"Farleigh was one of a series of wonderful mentors I had," Forbes says. Many designers have important mentors, but in Forbes's case their guidance had to do as much with management as with design. In the mid-Sixties Ian Hay-Davidson, of Arthur Andersen, instructed him in issues of partnership. Another mentor was a printer's representative who "gave me tips about running a business and introduced me to such simple commercial realities as the need for cash flow." Another was Bernard Scott (later Sir Bernard Scott), chairman of Lucas Industries, who recommended that Forbes read J. P. Sloan's *My Years at General Motors*, to learn something about the diversification of profit centers. He did, and also learned "the importance of distinguishing between operational decisions and policy decisions."

While studying at Central, Forbes worked as assistant to Herbert Spencer, and upon graduating began doing freelance assignments. At the same time, he held a lecturing post at Central, which he left to work as art director with a small advertising agency. Within the year he returned to the Central School as Head of Graphic Design. He was 28.

In 1960, largely on the basis of having been retained as design consultant to Pirelli in England, he left teaching to begin his own practice. During a visit to the United States, armed with a letter of introduction to Aaron Burns, he called on Burns and on a number of designers he admired, including Will Burtin, Gene Federico, and Paul Rand. Among the younger American designers he met, Forbes was particularly impressed by Robert Brownjohn, Ivan Chermayeff, and Tom Geismar, who, as the fledgling firm of Brownjohn, Chermayeff and Geismar, struck him as "three young guys doing interesting things." Back in London in 1962 he joined Alan Fletcher and Bob Gill, an American living in London, to form Fletcher, Forbes and Gill. They too were three young guys (all in their early thirties) and at least two of the first things they did were interesting, if only because in England they were so unusual: they invested more money than they could afford in the design of their own offices, and they undertook a program of self-promotion.

That may really have been the beginning of Forbes's development into the very special kind of designer he has become. "I had abilities that complemented theirs," he says. "I was the one who planned. This was partly by default — no one else was doing it — and partly because I was good at it. Actually I'm shy and introverted, but I do have good people skills and good diplomatic skills. In any case, I gained more from Fletcher, Forbes and Gill than either Fletcher or Gill did."

England was ablaze with creative activity in the early Sixties. Before our very eyes and ears The Beatles were transmogrified from a funky Liverpool group into an international musical life force. The satiric revue "Beyond the Fringe" launched Jonathan

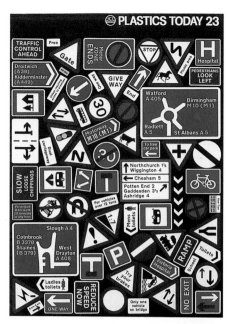

Series of cover designs
for *Plastics Today*, 1970s.

Conways'

Logo and application
for Conways photosetting
company.

Miller, Alan Bennett, Dudley Moore and Peter Cook as comics and social critics. Mary Quant was influencing the way women designed themselves.

Graphic design was part of the cultural explosion, and Fletcher, Forbes and Gill belonged to it. But although they were soon doing well, they were doing well in a way they had not prepared for and were unable to control.

"About half of our business," Forbes says, "was trouble-shooting for advertising agencies. When an agency was out to get a new account or to save one they thought was at risk, they would give us a job on Friday that they wanted by Monday. We felt that we were being used as a 'hot shop' to build someone else's business, and we didn't want to continue doing that. We took a hard look at the situation and decided there were two choices: to become an advertising agency ourselves or to move into the design mainstream. The first wasn't really a choice. We didn't have any interest in becoming an agency and didn't have the competence either. So we chose the mainstream."

One mainstream project for Fletcher, Forbes and Gill was the graphics program for the 1965 Triennale in Milan, which they were doing in collaboration with the architect Theo Crosby. That experience led the architect and the three graphic designers to join forces. "Whoever needed a letterhead or a brochure," Forbes says, "probably had an office, shop or showroom. Who-ever wanted new offices probably needed mailing pieces."

It was at this point that the cluster of freelancers began to be an Organization. At the time he joined them in 1965, Theo Crosby was working on a town center complex. According to an article by Michael McNay in *Design*, "Gill asked him when the first buildings would go up. 'About 1973,' Crosby said. 'That's a long time to have to wait for a proof,' Gill said, and shortly after departed."

Fletcher, Forbes and Crosby had become a team in order to take on large-scale, multidisciplinary projects. But when they got such projects to work on, they found that they still did not have the requisite disciplines in-house. Designing British Petro-leum service stations, for example, brought the firm face to face with the problem of gas pumps. Just as they had previously worked with Crosby on the Triennale, they now collaborated with the young but already established product designer Kenneth Grange. And just as the relationship with Crosby had led to his joining them as a partner, the collaboration with Grange led to *his* joining them as a partner. The team, which had by that time strengthened their graphics capacity with the addition of Mervyn Kurlansky, had suddenly become five

Three in a series of 26 posters promoting typefaces, 1970.

Sample pages from a booklet on photographic distortion, 1971.

partners in search of a name. Alan Fletcher, the designer most likely to be caught reading a book about witchcraft, came across the word "Pentagram" in a book on the subject. If the rest is design history, it is history that Colin Forbes, as the founding partner who chaired the partner's policy meetings for 20 years, had a great deal to do with making and planning.

But for all his emphasis on the planning aspect of design, Forbes believes no designer can stray very far from the craft of design. Even his analytical skills, he believes, were developed by his designing with type. The other craft that informs all his work is drawing, and he quotes approvingly a drawing teacher who told him, "Colin, the reason you don't draw correctly is that you don't see correctly." "He was right," Forbes says, "and if I hadn't been trying to learn how to draw, I might never have been forced to learn how to see, which is far more important for a designer." How clearly he sees is evident in the work on these pages.

For "The Craftsman's Art," a catalogue done 20 years ago for a show at the Victoria and Albert Museum in London, the lettering was incised in shale by hand, a process less expensive than phototypesetting and more germane to the subject. The "Connections" poster for Simpson is, like much of Forbes's work, simultaneously self-explanatory and intriguing. A brochure for a type house reverses the image of Laurel and Hardy to illustrate distortion. A poster explains the metric system (which was then about to become standard in Britain) in terms of the sizes of objects that are both familiar and —

Make Laurel, Hardy...

...and Hardy, Laurel.

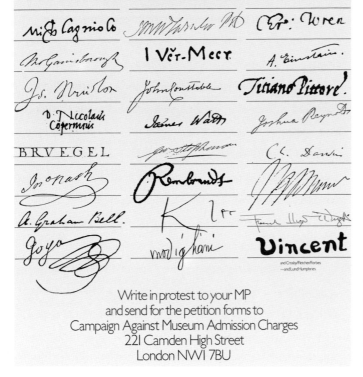

Poster for the Campaign
Against Museum Admission
Charges, 1975.

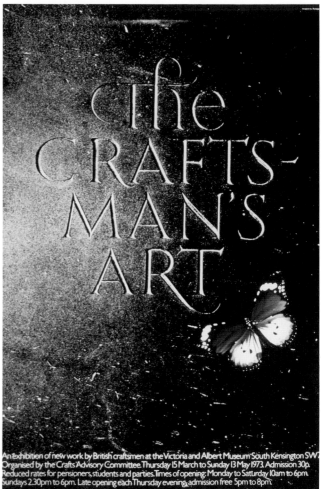

Poster for Craft
exhibition, 1974.

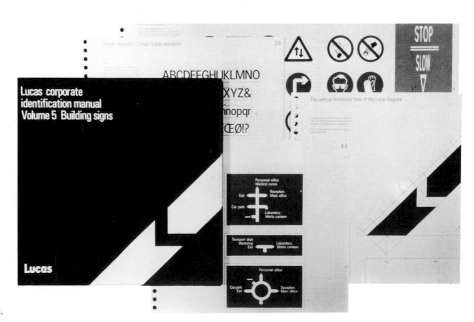

Corporate identity for
Lucas Industries, 1976.

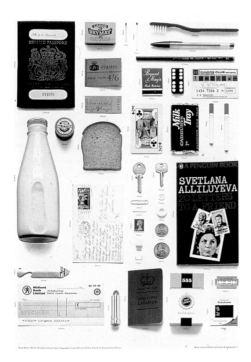

Think Metric, mailers promoting metrification, 1968.

particularly in juxtaposition — graphically interesting. Sometimes there are startlingly simple solutions, like the advertisement signed by great artists and thinkers protesting museum admission fees.

These pieces seem almost to have an 18th century English sensibility (at least, *stereotypically*) in their wit, reason and clarity — qualities that are also characteristic of Pentagram. The firm has introduced a certain Age of Reason civility into design office management. Their celebrated in-house luncheon facilities are an example, of sorts, but Pentagram civility is probably best expressed in the firm's publications. These designers began publishing their own books almost as soon as they began practicing design! In 1963 Fletcher, Forbes and Gill produced *Graphic Design: Visual Comparisons*. In 1972 the five Pentagram partners published *Pentagram: The Work of Five Designers*, followed by *Living By Design* in 1978, and *Ideas on Design* in 1986. A new book, *A Pentagram Compendium*, will appear later this year.

In addition, there are the widely admired *Pentagram Papers*, which are not a series of documents stolen from the CIA by Daniel Ellsberg, but a series of small publications issued occasionally on whatever design-related subjects interest the partner-editors.

The success of Colin Forbes, and of Pentagram, can be described as coming close to the simple ideal of liking what you do.

Book design for Cotswold silversmith, 1977.

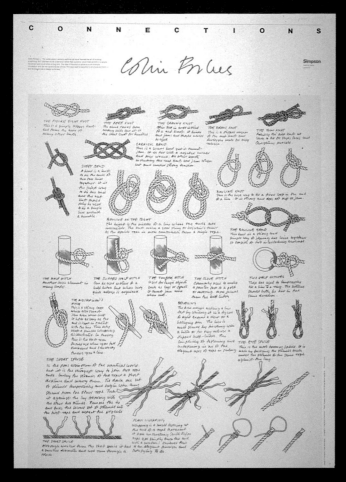

Simpson Paper Company
"Connections" poster, 1982.

Logo for Nissan Motor
Company, 1981.

Symbol for the New
Britian Symphony
Society, 1980.

Book jacket
design, 1978.

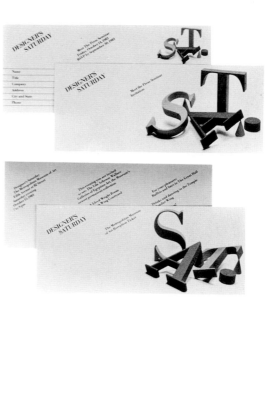

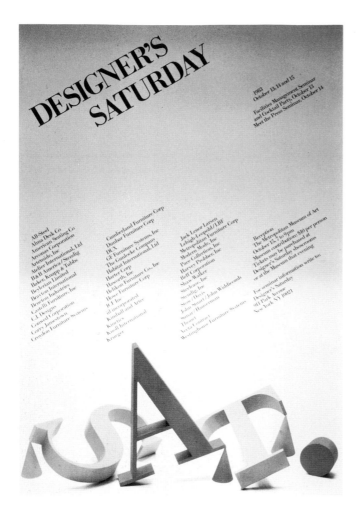

Poster and brochures for
Designer's Saturday, 1983.

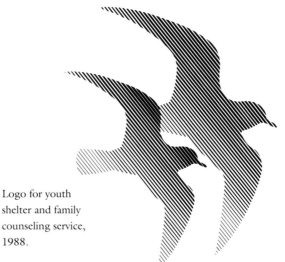

Logo for youth
shelter and family
counseling service,
1988.

In 1978 Forbes established a New York office for Pentagram. It was a risky move, one no foreign design office had done successfully.

There were, to be sure, some reasons to justify the risk. Half of the Fortune 500 companies were concentrated in the eastern U.S. So many American companies were doing business in Europe that an American-based design office would be in a good position to get European work. And New York was the world's largest market for design services. Forbes saw that market as divided between two kinds of design firms: the traditional offices run by designers, and the offices that were organized — on the Lippincott and Margulies model — very much like advertising agencies, with design and designers subordinate to other disciplines. Pentagram belonged inescapably to the first

category, but Forbes believed they could offer a managerial sophistication that few traditional offices even aspired to.

All of that made good sense, but it would have made no sense at all were it not for the *real* reason for opening an office in New York: Colin just plain wanted to live there. His experience in bringing Pentagram to the U.S. is typical, combining the passionately personal with the organizationally strategic. He established a beachhead in George Nelson's office. It was a curious match, and one that did not last long. Perhaps its most notable product is the dust jacket Forbes designed for the book *Nelson on Design*.

Designing an organization, like designing almost anything else, carries risks. Guy Laliberte, the former fire-eater who manages the Canadian circus called Cirque du Soleil, was asked

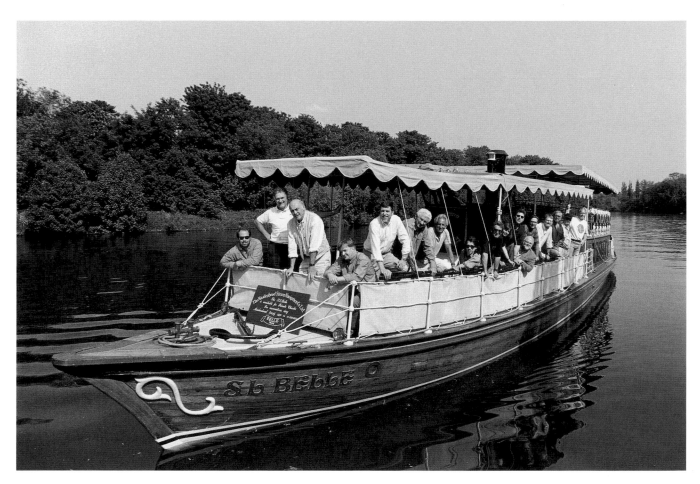

River Thames, United Kingdom, 1992; Pentagram's 39th International Policy Committee Meeting. These meetings are held alternatively every six months in North America and Europe. Photographer: Peter Harrison. Partners, left to right: Michael Bierut, Kenneth Grange, Alan Fletcher, John Rushworth, Peter Harrison, Theo Crosby, Mervyn Kurlansky, Peter Saville, David Hillman, Paula Scher, Jim Biber, Kit Hinrichs, Woody Pirtle, Neil Shakery, Colin Forbes, John McConnell, Lowell Williams.

Drexel Burnham Lambert 100th Anniversary book, 1986.

Logo for Japanese manufacturing conglomerate, 1989 (top); identity for Japaneses synthetics manufacturer, 1984 (above).

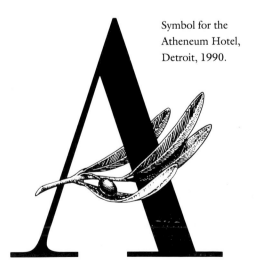

Symbol for the Atheneum Hotel, Detroit, 1990.

Symbol and logo for a children's aerobic team, 1991.

in the *Wall Street Journal* whether it was tougher to make a living by eating fire or by running an organization. "You can get burned doing both," Laliberte replied.

If Forbes has been burned, it has not kept him from bringing to the design community at large the kind of managerial fire-eating he practiced at Pentagram. From 1976 to 1979 he was president of the Alliance Graphique Internationale, and from 1984 to 1986 he was president of the American Institute of Graphic Arts.

Wim Crouwel, who followed him into the AGI presidency, says Forbes's tenure there betokened a "combination of great designer, perfect organizer and brilliant manager." Nancye Green, who succeeded Forbes as AIGA president, has a more specific observation: "Colin's contribution, both as a designer and as AIGA president, has been the translation of business practice into design practice."

Professionally, Colin Forbes has gone beyond the complexities of a large practice to compile an extraordinary record of design statesmanship. But in design, as in politics, there can be no statesmanship without citizenship. This year's AIGA Medalist is an impeccable citizen of the design world.

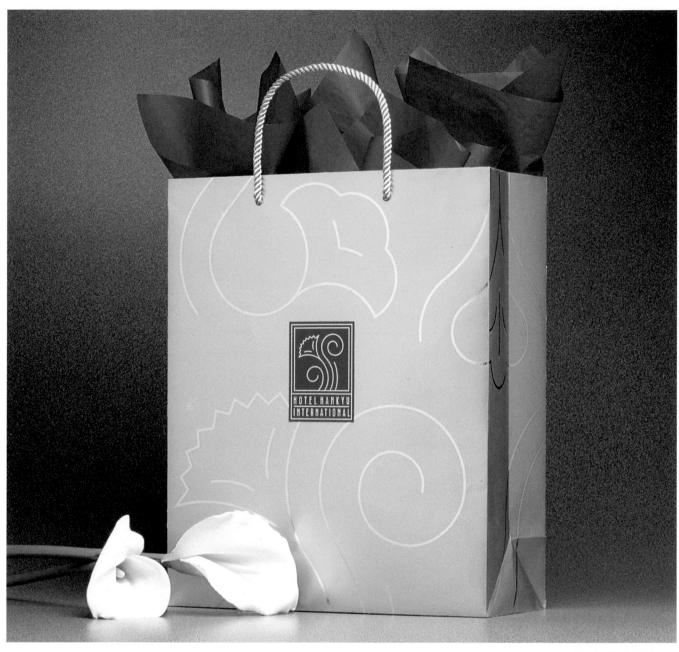

Identity program for Hotel
Hankyu in Osaka, Japan,
1991, (above and below).

Collaboration is intrinsic to Pentagram and most projects
have input from more than one partner or associate.
However, special credit should be given to the following
graphic designers and other specialists for the their contri-
butions: *Conway's Phototypesetting,* Alan Fletcher, Garter Bell;
Lucas Industries, Alan Fletcher, Jean Robert; *Nissan,* Mathew
Carter; *Toray,* Alan Fletcher; *Drexel Burnham Lambert,*
Kaspar Schmidt; *Kubota;* Woody Pirtle, Michael Gericke;
Hotel Hankyu International, Michael Gericke, McRay
Magleby; *Atheneum,* Michael Gericke, Mirco Ilic.

E. MCKNIGHT KAUFFER

THE ESSENTIAL MODERNIST

By Steven Heller

Edward ("Ted") McKnight Kauffer (1890-1954) was one of Europe's most prolific and influential advertising poster artists during the Twenties and Thirties, and as innovative as his more celebrated French counterpart, A.M. Cassandre. In England, where he lived and worked, Kauffer was hailed for elevating advertising to high art, yet in America only the design cognoscenti knew of his achievements when the Montana-born expatriot returned to New York City from London in 1940 — after 25 years there. Kauffer had attempted repatriation once before in 1921, when he was invited to show his early posters at New York's Art and Decoration Gallery; at that time he also attempted to find work with American advertising agencies. Except for a few commissions to design theatre posters, "America was not ready for him," wrote Frank Zachary in *Portfolio #1* (1949). "So, feeling a 'great rebuff,' he returned to England, where he continued to pile up honors.

That Kauffer was still unappreciated in New York after his second return was perplexing because only three years earlier, in 1937, The Museum of Modern Art in New York (under Alfred H. Barr's direction) gave him a prestigious one-man show. In America, however, the essential Modern poster with its symbolic imagery and sparse selling copy, which Kauffer helped pioneer, was acceptable on a museum wall, but not on the street. At that time most advertising agents blindly adhered to copy-heavy, romantic imagery keeping all but a few progressive designers from breaking the bonds of mediocrity. After that first disappointment, Kauffer returned to his adopted country where his work was considered a national treasure. After the outbreak of war in 1940, he believed that living and working in London was no longer a viable option. Kauffer was prohibited, as an alien, from contributing to England's war effort; feeling he was a liability, he and Marion Dorn left the country on the last passenger ship to the United States (leaving most of their belongings behind). Kauffer

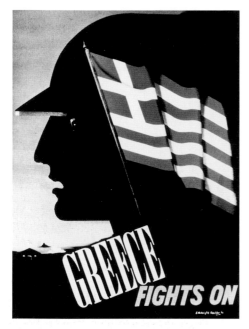

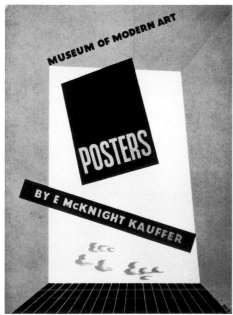

Greece Fights On, poster for Greek Office of Information, 1942 (top); cover design for exhibition catalogue, Museum of Modern Art, New York, 1937 (above).

Twickenham By Tram,
poster for Underground
Railways Company, 1924
(top); Autumn Woods,
poster for London Passenger
Transport Board, 1938
(above).

lived in New York for 14 years, until his death in 1954. Though he worked for various clients during that time, he was never given the same recognition he enjoyed in England. With a few notable exceptions, the honors came posthumously. Indeed, only after 38 years is he finally the recipient of an AIGA award.

•

The reason that Kauffer's career lost steam in America was not entirely because colleagues and clients rejected him. In fact, some designers did their best to help establish his reputation here, and as a freelance he acquired some significant accounts. Despite his adamant refusal to renounce his American citizenship, after spending almost half a lifetime in England he felt like an alien in his native land. Kauffer was adrift in a fast-paced, competitive New York where he never satisfactorily developed the intimate artist/client relationships that, in England, allowed him to push the conventions of advertising. Anger and frustration took their toll not only on his work, but his health. The American period of his career, though by no means undistinguished, ended in despair.

Yet if at 22 Ted Kauffer had not been sent abroad at the behest of Professor Joseph McKnight (who was Kauffer's mentor during his formative years and from whom he took his middle name), he might never have become a poster artist and graphic designer. If Kauffer had not set sail in 1913 for Germany and France, where he was introduced to Ludwig Hohlwein's poster masterpieces in Munich and attended the Academie Moderne in Paris, his life would have taken a much different turn. Prior to leaving San Francisco, where he worked during the day in a bookstore and at night studying art at the Mark Hopkins Institute, he had a small exhibit of paintings in which he showed real promise as a painter. Before crossing the Atlantic he stopped in Chicago where he enrolled at the Art Institute for six months. But he became increasingly bored with the academic trends in American art. While in Chicago, however, Kauffer was profoundly influenced by a major cultural event: The Amory Show, the legendary exhibit offering Americans their first exposure to the burgeoning European avant-garde. "I didn't understand it. But I certainly couldn't dismiss it," he told Frank Zachary. Some years later these same paintings would inspire his own benchmark work, "Flight" (1916), which in 1919 was adapted as a poster for the London *Daily Herald* with the title, "Soaring to Success! The Early Bird," and was the first Cubist advertising poster published in England.

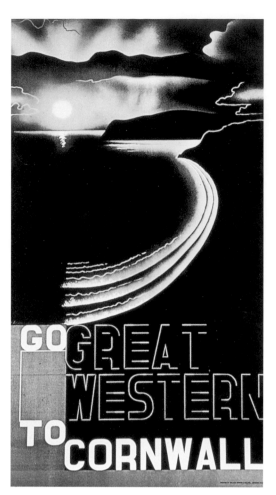

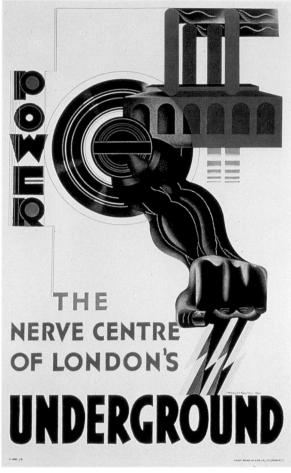

Go Great Western to Cornwall, poster for Great Western Railways, 1932. (right); Power: The Nerve Centre of London's Underground, poster for Underground Railways Company, 1930 (far right).

The art capitals of Europe beckoned, but the clouds of war loomed, and in 1914 Kauffer became a refugee with just enough money in his pocket to return to America. Instead of sailing straight home, however, he discovered England, and with it a tranquility he had not experienced in America. "I felt at home for the first time," he told Zachary. Kauffer volunteered to serve in the British army but was ineligible as an American citizen. Instead he performed a variety of menial jobs while waiting for painting commissions to come along.

It was during this time that Kauffer met John Hassall, a well-known English advertising poster artist who referred him to Frank Pick, the publicity manager for the London Underground Electric Railways. Pick was responsible for the most progressive advertising campaign and corporate identity program in England. He commissioned Edward Johnston to design an exclusive sans serif typeface and logo for the Underground (both are still in use), as well as hire a number of England's best artists to design

beautiful posters for its stations. Kauffer's first Underground posters produced in late 1915 were landscapes rendered in goache which advertised picturesque locales. These and his 140 (according to Keith Murgatroyd's article, "McKnight Kauffer: The Artist in the World of Commerce," in *Print* magazine) subsequent Underground posters, spanning 25 years, are evidence of Kauffer's profound creative evolution towards Modernism.

During his first year in England Kauffer became a member of the London Group, a society of adventuresome painters who embraced Cubism. He refused to abandon painting for his new advertising career; rather, he questioned the growing schism between fine and applied art. "He could see no reason for conflict between good art work and good salesmanship," wrote Zachary. In fact, he was dismayed by the inferior quality of English advertising compared to work being done on the continent. During the 1890s there was a period in which the "art poster" flourished in England, exemplified by the Beggarstaff Brothers, yet this brief

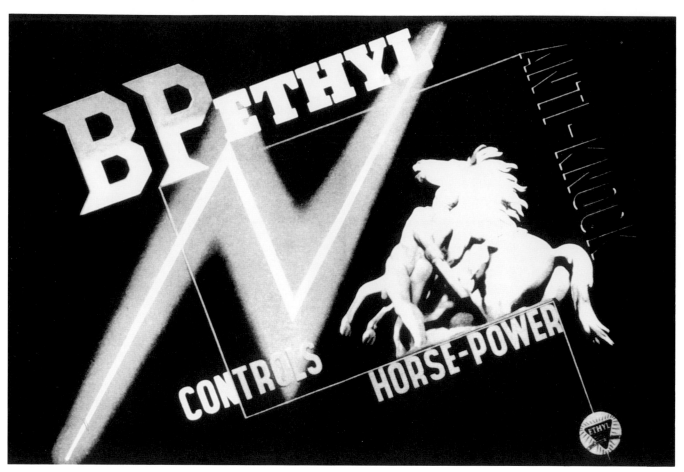

BP Ethyl Controls Horse Power, poster for Shell-Mex Ltd., 1933.

This page and opposite, a selection of three posters for Shell-Mex Ltd., 1934.

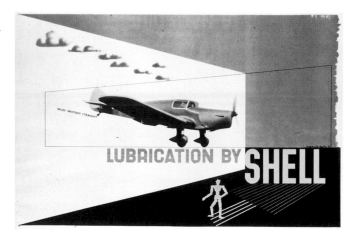

flicker of progressivism was soon snuffed out by nostalgic fashions. Although Kauffer's earliest posters were picturesque, they were hardly sentimental; he intuitively found the right balance between narrative and symbolic depiction in stark prefigurations of his later abstract images.

In the biography *E. McKnight Kauffer: A Designer and His Public* (Gordon Fraser, London, 1979), author Mark Haworth-Booth says that it is likely that Kauffer saw the first exhibit of the Vorticists in 1916, and that this avant-garde movement of English abstractionists who worshipped the machine as an icon and war as a cleansing ritual had an impact on his own work. Through its minimalism and dynamism "Flight" echoes the Vorticists' obsession with speed as a metaphor for the Machine Age. This is "Kauffer's major work," writes Haworth-Booth, "...[and] also the finest invention of his entire career." In fact, the image departed enough from a direct Cubist influence to become the basis for a distinctly personal visual language. "He had a child-like wonder and admiration for nature," continues Haworth-Booth, referring to how Kauffer based this image not on imagination but on his first-hand observation of birds in flight. However, "Flight" might not have become an icon of modern graphic design if Kauffer had not submitted it, in 1919, to *Colour* magazine, which regularly featured a "Poster Page" where outstanding unpublished designs were reproduced free of charge to encourage businessmen to employ talented poster artists as a means of helping England get back on a sound commercial footing after the war. "Flight" was bought by Francis Meynell, a well-known English book publisher and printer, who organized a poster campaign for the Labour Party newspaper, *The Daily Herald*. Meynell believed that the soaring birds represented hope, and the unprecedented design somehow suggested renewal after the bloody world war. The poster was

ubiquitous and soared its maker into the public eye. Kauffer soon received commissions to design campaigns for major English wine, clothing, publishing, automobile, and petroleum companies.

Even with a promising advertising career, Kauffer continued to think of himself as a painter. He was the secretary of the London Group, responsible for mounting and publicizing exhibits, and was a founding member of the X Group, which promoted the post-Vorticist avant-garde. He was loosely connected to the Bloomsbury Group of English writers and artists, and exhibited work at Roger Fry's Omega Workshop. He ran an avant-garde film society that introduced experimental cinema to London audiences. He joined the Arts League of Service (ALS), which was comprised of various fine and applied artists whose mission was to create work that would offset the destruction of the war. His career as a painter was finished, however, when in 1920, the X Group failed due to its own inertia, and he quit the London Group, too. "Gradually I saw the futility of trying to paint and do advertising at the same time," wrote Kauffer in the catalog to his exhibition at the Museum of Modern Art. Haworth-Booth reports that Kauffer then disappeared underground and the train station tunnels became his primary gallery.

Kauffer was a good painter, but his real genius was in advertising art (and for advocating the virtues of Modern art to business). His urbanity and intelligence opened many executive office doors, and he became friends with many of these business leaders. "Personal contact with the men requiring advertising art in the exploitation of their products is an absolute necessity in obtaining good results," he wrote to a colleague. But it was Kauffer's mastery of synthesis — wedding abstract, dynamic form to everyday products — that made him invaluable in the promotion of commercial enterprise. His posters and advertisements

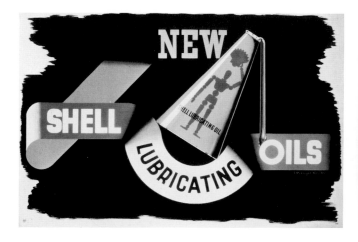

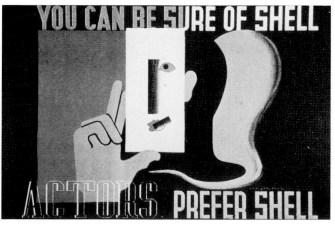

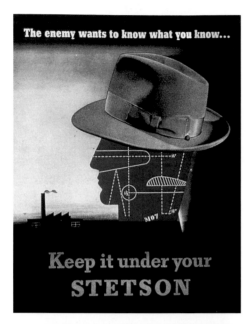

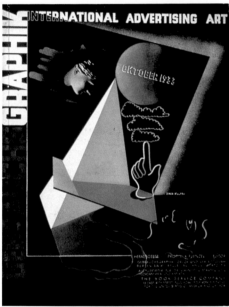

The Enemy Wants to Know
What You Know ...Keep It
Under Your Stetson (top);
cover design for *Graphik*
(above).

were not motivated by the common tactic of deceiving a customer into believing false claims, nor by appealing to their base instincts; rather he wanted to encourage people to simply be aware of a product or message by peaking their aesthetic sensitivities. Kauffer's strategy was consistent with the Modern ideal that art and industry were not mutually exclusive.

Kauffer often argued that non-representational and geometrical pattern designs "can effect a sledge hammer blow if handled by a sensitive designer possessing a knowledge of the action of color on the average man or woman." Nevertheless, even Kauffer had to lead clients by the hand: "In most cases, it has not been possible to give me full freedom," he wrote in the Museum of Modern art catalog, "and my clients have gone step-by-step rather than by leaps, but by this slow process we have reached a synthesis, and it is because of this mutual understanding that I confidently expect England to progress to international distinction, not because of myself but through the new talent that is making way in many directions ..." His own productivity is evidence that certain business men appreciated the communicative power of unconventional form, but even in such a receptive milieu there were hostile critics who referred to Kauffer's abstract designs as "McKnightmares."

Despite these occasional barbs, critics realized that Kauffer made significant trends in the applied arts, first in the application of Cubist form, and then after 1923, when he realized that Vorticism no longer offered viable commercial responsibilities and entered his so-called "Jazz style," in which he created colorful, art moderne interpretions of traditional form. Kauffer also successfully engaged in a number of different disciplines during the mid-Twenties. He designed scenery and costumes for the theatre starting in 1922; authored *The Art of the Poster* in 1924; designed office spaces beginning in 1925; illustrated books for the Nonesuch Press in 1926 (and illustrated poems by his good friend T.S. Eliot); and also began designing rugs, sometimes in concert with Marion Dorn, around 1929. In 1927 he took a three-day-a-week job at Crawford's, the largest advertising agency in England; that lasted two years and marked the end of his Jazz style and the move toward Modernist photomontage, influenced by German and Russian advertising of the time. He expanded on this revolutionary vocabulary, and in his own work replaced diagonal with rectilinear layouts, crushed his type into parallelograms, used positive/negative lettering frequently, and most important, took up the airbrush to achieve the streamlined effect that characterized his work of the Thirties. In addition to montages for ads and posters, Kauffer was involved with the

Detail, "Flight" (Untitled), 1919. Collection of The Museum of Modern Art, New York. Gift of the designer. Photograph copyright 1992, The Museum of Modern Art. The complete poster, fully titled "The Early Bird: Soaring to Success" was printed in *The Daily Herald*

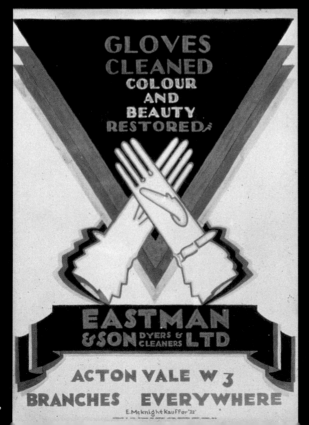

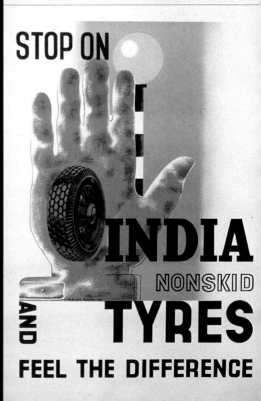

Gloves Cleaned:
Colour and Beauty,
poster for Eastman
& Son, 1922 (right);
Stop On India Non-
skid Tyres and Feel
The Difference, poster,
1935 (far right)

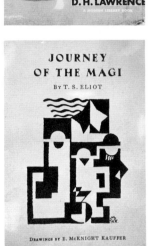

A selection of book cover
designs, 1927-1930s.

popular new medium of photomurals, and he developed the conceit of the "space frame" to give an illusion of multiple vantage points on a single picture plane.

In a review of one of his frequent exhibitions during the Thirties Kauffer was referred to as the "Picasso of Advertising Design." Critic Anthony Blount wrote: "Mr. McKnight Kauffer is an artist who makes one resent the division of the arts into major and minor." And in the introduction to the 1937 Museum of Modern Art exhibition catalog, Aldous Huxley praises Kauffer's primary contribution to modern design: "Most advertising artists spend their time elaborating symbols that stand for something different from the commodity they are advertising. Soap and refrigerators, scent and automobiles, stockings, holiday resorts, sanitary plumbing ...are advertised by means of representations of young females disporting themselves in opulent surroundings. Sex and

money — these would seem to be the two main interests of civilized human beings ...McKnight Kauffer prefers the more difficult task of advertising products in terms of forms that are symbolic only of these particular products. Thus, forms symbolic of mechanical power are used to advertise powerful machines; forms symbolic of space, loneliness and distance to advertise a holiday resort where prospects are wide and houses are few. ...In this matter McKnight Kauffer reveals his affinity with all artists who have ever aimed at expressiveness through simplification, distortion, and transposition. ..."

In Kauffer's hands the poster (or the book jacket, which for him was a mini-poster) was designed to be interpreted rather than accepted at face value. In this regard he continually struggled with the paradox of how to meet his creative needs, his clients' commercial interests, and his viewers' aesthetic preferences, all in a limited period of time. In a speech before the

Royal Society of Arts in 1938 (quoted by Keith Murgatroyd in *Print*) Kauffer candidly explained his methodology and resultant angst: "When I leave my client's office I am no longer considering what form my design or my scheme will take, but the urgent fact that I only have so much time in which to produce the finished article. I find this irritating, and am often overcome by a feeling of hopelessness about the whole business. ...On my way home I think ...will my client understand what I propose to do? Will he understand I may not give him an obvious, logical answer to his problem? Does he suppose I have magical powers, or does he believe that I can solve his sales problem as simply as one might add two and two together and make four? ...I have now reached my studio. I pick up a book. I lay it down. I look out of the window ...I stare at a blank wall, I move about ...I go to my desk and gaze at a blank piece of paper. I write on it the names of the product. I then paint it in some kind of lettering. I make it larger — smaller — slanting — heavy — light ...I make drawings of the object — in outline, with shadow and colour, large and then small — within the dimensions I have now set myself ..."

Kauffer's friends agree that he was restless long before he returned to America, which may account for his frequent changes in graphic style and media. He could be impetuous, yet also mercurial as evidenced in the description by Haworth-Booth of Kauffer's office at Crawford's — painted in various shades of grey to avoid the reflection of unwanted harsh light on his work. Kauffer was a slave to his passions. When war came to Britain he felt so passionate about turning his attention from commerce to public service that he decided to leave rather than be a liability to England. He and Marion immediately packed up a few belongings, left their car at the train station where they boarded a train to Ireland, and departed for New York on the *S.S. Washington* without even notifying their closest friends.

"It was a tragic mistake," says Haworth-Booth, who reprinted a letter from Kauffer to a friend in England which revealed profound remorse: "No day goes by — hardly an hour — the last thing at night — the first thing in the morning — our thoughts are of England." Frank Zachary, recalls that "Ted was a lost soul. Here was the most civilized, urbane man I ever met, and the top designer in England, unable to acclimatize himself to New York and American advertising." In one of the many letters sent back home to friends, Kauffer complains about the "big shots in New York designing and ...how they do not design at all? It's a wonderful racket. I look on in rapt amazement. I now know what's wrong with U.S. design." Although he was

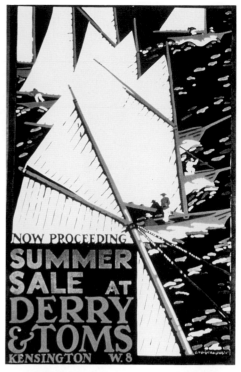

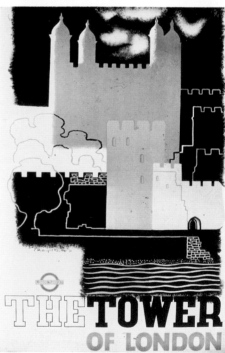

Summer Sale at Derry & Toms, poster, 1919 (top); The Tower of London, poster design for London Passenger Transport Board, 1934 (above).

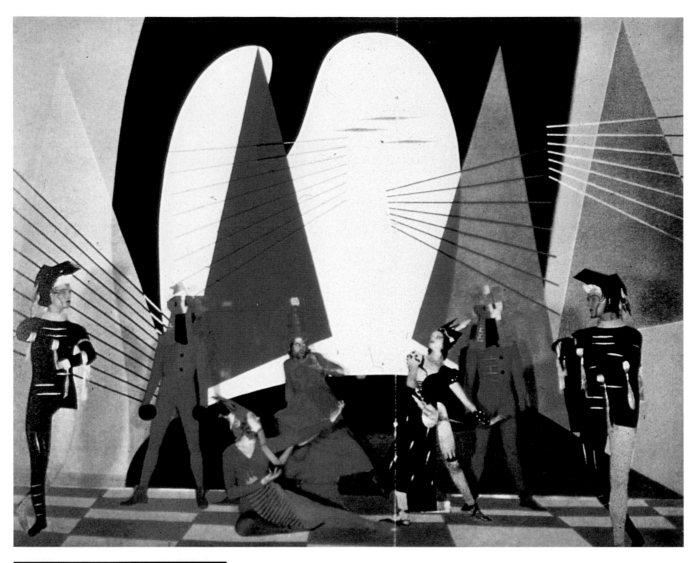

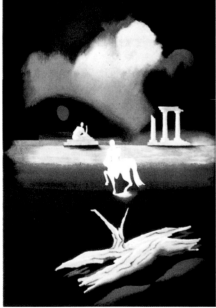

Set and costume designs for
Checkmate, a Vic-Wells ballet,
1937 (top and above).

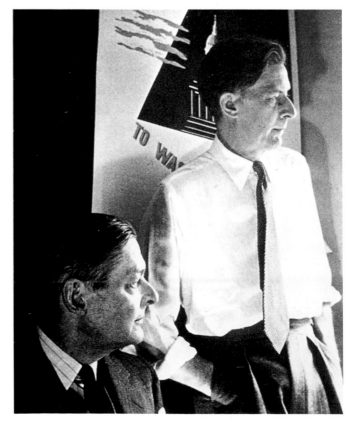

T.S. Eliot (left), and
Kauffer, New York,
1940s.

invited to show in a 1941 exhibition at New York's A-D Gallery, titled "The Advance Guard of Advertising Artists," he suffered a breakdown that year from which he never totally recovered. Despite several poster commissions (usually from institutional rather than commercial clients, i.e., War Relief, Red Cross, Office of Civilian Defense, etc.) and many magazine covers, book jackets and book illustrations, as well as jobs for Container Corporation, Barnum and Bailey Circus, and The New York Subways Advertising Company, he was not fulfilled. "In the extreme competitiveness of New York advertising he found it difficult to sell his work because he was no longer confident enough to sell himself," concluded Haworth-Booth.

In 1947 Kauffer was discovered by Bernard Waldman, a young New York advertising man who wanted to bring the European poster tradition in America. He commissioned Kauffer to do a series for American Airlines promoting California, Nevada, Arizona, and New Mexico as sun countries, a trip which required him to travel throughout these states. "Ted was in his proper enviroment. For weeks, months and years he talked about the West, which to him was more America than New York City, a place he called a 'depressing canyon of mortar, steel, bricks, and glass,'" wrote Waldman. The series of "lyrical landscapes" that continued until 1953 represented some of Kauffer's best American work, and helped him regain his confidence, albeit briefly. "After 1953, Kauffer's interest in advertising was on the wane," recalls Zachary, who as art director of *Holiday* magazine at that time had conceived a project for Kauffer that would pair him and his old friend (and American expatriot) T.S. Eliot on a riverboat journey down the Mississippi, during which time they would record the trip in words and pictures. However, during the planning stage Ted died. His friends say he killed himself with liquor.

In England Kauffer debunked the commonly held concept that if an artist was involved in commerce it was because he was really a creative failure. Even in America, despite its constricting conventions, Kauffer believed that art and commerce were perfect bedfellows. During the course of his career Kauffer was not only an original but also inspired originality in others, and his influence was felt in England into the Fifties. He was not afraid to shock, but was always responsible to his clients. And he never patronized his public. As Keith Murgatroyd has written, Kauffer, with style, grace, and intelligence "achieved all those things which every deeply committed designer strives for: creative vigor, originality, functional effectiveness, recognition by his fellow practitioners, and, of course, public acclaim."

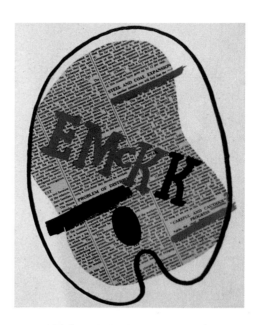

SELF PORTRAIT
E. McKnight Kauffer

Kauffer's signature graphic (top); and a self portrait (above).

GEORGE NELSON

Logo design for Whitney Publications' Interiors Library, early 1950s. Nelson was an editor and designer for the imprint (top); corporate logo for Soltroia, a proposed resort complex in Portugal, 1964-1965. The project was never realized (above).

By Judith Nasatir

You may not recognize much of the work on these pages. You should comprehend its spirit, though, even if you can't place its author. Over the years, countless words have been written about the force behind this, relatively little-known, work and other, much more publicized ventures. It is the work of George Nelson, a man whom some associate with the post-war glory years at Herman Miller and others with the founding of *Industrial Design* magazine. Still others may curse him for the development of the office system. But there are those who've read his lucid, if frequently caustic, prose or are familiar with his practical sense of whimsy and miss the resonance of a voice that was continually aimed with laser-like precision at the problems of design and the problems with designers.

Those who knew him, and worked with or for him, recall his ability to make the unexpected connections that resulted in new solutions, or to ask more interesting questions, or to dismiss the rote answer in design or anything else. Most especially, they remember his ability to develop an airtight argument with the tools offered by the discipline of design, and by the necessity of language, thus effectively forcing them to see and to think differently, and always clearly. As for the entire generation of designers who remain uninitiated, Stanley Abercrombie has written a forthcoming book on Nelson, *George Nelson: The Design of Modern Design*, which should fill the lacuna.

George Nelson was not a graphic designer. He called himself, simply, a designer. He practiced a variety of the so-called design disciplines during his fifty-odd calendar years of ceaseless professional activity. His formal training was in architecture. He became extremely well known as a furniture designer, an industrial designer, an interior designer, and exhibition designer. He was in the vanguard of a quiverful of design "disciplines" which were only becoming bona fide professions, or at least ways to make a living, at the same time he began to turn his hand to

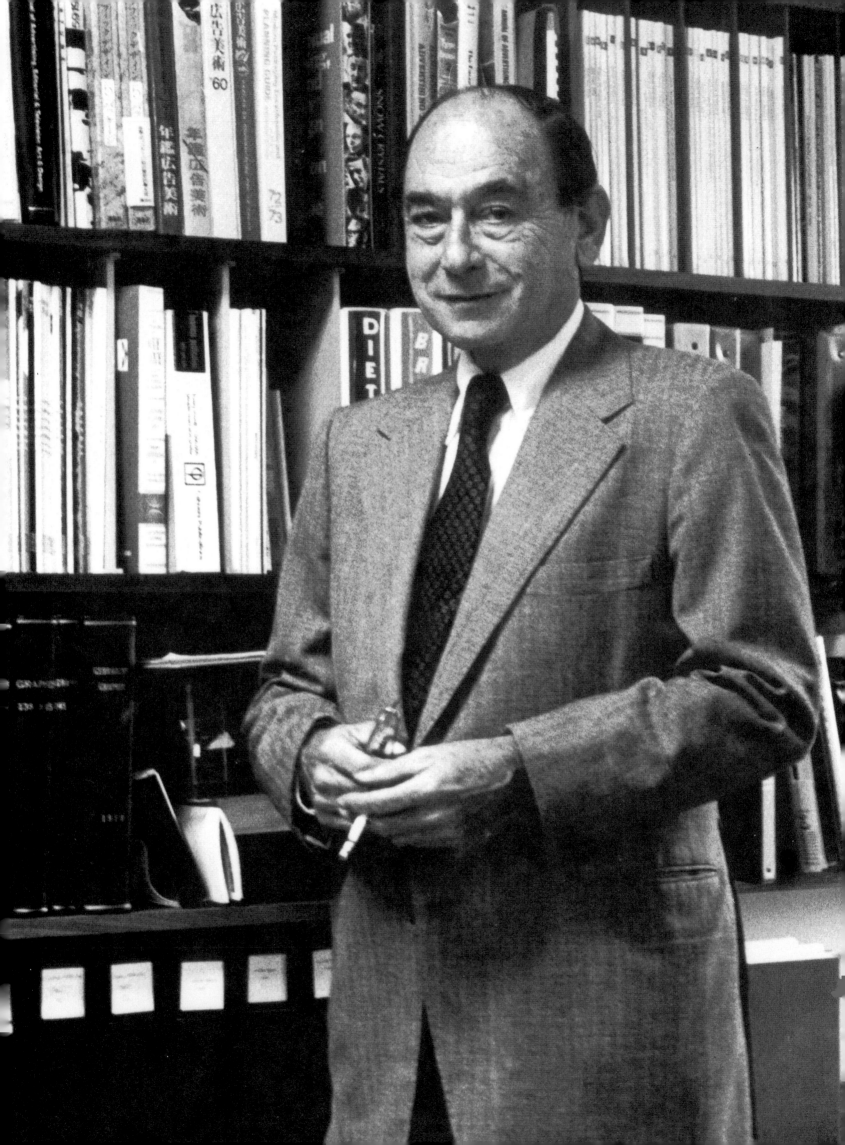

them. Or when he began to write about them. Or when he began to do the work that proliferated and sneaked in many, often unexpected, directions.

George Nelson in the course of this rather remarkable career managed to excel in several professions requiring skills of articulation seemingly removed from those of design. He was a marvelous writer. He was a reporter, an editor and an essayist. It may be that the designs he wrought from the English language were his greatest designs of all. Unfortunately, those essays, as well as the several books and countless magazine articles, have long been out of print.

He also taught, on and off, on and on, through those fifty years. And he travelled and took pictures, examining the world with a typewriter, a sketchbook and a camera. Then he wrote some more and designed some more, travelled some more and taught some more. And learned some more.

That pattern of integrated interests and abilities and diverse energies began establishing itself relatively early. George Harold

Nelson was born in 1908 in Hartford, Connecticut, and graduated from Hartford Public High School in 1924. He graduated in 1928 from Yale University, where he had discovered architecture, with a Bachelor of Arts degree. Afterwards, he pursued a Bachelor of Fine Arts at the Yale School of Fine Arts — the predecessor to the architecture school, where he was an instructor — which he received, with honors, in 1931. While in school and teaching, he also worked as a renderer in the New York architecture firm of Adams and Prentice. He headed south to do graduate work at Catholic University in Washington, D.C. and to prepare for the Paris Prize competition. Ironically enough, while he only made the finals of the Paris Prize, he won the Rome Prize in 1932.

He spent the next two years based in Rome, but it seems that he travelled throughout Europe quite a bit at a time when both Modernism and Fascism were on the rise. In a remarkable series of interviews with, among others, Gropius, Mies van der Rohe, Le Corbusier, Gio Ponti, the Luckner brothers (some of

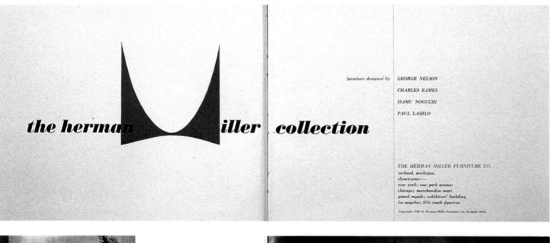

the herman Miller collection

furniture designed by GEORGE NELSON
CHARLES EAMES
ISAMU NOGUCHI
PAUL LASZLO

THE HERMAN MILLER FURNITURE CO.
zeeland, michigan.
showrooms —
new york; one park avenue
chicago; merchandise mart
grand rapids; exhibitors' building
los angeles; 816 south figueroa
Copyright, 1948, by Herman Miller Furniture Co., Zeeland, Mich.

Herman Miller was the client that launched Nelson into business in 1945. The company's first catalog was produced as a hardcover book. Irving Harper of the Nelson office created the Herman Miller "M," still in use.

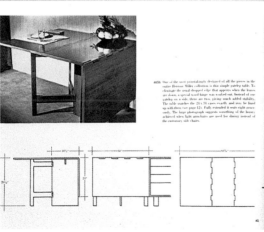

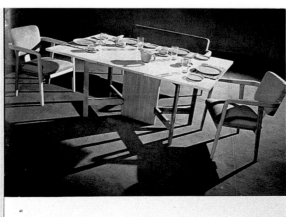

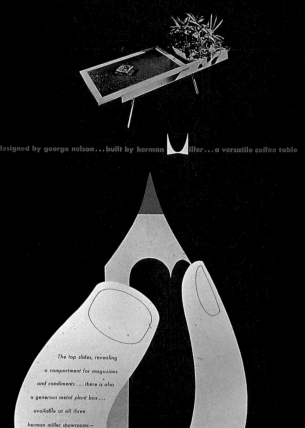

designed by george nelson...built by herman Miller...a versatile coffee table

The top slides, revealing
a compartment for magazines
and condiments... there is also
a generous metal plant box...
available at all three
herman miller showrooms—
one park avenue, new york,
622 merchandise mart, chicago,
exhibitors' building, grand rapids.

herman miller furniture company, zeeland, michigan

Furniture for
the bedroom

Nelson's first furniture
collection for Herman Miller,
totalling approximately 80
pieces, debuted in 1946.
On this page is a selection
of work from the advertising
and graphics of the original
catalogues.

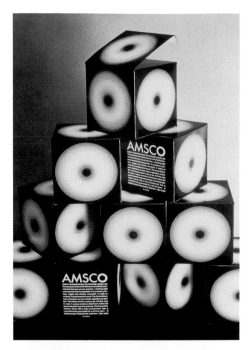

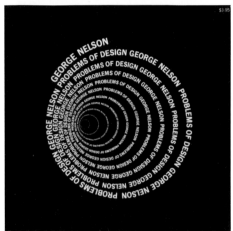

Packaging design for American
Musical Sales Corporation
(AMSCO), 1966 (top); cover
of *Problems of Design*, a collec-
tion of Nelson's essays, 1957
(middle); and corporate identity
for Everbrite Electric Signs,
early 1960s (above).

whom would die, some of whom would emigrate to the U.S.,
others of whom remained to rebuild Europe after the war or to
populate the obscurity into which many contemporary luminar-
ies often fall) he captured the political tenor of the age and
its effect or absence of effect on the life and work of designers.
These interviews were the first ever published in the United
States with these men, whose very existence would change the
way we live and work. There were twelve, published over a year
or so in *Pencil Points*, the architecture journal that eventually
evolved into *Progressive Architecture*. They appeared in print with
the editors' frequently repeated and increasingly strong caveat
about using that modern work as a paradigm for American arch-
itecture. That caveat was ignored by Nelson, some of his con-
temporaries, and an entire subsequent generation of architects
who saw the world differently.

After Nelson had sold the series to *Pencil Points*, but prior
to its complete publication, he landed a position in 1935 as an
editorial staff writer at *Architectural Forum*, the leading profes-
sional journal of the time, published by Time Inc. His first
written work for any journal in the Luce empire was for *Fortune*
magazine, and unsigned: it was an article in the February 1934
issue titled "Both Fish and Fowl ...is the Depression-weaned
Vocation of Industrial Design."

During the following decade at Time Inc. he went on to
become the co-managing editor of *Architectural Forum*, a special
contributor to *Fortune*, the head of the Fortune-Forum Experi-
mental Department, and a peripatetic who had, in the course of
roughly a decade that overarched the period of our delayed entry
into and successful exit from World War II, plotted the future
of housing, of city planning, the state of industry and of travel,
among many other varied topics. He published his first book in
1938 and, until America entered the war, he was also a partner,
with William Hamby, in an architecture firm that did rather well,
designing, among other things, a widely-published "machine
for living" house for Sherman Fairchild, the aircraft mogul, in
Manhattan. He also found time to teach evening courses at
Columbia, in the early Forties.

After the war Nelson met D.J. DePree, a mid-westerner
with a mission to find a new designer for the modern furniture
that his company, Herman Miller, had been making. This
meeting happened as a consequence of some work Nelson had
done for Time Inc. The project was the Storagewall, an insight
about interior space, organization, and efficiency that was even-
tually published in *Architectural Forum*, made the cover of *Life*
magazine, and filled a chapter in Nelson's book, *Tomorrow's*

Nelson developed a complete corporate image program for Abbott Laboratories from 1957-1958. The program included logo and packaging design, letterhead, building signage and literature. Nelson designed an exhibit for the client for the Seattle World's Fair in 1962.

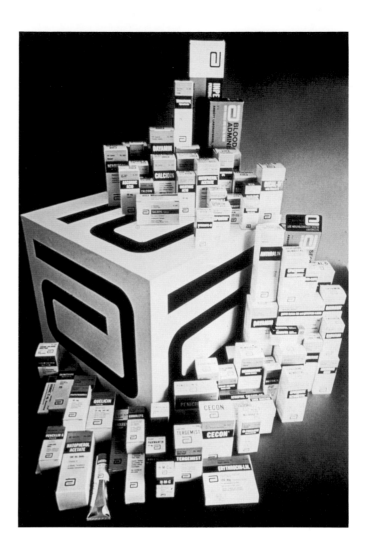

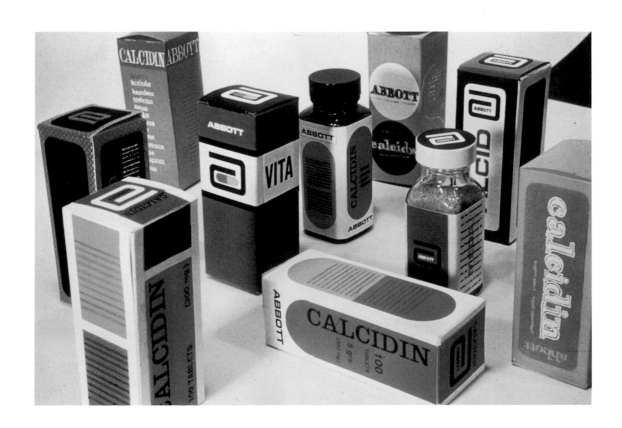

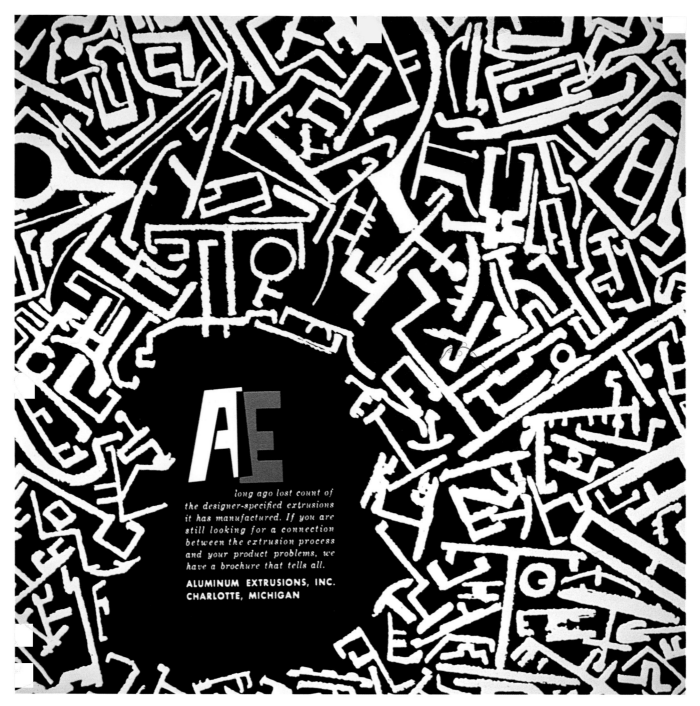

Over the period of 1950-1959, Nelson developed a complete graphic
identity for Aluminum Extrusions of Charlotte, Michigan. In 1957,
the company launched a subsidiary called Structural Products Inc.,
with a Nelson-designed pole-based storage system called OMNI,
whose corporate identity Nelson also designed (above and below).

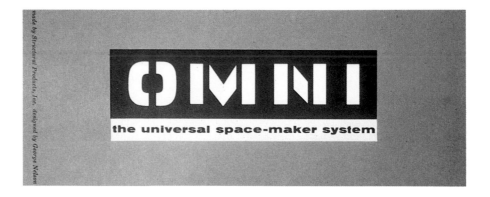

House, co-authored with Henry Wright, a colleague at *Architectural Forum*. The Storagewall, an architect's answer to getting rid of the unnecessary clutter that accumulated with post-war prosperity, signalled an unusual, and fortunate, convergence of purpose, training, and insight. It also indicated a preference for the sooner-rather-than-later extinction of free-standing furniture that Nelson would ceaselessly propose for the rest of his furniture-designing existence. All of which, with a few martinis on Nelson's part, several trips to the wilds of Zeeland, Michigan, and a handshake, led to a very long (nearly forty years) association between Nelson and Herman Miller.

The association segued naturally into the opening of Nelson's own design office and the exploration of other design interests. It led, naturally, to the winding down of the relationship with Time Inc., and, not surprisingly, to a contributing editorship with *Interiors* magazine and later to the evolution of *Industrial Design* magazine. But what it led to most importantly was the opportunity for Nelson to let his instincts flourish, to tease his thoughts free from the morass of extraneous information, and enable him to oversee the process required to translate an idea or insight into a physical, often useful and occasionally beautiful thing. This, bore a certain resemblance to the considerably reductive and always hasty cycle of magazine life.

The chance to put a keen critical sense to the practical test of developing designs for products, for what came to be called corporate image and graphic programs, for signage, for interiors, of really seizing an opportunity for design to play a significant role in commerce and, by extension, in culture didn't exactly come with Nelson's role as design director for Herman Miller. He just made it happen that way, by applying design to every designable aspect of the company: from his first furniture collection and the development of the Herman Miller mark to the design of the company's first, and subsequent catalogues; to letterhead and truck signage, advertising, secondary and tertiary literature, invitations and hangtags — even to collecting other designers to develop products for the company. It was all an act of faith. And it also yielded a great deal of growth for the company and for Nelson's design office. Perhaps most important, it endowed the general practice of design with a certain specificity and legitimacy it may well have lacked prior to the overwhelmingly convincing example Nelson provided.

That, in turn, gave Nelson a mission of his own: to make people see clearly what design was and was not, what it might be capable of achieving and what it would require, as a discipline, to reach its potential. He also tried his damndest to make people

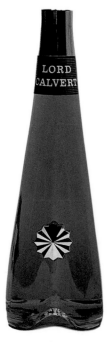

Poster and graphics for the movie *The Misfits*, for Seven Arts Productions, 1960. Don Ervin was the designer in charge.

Bottle and packaging design for Calvert Distillers, a client from 1955-1957.

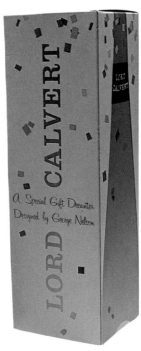

Logo design for Creative Playthings, 1967-1968. The Nelson office also designed packaging, furniture and clocks for the client.

Hanes was a Nelson client from 1969-1970. The office designed a new logo, which was used, but other graphics applications were not.

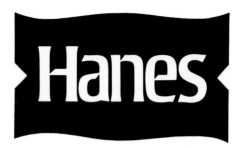

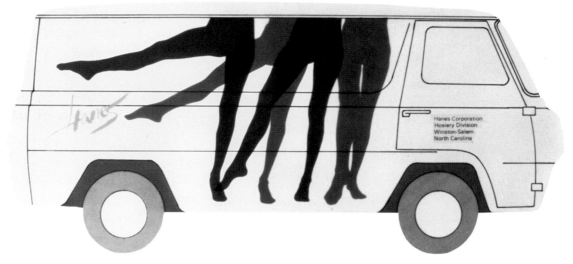

see that there was a thought process driving design, one which had a certain universality, with clearly beneficial effects for all those who disciplined themselves to look beyond visual style, to see more clearly the world they were making for themselves so that they would, at worst, synthesize and, at best, design a better one.

The effort to do this occupied Nelson for years. He fought the prejudice of a population he termed "visual illiterates," people who confused design with style, who hadn't developed any critical visual faculty, who didn't understand that the immediately apparent "look" of something was not design at all; that design was, to the contrary, an internal, necessary, and ineradicable logic inherent in the fabricated, synthetic world. Design, for Nelson, made the mind's eye visible, tangible, comprehensible in the language of materials of the physical world.

His argument has faded more rapidly and more completely than seems possible given his pre-eminence as an

ardent, provocative and persuasive articulator of a substantial underlying reason for design. He believed that the natural world and the natural sciences provided a kind of basic model that could be used by designers to design the manufactured world. He believed that designers ought to attempt to develop a scientific method for critical assessment of design. He believed that design, like science, needed a system as objective as theory, hypothesis and experimental investigation to insure its integrity. Of course, Nelson was at his most effective as a designer during the time when the scientific discoveries about the "design" of the physical world were thrillingly changing our perceptions and providing new models and metaphors to obtain greater clarity and depth of understanding of that physical world.

From the mid-1940s to the mid-1980s the Nelson office had a client list that included a host of Fortune 500 clients, a choice selection of those decades' entrepreneurs, some wacky projects, some possibly revolutionary proposals that were never realized, a number of endeavors years ahead of their time and,

Logo design and application for The Children's Place, a store for
kids, was developed from 1968-1970. Nelson also designed the
store interiors.

the children's place

Advertising designs for
Danskin, 1968-1969.

Literature for the U.S. Department of Health, Education and Welfare, Social Security Administration. Nelson developed a complete graphics standards for H.E.W. in 1970, and 1974-1976.

The 1976 inaugural exhibition of the Cooper-Hewitt Museum was "Man Transforms," for which Nelson designed the catalog and wrote the introduction and an essay, "The City as Mirror and Mask."

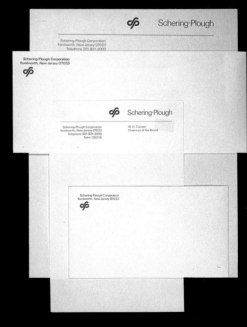

A complete graphics program for Schering Plough, a client from 1975-1983, included a logo design and letterhead.

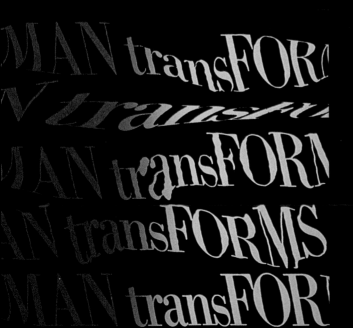

most unusual, a series of corporate brain trust-like consultancies even now outside the range of most designers' activities. Nelson continued to write, design, travel, lecture, organize (particularly Aspen conferences), and to serve generally as a self-appointed gadfly buzzing around the design community, stinging it awake every so often with an outrageous truth.

It is impossible, within the confines of this essay, to chronicle, even in precis, the work that Nelson himself and the Nelson office produced from 1945 until its close in the mid-1980s. That a gargantuan number of designs came to fruition is a wonder of its own. Much of the work has remained memorable, some of it has achieved icon status, and some designs have become cult classics. That this is so is a tribute indeed to the rigor of thought and agility of mind that went into their development. Other of Nelson's works, perhaps, were just a matter of luck: — the right idea came at the right time; the flash of insight illuminated unexpected possibilities.

Over the years, various people were more and less responsible for interpreting, translating and executing Nelson's ideas into graphics and packaging. The "paper" work and its applications were in concert with and expressive of design ideas contained in other aspects of any given project. The list of designers in the Nelson office who created graphics includes Irving Harper, Chris Pullman, Tomoko Miho, George Tscherny, Don Ervin, Fred Witzig, Herbert Lee, Tobias O'Mara, Philip George and Anthony Zamora, to name several.

The zest, appetite, curiosity, skill, and, in a way, innocence — or at least a certain idealism — Nelson brought to his life and work characterize him as a man of a specific time: an era which saw the rise and fall of a faith in America as a benevolent superpower with might and right on its side; an era which saw science fail to succeed its successes in its role as a catalyst; an era of progress usurped by politics and the force of economics.

Most fortuitously, Nelson lived during the roughly one-half century of the post-war period when design really could have mattered. Its current concerns, ideals, and style may unfortunately no longer mirror those that preoccupied him. But while they did, there was not a stronger, more eloquent nor more articulate practitioner than George Nelson.

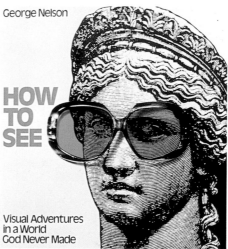

Poster design for Foster and Kleiser of Los Angeles, 1976, was commissioned for an art exhibit (top); cover design for Nelson's book, *How to See: Visual Adventures in a World God Never Made*, published by Little, Brown in 1977 (above).

MTV

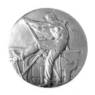

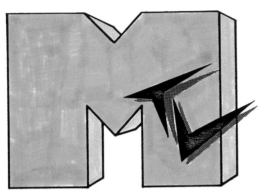

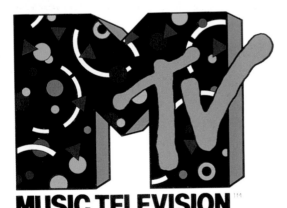

The first sketch of the MTV logo (top) by Pat Gorman of Manhattan Design, and one of its recent incarnations (above).

By Veronique Viènne

As you switch channels around, searching for a program on T.V. where you can drop your anchor and rest your brain, you always come across a zone of excitement, where sex, politics, fashion, music and money bob up and down on the screen like skiffs in the wind. You have just come across MTV — the station that brings you a visual climax, an emotional high, a conceptual orgasm. You have passed through the eye of the cultural storm.

MTV came into existence in August 1981. "It was a simple concept," remembers Robert W. Pittman, then a 27-year-old disk jockey. "We felt the fast-growing cable system would give us the opportunity to create a new medium, one that truly combined T.V. and rock 'n roll, for a generation of kids who had grown up with both as two isolated forms." Often credited for coming up with MTV's initial format, Pittman had announced: "It is going to be a channel with no programs, no beginning, no middle, no end."

Revolutionary concepts don't need a mission statement — they don't even need a name — but they still need a logo! Before the new cable network was able to agree on its content (was it going to be identified as a music or rock 'n roll channel?) Pittman had asked young designers to submit — on spec — their ideas for the corporate identity of the channel yet to be.

It is reassuring to think that graphic design, a linear discipline, can serve as a foil for a complex, soul-searching process. "We had no money and could not afford the Star Wars electronic super-graphics popular in those days," recalls Pittman. "We did not want to be conventional, stiff, or straight. Another 24-hour cable network, called Video Concert Hall, was being launched at the same time. We didn't want to be just another delivery system for music video clips. But what would make us different? We didn't know."

Not knowing turned out to be MTV's greatest strength. Not knowing meant that everything was possible. Not knowing

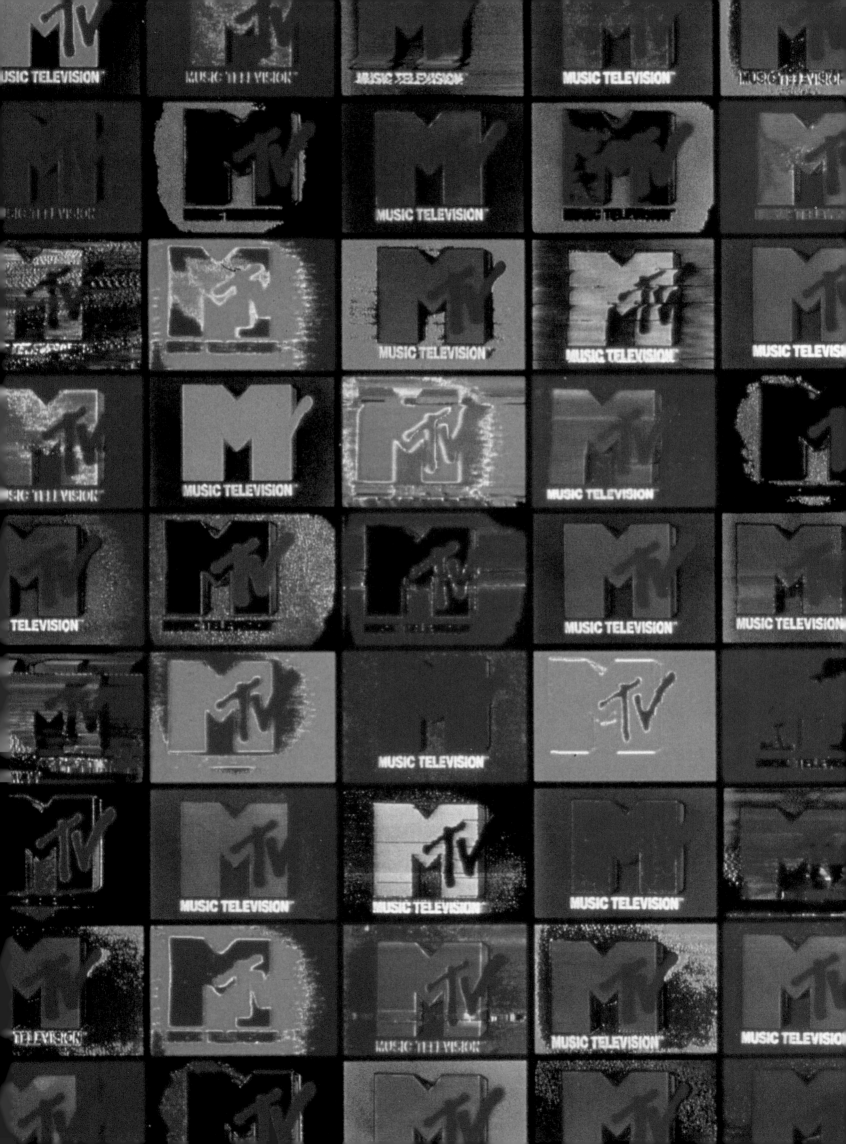

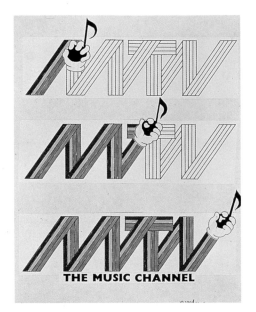

Some early attempts at the development of a graphic identity for the newly created music station.

preserved the station's innocence. Not knowing guaranteed it would be committed to innovation and experimentation.

"We invented new rules that were non-rules," says Fred Seibert, who, with his partner Alan Goodman, came up with the concept of the on-air promotional clip, the 10-second I.D. spot that soon became MTV's unique trademark. "We did not know what we wanted, but we knew what we didn't want — to do what everyone else did. For example, we were told that we had to have only one supplier to get a coherent identity. So of course we did the opposite — we asked a dozen people to contribute to a piece of the MTV look." Siebert wanted to capture on the screen and in movement the exhilarating feel and the graphic feast of album covers of the Sixties and Seventies. Illustrators including Mark Hess, Seymour Chwast, Milton Glaser, Lou Beach, Tony Lane, Michel Folon, Jean-Paul Goude, Mick Haggerty and Neville Brody had done some of the best covers of the time.

For the logo, Siebert suggested a rock 'n roll enthusiast, his boyhood friend Fred Olinsky, an unknown designer who had just opened a graphic design studio called Manhattan Design. Pittman gave his approval. Pat Gorman, one of Frank Olinsky's partners, says Bob Pittman was unusually supportive. "He told us that we could do anything. He *always* got it," recalls Gorman. "But the 'cigars,' as we used to call the station's business people, were nervous. Remember, at the time the station was nothing — and we were nothing. They could not afford a legitimate big-name designer — we could not afford a xerox machine." Pat and Frank drew loose sketches with markers and turned up hundreds of eclectic ideas, everything from a cartoon glove squeezing a musical note to a logo as colorful as a rainbow. The station was looking for something with energy and life, something with a constant element of improvisation. From the beginning, they all agreed that the MTV logo was going to be a very public thing, a concept that would be shared with friends and viewers, just like rock 'n roll.

One day, as they were about to send their recommendations to the station, Frank and Pat had an argument. She had designed a logo with a big "M" and a small lowercase "tv." He thought it was ugly, and threw the sketch into the wastebastket. "I wasn't going to say anything," recalls Pat, "but then, I figured, we were partners, and it was time I learn to assert myself. I fished the crumpled drawing out of the trash and explained that I wanted the 'M' to be monumental, a cultural entity, like Superman." She convinced Frank. He quickly spray-painted a new-and-improved "tv" and they sent the patched-up collage along with the other drawings. The rest is history. "I thought the drip on the spray-

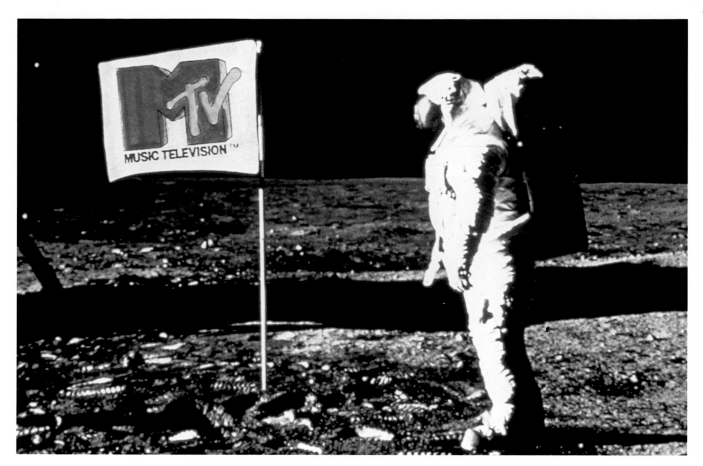

MTV makes a landing in August, 1981 (above); the original television spot ad. Some test runs of projected ideas for various logos which were never used (below).

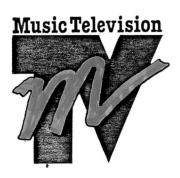

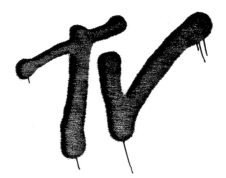

painted 'tv' was too limiting, so they got rid of it," says Pittman. "That's the only change I suggested." Designed to sustain endless abuse and permutations, the logo came through this first review almost in one piece.

But the station was getting cold feet and having second thoughts. "Some people suggested the 'M' be brown and the 'tv' be teal grey," says Pat. As she had hoped, the thing had a life of its own. Launched August 1, 1981, MTV introduced its logo in a short crude video showing an inscribed flag being planted on the moon. The public adopted it at once. Subscribers reacted by sending postcards showing their own version of the logo. It was an instant sensation. No matter what you did to it, the big "M" and its sidekick, the wiry "tv," were always recognizable.

Faithful to its original intention, MTV invited painters, photographers, film makers, illustrators, cartoonists, animators, performance artists, stand-up comics, puppeteers, and even musicians and rock 'n roll singers, to submit their own version. The endless logo transmogrifications were playful metamorphoses exploiting the graphic possibilities of such cultural icons as a pair of jeans, the hood of a truck, Formica patterns, junk food, electronic equipment, scenes from old movies. Everything they did seemed to work.

The MTV logo, like the station itself, is an open-ended format that encourages interpretations and proclaims that the process of becoming, rather than its outcome, is the main event. MTV was conceived as — and still is — a phenomenon, a form

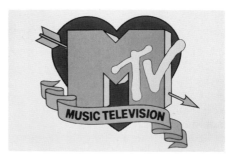

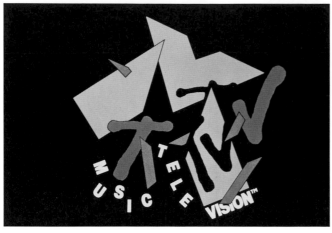
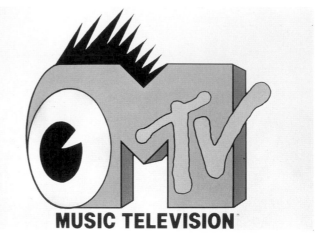

This page and opposite, over a period of time, Manhattan Design exploited the graphic possibilities of the MTV logo and its open-ended format.

of collective improvisation. It is visual rock 'n roll.

Music Television reinvented the way we watch T.V. by making us see with our ears and listen with our eyes. The secret of its appeal is its powerful visual beat. Making the most of contrasts and juxtapositions, the station creates a throbbing rhythm of images that oscillate all day long. It alternates short and snappy clips with cool and mellow "veejays" commentaries; gritty rap music with nostalgic rock 'n roll; fast delivery with tedious repetitions; color with black-and-white; soft focus with sharp, giant close-ups; politically correct rock videos with crass commercial advertising. MTV is a binary delivery system. Its main content is its all encompassing duality that embraces and surrounds everything. More than a network, MTV is a frame-work for our sensory perceptions.

The audience, catching random fragments of this seamless video environment, generates a fluctuating pattern of awareness, as serendipitous as a jazz melody. To encourage a freer, im-promptu and interactive attitude among its viewers, the station sponsors numerous call-in surveys, competitions and contests. A dialogue takes place between the station and its 260 million subscribers in 56 countries. Impulsive, spontaneous, effortless, T.V. watching — *not* watching T.V. — is a new form of enter-tainment. The so-called short attention span of the MTV genera-tion is a myth. The speed of delivery of the images, the tempo of

the sound track and the thin line that separates art from com-merce, together promote an invigorating alertness. The attention span required to participate is fluid, condensed, focused.

MTV's main graphic mandate is the constant exploration of the relationship between music and television, listening and watching, the viewer and the tube. The success of the formula depends on keeping that relationship alive. Tom Freston, who created MTV's marketing division and is now chairman and ceo of MTV Networks, believes that the quality of the work is inversely proportionate to the distance between the original idea and its delivery. The shorter the pipeline, the greater the impact. To make sure that the viewers are involved with the process, the station hires it fans and expects them to have as much fun working for MTV as they have watching it. The office looks like the inside of a television set. The atmosphere is homey. But there are no couch potatoes. The staffers (average age, 26) flash in and out of rooms, like images on the screen.

The direct link between inspiration and creation is clearly visible in MTV's 10-second I.D. clips, the brief elliptical art films or mini-position statements that act as station identification spots and reaffirm the network's commitment to graphic innovations. "Our brief is simple," says Abby Terkuhle, who is responsible for assigning the animated clips and on-air promotions to an in-ternational talent pool of film makers, animators, and cartoonists.

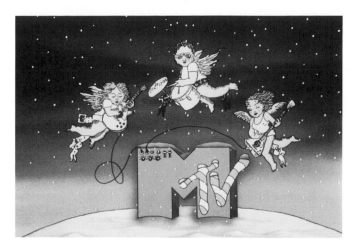
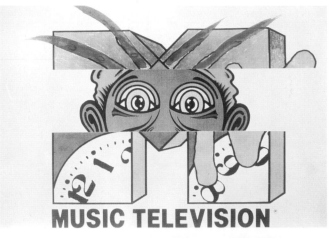

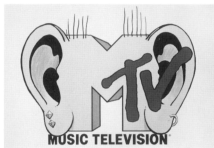
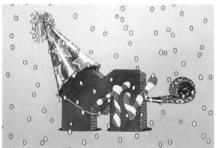
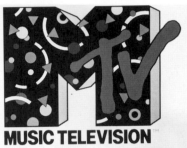

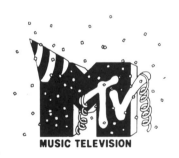

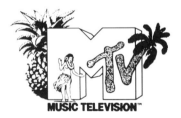

Preliminary sketches by Manhattan Design of MTV logo.

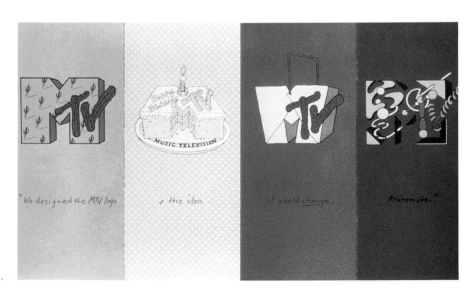

Manhattan Design self-
promotional piece, 1985.

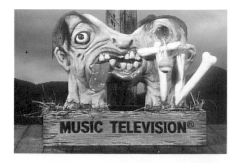

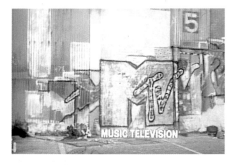

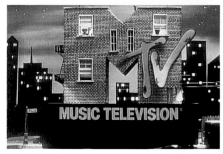

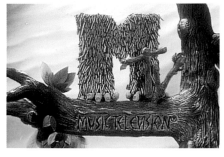

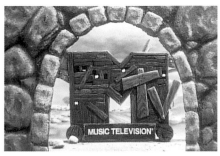

Sequence stills from various
MTV identification video clips.

"Make the logo the protagonist. Ten seconds a piece, two seconds of which are dedicated to the logo. Don't assume that the 'M' is necessarily the punch line. Have fun. Take a risk." The assignment is always a creative challenge, but never a financial opportunity for the film makers or studios who are invited to submit storyboards for an MTV clip. Low budgets, a necessity in the early days, keep the station form losing its defiant and disrespectful resonance. The resulting short films, thrown into the programming mix like so many insignificant tidbits, are in fact intensely effective reminders of the purpose of MTV, which is to reinvent T.V. by trivializing it. Intriguing, foolish, nonsensical, they insult and ridicule the very experience of watching: a logo is tumbling in the wash cycle; a little skeleton is giving the viewer a haircut; a giant insect is xeroxed over and over to form a logo; a coded message is flashed on the screen, but disappears before you can read it. "This is not television," proclaims a Magritte parody of the famous painter's "Ceci n'est pas un pipe" canvas. O.K then, what is it?

Judith McGrath, MTV's creative director, magnet, mother, cheerleader, conceptualizer and patron saint, understands the big picture — and the big picture, she says, is the sound track. "It still takes a great song. The audio always comes first. We cut the visuals to the music, never vice-versa." She explains that Michael Jackson and Madonna are most influential in the business because they understand how to use images to support the melody, the rhythm and the lyrics. Not everyone can be a great singer — and an inspired graphic artist.

"We are both the mirror and the window," suggests Terkuhle. "My staff and I, as you can imagine, watch MTV a lot. We get tired of the stuff before viewers do. Our only constant is change. Our main challenge is to remain open."

"We are an extraordinary group of people," offers Robert Pittman, who left MTV and is now president and ceo at Time Warner. "We understood how to take advantage of the speed of electronic technology. Most of the original group left MTV, but we are all over, creating new ideas, contributing to the cyclical renewal of creative T.V."

One thing is certain: When it comes to MTV, it is not what it appears to be. It's not music; it's not television; it's not good and it's not bad; it's not important, yet it's phenomenal. It has nothing to do with graphic design — but it is a powerful graphic device. By refusing to be any one thing, MTV is everything at once, 24-hours-a-day, seven-days-a-week, in every language.

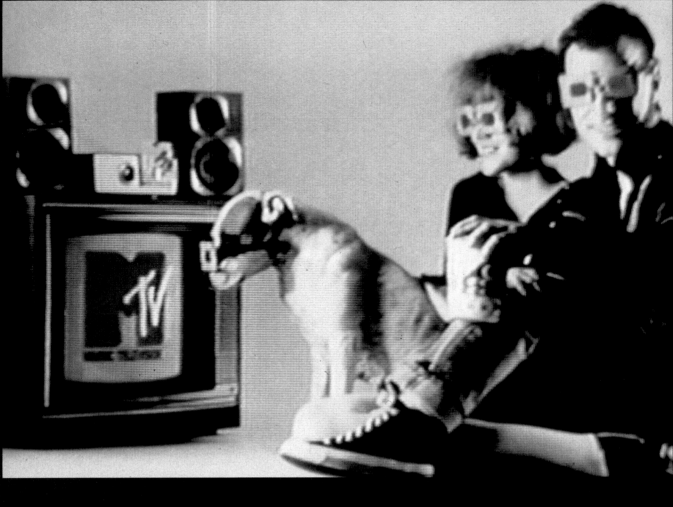

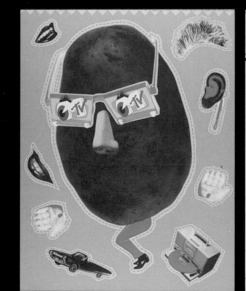

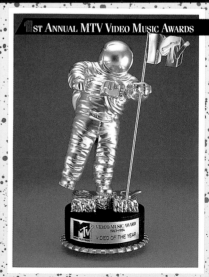

Print materials from the
first annual MTV Video
Music Awards (above and
right); the MTV "Oscar"
is a recreation of the first
MTV on-air clip showing
a man landing on the
moon (far right).

OLIVETTI

DESIGNING A WORLD

Poster by Xanti Schawinsky
for the Olivetti M1 typewriter,
1935 (top); Egidio Bonfante's
poster for the Christmas
campaign, 1976 (above).

By Hugh Aldersey-Williams

In presenting the annual Design Leadership award to the
Italian computer and office equipment manufacturer, Olivetti,
the American Institute of Graphic Arts praises that company's
patronage of graphic design during its 84 years of existence.
Yet to single out graphic design from among Olivetti's areas of
excellence tells less than the whole story. It is only by examining
the patronage of all the design professions by Olivetti — and
indeed by examining that patronage in the far broader context
of Italian culture as a whole — that a measure of the company's
true achievement may be gained.

Foreign observers seeking to examine the prominence
given to design at Olivetti quickly light upon the importance of
something vaguely termed "the Italian culture" in shaping the
company's attitude. While it is virtually unavoidable that we
should wonder at this, the scrutiny merely perplexes the Italians
themselves, so deeply rooted is the cultural in everyday matters
of life and business.

It is this symbiosis of commercial and cultural priorities that
gives much of Italian industry its strength and confidence as it
confronts the Single Market of Europe after 1992. At Olivetti, it
helps to explain how two of the world's best industrial designers,
Ettore Sottsass Jr. and Mario Bellini, were "found" by Olivetti
not when they were already running successful consultancies, but
at the outset of their careers, based on sight — and comprehen-
sion of the merit — of early projects, or more telling still, from
having read their writings.

It is well known that IBM's Thomas J. Watson Jr. was
influenced by Olivetti's outstanding design in the Fifties. It is less
frequently noted that Watson was merely returning a trans-
Atlantic compliment. Adriano Olivetti, the head of the company
from 1924 to 1960, like his father, Camillo, before him, was
much influenced by a sojourn in the United States. He admired
the latest advertising techniques and the new ideas about

olivetti

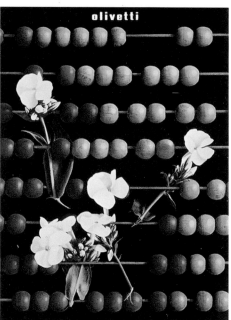

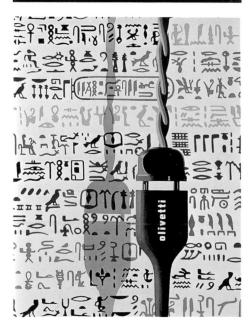

Poster designs by Giovanni
Pintori, 1947, 1953.

corporate image-building. Upon his return to Italy, he applied what he had seen. "However, he did not go along with the American model," according to a book on Olivetti design, "but tried to introduce a new style of communication, which should be far more than a simple sales device. Starting with his basic attitude to the purpose of the product and the function of the company, he had a message that ultimately dealt with modern civilization, its development by means of technological progress and the corresponding products and methods." [1]

This sort of talk would be sheer hyperbole coming from an American company; from Olivetti, as from many Italian companies, it merely describes the way things are. Consider one of Olivetti's most famous products, the Valentine typewriter. Designed by Ettore Sottsass in the Sixties, this bright red portable signaled through its design its intention to break free of the conventional wisdom of how such things should look. This typewriter was recreational, even playful. Milton Glaser's posters advertising the product — impishly inserting it into details of classical paintings — developed the theme of playfulness. Similarly, Jean-Michel Folon's hilarious yet disturbing depictions of men dwarfed by machines in another series of illustrations seem a little ironic put to use by Olivetti, but they too place the company's products in a broader context by their reference to man's relationship with his technological world.

The union of spirit between graphics and products is perhaps closest, however, with the earlier posters of Giovanni Pintori for the machines designed by Marcello Nizzoli. Both designers enjoyed an association with Olivetti over three decades. Perhaps the most endearing example of the collaboration is a poster for the Lexikon 80 typewriter in which a ball skips across the keys of the typewriter leaving a trail of dots behind it like a frog hopping from lilypad to lilypad. With supreme lightness of touch, Pintori demonstrates the lightness of touch needed to operate the machine.

The Olivetti patronage is notable for these high points, but also for its continuity. Where other 20th century patrons of design have experienced one period that surpassed others (IBM during the Fifties and Sixties, the German company AEG during the early 1900s, London Transport during the Thirties), Olivetti has rarely slipped. As Renzo Zorzi, the company's consultant on cultural activities, writes: "There are times when product design takes first place, and others when architectural achievements are prominent, or when the company's relationship with its public is most strongly typified by its graphics work, ...But no strand is ever broken..." [2]

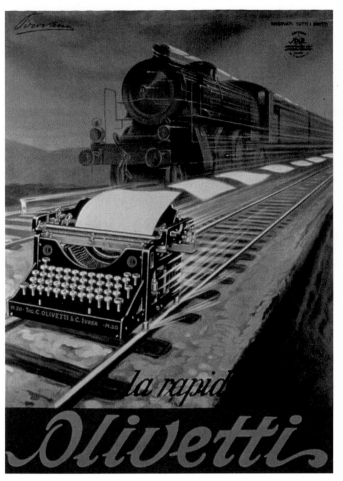

Poster design by Pirovano
for the Olivetti M20, 1920.

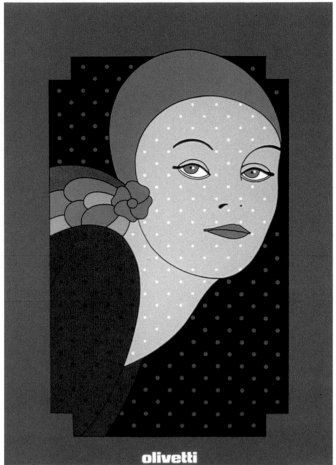

Poster design by Walter
Ballmer, 1974.

The Olivetti story began in the United States when the founder of the company, Camillo Olivetti, noticed that the typewriters (originally an Italian invention, it is claimed) being manufactured there could be improved. Olivetti's first typewriter went into production in 1911. Even with this first product, the M1, which well predated the emergence of a distinct profession of industrial design, Olivetti recognized that the aesthetics of the object were important. He also saw no distinction between excellence in three dimensions and excellence in two dimensions. Graphic design was the equal of product design from the beginning, seen in magnificent advertising posters, by Teodoro Wolf-Ferrari depicting Dante recommending the M1 in 1912, and of a subsequent model memorably drawn by Pirovano racing down a railroad track with a steam train thundering alongside in 1920.

When Adriano Olivetti took over from his father to run the company from 1924 to 1960, he took steps to formalize the design structure. He introduced the concept of corporate image and identity, long before it was generally recognized as a business tool. Unlike AEG or IBM which relied largely on single figure (Peter Behrens, Eliot Noyes) to engender a design consciousness, Olivetti took a more heterogeneous approach that suggests a greater cultural confidence.

The company continued under family control after Adriano's death in 1960, but design slipped down the list of priorities. The early Sixties marks one of those relative lapses that punctuate any history of patronage. Management grew more complex. Products were becoming more diversified, requirements for graphics were growing exponentially, and the design policy was becoming confused. The company recognized the situation and resolved it with the promotion of Renzo Zorzi, who at that time was running an Olivetti publishing house, to the all-encompassing role of cultural coordinator. Zorzi had known Adriano and understood the ineffable principles by which he sought to nurture his company and its cultural contribution. Under Adriano Olivetti's successors, Bruno Visentini (chairman for a 20-year period), and, subsequently, entrepreneur Carlo De Benedetti, Zorzi had the authority he needed to institutionalize this early, essentially personal

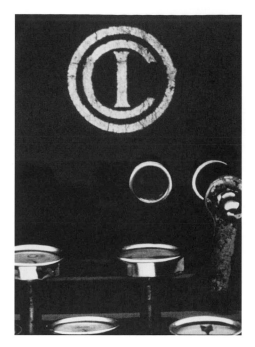

Trademark and logotype used
by Camillo Olivetti for the M1.
Photograph © Ezio Frea.

The Olivetti trademark
logo, 1930, 1934, 1947,
1970. The new logotype
(1970) designed by
Walter Ballmer, reflects
the evolution of the three
preceding verisons.

Olivetti

olivetti

olivetti

olivetti

Trademark designed
by Nizzoli, 1956.

patronage. "Zorzi must have seen that Olivetti could keep its 'soul' under a neutral management only if he succeeded in establishing an institution right at the center of the company which would serve precisely to maintain and publicize this 'soul,' that is, the company philosophy. ...Zorzi not ony set up the appropriate organizational structure for this division, he also created the theoretical and abstract foundations for defining the purpose and necessity of a corporate image policy in a modern company." [3]

Zorzi headed the Corporate Image Department. Its aim was to gather into one department control of all activities that gave Olivetti its material expression. The Corporate Image took five aspects. There were two product design divisions, one for the larger product types based at Sottass's studio in Milan, the other, for office equipment, under Mario Bellini, at first working at Olivetti's headquarters in Ivrea outside Turin before he too set up his own studio in Milan. The arrangement continued that begun by Adriano Olivetti under which product designers

remained as freelance consultants with the own studios, yet also contributed greatly to the shaping of the Olivetti material culture. It also provided evidence of the seriousness of Olivetti's cultural commitment, continuing links with Milan — Italy's center of artistic and intellectual activity — that had been set up as long ago as 1931.

In addition, Zorzi set up a department of graphic design (under Roberto Pieraccini and then Hans von Klier), including typeface design, a corporate identity department, and an office with responsibility for cultural activities. This last department, to which Zorzi serves as a consultant to this day, coordinated a wide range of exhibitions from icons of Italian culture and fine art to thought-provoking shows of contemporary design (the "New Domestic Landscape" exhibit of Italian design at the New York Museum of Modern Art was one example). Although the subject matter is eclectic, each topic reflects some aspect of Olivetti's own culture.

Bellini, Sottsass and von Klier form an inner circle of reg-

ular, but still freelance, designers who have shaped modern Olivetti. Within this framework, the company has made good use of other designers and artists, among them Milton Glaser, Jean-Michel Folon, Paul Davis, the Vignellis, George Nelson, Michele De Lucchi and Leo Lionni.

In graphics, there is no one figure today who fulfills the role taken by Sottsass and Bellini in product design. Giovanni Pintori came closest to this position during his long association with the company and with Nizzoli's products. His place was gradually taken by Franco Bassi. Bassi's rigorous training brought a sharp change from Pintori that saw Olivetti's advertising into the electronic era with a use of geometry that was "very nearly moral" and a sparing use of color. Zorzi wrote in *Graphis*: "Franco Bassi has been involved in the field of graphic communications — together with Walter Ballmer — for the Olivetti company, an enterprise that has endeavored for many years to create an identity of its own, with a homogeneous visual style, in all fields of industrial design, architecture, interior decoration, printed matter, advertising and cultural activities. ...the interaction of designer and company has been so close over a long period that it is often difficult to draw a dividing line." [4] The situation that Zorzi describes is typical of the equilibrium that Olivetti achieves with its designers.

For his part, Ballmer was responsible for the new company logotype of 1970 that is still in use. His posters provided a necessary counterbalance to Bassi's abstractions. "In the creation of the most direct advertising ...the artist applies his pictorial fantasy and his typographical experience to communications often aimed at suggesting the cultural effects associated with the use of the product in question." For example, a drawing of a fragment of a keyboard shows four giant keys in an exaggerated perspective, emphasizing the link to Olivetti's industrial design as the selling point. "Ballmer's graphic messages are always guided by rational, explanatory and even didactic intentions." [5]

Edigio Bonfante took Ballmer's technique further, sacrificing some of its instructive nature in favor of a more oblique, Surrealist-inspired approach. The Anglo-Spanish Perry King and Santiago Miranda worked with von Klier on the company's monumental corporate identity manual, and ewre rewarded in the early Eighties with the freedom to design posters and other artwork. King and Miranda's images were unlike the graphics of Bassi and Ballmer. Their approach was to set mysterious geometric shapes and symbols against backgrounds distorted in their perspective, and often framed, like the paintings of the early Renaissance, although these symbols once again often had a

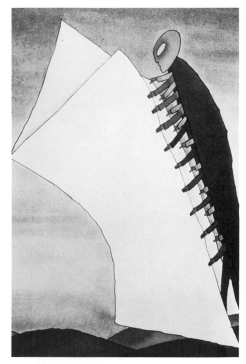

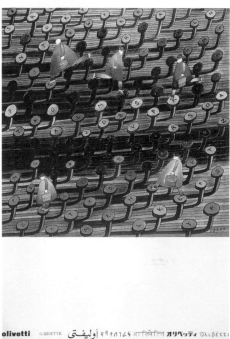

Poster and Olivetti Diary designs by Jean-Michel Folon, 1970s.

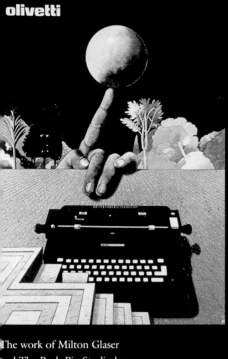

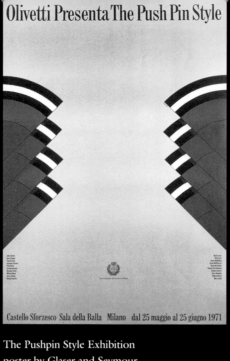

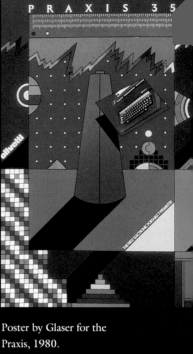

The work of Milton Glaser and The Push Pin Studio has appeared on many Olivetti graphics. Poster by Glaser for the Lexicon 83DL, 1976 and 1977.

The Pushpin Style Exhibition poster by Glaser and Seymour Chwast, 1971.

Poster by Glaser for the Praxis, 1980.

"Olivetti in the World" poster design by Perry A. King and Santiago Miranda, 1978.

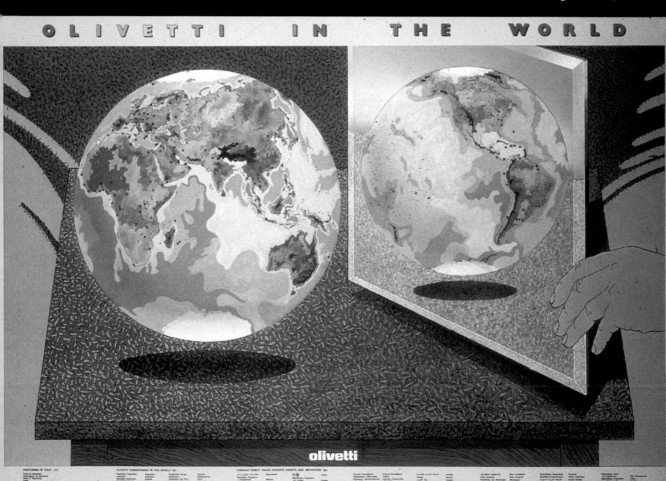

didactic intent, most notably perhaps with the twisted crystal motif that was used for the Design Process Olivetti exhibition and the accompanying book to illustrate the interconnection between Olivetti's design and cultural activities. Zorzi described King and Miranda's work in the following terms: "Graphic design, ...seems to be carving out something new and strong in visual images as well as in figurative representation, moving away from a fairly frigid form of graphic symmetry in which expression became little more than an exaltation of typogaphic characters, their careful arrangement on a page, the balance of their densities." [6] Another mainstay of Olivetti design is a creative graphics linked with specific expressive forms, used to illustrate special editions of major literary works and the Olivetti diary. The illustrations for these publications, which are offered as gifts to customers and the Olivetti public, are commissioned from leading international artists. Selections are coordinated by another great name in the history of Olivetti's corporate image, the author Giorgio Soavi. But in recent years the progression from abstraction to allegory has been interrupted by banal, copy-heavy advertising flagged with bold capital headlines in the undistinguished typeface that might be used by any corporation. In product design, not withstanding some fine typewriters by Bellini, the Eighties saw some personal computers with little to distinguish them from the pack. Even Olivetti, it seems, cannot pull itself entirely free from the market force that leads to greater product uniformity.

The mid-Eighties, like the early Sixties, marks another lapse. Pressured by greater international competition, Olivetti briefly turned its back on the values that had held good for three quarters of a century. However, with the return of De Benedetti early in 1992, these moves have been reversed and Zorzi is back in his familiar role as consultant on all matters cultural. As European companies prepare for the more competitive Single Market, Olivetti will now have the opportunity to put to the test the real commercial merit of its design patronage.

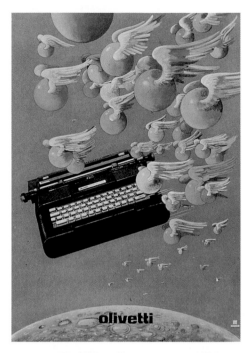

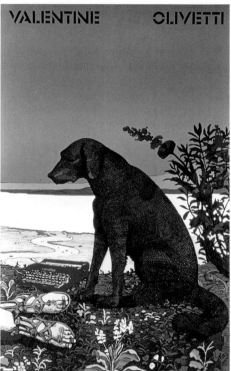

Poster design by Milton Glaser for the Lexicon 82, 1976 (top); Glaser's poster for the Valentine portable typewriter. The poster was inspired by a painting by Piero di Cosimo depicting a dog grieving over the body of its master (above).

References:

1 Sybille Kircherer, *Olivetti, A Study of the Corporate Management of Design,* Trefoil, London, 1990.
2 *Design Process Olivetti 1908-1983*, Olivetti, Ivrea, 1983.
3 Kircherer, ibid.
4 Renzo Zorzi, Franco Bassi, *Graphis*, 214 pp 134-141.
5 *Design Process*, ibid.
6 Renzo Zorzi, "Introductory Note," in Gianni Barbacetto, *Design Interface: How Man and Machine Communicate. Olivetti Design and Research by King and Miranda*, Arcadia Edizioni, Milan, 1987.

Quite a few of the submissions, although conceptually good and appealing to children, were not acceptable from the judges' points of view in terms of layout and typography. There was an abundance of emphemera promoting on a mass scale items for children that did nothing to elevate the advancement of visual communication. Where were all the experimental games, toys, learning environments, kits, etc. — brilliant things the likes of Zolo — and Bruno Munariesque inventiveness integrating the technology that is now available? Where were the young people who take chances on their design? Perhaps too poor in a recession to submit. There were glimmers of refreshing surprises, one in particular being the environmental and economically concerned *Koo Koo News*, which was produced by kids. I subscribed.

Keith Godard, Chairman
Communicating With Children

Call-for-Entries

Design and model kit: Keith Godard/Studio Works

Layout and Typography: Christy Trotter/Studio Works

Linotronic Typesetting: PDR New York

Printing: Danbury Printing

Printed on Celesta Dull Cover, donated by Westvaco

JURY

Andy Ackerman *Executive Director*
Children's Museum of Manhattan

Lois Ehlert *Graphic designer and illustrator*

Steff Geissbuhler *Principal*
Chermayeff and Geismar Associates, Inc.

Keith Godard *Principal*
Studio Works

Karen Skelton *President*
Bellwether Design, Inc.

iscovery nteraction cience reativity

1

2

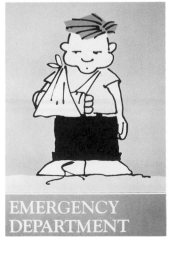

PATIENT REGISTRATION

EMERGENCY DEPARTMENT

RADIOLOGY

REHABILITATION SERVICES

1
Poster **DISCOVERY: CHILDREN'S MUSEUM OF LAS VEGAS**
Art Directors **GILBERTO SCHAEFER, PETER PIGOTT**
Photographers **JOHN SCHAEFER, JOHN KIDDY**
Design Firm **INNOVATION ADVERTISING & DESIGN, SALT LAKE CITY, UT**
Client **MARILYN HITE/NOVATRIX**
Printer **PARAGON PRESS**
Paper Manufacturer **S.D. WARREN PAPER COMPANY**
Paper **LUSTRO DULL CREAM**

2
Signage **COOK-FT. WORTH CHILDREN'S MEDICAL CENTER**
Art Director **CRAIG BUTLER**
Designer **EILEEN AVERY**
Illustrator **LARRY BROOKS**
Design Firm **BUTLER INC., LOS ANGELES, CA**
Publisher **COOK-FT. WORTH CHILDREN'S MEDICAL CENTER**
Printer **ASI/ENAMELTEC**

3
Art Guidebook **GATEWAY GALLERY**
Art Director/Designer/Illustrator **REX PETEET**
Photographer **GARY MCCOY**
Design Firm/Typographer **SIBLEY/PETEET DESIGN, DALLAS, TX**
Publisher/Client **THE DALLAS MUSEUM OF ART**
Printer **HARP PRESS**

3

1

Guidebook and Membership Card **FRESH FORCE**
Art Director/Designer **CHARLES S. ANDERSON**
Illustrators **CHARLES S. ANDERSON, LYNNE SCHULTE**
Design Firm **THE DUFFY DESIGN GROUP, MINNEAPOLIS, MN**
Publisher **FRESH FORCE-YOUTH VOLUNTEERS**
Typographer **TYPESHOOTERS**
Printer **RAINBOW SIGN**

2

Spot Video **THE BIRD IS THE WORD**
Art Director/Designer/Illustrator **MARK QUEEN**
Design Firm/Publisher **WSMV-TV 4, NASHVILLE, TN**

3

Packaging **CARTON CONSTRUCTION**
Art Director/Designer **MARLA GUTZWILLER**
Design Firm **EPSTEIN, GUTZWILLER, & PARTNERS, CLEVELAND, OH**
Client **CREATIVITY FOR KIDS**
Typographer **TSI, INC.**

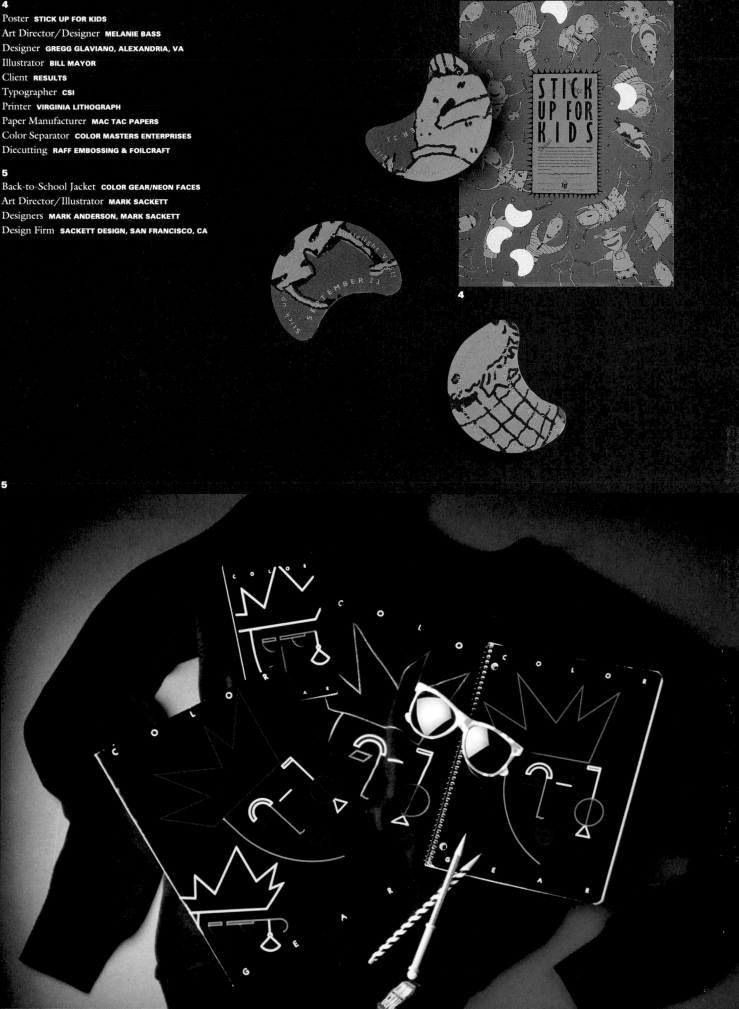

4

Poster **STICK UP FOR KIDS**

Art Director/Designer **MELANIE BASS**

Designer **GREGG GLAVIANO, ALEXANDRIA, VA**

Illustrator **BILL MAYOR**

Client **RESULTS**

Typographer **CSI**

Printer **VIRGINIA LITHOGRAPH**

Paper Manufacturer **MAC TAC PAPERS**

Color Separator **COLOR MASTERS ENTERPRISES**

Diecutting **RAFF EMBOSSING & FOILCRAFT**

5

Back-to-School Jacket **COLOR GEAR/NEON FACES**

Art Director/Illustrator **MARK SACKETT**

Designers **MARK ANDERSON, MARK SACKETT**

Design Firm **SACKETT DESIGN, SAN FRANCISCO, CA**

1
Logo **NEW JERSEY STATE AQUARIUM AT CAMDEN**
Art Directors/Designers **ROGER COOK, DON SHANOSKY**
Illustrator **DON SHANOSKY**
Design Firm **COOK AND SHANOSKY ASSOCIATES, INC., PRINCETON, NJ**
Client **ZOOLOGICAL SOCIETY OF PHILADELPHIA**

1

2
Logo **VIDIOTS ARCADE**
Designer/Illustrator **JOHN EVANS**
Design Firm/Typographer **SIBLEY/PETEET DESIGN, DALLAS, TX**
Publisher/Client **MILTON BRADLEY**

3
Booklet **SUNBEAMS AND SUNBURN**
Author **JUNE LEAMAN**
Art Director **LORETTA LEIVA**
Designer/Illustrator **JOHN SPOSATO**
Design Firm **JOHN SPOSATO DESIGN, NEW YORK, NY**
Publisher/Client **ESTEÉ LAUDER**
Typographer **THE TYPE SHOP**
Printer **BIANCA**
Paper Manufacturer **SIMPSON PAPER COMPANY**

2

3

4

Book **LINES**
Author **PHILIP YENAWINE**
Art Directors **TAKAAKI MATSUMOTO, MICHAEL MCGINN**
Designer **MICHAEL MCGINN**
Illustrators **VARIOUS**
Design Firm **M PLUS M INCORPORATED, NEW YORK, NY**
Typography **M PLUS M INCORPORATED**
Jacket Design/Illustration **M PLUS M INCORPORATED**

5

Book **STORIES**
Author **PHILIP YENAWINE**
Art Directors **TAKAAKI MATSUMOTO, MICHAEL MCGINN**
Designer **MICHAEL MCGINN**
Illustrators **VARIOUS**
Publishers **THE MUSEUM OF MODERN ART, DELACORTE PRESS**
Design Firm **M PLUS M INCORPORATED, NEW YORK, NY**
Typography **M PLUS M INCORPORATED**
Jacket Design/Illustration **M PLUS M INCORPORATED**

6

Book **SHAPES**
Author **PHILIP YENAWINE**
Art Directors **TAKAAKI MATSUMOTO, MICHAEL MCGINN**
Illustrators **VARIOUS**
Publishers **THE MUSUEM OF MODERN ART, DELACORTE PRESS**
Design Firm **M PLUS M INCORPORATED, NEW YORK, NY**
Typography **M PLUS M INCORPORATED**
Jacket Design/Illustration **M PLUS M INCORPORATED**

7

Book **COLORS**
Author **PHILIP YENAWINE**
Art Directors **TAKAAKI MATSUMOTO, MICHAEL MCGINN**
Designer **MICHAEL MCGINN**
Illustrators **VARIOUS**
Publishers **THE MUSEUM OF MODERN ART, DELACORTE PRESS**
Design Firm **M PLUS M INCORPORATED, NEW YORK, NY**
Typography **M PLUS M INCORPORATED**
Jacket Design/Illustration **M PLUS M INCORPORATED**

1

1
Book **PIGGIES**
Authors **AUDREY WOOD, DON WOOD**
Art Director/Designer **MICHAEL FARMER**
Illustrator **DON WOOD**
Publisher **HARCOURT BRACE JOVANOVICH, SAN DIEGO, CA**
Typographer **THOMPSON TYPE**
Jacket Designer **DON WOOD**

2
Jigsaw Puzzle **ALPHAPUZZLE**
Art Director **MARTIN MOSKOFF**
Design Firm **MARTIN MOSKOFF, NEW YORK, NY**
Photography **COMMERCIAL GRAPHICS, INC.**
Publisher/Client **THE MUSEUM OF MODERN ART**
Typographer **TRUFONT**
Printer **PROMOTIONS BY DESIGN, INC.**
Paper **LITHOPERFECT**

2

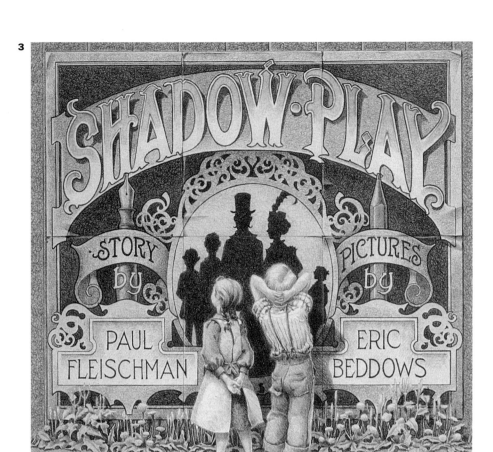

3
Book **SHADOW PLAY**
Author **PAUL FLEISCHMAN**
Art Director **PAT TOBIN**
Illustrator **ERIC BEDDOWS**
Publisher **A CHARLOTTE ZOLOTOW BOOK/HARPERCOLLINS, NEW YORK, NY**
Typographer **LINOPRINT**
Printer **HOROWITZ-RAE**
Jacket Design/Illustrator **ERIC BEDDOWS**

4
Poster **BO JACKSON/SUPER HEROES SERIES**
Art Director **JIM NUDO**
Illustrator **FRED INGRAM**
Design Firm **NIKE DESIGN, BEAVERTON, OR**
Client **NIKE, INC.**
Printer **GRAPHIC ARTS CENTER**
Paper Manufacturer **POTLATCH CORPORATION**

1
Book **THE UPSIDE DOWN RIDDLE BOOK**
Author **LOU PHILLIPS**
Art Director/Illustrator **BEAU GARDNER**
Design Firm **BEAU GARDNER ASSOCIATES, NEW YORK, NY**
Publisher **LOTHROP, LEE & SHEPARD**
Jacket Designer/Illustrator **BEAU GARDNER**

2
Book **LOOK AGAIN…AND AGAIN, AND AGAIN**
Author/Art Director/Illustrator **BEAU GARDNER**
Design Firm **BEAU GARDNER ASSOCIATES, NEW YORK, NY**
Publisher **LOTHROP, LEE & SHEPARD**
Jacket Designer/Illustrator **BEAU GARDNER**

3
Book **GUESS WHAT?**
Author/Art Director/Illustrator **BEAU GARDNER**
Design Firm **BEAU GARDNER ASSOCIATES, NEW YORK, NY**
Publisher **LOTHROP, LEE & SHEPARD**
Jacket Designer/Illustrator **BEAU GARDNER**

4
Game **INSECT DOMINOES**
Designer/Illustrator **JEAN SANCHIRICO**
Design Firm **THE NATURE COMPANY, BERKELEY, CA**

5
Posters **INANIMATE ANIMALS**
Art Director/Designer **MARK SACKETT**
Illustrator **KIM HOWARD**
Design Firm **SACKETT DESIGN, SAN FRANCISCO, CA**
Publisher/Client **CALIFORNIA CRAFTS MUSEUM**
Typographer **DISPLAY LETTERING & COPY**
Printer **HERO**
Paper Manufacturer **FRENCH PAPER COMPANY**

5

1
Poster **FRESH FORCE**
Art Director/Designer **CHARLES S. ANDERSON**
Illustrators **CHARLES S. ANDERSON, LYNNE SCHULTE**
Design Firm **THE DUFFY DESIGN GROUP, MINNEAPOLIS, MN**
Publisher **FRESH FORCE-YOUTH VOLUNTEERS**
Typographer **TYPESHOOTERS**
Printer **RAINBOW SIGN**

2
Paper Masks **METAPHORS**
Art Director/Designer **ALAN HOPFENSPERGER, NEW YORK, NY**
Printer **JANUS SCREEN GRAPHICS STUDIO**
Paper Manufacturer **CURTIS PAPER COMPANY**

To play is to learn BRIO Discovery is what growing up is all about BRIO Imagination is more important than knowledge BRIO Give them roots and give them wings BRIO

Posters **BRIO**

Art Directors **RICK THARP, THOM MARCHIONNA**

Illustrator **THOM MARCHIONNA**

Design Firm **THARP AND/OR MARCHIONNA, LOS GATOS, CA**

Publisher **BRIO SCANDITOY**

Typographer **FOTOCOMP**

Printer **IMPERIAL LITHOGRAPHING**

Paper Manufacturer **SIMPSON PAPER COMPANY**

Catalog/Workbook **ART IS**

Authors/Art Directors/Designers **MYRA KRAMER, JOHN SIMON**

Photographers **THOMAS BURKE, TONY GRANT, ROBERT HAVIE**

Illustrators **JAMES LAMARCHE, KIMBERLEY CATANZARO**

Design Firm **?PARADOX?, SAN FRANCISCO, CA**

Publisher **THE ART MUSEUM OF SANTA CRUZ COUNTY**

Typographer **TYPOLA**

Printer **BAYSHORE PRESS**

Paper Manufacturer **BUTLER PAPER COMPANY**

Binder **SPIRAL BINDING COMPANY, INC.**

A working handbook on the basic elements of art and supporting catalog for the exhibition Art Is

Art Is

1

1
Toy **NORTH COAST HARBOR MODEL BLOCKS**
Art Director **STEVEN SCHULTZ**
Design Firm **EPSTEIN, GUTZWILLER, & PARTNERS, CLEVELAND, OH**
Manufacturer **ROGERS DISPLAY COMPANY**

2
Zoo Signage **MEET THE KEEPER**
Art Director **VIRGINIA GEHSHAN**
Designer **JEROME CLOUD**
Design Firm **CLOUD AND GEHSHAN ASSOCIATES, INC., PHILADELPHIA, PA**
Illustrator **TOM CRANE**
Client **ZOOLOGICAL SOCIETY OF PHILADELPHIA**

2

3

Learning Kit **FUN WITH HIEROGLYPHS**
Art Director/Designer **MIRIAM BERMAN**
Project Director **ROBIE ROGGE**
Editor **MARY BETH BREWER**
Illustrators **BETH JENNINGS, WILLIAM SCHENCK**
Design Firm **MIRIAM BERMAN GRAPHIC DESIGN**
Production Manager **KATHERINE VAN KESSEL**
Publishers **THE METROPOLITAN MUSEUM OF ART,**
VIKING DIVISION OF PENGUIN BOOKS, NEW YORK, NY
Printer **ADVANCE GRAPHIC**

4

Book **ON THE DAY YOU WERE BORN**
Author/Illustrator **DEBRA FRASIER**
Art Director **MICHAEL FARMER**
Designer **JOY CHU**
Publisher **HARCOURT BRACE JOVANOVICH, SAN DIEGO, CA**

3

4

While you waited in darkness,
tiny knees curled to chin,
the Earth and her creatures
with the Sun and the Moon
all moved in their places,
each ready to greet you
the very first moment
of the very first day you arrived.

1
Poster **NEW YORK IS CHILDREN**
Art Director/Illustrator **STEFF GEISSBUHLER**
Design Firm **CHERMAYEFF & GEISMAR, INC., NEW YORK, NY**
Publisher **NEW YORK CITY DEPARTMENT OF CULTURAL AFFAIRS**
Printer **PERRY GUGLER**

2
Toy Ball and Packaging **UNPREDICTABALL**
Art Directors/Designers **KARL HEISELMAN, KATHY WARINNER,**
KRISTIN BUMGARNER
Design Firm/Client **THE NATURE COMPANY, BERKELEY, CA**
Typographer **MARK HAGAR TYPOGRAPHY**

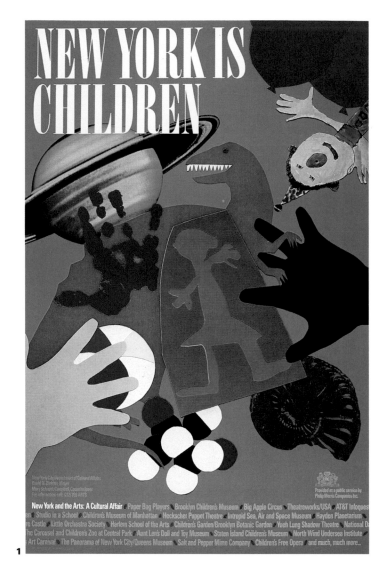

1

2

3

Book **DINOSAURS, DINOSAURS**
Author/Illustrator **BYRON BARTON**
Art Director **HARRIET BARTON**
Publisher **HARPERCOLLINS, NEW YORK, NY**
Typographer **LINOPRINT**
Printer **PRINCETON POLYCHROME**
Jacket Designer/Illustrator **BYRON BARTON**

4

Book **DINOSAUR BOB**
Author/Illustrator **WILLIAM JOYCE**
Art Director **HARRIET BARTON**
Designer **CATHRYN S. AISON**
Publisher **HARPERCOLLINS, NEW YORK, NY**
Typographer **CARDINAL TYPE**
Printer **HOROWITZ-RAE**
Jacket Designer/Illustrator **WILLIAM JOYCE**

5

Book **BONES, BONES, DINOSAUR BONES**
Author **BYRON BARTON**
Illustrator **HARRIET BARTON**
Publisher **HARPERCOLLINS, NEW YORK, NY**
Typographer **LINOPRINT**
Printer **PRINCETON POLYCHROME**
Jacket Illustrator **BYRON BARTON**

3

4

5

6

6

Book **THE SALAMANDER ROOM**
Author **ANNE MAZER**
Art Director **DENISE CRONIN**
Designer **LOU FRANCHER**
Illustrator **STEVE JOHNSON**
Publisher **ALFRED A. KNOPF, INC., NEW YORK, NY**
Typographer **CT & PHOTOGENIC, INC.**
Printer **TIÈN WAH PRESS**
Paper **130 GSM MATTE**
Jacket Designer/Illustrator **STEVE JOHNS**

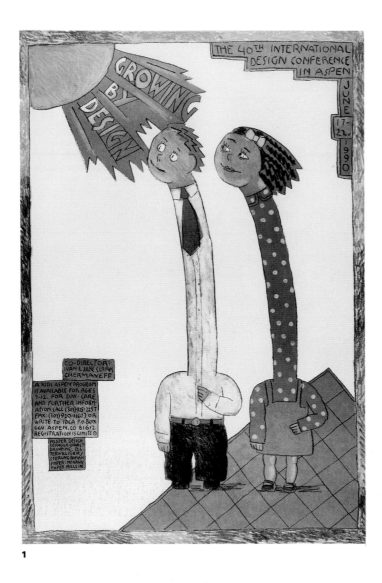

1

1
Poster **GROWING BY DESIGN**
Art Directors **IVAN CHERMAYEFF, JANE CLARK CHERMAYEFF**
Designer/Illustrator **SEYMOUR CHWAST**
Design Firm **THE PUSHPIN GROUP, NEW YORK, NY**
Publisher/Client **INTERNATIONAL DESIGN CONFERENCE OF ASPEN**

2
Animated Video **ANANSI**
Art Director **TIM RAGLIN**
Illustrator **STEVEN GUARNACCIA, NEW YORK, NY**
Publisher **RABBIT EARS**

2

First Shapes

Premières Formes Primeras Formas Erste Formen Prime Forme

Ivan and Jane Clark Chermayeff

3

Shapes are used to describe and to remember. Shapes can be added onto or carved out of. They can be arranged in patterns: up, down, and every way. Simple shapes are best, but the compli-cated ones can be nice, too.

A *square* has four sharp corners. It has two sides and a top and a bottom that are the same size. Turn it on a corner and it becomes a *diamond.* Push or pull two sides of a square and it is a *rectangle.* A *triangle* will always have three sharp corners instead of four.

A *circle* has one big side that goes all the way around. A circle is often found in the center of things... for instance, where a pebble has been dropped in a pool of water.

If a tiny circle has no hole, then it is a *dot.* When it is flattened out a little, as though some-one sat on it, it becomes an *oval.* If a circle inside another circle is very big and only leaves a little bit of the out-side circle on one side, it makes a *crescent.* Sometimes the moon is a crescent shape.

A *heart* has a dent in the round part on top of a circle, which makes two puffed-out places. It is pointed on the opposite side, usually on the bottom... unless it is an upside-down heart. There are thin hearts and fat hearts, just as there are thin and fat girls and boys and dogs and cats.

Sometimes sides or lines that don't connect make shapes. Back-and-forth lines make a saw shape called a *zigzag;* but when the line just rolls along, it is called a *wave,* because it looks like the surface of a sea.

One up-and-down line, with another across the middle, makes a *cross.* If a line goes around and around and around, getting bigger and bigger, it is a *spiral.*

Petals and parts spinning and turning, *stars* and *pinwheels* are like flowers with five, six, twelve, or more points.

The world of shapes is the world around us. When you learn to recognize shapes, you are on your way to knowing a lot about a lot of things.

Looking and seeing provides endless opportunities for exploration and learning, and that is what this book is all about. I.C. & J.C.C.

First Words

Premiers Mots Primeras Palabras Erste Worte Prime Parole

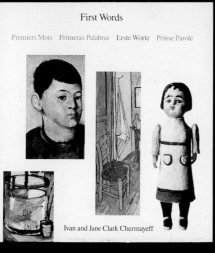

Ivan and Jane Clark Chermayeff

4

cat le chat el gato die Katze il gatto

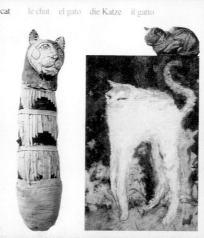

3
Book **FIRST SHAPES**
Authors **IVAN AND JANE CLARK CHERMAYEFF**
Art Director/Designer **IVAN CHERMAYEFF, NEW YORK, NY**
Photographer **DANIEL HADDAD**
Publisher **HARRY N. ABRAMS, NEW YORK, NY**
Typographer **PRINT & DESIGN**
Printer **SOUTH CHINA PRINTING COMPANY**
Paper **157 GSM MATTE**

4
Book **FIRST WORDS**
Authors **IVAN AND JANE CLARK CHERMAYEFF**
Art Director/Designer **IVAN CHERMAYEFF, NEW YORK, NY**
Illustrators **VARIOUS**
Publisher **HARRY N. ABRAMS, NEW YORK, NY**
Typographer **PRINT & DESIGN**
Printer **SOUTH CHINA PRINTING COMPANY**
Paper **157 GSM MATTE**

5
Art-to-Schools Van **GO VAN GOGH**
Art Director/Designer **REX PETEET**
Design Firm **SIBLEY/PETEET DESIGN, DALLAS, TX**
Publisher/Client **DALLAS MUSEUM OF ART**

GO VAN GOGH

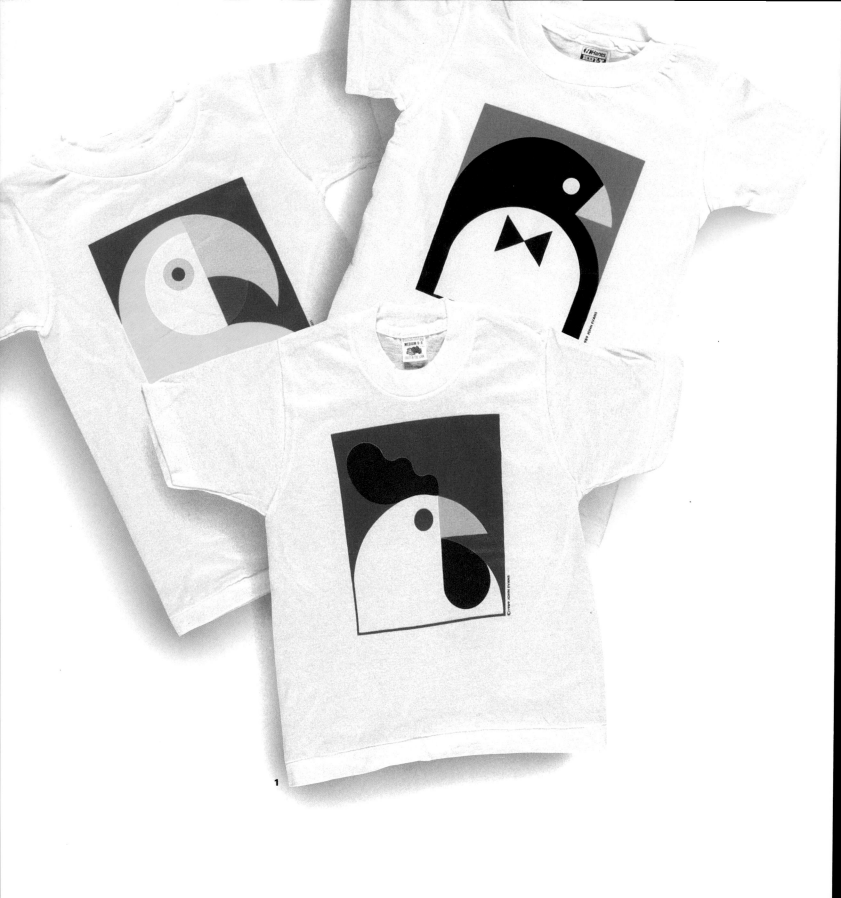

1

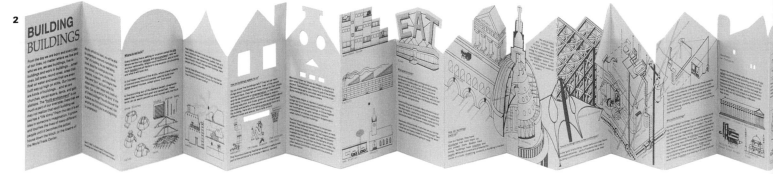

2

1

T-Shirts **PARROT, PENGUIN, ROOSTER**
Art Director/Designer/Illustrator **JOHN EVANS**
Design Firm **SIBLEY/PETEET DESIGN, DALLAS, TX**
Printer **ADRIAN RAY**

2

Book **BUILDING BUILDINGS**
Art Director **KEITH GODARD**
Illustrator **MARNIE KROSS**
Design Firm **STUDIOWORKS, NEW YORK, NY**
Publisher **STATEN ISLAND CHILDREN'S MUSEUM**
Typographer **TYPOGRAM**
Printer **GREENLEAF PRESS**

3

Gift Box/Packaging **JAM 'N ROLL**
Art Director **JOE DUFFY**
Designers **JOE DUFFY, SHARON WERNER**
Design Firm **THE DUFFY DESIGN GROUP, MINNEAPOLIS, MN**
Typographer **TYPESHOOTERS**
Client **LEE JEANS**

4

Book **COLOR ZOO**
Author/Illustrator **LOIS EHLERT**
Art Director **HARRIET BARTON**
Publishers **HARPERCOLLINS, NEW YORK, NY**
Typgrapher **LINOPRINT**
Printer **TIEN WAH PRESS**
Jacket Designer/Illustrator **LOIS EHLERT**

5

Book **COLOR FARM**
Author/Illustrator **LOIS EHLERT**
Art Director **HARRIET BARTON**
Publisher **HARPERCOLLINS, NEW YORK, NY**
Typographer **LINOPRINT**
Printer **TIEN WAH PRESS**
Jacket Designer/Illustrator **LOIS EHLERT**

3

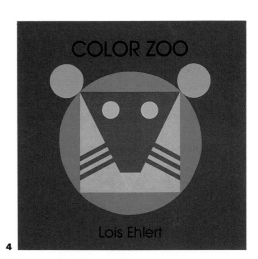

4

5

1

1

Book **BUSHY BRIDE**

Art Director **RITA MARSHALL**

Illustrator **SEYMOUR CHWAST**

Design Firm **THE PUSHPIN GROUP, NEW YORK, NY**

Publisher **CREATIVE EDUCATION, INC.**

2

Newspaper **KOO KOO NEWS**

Designer **LEIGH HENRY, STRASBURG, VA**

Illustrators **VARIOUS**

Printer **SHENANDOAH PUBLISHING**

Paper Manufacturer **BEAR ISLAND**

2

3
Book **SUPERPOWER: THE MAKING OF A STEAM LOCOMOTIVE**
Author **DAVID WEITZMAN**
Designer/Illustrator **DAVID WEITZMAN, INVERNESS, CA**
Publisher **DAVID R. GODINE**
Typographer **MERIDEN-STINEHOUR PRESS**
Printer **IMAGO PUBLISHING**

4
Book **TRAIN SONG**
Author **DIANE SIEBERT**
Art Director **AL CETTA**
Illustrator **MIKE WIMMER**
Publisher **HARPERCOLLINS, NEW YORK, NY**
Typographer **LINOPRINT**
Printer **PRINCETON POLYCHROME**
Jacket Designer/Illustrator **MIKE WIMMER**

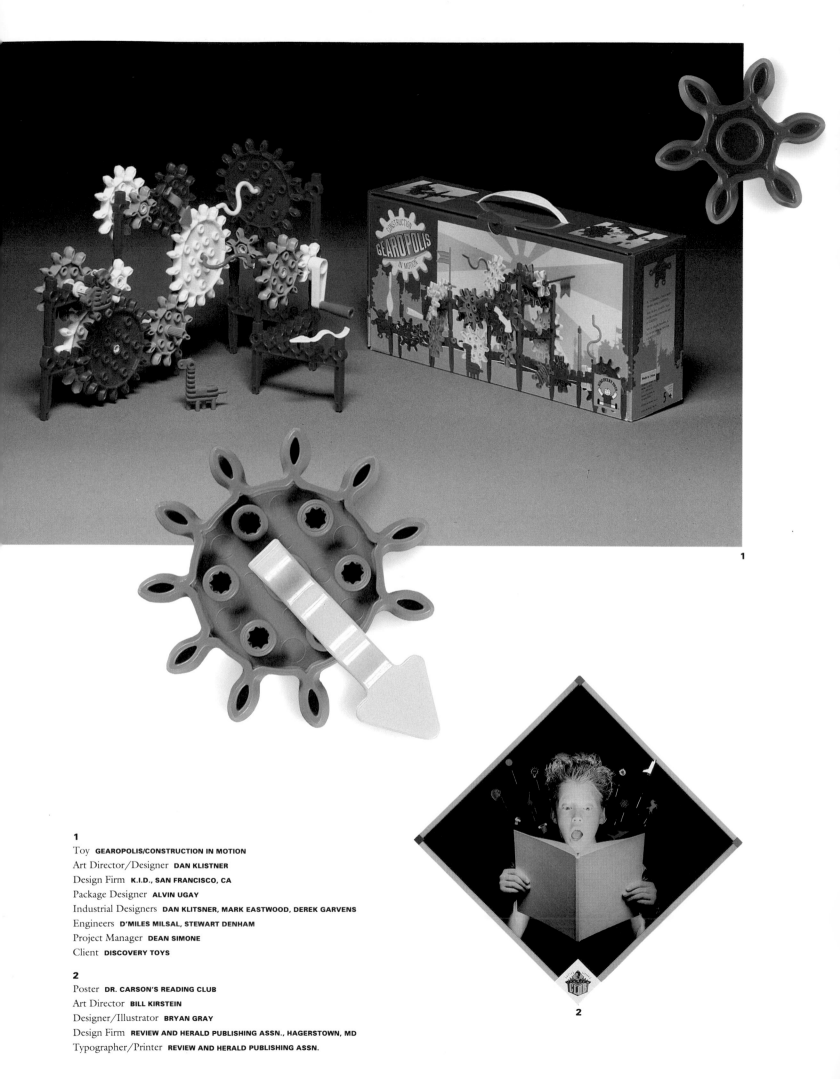

1

Toy **GEAROPOLIS/CONSTRUCTION IN MOTION**

Art Director/Designer **DAN KLISTNER**

Design Firm **K.I.D., SAN FRANCISCO, CA**

Package Designer **ALVIN UGAY**

Industrial Designers **DAN KLITSNER, MARK EASTWOOD, DEREK GARVENS**

Engineers **D'MILES MILSAL, STEWART DENHAM**

Project Manager **DEAN SIMONE**

Client **DISCOVERY TOYS**

2

Poster **DR. CARSON'S READING CLUB**

Art Director **BILL KIRSTEIN**

Designer/Illustrator **BRYAN GRAY**

Design Firm **REVIEW AND HERALD PUBLISHING ASSN., HAGERSTOWN, MD**

Typographer/Printer **REVIEW AND HERALD PUBLISHING ASSN.**

3
Glow-in-the-dark Book **A LITTLE NIGHT BOOK**
Art Director **KEITH GODARD**
Designers/Illustrators **KEITH GODARD, EMMETT WILLIAMS, NEW YORK, NY**
Publishers **WORKS EDITIONS**
Typographer **TYPE BY BATIPAGLIA**
Printers **EASTERN PRESS, SIROCCO**
Binder **MUELLER TRADE BINDERY**

4
Book **BORREGUITA & THE COYOTE**
Author **VERNA AARDEMA**
Art Director **DENISE CRONAN**
Designer **EDWARD MILLER**
Illustrator **PETRA MATHERS**
Publisher **ALFRED A. KNOPF, INC., NEW YORK, NY**
Typographer **TYPOGRAPHIC IMAGES**
Printer **TIEN WAH PRESS**
Paper **130 GSM MATTE**
Jacket Illustrator **PETRA MATHERS**

3

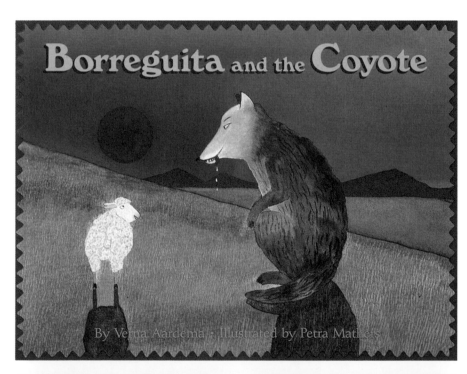

4

Book **MATTHEW'S DREAM**
Author/Illustrator **LEO LIONNI**
Designers **LEO LIONNI, MARY OTTINGER**
Art Director **DENISE CRONAN**
Publisher **ALFRED A. KNOPF, INC., NEW YORK, NY**
Typographer **CENTENNIAL GRAPHICS, INC.**
Printer **NATIONAL LITHO, INC.**
Paper Manufacturer **POTLATCH CORPORATION**
Jacket Designer **LEO LIONNI**

Book **FOLLOW THE DRINKING GOURD**
Author/Illustrator **JEANETTE WINTER**
Art Director **DENISE CRONIN**
Designer **ELIZABETH HARDIE**
Publisher **ALFRED A. KNOPF, INC., NEW YORK, NY**
Typographer **CT & PHOTOGENICS**
Printer **NATIONAL LITHO, INC.**
Manufacturer **WESTVACO**
Jacket Designer/Illustrator **JEANETTE WINTER**

2

Walking by night, sleeping by day,
for weeks they traveled on.
Sometimes berries to pick
and corn to snatch,
sometimes fish to catch,

sometimes empty bellies to sleep on.
Sometimes no stars to guide the way.

3

Book **FAST AS THE WIND**
Authors **VARIOUS**
Art Director **LESLIE SMOLAN**
Designer **ALYSSA ADAMS**
Illustrators **VARIOUS**
Design Firm **CARBONE SMOLAN ASSOCIATES, NEW YORK, NY**
Publisher **HOUGHTON-MIFFLIN COMPANY**

4

Exhibition **DO YOU KNOW HOW TO FLY? BE A BIRD**
Art Director **HANNAH JENNINGS**
Designers/Illustrators **PETER SKACH, RAY ROBINSON, EDIE EMMENEGGER,**
HANNAH JENNINS, RAY ROBINSON
Client **BROOKFIELD ZOO DESIGN DEPT., BROOKFIELD, IL**

3

4

Propaganda for a good cause has a venerable position in the history of art, but it often goes unsung. Many with a social conscience however, donate their time for little or no money, producing the materials themselves or for organizations with little or no budgets. The jury took this into consideration. The range of design sophistication of the work submitted was great; the quality varied greatly. We were judging slick four-color posters alongside black-and-white photocopy posters. What was paramount was the power of the message.

A tense discussion in the judging emerged when the quality of a particular submission went up against the cause it represented. One juror wanted to include the admittedly mediocre drawing because the importance of the subject became the overriding critical factor. The piece was finally rejected, but not before raising the awareness in us that factors other than design and aesthetics must be considerd in a show such as this.

This is the first in my memory to be dedicated to our social and political concerns. Because of its very nature, the costs of producing the exhibit had to be partly subsidized and for that the AIGA must be commended. The show which received grants in part from the National Endowment for the Arts and the New York State Council on the Arts. It reveals to everyone, especially young designers, that we are involved in the real world as well as the crass commercial one.

Seymour Chwast, Chairman
Issues and Causes

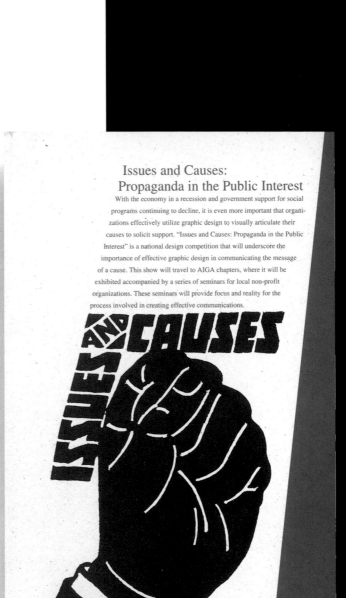

Issues and Causes:
Propaganda in the Public Interest

With the economy in a recession and government support for social programs continuing to decline, it is even more important that organizations effectively utilize graphic design to visually articulate their causes to solicit support. "Issues and Causes: Propaganda in the Public Interest" is a national design competition that will underscore the importance of effective graphic design in communicating the message of a cause. This show will travel to AIGA chapters, where it will be exhibited accompanied by a series of seminars for local non-profit organizations. These seminars will provide focus and reality for the process involved in creating effective communications.

Call-for-Entries

Design: Seymour Chwast/The Pushpin Group
Printer: Williamson Printing, Hansford Ray
Ink: Flint Ink Corporation
Pre-Press: Classic Color
Paper: Strathmore Renewal, recycled, Spackle, Cover Basis 80

ISSUES AND CAUSES

JURY

Art Director
Washington Post Magazine

Chairman-Worldwide
Chiat/Day/Mojo

Director
The Pushpin Group

Artist

Artist

Professor
Head of Graphic Design Department,
Pennsylvania State University

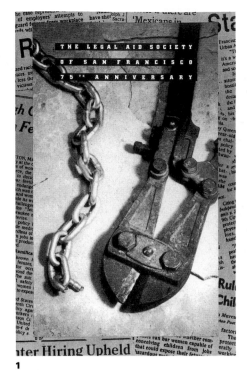

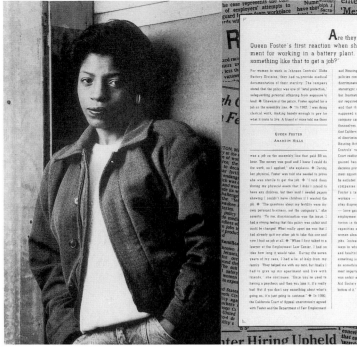

1
Annual Report **THE LEGAL AID SOCIETY OF**
SAN FRANCISCO SEVENTY-FIFTH ANNIVERSARY
Art Director **MARK FOX**
Designers **MARK FOX, GIORGIO BARAVALLE**
Photographer **WILL MOSGROVE**
Design Firm **BLACKDOG, MILL VALLLEY, CA**
Client **THE LEGAL AID SOCIETY OF SAN FRANCISCO**
Typographer **BLACKDOG**
Printer **PARAGRAPHICS**
Paper Manufacturer **SIMPSON PAPER COMPANY**

2
Boxed Catalog **WE THE PEOPLE**
Art Direction **GROUP MATERIAL**
Designers **CHRIS MYERS, NANCY MAYER**
Photographer **GREG BENSON**
Design Firm **THE OFFICE OF MAYER & MYERS, PHILADELPHIA, PA**
Clients **GROUP MATERIAL, THE TEMPLE UNIVERSITY ART GALLERY**

3

T-Shirt **U.S. OUT OF MY UTERUS!**

Art Director **MICHELE WETHERBEE**

Design Firm **WETHERBEE DESIGN, SAN FRANCISCO, CA**

Client **SAN FRANCISCO AREA PRO-CHOICE COALITION**

Calligraphy **MICHELE WETHERBEE**

Printer **THE SILKEN SCREEN**

4

Tabloid Magazine **NORTHWEST EXTRA, VOL. 1 #6/ABORTION**

Art Director/Designer **ART CHANTRY, SEATTLE, WA**

Illustrator **CAROL LAY**

Publisher **DENNIS P. EICHHORN**

5

Postcard **SHELTER CIRCA 1990**

Art Director/Illustrator **KIYOSHI KANAI**

Design Firm **KIYOSHI KANAI, INC., NEW YORK, NY**

Client/Publisher **ARCHITECTS, DESIGNERS, & PLANNERS**

FOR SOCIAL RESPONSIBILITY

Typographer **KIYOSHI KANAI**

Printer **CONCEPTUAL LITHO INC.**

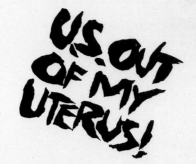

3

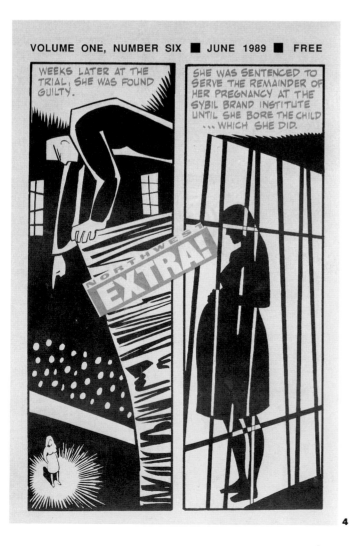

4

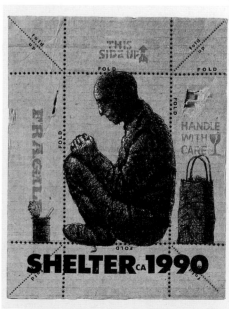

5

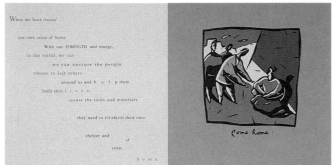

1
Brochure **HOME**
Art Director **STEWART MONDERER**
Designers **ROBERT DAVISON, JANE WINSOR, STEWART MONDERER**
Illustrator **MARK MATCHO**
Design Firm **STEWART MONDERER DESIGN, INC., BOSTON, MA**
Publisher **STEWART MONDERER DESIGN, INC.**
Typographer **GRAPHICS EXPRESS**
Printer **THE NINES DISCRIMINATING PRINTERS, INC.**
Paper Manufacturer **JAMES RIVER PAPER COMPANY**

2
Catalog **27 CHAIRS/THE SUNSHINE MISSION**
Art Director/Photographer **SUSAN SILTON**
Design Firm **SOS, LOS ANGELES, CA**
Client **THE SUNSHINE MISSION**
Typographer **SUSAN SILTON/MACINTOSH II**
Printer **NEGASTRIP LITHOGRAPHERS**
Paper Manufacturer **GILBERT PAPER COMPANY**

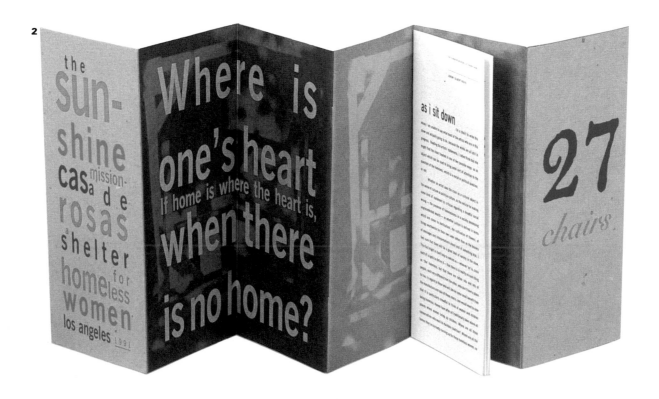

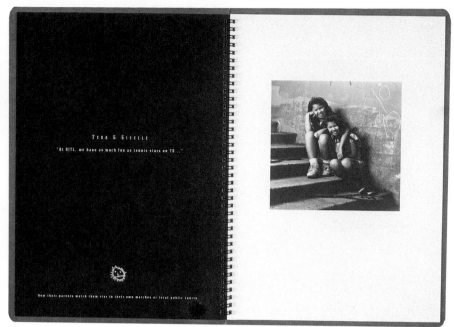

3

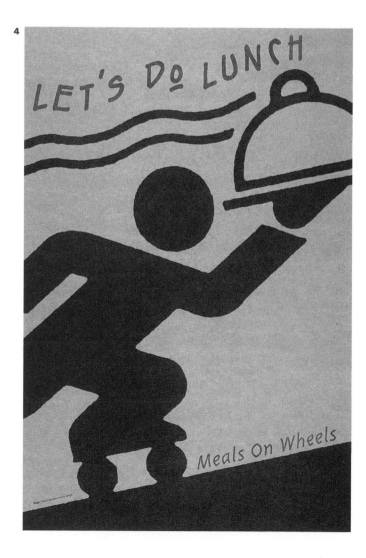

4

3

Brochure **NATIONAL JUNIOR TENNIS LEAGUE**
Art Director **BILL CAHAN**
Designer **STUART FLAKE**
Illustrators **THE KIDS**
Photographer **WILL MUSGROVE**
Design Firm **CAHAN & ASSOCIATES, SAN FRANCISCO, CA**
Client **NATIONAL JUNIOR TENNIS LEAGUE**
Printer **FRUITRIDGE PRINTING & LITHOGRAPH COMPANY**
Paper Manufacturers **S. D. WARREN PAPER COMPANY,
FRENCH PAPER COMPANY**

4

Poster **LET'S DO LUNCH/MEALS ON WHEELS**
Art Director **TODD A. MULLIGAN**
Illustrator **THE DESIGN COMPANY**
Design Firm **TODD MULLIGAN GRAPHIC DESIGN, ST PAUL, MN**
Client **METROPOLITAN MEALS ON WHEELS PROGRAM**
Typographer **BEAUTIFUL FACES/CHAMPION PAPERS**
Linotronic Output **LIGHTNING INK**
Printer **THE PRINT SHOPPE**

1

1

Annual Report **STUART M. KETCHAM — DOWNTOWN YMCA 1990**

Art Director **KIMBERLY BAER**

Designer **BARBARA COOPER**

Photographer **MARC CARTER**

Design Firm **KIMBERLY BAER DESIGN ASSOCIATES, VENICE, CA**

Client/Publisher **STEWART M. KETCHUM-DOWNTOWN YMCA**

Printer **PLATINUM PRESS**

2

Fundraising Poster **SHOOTING BACK/CUT-A-THON**

Art Director **ANTONIO ALCALA**

Photographer **COLUMBIA THOMAS**

Design Firm **STUDIO A, ALEXANDRIA, VA**

Client **SHOOTING BACK**

Publisher **TIME-LIFE, INC.**

Typographer **PICA & POINTS TYPOGRAPHY, INC.**

Printer **THE PRESS, INC.**

Paper Manufacturer **CHAMPION INTERNATIONAL PAPER**

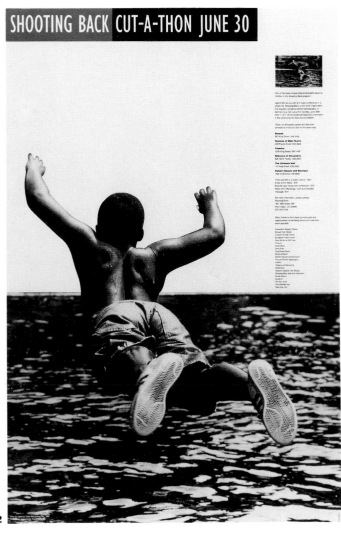

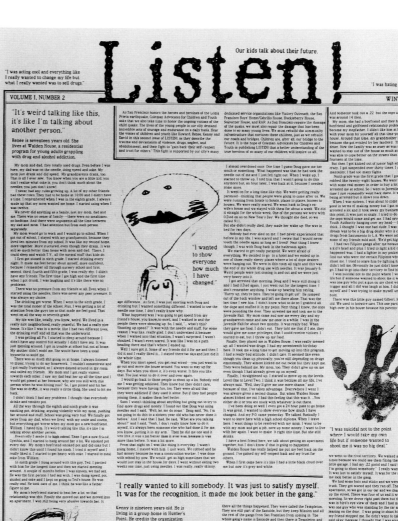

3
Newspaper **LISTEN, VOL. 1, NO. 1 & 2**
Art Director **DUGALD STERMER**
Editor **JEANIE KORTUM-STERMER**
Illustrators **VARIOUS CHILDREN**
Design Firm **DUGALD STERMER, SAN FRANCISCO, CA**
Publisher **COLEMAN ADVOCATES FOR CHILDREN**
Typographer **JEANIE KORTUM-STERMER**

4
Annual Cover **DO YOU KNOW WHAT TIME IT IS?**
Design Firm/Client **YOUTH FORCE/CITIZENS COMMITTEE FOR NYC**
Art Director **KIM MCGILLICUDDY**
Designers **RICHARD JAZQUEZ, FITZCARL REID, RAUL RATCLIFFE**
Illustrator **HENRY DIAZ**
Typographer **FITZCARL A. J. REID**
Printer **RAGGED EDGE PRINTING**

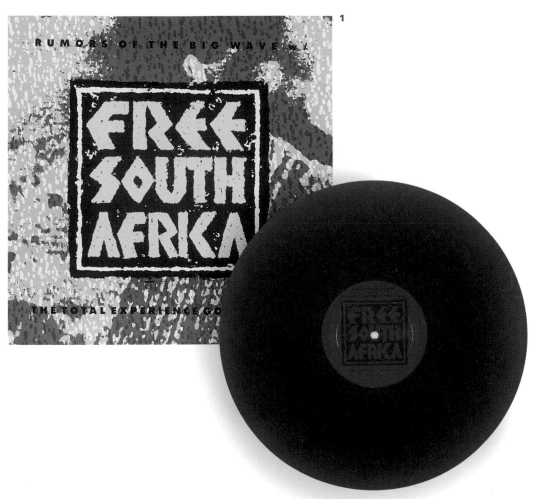

1

Poster/Record Jacket FREE SOUTH AFRICA

Art Director ART CHANTRY

Design Firm ART CHANTRY DESIGN, SEATTLE, WA

Client RUMORS OF THE BIG WAVE

Typographer ROCKETTYPE

2

T-Shirt NAMIBIA

Art Director JAN ARNESEN

Illustrator JOSEPH MADISIA

Design Firm/Client UNITED NATIONS TRANSITION

ASSISTANCE GROUP, (UNTAG)

Typographer/Printer PIDGEON PRESS

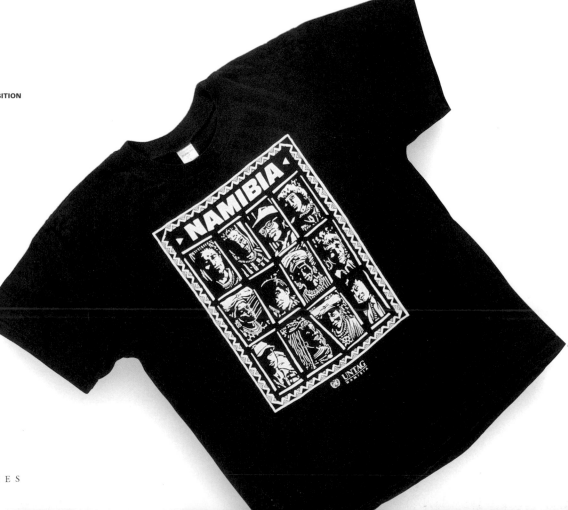

3
Brochure **CHILDREN OF LIGHT**
Art Director **JAMES LAMBERTUS**
Writer **TERRY TAFOYA**
Illustrator **JEFFRY NEWBURY; THE AMERICAN MUSEUM OF NATURAL HISTORY**
Design Firm **H₂O, SAN FRANCISCO, CA**
Client **AMERICAN INDIAN AIDS INSTITUTE**
Printer **PARAGRAPHICS**
Paper Manufacturer **FRENCH PAPER COMPANY**

4
Annual Report **FREEDOM HOUSE 1989-1990**
Art Director **JUREK WAJDOWICZ**
Designers **JUREK WAJDOWICZ, LISA LaROCHELLE**
Design Studio **EMERSON, WAJDOWICZ STUDIOS, INC., NEW YORK, NY**
Client **FREEDOM HOUSE**
Typographer **EMERSON, WAJDOWICZ STUDIOS, INC.**
Printer **RAPOPORT/METROPOLITAN**
Paper Manufacturer **S. D. WARREN PAPER COMPANY**

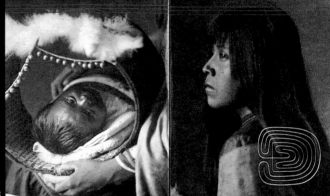

3

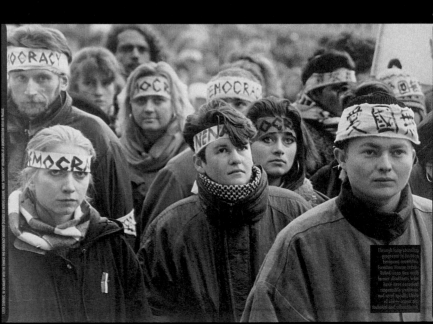

4

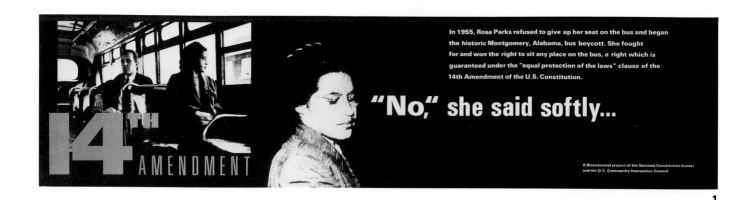

In 1955, Rosa Parks refused to give up her seat on the bus and began the historic Montgomery, Alabama, bus boycott. She fought for and won the right to sit any place on the bus, a right which is guaranteed under the "equal protection of the laws" clause of the 14th Amendment of the U.S. Constitution.

"No," she said softly...

14TH AMENDMENT

A Bicentennial project of the National Constitution Center and the D.C. Community Humanities Council

1

1
Bus Placard **"NO," SHE SAID SOFTLY**
Art Director **CHRIS MYERS**
Designer **NANCY MAYERS**
Design Firm **THE OFFICE OF MAYER & MYERS, PHILADELPHIA, PA**
Client **NATIONAL CONSTITUTION CENTER**

2
Poster **HUMAN EQUALITY**
Art Director/Designer/Illustrator **LANNY SOMMESE**
Design Firm **SOMMESE DESIGN, STATE COLLEGE, PA**
Publisher **SOMMESE DESIGN**
Printer **DESIGN PRACTICOM**

3
Poster **TAKE MY PICTURE, SHOW MY FACE**
Illustrator **PAUL DAVIS**
Design Firm **PAUL DAVIS STUDIO, NEW YORK, NY**
Client/Publisher **UNITED JEWISH APPEAL AND FEDERATION OF JEWISH PHILANTHROPIES**

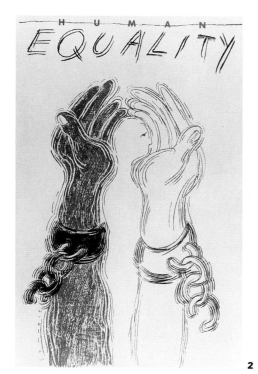

HUMAN EQUALITY

2

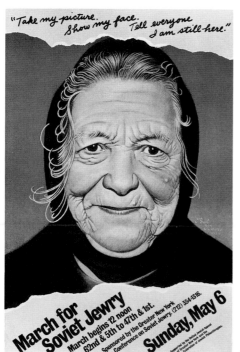

"Take my picture. Show my face. Tell everyone I am still here."

March for Soviet Jewry
March begins 12 noon
62nd & 5th to 47th & 1st.
Sponsored by the Greater New York
Conference on Soviet Jewry. (212) 354-6316.
Sunday, May 6

3

P R E
NIGGER SPICK

"*Long years ago I ask myself a question, Am I my brother's keeper? And the answer that I got was, You are. So then I decided to myself, since I'm no better than anybody, I don't feel I'm any worse than anybody. I decided to do anything I can to help people in order to help myself."*
– Mr. Esau Jenkins

why do we hate ?

4
Brochure **ON THE BUS**
Art Director **TODD A. MULLIGAN**
Handwriting **TODD A. MULLIGAN**
Design Firm **TODD MULLIGAN GRAPHIC DESIGN, ST PAUL, MN**
Publisher **MINNEAPOLIS COLLEGE OF ART AND DESIGN**
Typographers **VILLAGER GRAPHICS, GET SET**
Printer **XEROX**
Paper Manufacturer **BECKETT PAPER CO.**

5
Bus Placard **PREJUDICE/RACISM**
Art Director **KATHLEEN O'REILLY**
Design Firm **KORE, LOS ANGELES, CA**
Publisher/Client **LOS ANGELES FESTIVAL/BUSZ WORDS**
Typographer **KATHLEEN O'REILLY**
Printer **JAPANESE AMERICAN CULTURAL CENTER**

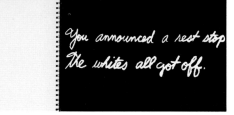

4

5

© 1990 Kathleen O'Reilly. From the series BUSZ WORDS, organized by Cheri Gaulke for the Los Angeles Festival.

1

Poster **SAFE SEX IS HOT SEX**
Art Director/Designer **HELENE SILVERMAN**
Photographer **STEVEN MEISEL**
Design Firm **HELLO STUDIO, NEW YORK, NY**
Client/Publisher **RED HOT & BLUE**

2

Street Tabloid **CONTROVERSIAL TIMES**
Art Director/Designer/Illustrator/Photographer **FRANK ZEPPONI**
Design Firm **FRANK ZEPPONI, SEATTLE, WA**
Publisher **FRANK ZEPPONI**
Printer **SNOHOMISH PUBLISHING**

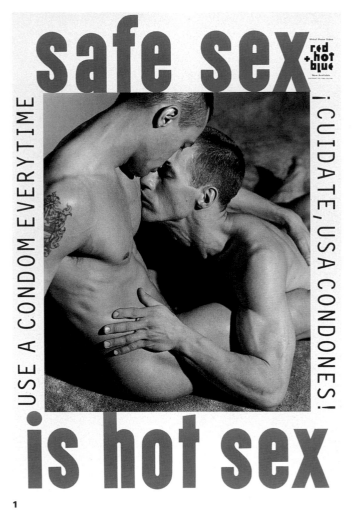

1

2

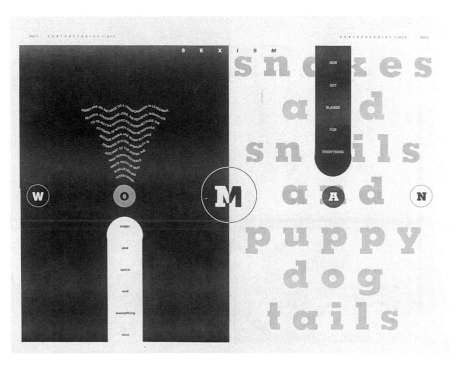

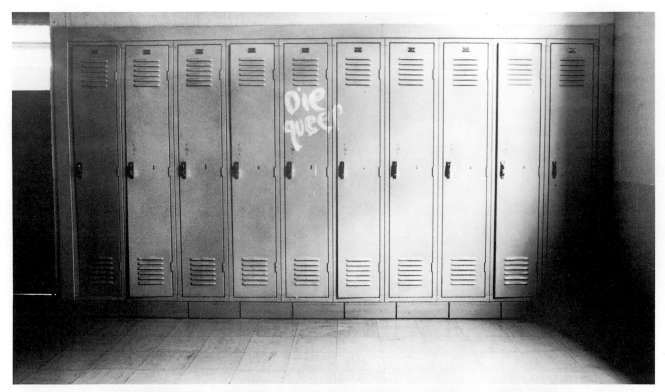

DON'T GET SCARED. GET HELP.

If you or someone you love is gay or lesbian, there's more to do than be afraid. The people at this number will direct you, confidentially and free of charge, to literature, legal assistance, organizations, support groups, or counseling in your area.

Horizons Community Services

(312) 929-HELP

3

3
Poster "DIE QUEER"
Art Director/Photographer **DEWITT KENDALL**
Design Firm **DEWITT KENDALL DESIGN, CHICAGO, IL**
Client/Publisher **ILLINOIS GAY AND LESBIAN TASK FORCE**
Typographer **PRO TYPOGRAPHY**
Printer **INLAND LITHOGRAPHY**

4
AIDS Poster **DON'T LET FEAR RUN US DRY**
Art Director/Designer **AL SCHROEDER**
Illustrator **EMIL KOSTELNY**
Design Firm **CARPENTER RESERVE PRINTING COMPANY, CLEVELAND, OH**
Client **AMERICAN RED CROSS/GREATER CLEVELAND AND NORTHERN OHIO BLOOD SERVICES**
Typographer/Printer **CARPENTER RESERVE PRINTING COMPANY**
Paper Manufacturer **CONSOLIDATED PAPER COMPANY**

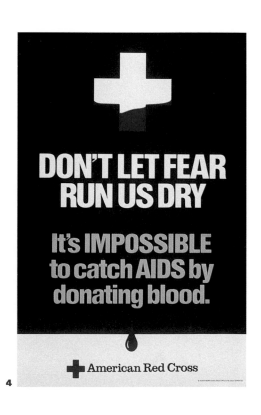

DON'T LET FEAR RUN US DRY

It's IMPOSSIBLE to catch AIDS by donating blood.

American Red Cross

4

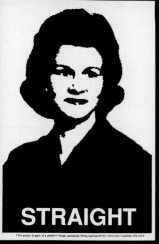
STRAIGHT

This poster is part of a positive image campaign being sponsored by University Lambda 478-1474

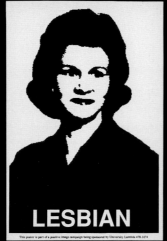
LESBIAN

This poster is part of a positive image campaign being sponsored by University Lambda 478-1474

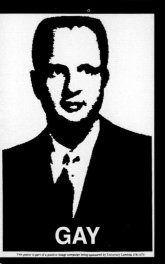
GAY

This poster is part of a positive image campaign being sponsored by University Lambda 478-1474

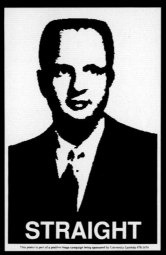
STRAIGHT

This poster is part of a positive image campaign being sponsored by University Lambda 478-1474

1

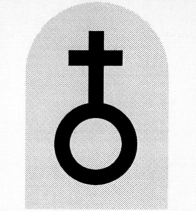

LAS MUJERES MUEREN

TRES VECES MAS RAPIDO

Las mujeres con el SIDA mueren tres veces mas rapido
que los hombres. Ellas mueren por culpa del govierno
que no quiere reconocer las enfermedades femeninas
relacionadas con el SIDA y les niega
a ellas tratamiento medico adecuado.

MUJERES, LUCHEN POR SUS VIDAS!

2

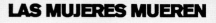

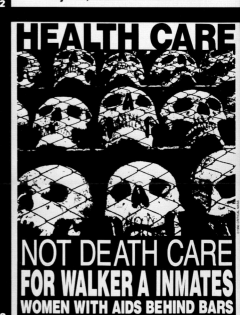

HEALTH CARE

NOT DEATH CARE
FOR WALKER A INMATES
WOMEN WITH AIDS BEHIND BARS

3

1

Posters **GAY AND LESBIAN POSITIVE IMAGE CAMPAIGN**

Art Director **KIRK BAUER**

Design Firm **BAUER DESIGN, AUSTIN, TX**

Publisher **UNIVERSITY LAMBDA/UNIVERSITY OF TEXAS, AUSTIN**

Printer **XEROX**

2

Street Stickers **WOMEN DIE/LAS MUJERES MUEREN**

Art Director/Designer **JAMES MOSS, SAN FRANCISCO, CA**

Client **ACT UP/NEW HAVEN**

Printer **IDEAL PRINTING COMPANY**

3

Poster **HEALTH CARE, NOT DEATH CARE**

Design Firm **CRITICAL MASS, LOS ANGELES, CA**

Designer **JOSH WELLS**

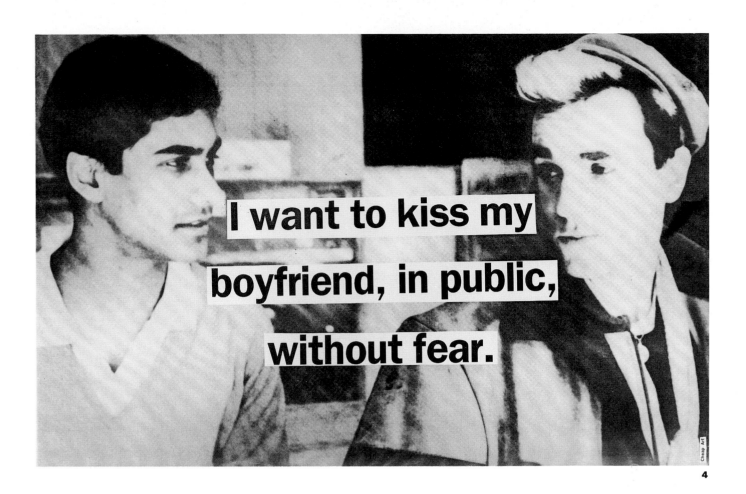

4

4
Poster **I WANT TO KISS MY BOYFRIEND**
Art Director/Designer/Illustration **CHEAP ART, NEW YORK, NY**

5
Letterpress Poster **"YOUR TURN JESSE" — FEDERALLY FUNDED HEALTH
CARE FOR SENATORS**
Designer/Publisher/Typographer/Printer **ERIC AVERY, SAN YGNACIO, TX**

6
Poster **TODAY I JUST WASN'T IN THE MOOD**
Art Director/Designer/Illustrator **STEPHANIE BASCH/CHEAP ART,
NEW YORK, NY**

6

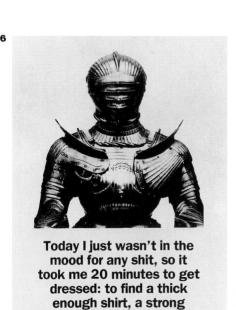

Today I just wasn't in the
mood for any shit, so it
took me 20 minutes to get
dressed: to find a thick
enough shirt, a strong
enough bra, and loose
enough pants. But I still got
the worst of the comments.

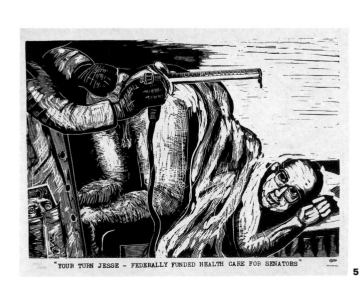

"YOUR TURN JESSE - FEDERALLY FUNDED HEALTH CARE FOR SENATORS"

5

1

Street Propaganda **SERIAL KILLER**
Art Director **VINCENT GAGLIOSTRO, NEW YORK, NY**
Client **ACT UP, NEW YORK**
Typographer **HARRISON SCOTT GRAPHICS**
Printer **EXPEDI PRINTING**

2

Street Propaganda **STOP THIS MAN**
Art Director **VINCENT GAGLIOSTRO, NEW YORK, NY**
Client **ACT UP, NEW YORK**
Typographer **HARRISON SCOTT GRAPHICS**
Printer **EXPEDI PRINTING**

3

Halloween Party Poster **GAY BASH**
Art Directors **KIRK BAUER, JOHN BOARDDMAN**
Designer **KIRK BAUER**
Design Firm **BAUER DESIGN, AUSTIN, TX**
Publisher **UNIVERSITY LAMBDA/UNIVERSITY OF TEXAS, AUSTIN**
Printer **XEROX**

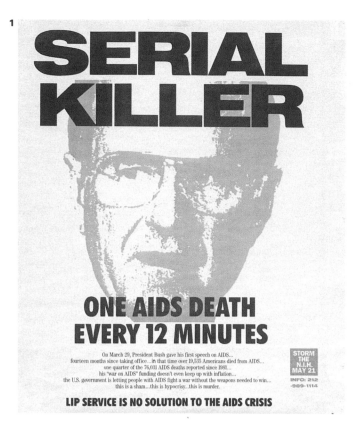

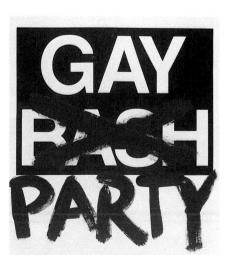

4
T-Shirt **CHOICE**
Art Director **MICHELE WETHERBEE**
Design Firm **WETHERBEE DESIGN, SAN FRANCISCO, CA**
Client **SAN FRANCISCO AREA PRO-CHOICE COALITION**
Typographic Rendering **KATHLEEN EDWARDS**
Printer **THE SILKEN SCREEN**

5
AIDS Walk-a-thon Poster **WALK FOR LIFE**
Art Director/Designer **TYLER SMITH**
Illustrator **EMILY LISKER, WOONSOCKET, RI**
Client **R.I. PROJECT AIDS**
Typographer **BLAZING GRAPHICS**
Printer **E.A. JOHNSON**
Paper Manufacturer **CARTER-RICE**

4

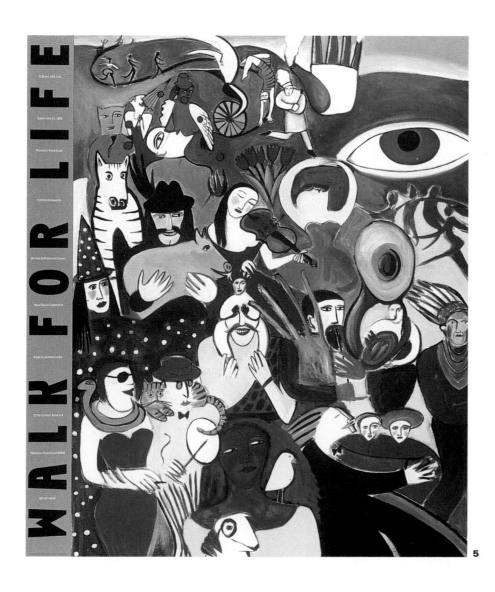

5

WEAR A CONDOM AND HELP PREVENT AIDS. A PUBLIC SERVICE MESSAGE BY PROPAGANDA FAKTORY

1

1
Poster JUST DO IT
Designer OREN SCHLIEMAN
Photographer JOE SOLEM
Design Firm INFO GRAFIK, HONOLULU, HI
Client PROPAGANDA FACTORY
Printer XEROX

2
Poster AIDS
Art Director/Designer/Illustrator McRAY MAGLEBY
Design Firm BYU GRAPHICS, PROVO, UT
Publisher/Client SHOSHIN SOCIETY
Typographer JONATHAN SKOUSEN
Silkscreen Printer RORY ROBINSON

2

3
Catalog **AIDS: THE ARTISTS' RESPONSE**
Art Director/Designer **ALAN JAZAK, COLUMBUS, OH**
Client **WEXNER CENTER FOR THE ARTS/THE OHIO STATE UNIVERSITY**
Typographer **DWIGHT YEAGER TYPOGRAPHERS**
Printer **THE OHIO STATE UNIVERSITY PRINTING FACILITY**

4
Logo/Poster **DAY WITHOUT ART**
Art Directors **TAKAAKI MATSUMOTO, MICHAEL MCGINN**
Designer **TAKAAKI MATSUMOTO**
Design Firm **M PLUS M INC, NEW YORK, NY**
Client **VISUAL AIDS**

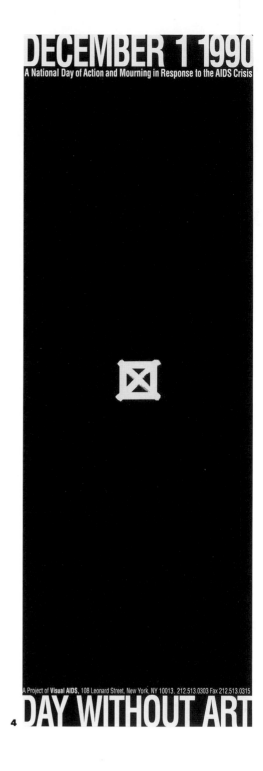

3

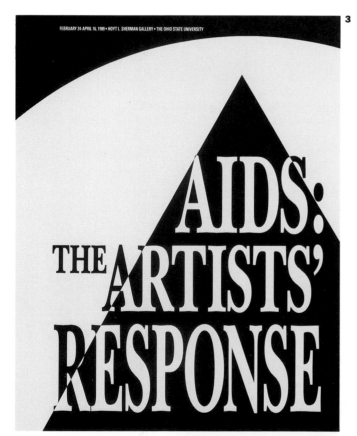

1

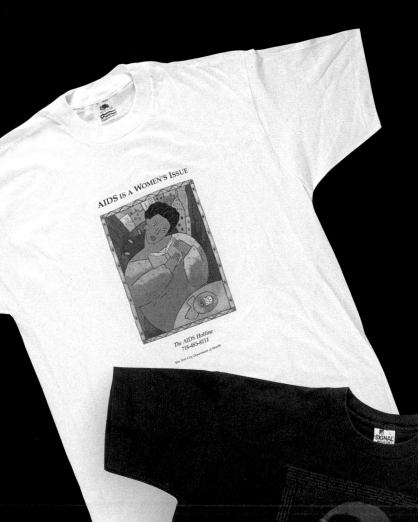

1

Annual Report **SAN FRANCISCO AIDS FOUNDATION 1990**
Art Directors **EDDIE EDWARDS, ROSE de HEER, NANCY KARIER**
Designer **NANCY KARIER**
Illustrators **EDDIE EDWARDS, NANCY KARIER, ANDRZEI DUDZINSKI, WARD SCHUMACKER, CHRISTINE MARTENSEN, JOHN HERSEY, MERCEDES MCDONALD**
Photographers **VOLDI TANNER, PHILIP KAAKE, HUGH KRETSCHMER, ROSA LAU, THEA SCHRACK**
Design Firm **STUDIO GRAPHICS, SAN FRANCISCO, CA**
Client **SAN FRANCISCO AIDS FOUNDATION**
Typographer **OMNICOMP**
Printers **WARRENS WALLER PRESS, WATERMARK PRESS, VENTUREGRAPHICS, PACIFIC LITHOGRAPHIC COMPANY**

2

T-Shirt **AIDS IS A WOMEN'S ISSUE**
Art Director **NAOMI BURSTEIN**
Illustrator **BETSY EVERITT**
Design Firm **BURSTEIN/MAX ASSOCIATES, INC, NEW YORK, NY**
Client **NEW YORK CITY DEPARTMENT OF HEALTH, DEPARTMENT OF AIDS SERVICES AND PROGRAMS**

3

T-Shirt **DAY WITHOUT ART**
Designers **GLORIA LEE, MATTHEW LYNAUGH, JAMES MOSS**
Design Collective **A BOY A GIRL AND A LITTLE OF BOTH, SAN FRANCISCO, CA**
Client **DAY WITHOUT ART AT YALE**

2

3

4

Poster **A GALA NIGHT FOR SINGING**

Illustrator **PAUL DAVIS**

Design Firm **PAUL DAVIS STUDIO, NEW YORK, NY**

Client/Publisher **THE EAST END GAY ORGANIZATION AND THE LINDA LEIBMAN HUMAN RIGHTS FUND**

5

Brochure **SEVEN**

Art Director **RENEE SULLIVAN**

Designers **TANDY BELEW, RENEE SULLIVAN**

Illustrators **GARY BASEMAN, GREG CLARKE, MARK FOX, JOHN HERSEY, MERCEDES MCDONALD, CHRIS MORTENSEN, MARK ULRICKSEN**

Design Firm **TANDY BELEW DESIGN, SAN FRANCISCO, CA**

Client **VISUAL AID**

Typographers **EUROTYPE, JET SET**

Printer **SINGER PRINTING**

Paper Manufacturer **SIMPSON PAPER COMPANY**

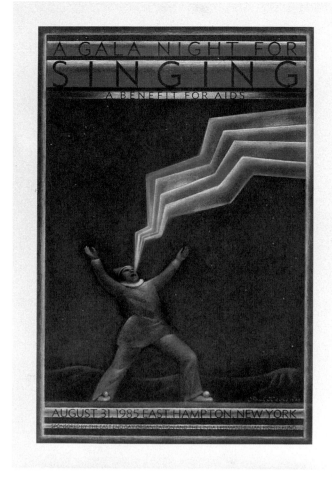

4

5

THIS IS THE HOUSE THAT CRACK BUILT

This is the drug
That lay in the house that Crack built.

This is the rat who sold the drug
That lay in the house that Crack built.

This is the cat who needed the shot
And bought from the rat
Who sold the drug
That lay in the house that Crack built.

This is the cop who worried the cat
Who needed the shot
And bought from the rat
Who sold the drug
That lay in the house that Crack built.

This is the man all tattered and torn
Who shot the cop who worried the cat
Who needed the shot
And bought from the rat who sold the drug
That lay in the house that Crack built.

This is the maiden all forlorn
Who carries a baby yet unborn
By the tattered man who killed the cop
Who worried the cat
Who needed the shot
And bought from the rat who sold the drug
That lay in the house that Crack built.

1
Booklet **MORDANT RHYMES FOR MODERN TIMES**
Art Director **YOLANDA CUOMO**
Designers **YOLANDA CUOMO, GWYNNE TRUGLIO**
Illustrator **FRAN BULL**
Design Firm **YOLANDA CUOMO DESIGN, NEW YORK, NY**
Publishers **FRAN BULL, ANN SALWEY**
Writer **ANN SALWEY**
Paper Manufacturer **GLEN EAGLE**

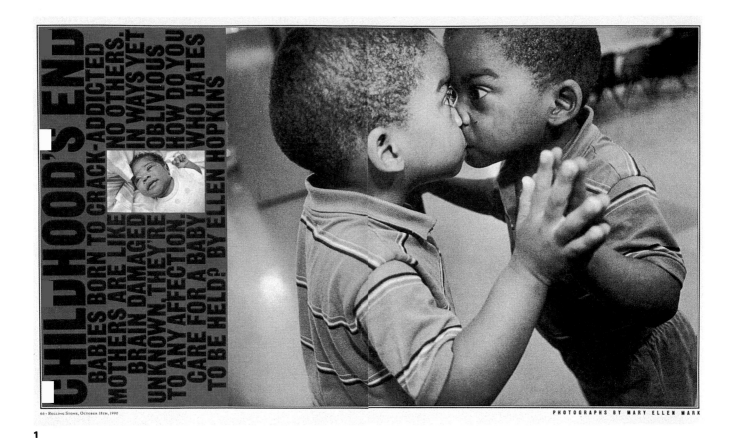

PHOTOGRAPHS BY MARY ELLEN MARK

1

1
Magazine Spread **CHILDHOOD'S END**
Art Director **FRED WOODWARD**
Designer **GAIL ANDERSON**
Photographer **MARY ELLEN MARK**
Design Firm **ROLLING STONE MAGAZINE, NEW YORK, NY**
Publisher **STRAIGHT ARROW PUBLISHERS**

2
Street Art **CRACK HOUSE, WHITE HOUSE**
Slogan Writer **MAGGIE SMITH**
Illustrators **PETER KUPER, SETH TOBOCMAN, NEW YORK, NY**

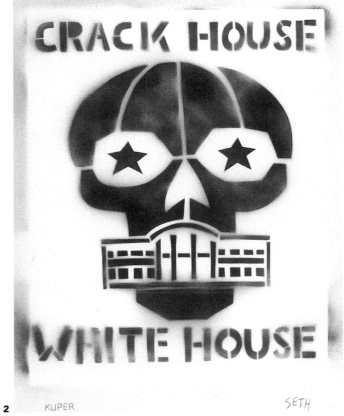

2

3

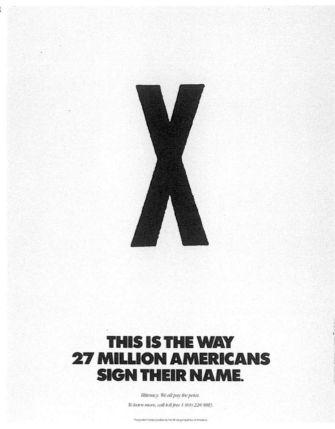

3

Poster **THIS IS THE WAY 27 MILLION AMERICANS SIGN THEIR NAME**
Art Director **JULIUS FRIEDMAN**
Design Firm **IMAGES, LOUISVILLE, KY**
Client/Publisher **BINDING INDUSTRIES OF AMERICA**
Typographer **QC, INC.**
Paper Manufacturer **S. D. WARREN PAPER COMPANY**

4

Poster **COME TO WHERE THE CANCER IS**
Designer **MELISSA ANTONOW, FIFTH GRADE STUDENT, QUEENS, NY**
Printer **SANJEAN GRAPHICS**

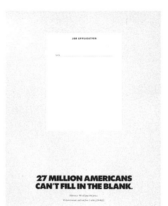

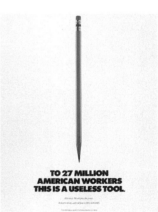

4

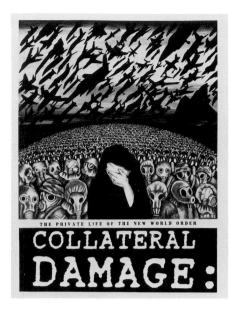

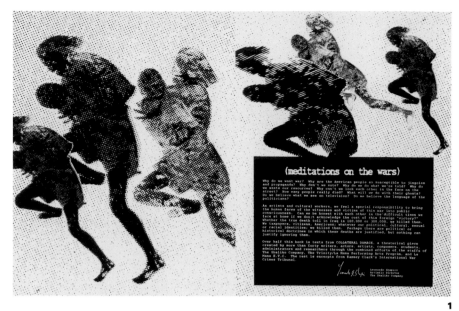

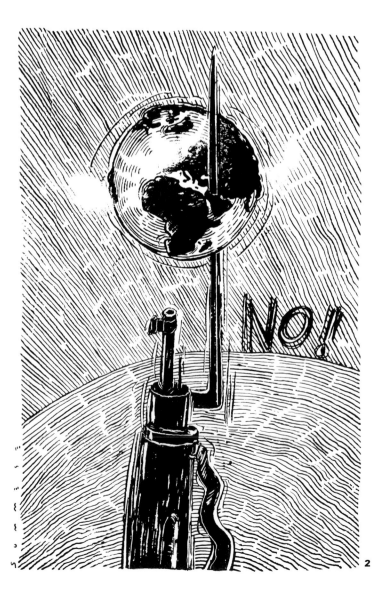

1
Magazine **COLLATERAL DAMAGE**
Art Director **SCOTT CUNNINGHAM**
Designer **STEVEN CERIO**
Illustrators **SUE COE, NANCY SPERO, POLLY WALKER, LEON GOLUB,**
OLLIE HARRINGTON, STEVEN CERIO, JAMES ROMBERGER, PETER KUPER,
MARK FRANK, DANNY HELLMAN, SCOTT CUNNINGHAM
Publisher **LEONARDO SHAPIRO/SHALIKO COMPANY, NEW YORK, NY**
Typographer **STEVEN CERIO**
Printer **LINCO PRINTING**

2
Poster **NO!**
Art Director/Designer/Illustrator **LANNY SOMMESE**
Design Firm **SOMMESE DESIGN, STATE COLLEGE, PA**
Publisher **SOMMESE DESIGN**
Printer **DESIGN PRACTICOM**

3
Poster **NEW WORLD ODOR**
Designer/Illustrator **MARK VALLEN, SHERMAN OAKS, CA**

4
Street Propaganda **STOP THE U.S. WAR MACHINE —**
NO CELEBRATION OF A MASSACRE
Art Director/Designer **RACHEL WALKER, NEW YORK, NY**
Photographer **KEN JARECKE**
Typographer **NICOLE HICKMAN**

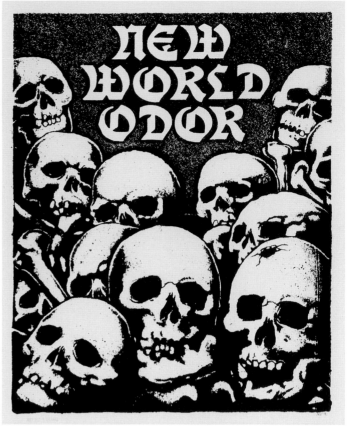

3

Iraqi soldier turned to ashes after being incinerated by a U.S. bomb, during attack on retreating Iraqi forces fleeing Kuwait. Published in the *London Observer*, 3/10/91 (one of many photographs censored by the U.S. media for showing the real horror of the Gulf War.)

Assemble With The Red and Black: E. Side of Broadway at Ann Street–9:30 A.M.
JUNE 10ᵀᴴ, NYC–THE WHOLE WORLD IS WATCHING.
Stop The U.S. War Machine Action Network, (212) 642-5288

4

1

Poster **AMERICA'S NEXT STEP IS UP TO YOU**
Art Director **KEITH CAMPBELL**
Illustrator **BRAD HOLLAND, NEW YORK, NY**
Agency **DICK FRIEL, JOHN BROWN & PARTNERS**
Client/Publisher **GIVE PEACE A CHANCE**
Typographer **THOMAS & KENNEDY**
Printer **FORWARD PRESS**

2

Poster **THERE HAVE ALWAYS BEEN DISPUTES**
Art Director/Designer/Illustrator **PETER G. SPIVAK**
Design Firm **PETER G. SPIVAK, AUBURN, AL**
Printer **SOFY COPY**

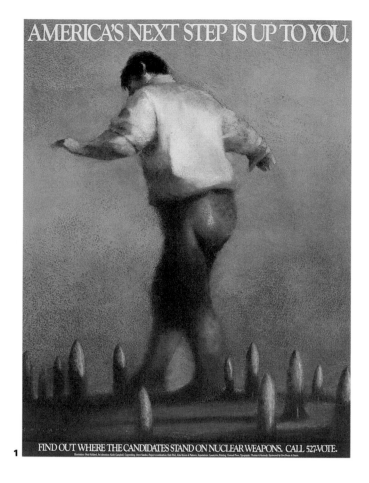

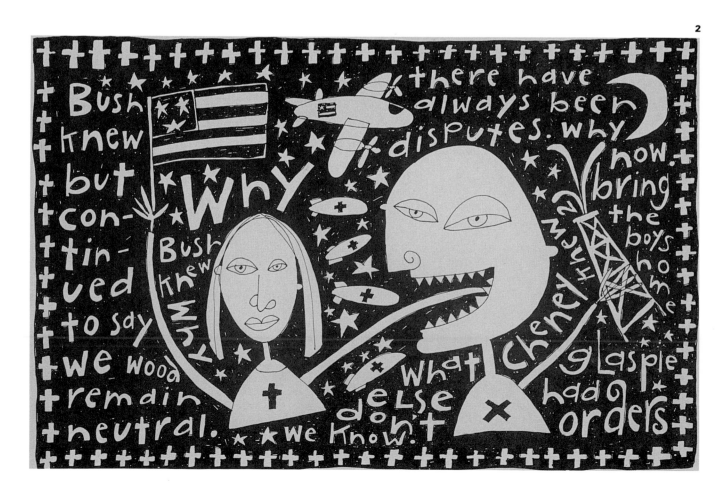

Living with the Bomb

7:30 pm Wednesday 23 April
229 Natural History Building
1301 West Green Street, Urbana

Paul Loeb

How do people who manufacture
weapons of atomic destruction
justify their work? How do
we all suppress or confront the
question of whether we will
survive the nuclear age?
How does the bomb affect us
even if the missiles are never
launched?

Paul Loeb, author of
Nuclear Culture, explores the
connections between
unprecedented global threats
and our ordinary lives.

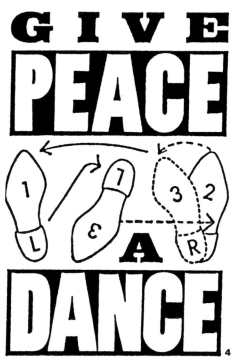

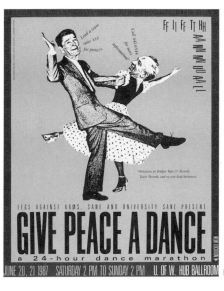

3

Poster **LIVING WITH THE BOMB**
Designer **ANN TYLER**
Photographer **TOM BYERLY**
Writer **JUDITH EDELSTEIN**
Design Firm **ANN TYLER COMMUNICATION DESIGN, CHICAGO, IL**
Client **GEORGE A. MILLER COMMITTEE, UNIVERSITY OF ILLINOIS
AT URBANA-CHAMPAIGN**
Typographer **INTELLITEXT**
Printer **ANDROMEDA PRINTING**

4

Logo **GIVE PEACE A DANCE**
Designer **ART CHANTRY, SEATTLE, WA**
Client **GIVE PEACE A DANCE/LIZ SMITH**

5

Poster **GIVE PEACE A DANCE**
Designer **ART CHANTRY, SEATTLE, WA**
Client **GIVE PEACE A DANCE/LIZ SMITH**
Typographer **ROCKET TYPE**
Printer **ACADEMY PRESS/STEVE PATTIE**

123

KINDER GENTLER CARPET BOMBING

GTO

1

1
Poster **KINDER GENTLER CARPET BOMBING**
Art Director **ART CHANTRY**
Designer **MARK FOX**
Design Firm **BLACKDOG, MILL VALLEY, CA**
Client **GRAPHIC TERRORIST ORGANIZATION**
Typographer **BLACKDOG**
Printer **XEROX**
Paper Manufacturer **ISLAND PAPER MILLS COMPANY**

2
Booklet **"YOU CAN'T SAY THAT!"**
Art Directors **CRAIG BERNHARDT, JANICE FUDYMA**
Designer **IRIS A. BROWN**
Photographers **VARIOUS**
Design Firm **BERNHARDT FUDYMA DESIGN GROUP, NEW YORK, NY**
Client **GILBERT PAPER COMPANY**
Typographer **GRAPHIC TECHNOLOGY**
Paper Manufacturer **GILBERT PAPER COMPANY**

2

At 14, He's Already a "Soldier."

Thanks to U.S.-backed contras, thousands of Nicaraguan children like Emerick Danilo Torrez Briones are getting a harsh education in the realities of war. Some have been forced to fight like adults to defend their homes. Others, including many who have been killed or wounded, are noncombatants–innocent victims.

Emerick's drawing shows a recent skirmish between contras and government troops. (His father and brother were both killed fighting contras in early 1984.) He has written on the bottom, "We don't want war... we want peace."

Over 39,600 Nicaraguan contras, government "compas," and civilians have been killed or wounded in the war since 1982. Is this carnage creating democracy in Nicaragua? Or is it making enemies for the U.S.?

Stop U.S. Aid to the Contras

The Day Contras Attacked His Home.

On December 8, 1986, Juan Agustin Lumbi Rizo, age 14, lost his father and a baby sister only 38 days old.

Both were killed when three contras attacked them in their home. Other family members were wounded. 22-month-old Mabel lost an arm when a bullet shattered the bone. And 5-year-old Elda Janet's cheek bears a large scar from a bullet wound.

Juan's drawing shows the contras, his older brother Porfino escaping out a window, and his father and baby sister dead in the house.

Over 35,000 Nicaraguans have been kidnapped, wounded or killed in the contra war since 1982, with your tax dollars.

Stop U.S. Aid to the Contras

What Did Santos See in the Church?

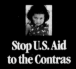

No one may ever learn the full story of Santos Fermin Lopez, the 12-year-old who drew the picture you see here. He was recently found wandering, dazed and alone, in the Nicaraguan countryside.

Santos himself can supply only a little information. He and his parents left their home in remote Cerro Grande about one and a half years ago, after contras attacked their village. His parents died from an unknown illness, leaving him to fend for himself.

What does Santos' drawing of the men with machetes in church represent? How long did he wander alone in the wild, and how did he survive? These are all mysteries.

But one thing is certain: Santos is only one of many casualties of the contra war. More than 250,000 Nicaraguans have been displaced from their homes since it began.

We say we're against terrorism. In Nicaragua, we're supporting it.

She Remembers the Truck. Not the Explosion.

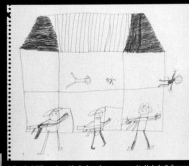

On October 20, 1986, 7-year-old Elda Uri Sanchez was riding on the back of a flatbed truck with dozens of other people. (Such hitchhiking is common in like vehicle-poor rural Nicaragua.)

Elda doesn't remember the truck hitting a mine buried by U.S.-backed contras. Six people were killed, 45 others wounded. Eleven of the injured had limbs amputated, including Elda, her father (a Pentecostal minister), and her 19-year-old sister.

All Elda remembers is waking up later in the hospital–with one leg gone

We say we're against terrorism. In Nicaragua, we're supporting it.

3
Mass Transit Billboards **THE WAR ON CHILDREN**
Art Director/Designer **MICHAEL LEBRON, NEW YORK, NY**
Writer **MARK WILLIAMS**
Photographers **PAUL DIX, MICHAEL LEBRON**
Typographer **U.S. LITHOGRAPH INC.**
Printer **K & L LABS**

1
Newsletter **THE WOLF FUND/WINTER-SPRING 1991**
Designers **JEFF AND ADRIENNE POLLARD**
Illustrators/Photographers **VARIOUS**
Design Firm **POLLARD DESIGN, HARTFORD, CT**
Client/Publisher **THE WOLF FUND**
Printer **THE POND-EKBERG COMPANY**
Paper Manufacturer **SIMPSON PAPER COMPANY**

2
Poster **DON'T BUY IVORY**
Art Director/Illustrator **KIYOSHI KANAI**
Design Firm **KIYOSHI KANAI, INC., NEW YORK, NY**
Client **WORLD WILDLIFE FUND**
Typographer **KIYOSHI KANAI**
Printer **JAPAN SLEEVE CO.**
Paper Manufacturer **KANZAKI PAPER CO.**

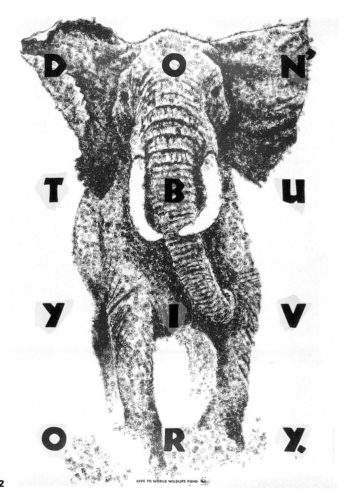

2

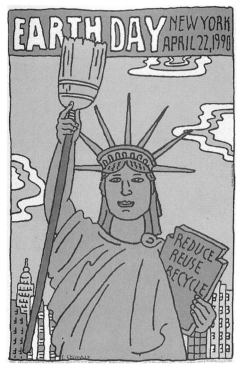

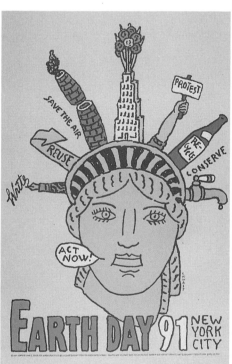

3

Poster **EARTH DAY 1990**
Designer/Illustrator **SEYMOUR CHWAST**
Design Firm **THE PUSHPIN GROUP, NEW YORK, NY**
Client/Publisher **MERYL PENNER/THE EARTH DAY COMMITTEE**
Printer **ECO-SUPPORT GRAPHICS**
Paper Manufacturer **FOX RIVER PAPER COMPANY**

4

Poster **EARTH DAY 1991**
Designer/Illustrator **SEYMOUR CHWAST**
Design Firm **THE PUSHPIN GROUP, NEW YORK, NY**
Client/Publisher **MERYL PENNER/THE EARTH DAY COMMITTEE**
Printer **ECO-SUPPORT GRAPHICS**
Paper Manufacturer **FOX RIVER PAPER COMPANY**

5

T-Shirt **THE PARK PEOPLE**
Art Directors **PAULA SAVAGE, TOMMY ODDO**
Designer/Illustrator **TOMMY ODDO**
Design Firm **SAVAGE DESIGN GROUP, HOUSTON, TX**
Client **THE PARK PEOPLE**
Typographer **SAVAGE DESIGN GROUP**
Printer **SCREEN IMAGES**

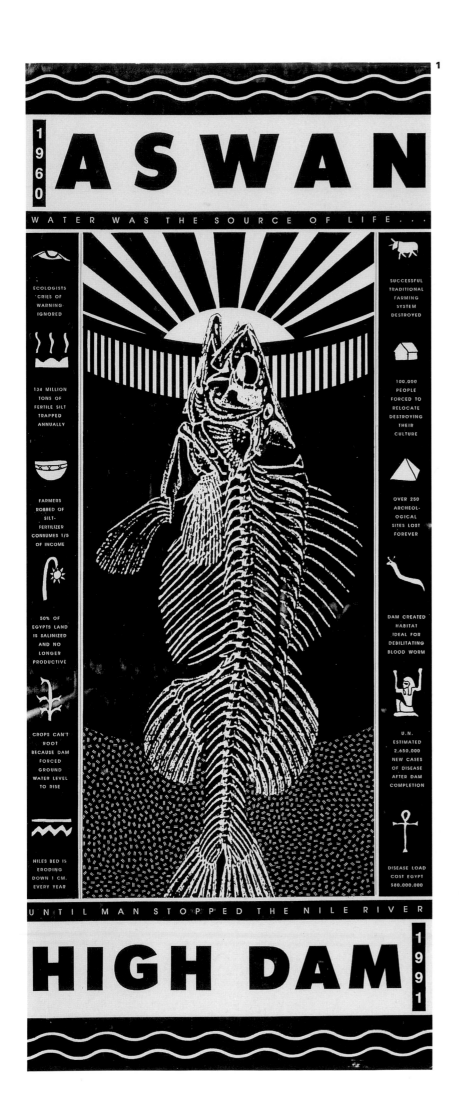

1
Poster **ASWAN HIGH DAM**
Designer/Illustrator/Typographer **PAUL BARTH,
RALEIGH, NC**
Publisher **IOWA STATE UNIVERSITY-COLLEGE OF
ENVIRONMENTAL STUDIES**
Printer **COPYCAT**
Paper Manufacturer **FRENCH PAPER COMPANY**

SaVE San Francisco Bay

2

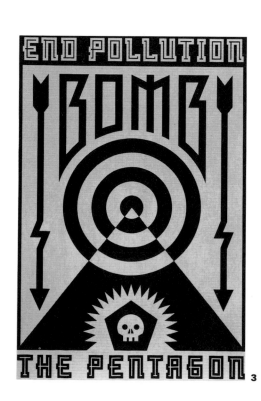

END POLLUTION

BOMB

THE PENTAGON

3

2
Poster **SAVE SAN FRANCISCO BAY**
Art Director **DOUG AKAGI**
Design Firm **AKAGI DESIGN, SAN FRANCISCO, CA**
Designers **DOUG AKAGI, KIMBERLY LENTZ POWELL**
Gyotaku Print Illustration **HIROSHI AKAGI**
Typography **LINOTRONIC COMPUTER**

3
Poster **BOMB THE PENTAGON**
Designer/Illustrator **MARK FOX**
Design Firm **BLACKDOG, MILL VALLEY, CA**
Client/Publisher **BLACKDOG**
Typographer **MARK FOX**
Printer **ACME SILK SCREEEN**

Judging the Communication Graphics Show — choosing the best, most representative fragment of the design whole — is similar to selecting a detail from an immensely complex painting, and then asking that small fragment to represent the entire picture. It must encapsulate the color, texture, mood, style and collective *spirit* of the artist's vision, not just the freshest paint or brightest palette. Choosing the wrong detail will distort the picture. An impossible job? Yes. Do we attempt it anyway? Of course.

Communication Graphics '92 is just such a detail. The work was selected from 4,281 entries, self-edited by the designers themselves from among their total year's work and submitted for selection during a week-long judging. Seven jurors, representing a geographic, cultural, experiential and generation cross-section of the profession, brought their personal biases as well as their common aesthetics — to choose this show. From my perspective, it represents the best picture of American graphic design today.

Kit Hinrichs, Chairman
Communication Graphics

Call-for-Entries

Design: Pentagram
Photographer: Bob Espara
Electronic Composite: TX Unlimited
Hand Model: Bill Austin
Typesetter: Omnicomp
Printer: Graphic Arts Center
Paper: Simpson Paper Company, Quest Recycled White, 80# Text

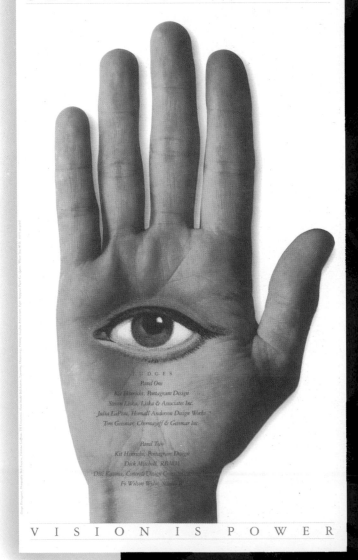

COMMUNICATION

It's been an interesting year. The Soviets plunge toward divorce while Apple and "Big Blue" dream of marriage. Our landfills overflow, yet our S&L's come up empty. We've had floods, droughts, volcanic eruptions and a brief desert storm. Our streets are dirty, but our money is laundered. And the Red Sox take us to the brink one more time. For designers, the times are no less troublesome. Are we artists or marketing consultants? Have we replaced content with style? Is creativity being enlivened, or killed by a small beige mouse? The Communication Graphics show will focus on the best, most innovative and powerful work created during 1991 and seek the visions and visionaries for the next century. — *Kit Hinrichs, Chairman*

GRAPHICS 1991–1992

VISION IS POWER

COMMUNICATION GRAPHICS

JURY ONE

Kit Hinrichs Partner
Pentagram Design

Steven Liska Principal
Liska & Associates Inc.

Janice Fudyma Principal
Bernhardt/Fudyma Design Group

Thomas Geismar Principal
Chermayeff and Geismar Associates, Inc.

1

2

1

Annual Report **LOGICON 1991**
Art Director **JIM BERTE**
Photographer **RUSS WIDSTRAND**
Design Firm **MORAVA OLIVER BERTE, SANTA MONICA, CA**
Publisher **LOGICON, INC.**
Typographer **COMPOSITION TYPESETTING**
Printer **LITHOGRAPHIX**
Paper Manufacturer **POTLATCH**

2

Brochure **ONE SUN**
Art Director **DEVIN IVESTER**
Designer **JULIE HEINZE**
Photographer **PAUL MATSUDA**
Design Firm **SUN CREATIVE, MOUNTAINVIEW, CA**
Client **SUN MICROSYSTEMS**
Printer **GEHRE GRAPHICS**

3

3

Calendar **ROCKWELL INTERNATIONAL**
Art Director **REGINA RUBINO**
Designer **ROBERT LOUEY**
Photography **NASA, BETTMAN ARCHIVES, GRANGER COLLECTION**
Design Firm **LOUEY/RUBINO DESIGN, SANTA MONICA, CA**
Client **ROCKWELL INTERNATIONAL CORPORATION**
Typographer **COMPOSITION TYPE**
Printer **GRAPHIC ARTS CENTER**
Paper Manufacturer **SIMPSON, S.D. WARREN**

1

Brochure **DESIGN & STYLE #7: THE BAUHAUS**
Art Director/Designer **SEYMOUR CHWAST**
Design Firm **THE PUSHPIN GROUP**
Client/Paper Manufacturer **MOHAWK PAPER MILLS, INC.**
Typographer **THE TYPECRAFTERS INC., NEW YORK**
Printer **LEBANON VALLEY OFFSET**

2

Brochure **EVERY ART DIRECTOR NEEDS HER OWN TYPEFACE**
Art Director/Designer/Illustrator **JONATHAN HOEFLER**
Design Firm/Client/Typographer **THE HOEFLER TYPE FOUNDRY, NEW YORK, NY**
Printer **J.F.B. & SONS LITHOGRAPHERS**
Paper Manufacturer **MOHAWK**

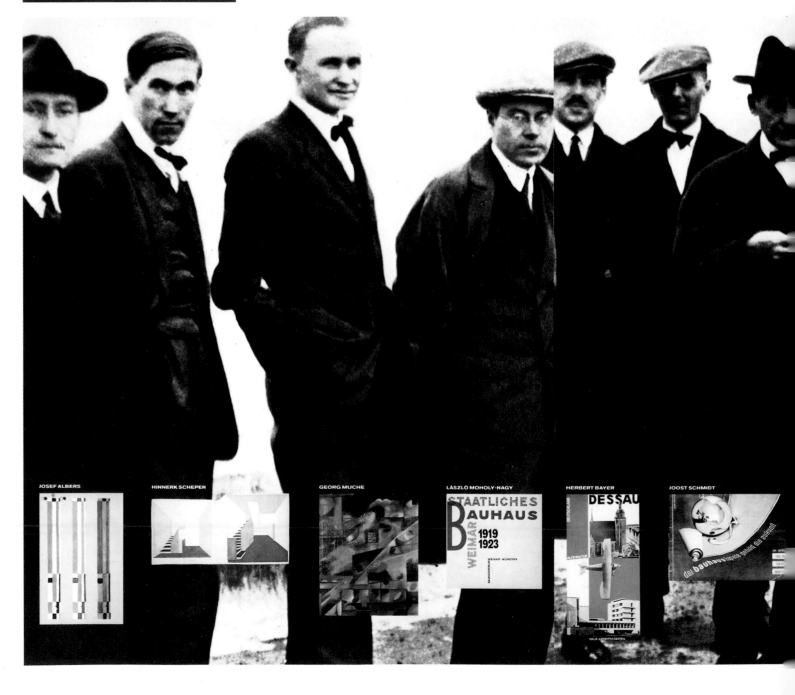

2

EVERY ART DIRECTOR
NEEDS HER OWN
TYPEFACE

The good news is that this same technology puts the tools of typeface manufacturing into the hands of type designers. Commissioning a new typeface, once the exclusive province of large foundries, is now a viable alternative for art directors seeking to create a distinctive identity through type. And since the commission of a new design is a one-time expense which leads to smaller typesetting bills, in many cases it pays for itself.

GRAZIA BODONI Publication designer Roger Black commissioned this new cut of Bodoni for his redesign of the Italian fashion magazine Grazia. Based closely on the original types of Giambattista Bodoni, the font was completed on February 26, 1990—Bodoni's 250th birthday.

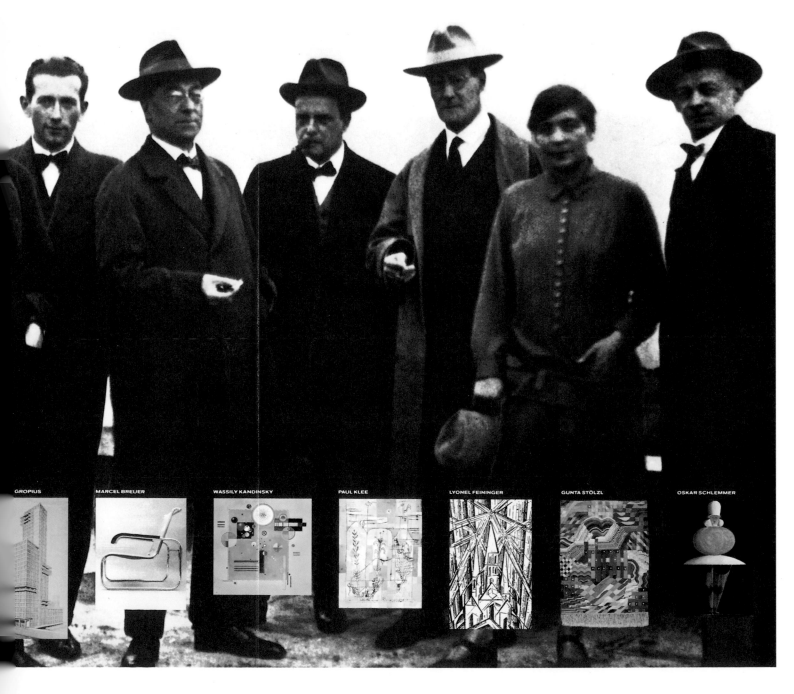

GROPIUS MARCEL BREUER WASSILY KANDINSKY PAUL KLEE LYONEL FEININGER GUNTA STÖLZL OSKAR SCHLEMMER

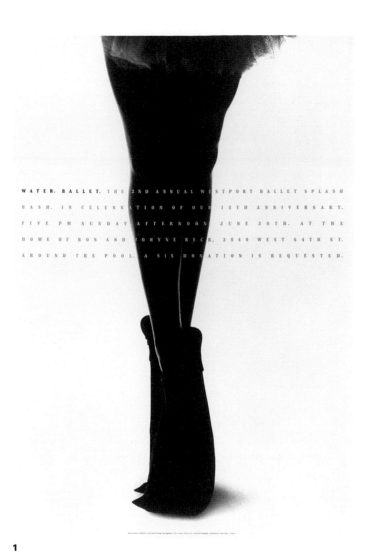

1

1
Poster **WATER BALLET**
Art Director **CARTER WEITZ, LINCOLN, NB**
Photographer **MICHAEL RUSH**
Writer **JOHN BENSON**

2
Brochure **THE SOCIETY FOR CONTEMPORARY CRAFTS:**
THE FIRST TWO DECADES
Art Director/Designer **MIKE SAVITSKI**
Art Director **RICK LANDESBERG**
Writer **BECKY BURDICK**
Design Firm/Typographer **LANDESBERG DESIGN ASSOCIATES,**
PITTSBURGH, PA
Client **THE SOCIETY FOR CONTEMPORARY CRAFTS**
Printer **MERCURY PRINTING**
Paper Manufacturer **JAMES RIVER CORPORATION**

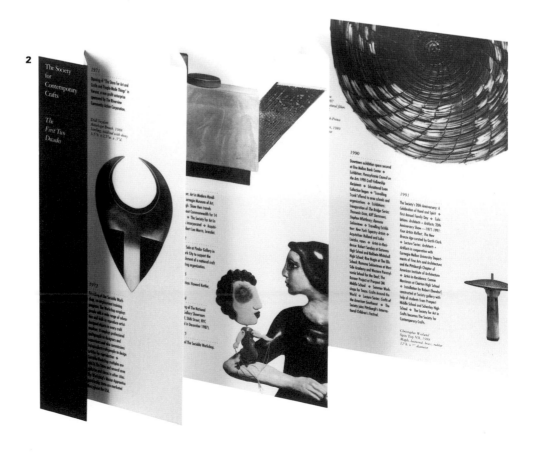

2

Parchment paper

Mr. Coffee filters

3

4

3
Brochure **"GARBAGE OR ART?"**
Art Director/Designer **PAULA SCHER**
Photographer **MARGARET CASELLA**
Design Firm **PENTAGRAM DESIGN, NEW YORK, NY**
Client **MARGARET CASELLA**
Typographer **JCH**
Printer **RAPPAPORT**

4
Catalog **RISD/JEWELRY AND LIGHT METALS DEPT.**
Art Director/Typographer **RENATE GOKL**
Photographer **VARIOUS**
Design Firm **RG DESIGN, SOMERVILLE, MA**
Client **RHODE ISLAND SCHOOL OF DESIGN**
Printer **DES OFFSET**

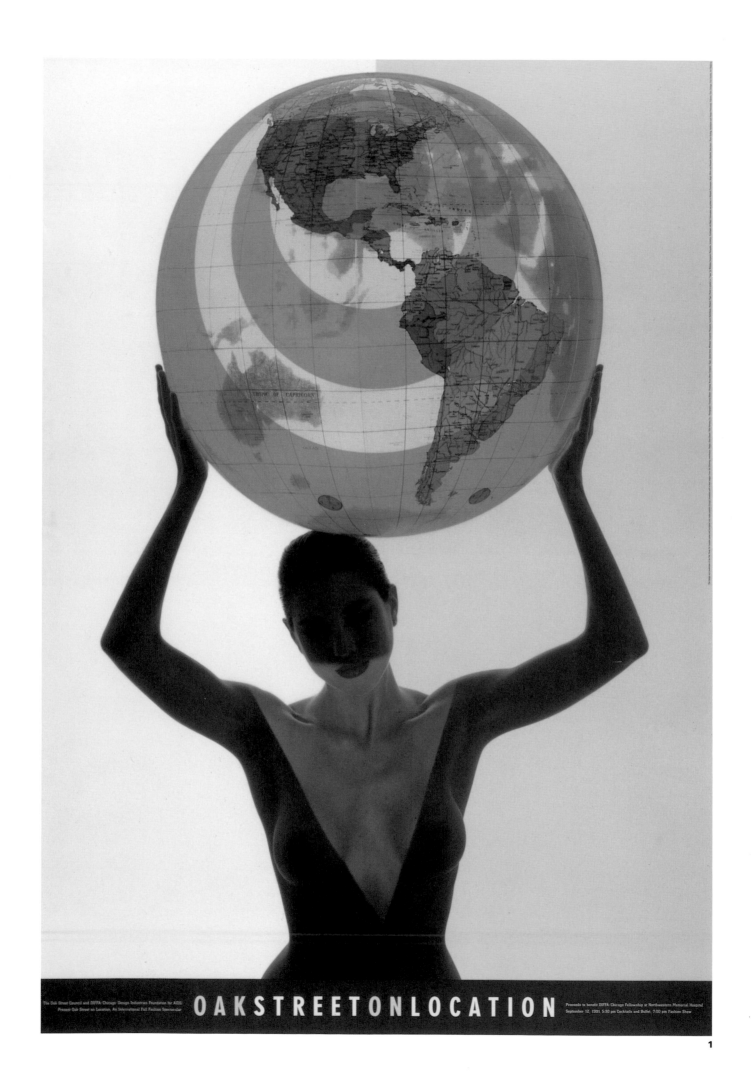

OAKSTREETONLOCATION

1

Poster **OAK STREET ON LOCATION**

Art Director/Designer **DANA ARNETT**

Photographer **FRANCOIS ROBERT**

Design Firm/Typographer **VSA PARTNERS, INC., CHICAGO, IL**

Client **DIFFA, (DESIGN INDUSTRIES FOUNDATION FOR AIDS), CHICAGO, IL**

Typographer **TYPOGRAPHIC RESOURCE**

Printer **BRUCE OFFSET**

Paper **WHITACRE CARPENTER**

2

Poster **RECYCLE OR DIE**

Designer/Illustrator **MICHAEL SCHWAB**

Design Firm **MICHAEL SCHWAB DESIGN, SAUSALITO, CA**

Publisher **BELLA BLUE**

Printer **CANNONBALL GRAPHICS**

3

Promo Piece **TAKE IT BACK WHEEL**

Project Director **KENT ALTERMAN**

Designer **TOM BRICKER**

Illustrator **PETER KUPER**

Agency/Typographer **FRANKFURT GIPS BALKIND, NEW YORK, NY**

Client **TAKE IT BACK FOUNDATION, JOLIE JONES**

Printer **HERITAGE**

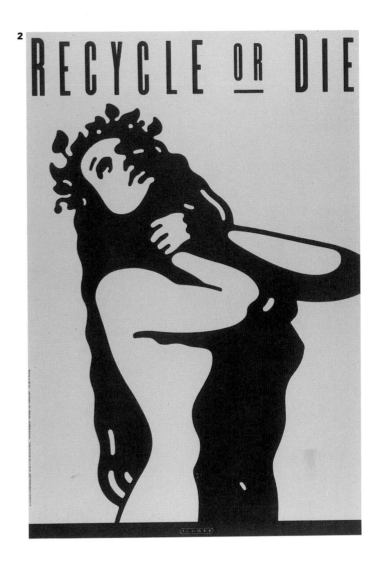

3

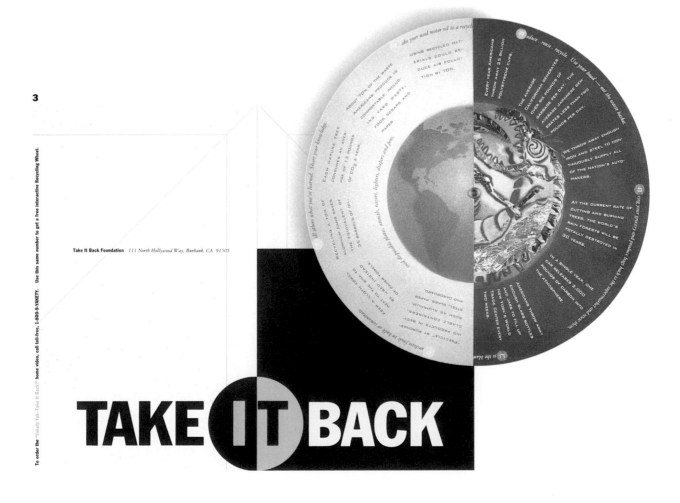

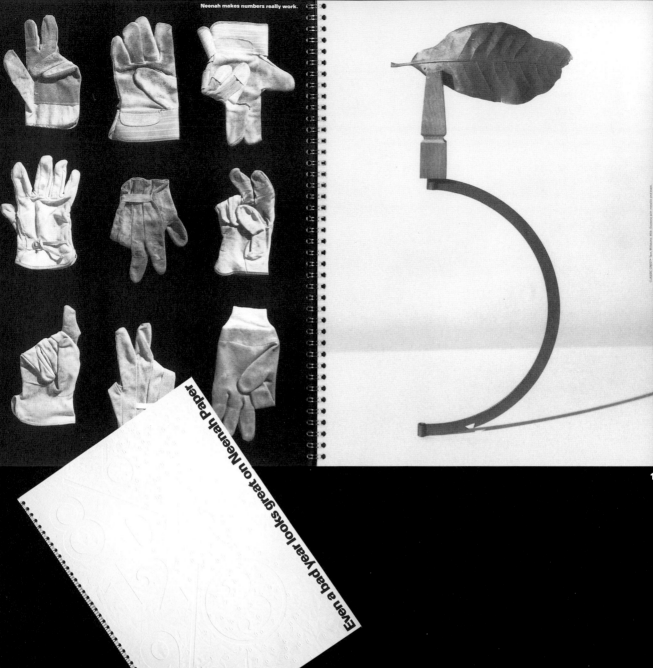

Even a bad year looks great on Neenah paper.

CHICKASAW MUDD PUPPIES

do you remember

4

3

1

Brochure **NEENAH PAPER: EVEN A BAD YEAR LOOKS GOOD ON NEENAH PAPER**
Art Directors **KERRY GRADY, MICHAEL GLASS**
Photographer **GEOF KERN**
Design Firm **MICHAEL GLASS DESIGN, INC., CHICAGO, IL**
Client **NEENAH PAPER**
Typographer **PAUL BAKER TYPOGRAPHY**
Printer **SERVICE LITHO-PRINT, OSHKOSH**

2

Album **CHICKASAW MUDD PUPPIES: DO YOU REMEMBER**
Art Director/Illustrator **MICHAEL KLOTZ**
Design Firm **POLYGRAM RECORDS INC., NEW YORK, NY**
Client **CHICKASAW MUDD PUPPIES**
Typographer **IN-HOUSE MAC**
Printer **SHOREWOOD**

3

Self-Promotion **DUFFY DESIGN GROUP WINE BOTTLE, '92**
Art Directors **TODD WATERBURY, JOE DUFFY**
Designer **TODD WATERBURY**
Design Firm/Client **THE DUFFY DESIGN GROUP, MINNEAPOLIS, MN**
Typographer **DAHL & CURRY**
Printer **COLOR-CRAFT SILKSCREEN DISPLAYS, INC.**

4

Menu **INN OF THE ANASAZI**
Art Director/Designer **LORI WILSON**
Designer **ELIZABETH WHITE**
Design Firm **DAVID CARTER GRAPHIC DESIGN ASSOCIATES, DALLAS, TX**
Printer **ETHRIDGE**
Paper Manufacturer **BECKETT**

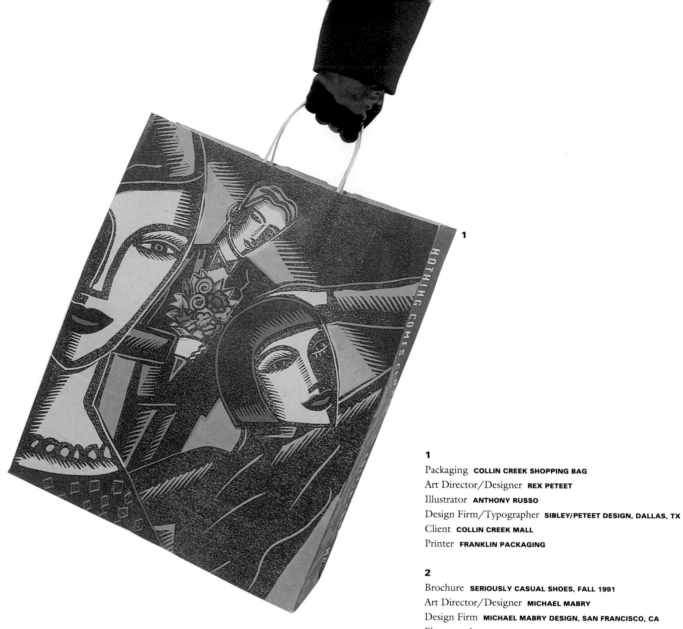

1

Packaging **COLLIN CREEK SHOPPING BAG**
Art Director/Designer **REX PETEET**
Illustrator **ANTHONY RUSSO**
Design Firm/Typographer **SIBLEY/PETEET DESIGN, DALLAS, TX**
Client **COLLIN CREEK MALL**
Printer **FRANKLIN PACKAGING**

2

Brochure **SERIOUSLY CASUAL SHOES, FALL 1991**
Art Director/Designer **MICHAEL MABRY**
Design Firm **MICHAEL MABRY DESIGN, SAN FRANCISCO, CA**
Photographers **BRIGITTE LACOMBE (PORTRAITS), DAN LANGLEY (PRODUCT)**
Agency **COLE & WEBER**
Client **NIKE**
Typographer **ON LINE TYPOGRAPHY**
Printer **GRAPHIC CENTER**

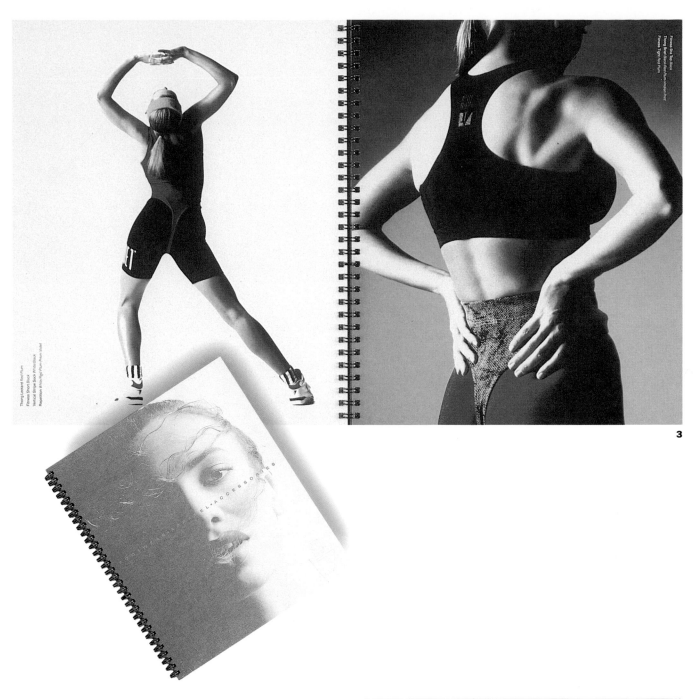

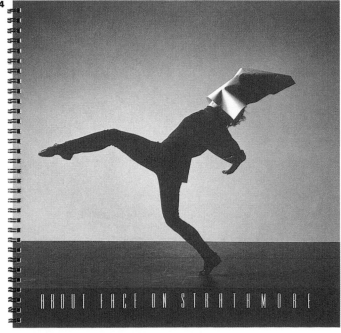

3

Catalog **SPRING '92 SIDE ONE CATALOG**
Art Director/Designer **VALERIE TAYLOR SMITH**
Illustrators **DAN LANGLEY, BARBARA PENOYAR**
Design Firm **NIKE DESIGN**
Typographer **SIDE 1**
Printer **OREGON PRINTING PLATES/SIMPSON**

4

Brochure **ABOUT FACE ON STRATHMORE**
Art Director **ELIZABETH OZIERSK**
Designers **MIKE SCRICCO, ELIZABETH OZIERSK**
Illustrators **JOHN CASADO, FRANK MARCHESE, CHRIS CALLIS,
LEE CRUM, BILL TUCKER**
Agency **KEILER & COMPANY, FARMINGTON, CT**
Client **STRATHMORE PAPER CO.**
Typographer **MATRIX TYPE**
Printer **THE FINLAY BROTHERS CO.**
Paper Manufacturer **STRATHMORE**

1
Invitation **IRONWORK**
Art Director **BILL GRIGSBY**
Designer/Illustrator **STEVEN GUARNACCIA**
Client **REACTOR GALLERY**
Printer **LUNAR CAUSTIC PRESS**
Paper Manufacturer **"SPECKLETONE COVER" BY FRENCH PAPER COMPANY**

2
Booklet **TEACHING AT ART CENTER**
Art Director **REBECA MENDEZ**
Designers **REBECA MENDEZ, ELLEN EISNER**
Illustrator **MARJO WILSON**
Design Firm/Agency **ART CENTER COLLEGE OF DESIGN, PASADENA, CA**
Typography **MACINTOSH**
Offset Lithographer **TYPECRAFT**
Letterpress **PATRICK REAGH PRINTERS**

2

II. Educational Structure and Philosophy

Departmental Organization

The courses of study at Art Center are distributed among ten instructional departments, some of which in turn support additional major study areas. A careful reading of the catalog will provide a sense of collegewide structure, but essentially the departments are Advertising, Computer Graphics, Film, Fine Art, Foundation Programs, Graphic and Packaging Design, Illustration (including Fashion Illustration), Industrial Design (including Transportation Design, Product Design, and Environmental Design), Liberal Arts and Sciences, and Photography. Responsible for overseeing the educational policy, direction, course requirements, and overall curriculum of each department is an appointed chair. Several

3
Stationery **ART KANE, PHOTOGRAPHER**
Art Director/Designer **JIM MIHO**
Design Firm **MIHO, PASADENA, CA**
Client **ART KANE**

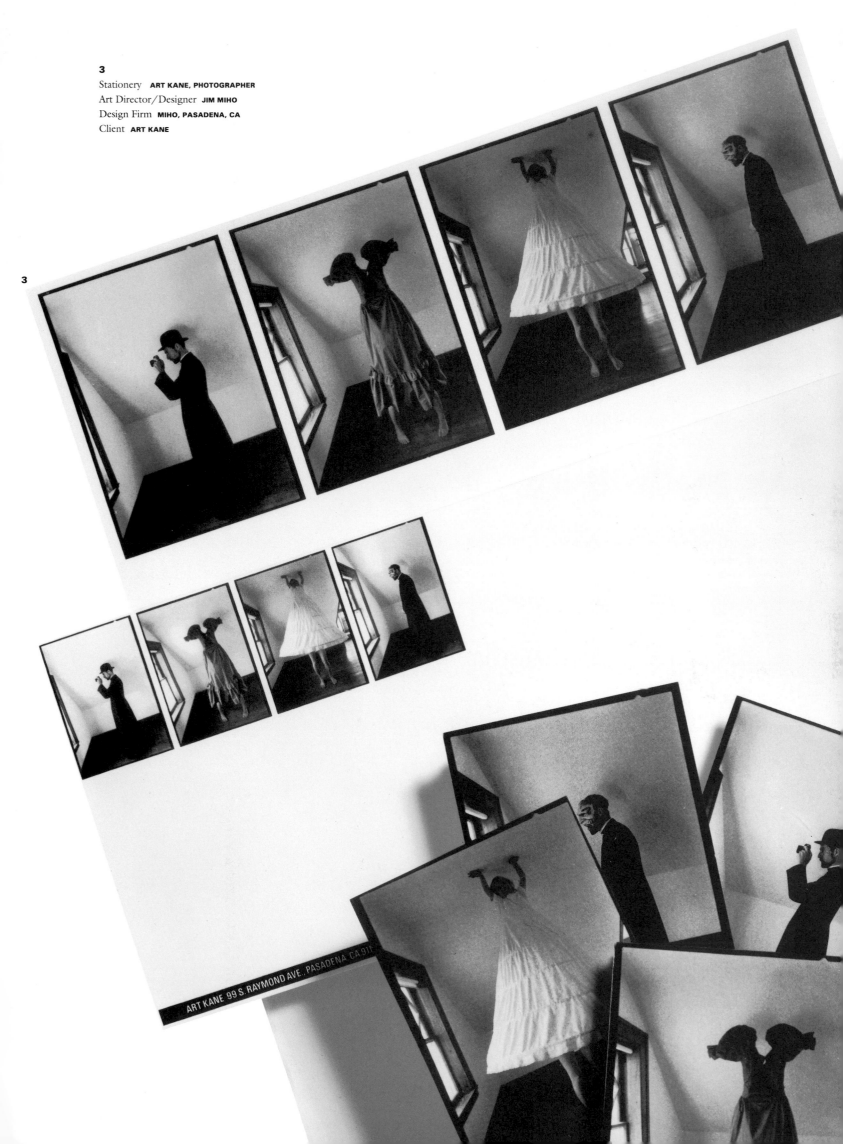

1

1

Annual Report **CENTRE REINSURANCE 1990**

Art Directors/Designers **FRANK OSWALD, RANDALL SMITH**

Design Firm/Typographer **WYD DESIGN, WESTPORT, CT**

Client **CENTRE REINSURANCE**

Printer **DANIELS PRINTING**

Paper Manufacturer **MOHAWK/KIMBERLY CLARK**

2

Packaging **SET OF GIFT BOXES**

Art Director/Designer/Photographer **SAM SMIDT**

Design Firm **SAM SMIDT INC., PALO ALTO, CA**

Client **NATURAL WONDERS**

2

3

Logo **NEW JERSEY STATE AQUARIUM**
Art Directors/Designers **ROGER COOK, DON SHANOSKY**
Design Firm **COOK AND SHANOSKY ASSOCIATES INC., PRINCETON, NJ**
Client **ZOOLOGICAL SOCIETY OF PHILADELPHIA**

4

Signage Graphics **THE CITADEL**
Art Director **SCOTT CUYLER**
Designer **HOLLY HAMPTON**
Design Firm **SUSSMAN/PREJZA & COMPANY, INC., CULVER CITY, CA**
Client **TRAMMELL CROW COMPANY**

3

4

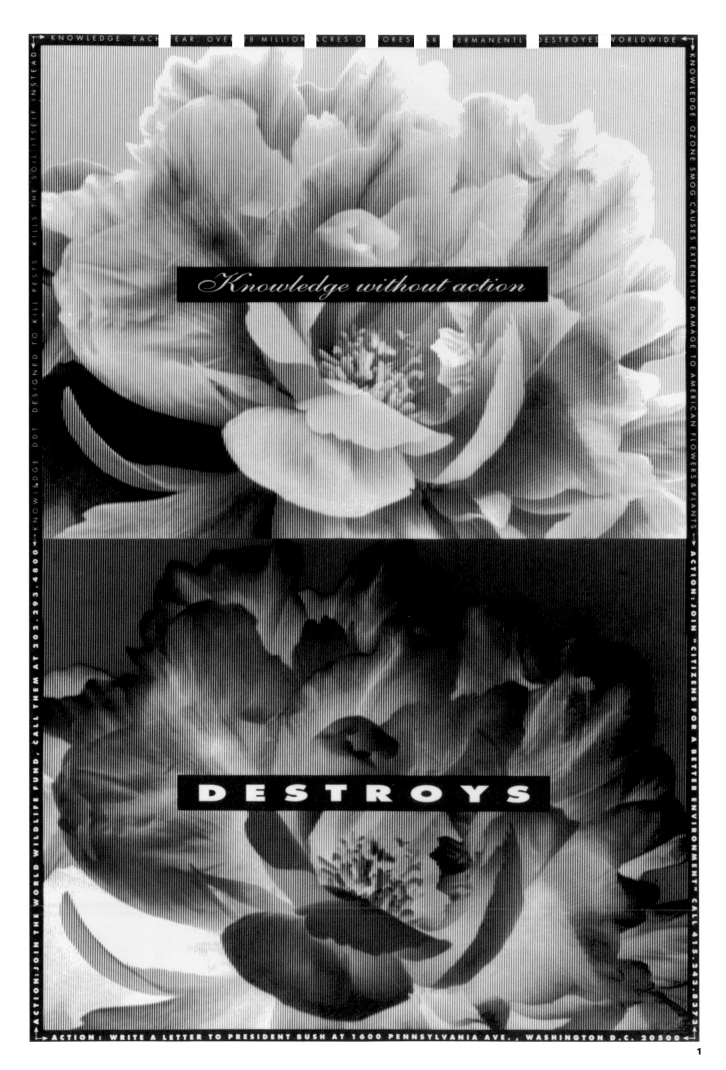

Knowledge without action

DESTROYS

2

1

Poster **AIGA: ENVIRONMENTAL AWARENESS POSTER**
Art Director/Designer **JENNIFER MORLA**
Designer **JEANETTE ARAMBURU**
Design Firm **MORLA DESIGN, SAN FRANCISCO, CA**
Client **SAN FRANCISCO AIGA**
Printer **FORD GRAPHICS**

2

Catalog **"CALL FOR ENTRIES" THE AR 100 SHOW**
Art Director/Desginer **STEVE LISKA**
Designer **BROCK HALDEMAN**
Design Firm **LISKA AND ASSOCIATES, INC., CHICAGO, IL**
Client **ALEXANDER COMMUNICATIONS**

3

Packaging **JUDY GARLAND**
Art Director/Designer/Typographer **HEATHER VAN HAAFEN**
Art Director **TOMMY STEELE**
Design Firm **CAPITOL RECORDS, INC., HOLLYWOOD, CA**
Typographer **LEAH HOFFMITZ**
Paper Manufacturer **GILL**

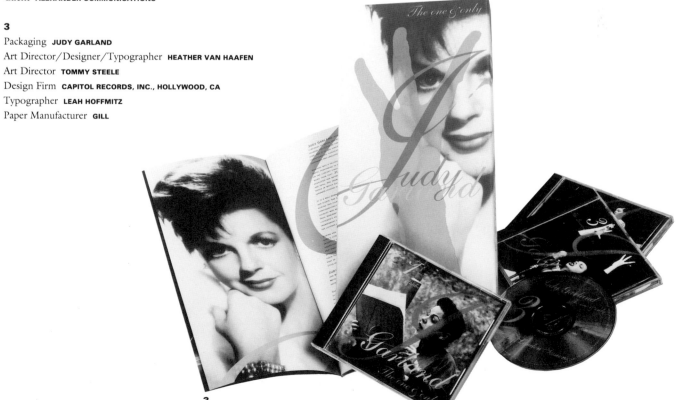

3

1

2

VOLUME 1 · NUMBER 1 · NOVEMBER 1991

IN THE SPIRIT OF

San Francisco is beautiful!"; "This city used to be much better." We have all heard these declarations. They imply that San Francisco, like all flawless jewels, should be left alone; that we see change as inherently bad; and that we fear that things can only become worse than they are. We cling to the cherished image that we have of San Francisco: a city of low buildings, buildings that are either dressed in colorful materials or somberly clad in brown shingles, their surfaces broken by bay windows. ¶ This image is a myth. In fact, throughout its history, San Francisco has been a city of constant change. Younger generations of architects have rebelled against their older colleagues. At the turn of the century, Willis Polk and Bernard Maybeck, among others, rebelled against the Victorians. In the 1920s and 1930s, William Wurster and Gardner Dailey demonstrated against ponderous classical buildings. They imported the images and lessons of the

MODERNISM

JAMES SHAY

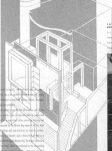

Peachtree Street is Atlanta's most historic thoroughfare. At the point where it intercepts West Peachtree Street lies the most commanding site in Atlanta. Indeed, this is the northern gateway to the downtown. ■ Here is the perfect place for Atlanta to carve its signature on the skyline. ■ That place is called One Peachtree Center. ■ A development of Portman Properties, One Peachtree Center soars 60 stories. But it is much more than one of the Southeast's most significant buildings. Designed by John Portman & Associates, One Peachtree Center is a symbol of continuing commitment by the Portman organization to the Southeast's most vibrant urban center, a commitment that began over 30 years ago with Peachtree Center. ■ Enfolding classic traditions of the past with the fresh excitement of Atlanta's future, One Peachtree Center is an eloquent gesture to the city's highest expectations.

1

Packaging **ECLAT AUTOMATED PRODUCT INFORMATION**
Art Director **PAUL CURTIN**
Designer **PETER LOCKE**
Designer/Illustrator **TIM CLARK**
Design Firm/Typographer **PAUL CURTIN DESIGN, SAN FRANCISCO, CA**
Client **ECLAT**
Printer **CLARK PACKAGING**

2

Newsletter **SFMOMA A&D FORUM — "IN THE SPIRIT OF MODERNISM"**
Art Director/Designer **LINDA HINRICHS**
Design Firm **POWELL STREET STUDIO, SAN FRANCISCO, CA**
Client **SAN FRANCISCO MUSEUM OF MODERN ART — A&D FORUM**
Typographer **DOUG MURAKAMI/DESIGN & TYPE**
Printer **COLORGRAPHICS, SAN FRANCISCO, CA**
Paper Manufacturer **SIMPSON PAPER**

1

1

Christmas Card **PADGETT PRINTING**
Art Director/Designer/Illustrator **CHUCK JOHNSON**
Photographer **DAN BRYANT**
Design Firm **BRAINSTORM, INC., DALLAS, TX**
Client **PADGETT PRINTING**

2

Brochure **MIRAWEB, BLACK MAGIC, METALLIC INC.**
Art Director **STEVE LISKA**
Designer **HEIDI FIESCHKO**
Photographer **LAURIE RUBIN**
Design Firm **LISKA AND ASSOCIATES, INC., CHICAGO, IL**
Client **INTERNATIONAL PAPER**

2

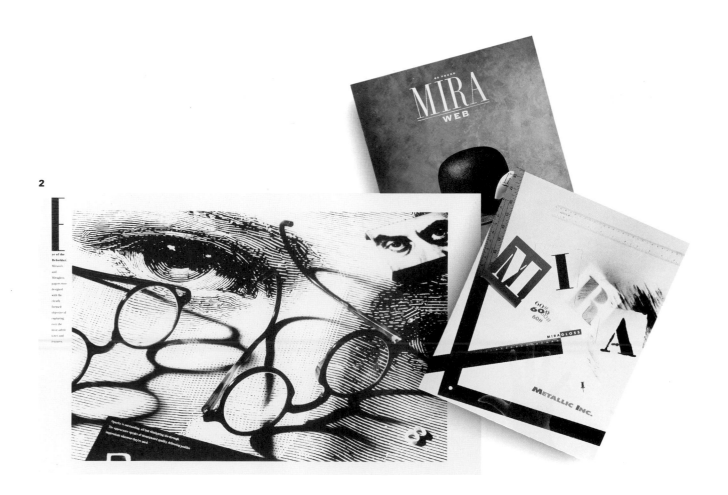

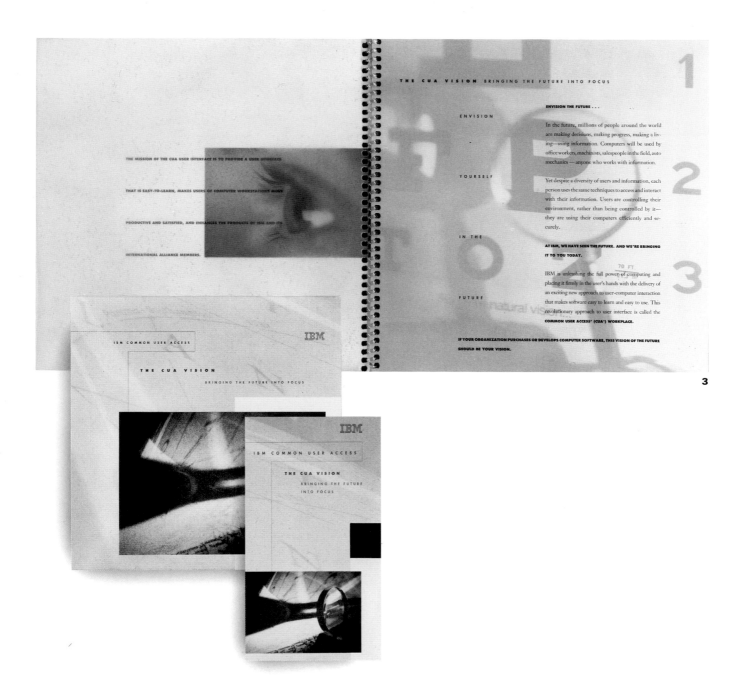

3

Booklet/Folder **IBM COMMON USER ACCESS — THE CUA VISION**

Designer/Art Director **CAROL NIX**

Art Direction **DAVID CHAPIN**

Photographer **DUANE SALSTRAND**

Design Firm **FORMA, RALEIGH, NC**

Clients **THE CUA VISION, KARL VON GUTEN (INFORMATION DEVELOPMENT MANAGER, IBM), DEAN DUFF (INFORMATION DEVELOPMENT PLANNER, IBM), DAVID SCHWARTZ, (CUA ARCHITECT, IBM), SARAH REDPATH (CUA GRAPHIC DESIGNER, IBM), CAROLINE MCLESTER (COPYWRITER, SKYES ENTERPRISES, INC.)**

Typographer **MARATHON TYPOGRAPHY**

Printer **COLOR GRAPHICS, INC.**

Paper Manufacturer **NEENAH, ZANDERS**

4

Logo **EAR WEAR**

Creative Director **BERNARDINO REYNOSO**

Designer **DIANA HERSCOVITCH**

Design Firm **DAKO DESIGN, NEW YORK, NY**

Client **EAR WEAR**

Typographer **IMAGES**

Printer **CUSTOM CAPABILITIES**

Paper Manufacturer **STRATHMORE**

1

1

Newsletter **ART CENTER REVIEW #8**
Designers **MARK SELFE, PIPER MURAKAMI**
Photographer **PRINCIPAL BY STEVEN A. HELLER**
Illustrators/Artists **STEPHANIE GARCIA, KIT HINRICHS**
Design Firm/Typographer **PENTAGRAM DESIGN, SAN FRANCISCO, CA**
Client **ART CENTER COLLEGE OF DESIGN**
Typographer **DESIGN & TYPE**
Printer **COLORGRAPHICS**
Paper Manufacturer **SIMPSON PAPER**

2

Poster **ANTIQUE AUTO SALES CENTER**
Art Director/Designer/Illustator/Typographer **DAVID CURTIS**
Design Firm **CURTIS DESIGN, SAN FRANCISCO, CA**
Client **DAWYDIAK AUTO SALES**
Printer **ASPEN GRAFICS**

2

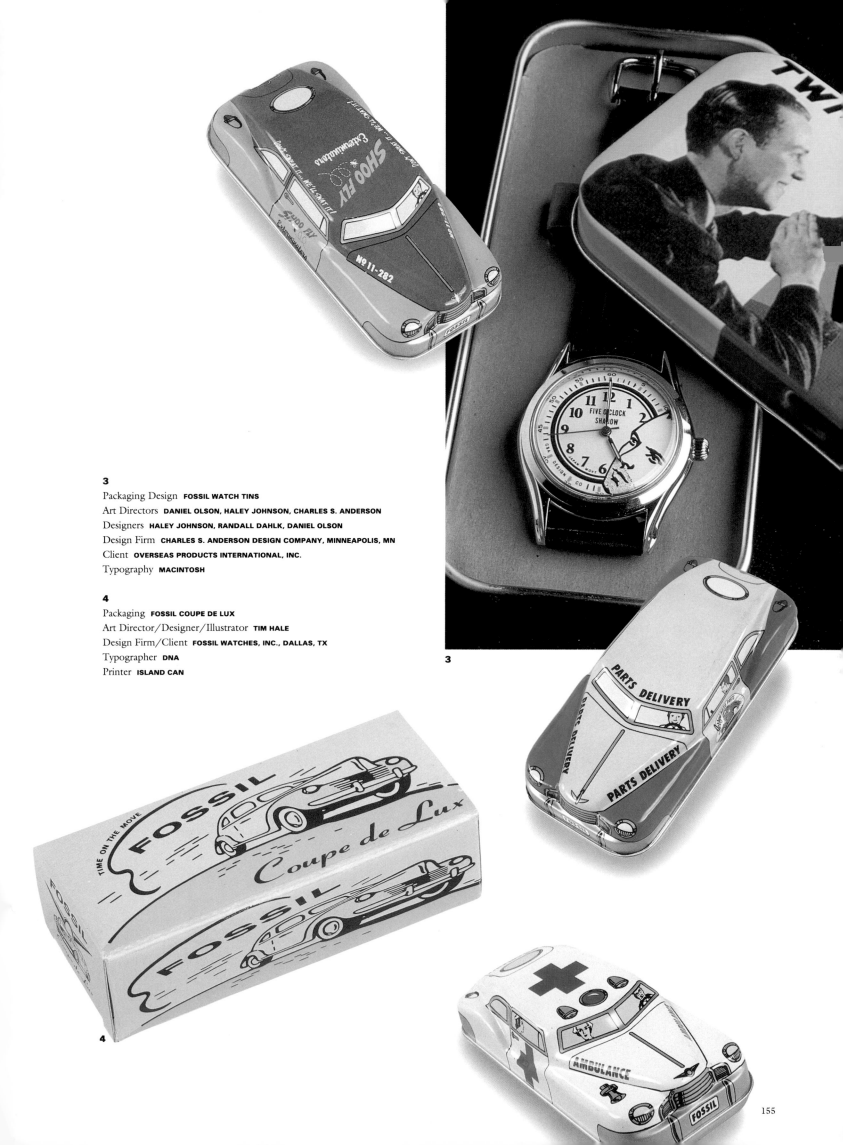

3

Packaging Design **FOSSIL WATCH TINS**
Art Directors **DANIEL OLSON, HALEY JOHNSON, CHARLES S. ANDERSON**
Designers **HALEY JOHNSON, RANDALL DAHLK, DANIEL OLSON**
Design Firm **CHARLES S. ANDERSON DESIGN COMPANY, MINNEAPOLIS, MN**
Client **OVERSEAS PRODUCTS INTERNATIONAL, INC.**
Typography **MACINTOSH**

4

Packaging **FOSSIL COUPE DE LUX**
Art Director/Designer/Illustrator **TIM HALE**
Design Firm/Client **FOSSIL WATCHES, INC., DALLAS, TX**
Typographer **DNA**
Printer **ISLAND CAN**

155

1

1
Brochure **ALLSTEEL AURORA BROCHURE**
Art Director/Designer **GREG SAMATA**
Art Director **NORM LEE**
Photographers **MARK JOSPEH, SANDRO MILLER, TERRY HEFFERNAN**
Design Firm/Typographer **SAMATA ASSOCIATES, DUNDEE, IL**
Client **ALLSTEEL INC.**
Printer **BRUCE OFFSET**
Paper Manufacturer **CONSOLIDATED**

2
Brochure **ZIBA DESIGN CAPABILITIES BROCHURE**
Art Director **DON ROOD**
Illustrator **VARIOUS**
Design Firm **DON ROOD DESIGN, PORTLAND, OR**
Client **ZIBA DESIGN**
Typographer **STUDIO SOURCE**
Printers **DYNAGRAPHICS, INC., GENE GAMBLE PRINTING**
Paper Manufacturers **CRANE, POTLATCH & STRATHMORE**

2

3

Stationery **THE WELLER INSTITUTE LETTERHEAD**

Art Director/Illustrator **DON WELLER**

Designer Firm/Client **THE WELLER INSTITUTE FOR**

THE CURE OF DESIGN, INC., PARK CITY, UT

Typographer **CHA CHA WELLER**

Printer **TED TUELLERS INK**

Paper Manufacturer **STRATHMORE**

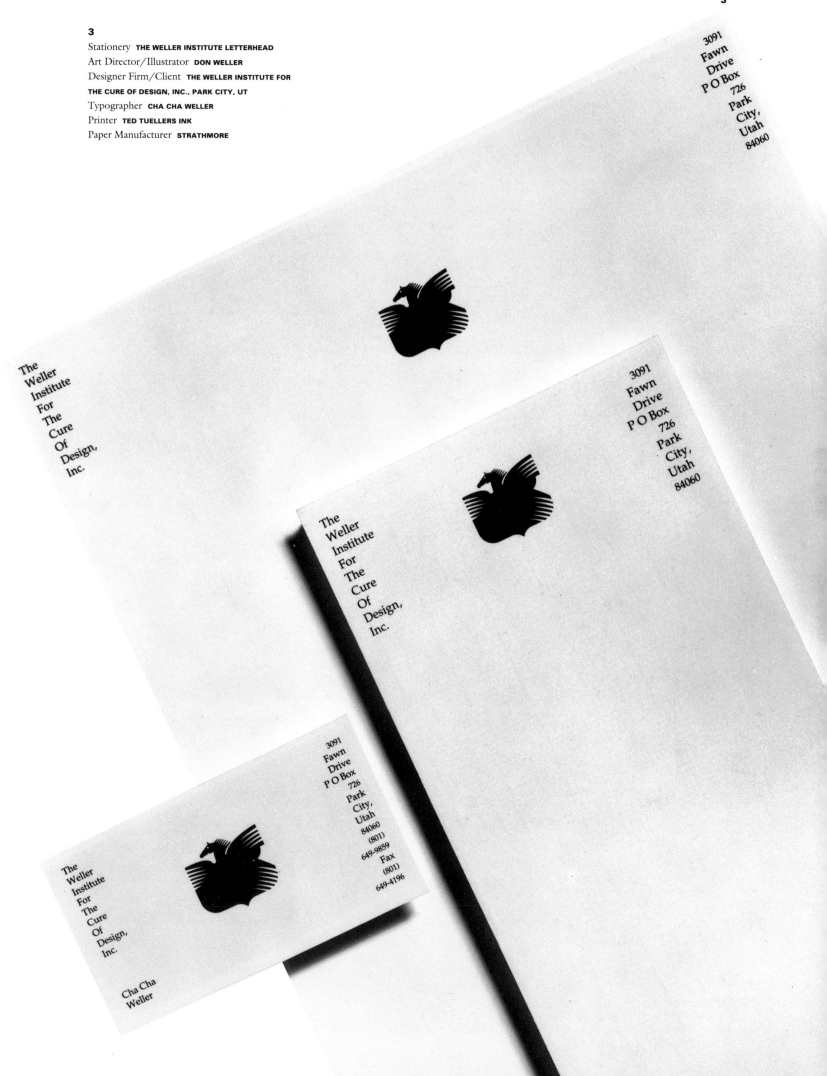

ATELIER MARTEX
T200

Cheetah

Luxury percale sheets and pillowcases,
200 thread count of 50% combed cotton
and 50% polyester.
Comforter
Tailored Pillow Sham
European Sham
Bedskirt
Duvet Cover
Continental Draperies
Breakfast Pillow
Tableround and Topper
Shower Curtain
Printed Towel

11

MARTEX
LUXOR PRISMS TOWEL

100% combed cotton loops, bath towel
27 x 50". Available in bath, hand, and
wash. Colors: Opal Blue, Moroccan Blue,
Pale Jade, Camel, Rosewood, Ruby, Teal,
White, and Signal Yellow.

45

1

1

Brochure **MARTEX REFERENCE / FALL 1991**
Art Director **JEAN MCCARTNEY**
Designer **PRODUCTION DESIGN: KEITH JONSTON**
Photographer **PATRICIA HEAL**
Agency **IN-HOUSE**
Client **MARTEX, WEST POINT PEPPERELL, INC., NEW YORK, NY**
Paper Manufacturer **CONSOLIDATED PAPER**

2

2

Promo **CARNIVAL**

Art Director **WOODY PIRTLE**

Designers **NANCY HOEFIG, LIBBY CARTON**

Photographers **K. STIER, J. VIESTI**

Illustrators **M. BARTALOS, J. KLOTNIA, R.O. BLECHMAN, A. RUSSO, L. CARTOR**

Design Firm **PENTAGRAM DESIGN, NEW YORK, NY**

Client **CHAMPION INTERNATIONAL**

Typographer **MONOGRAM**

Printer **POMCO GRAPHICS**

Paper Manufacturer **CHAMPION INTERNATIONAL**

3

Journal **ARCHITECTURE & DESIGN FORUM JOURNAL #2**

Art Director **LINDA HINRICHS**

Desinger **MARK SELFE**

Design Firm/Typographer **PENTAGRAM DESIGN, SAN FRANCISCO, CA**

Client **ARCHITECTURE & DESIGN FORUM**

Typographer **DESIGN & TYPE**

Printer **MASTERCRAFT PRESS**

Paper Manufacturer **SIMPSON PAPER COMPANY**

3

PERKINS SHEARER
11TH ANNUAL
POLO CUP

HIGHLANDS RANCH

1

Poster **11TH ANNUAL POLO CUP**
Art Director **BILL MERRIKEN**
Designer/Illustrator **MICHAEL SCHWAB**
Design Firm **MICHAEL SCHWAB DESIGN, SAUSALITO, CA**
Client **PERKINS SHEARER**
Printer **B&R SCREEN GRAPHICS**

2

Logo **HOTEL HANKYU INTERNATIONAL IDENTITY**
Art Director **COLIN FORBES**
Art Director/Designer **MICHAEL GERICKE**
Designer **DONNA CHING**
Illustrator **McRAY MAGLEBY**
Design Firm **PENTAGRAM DESIGN, NEW YORK, NY**
Client **HANKYU HOTELS CORPORATION**
Typographer **TYPOGRAM**
Printer/Paper Manufacturer **VARIOUS**

3

Packaging **MON JARDINET PURE VEGETABLE SOAP**
Designer **MICHAEL MABRY**
Design Firm **MICHAEL MABRY DESIGN, SAN FRANCISCO, CA**
Client **MON JARDINET, LTD.**
Printer **BELLSHIRE LTD., ONTARIO**
Paper Manufacturer **CROSS POINTE**

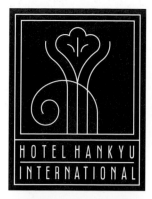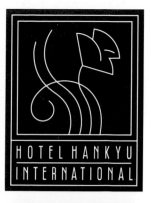
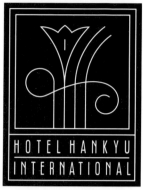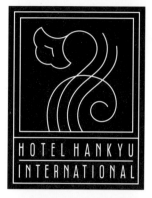
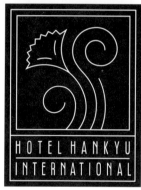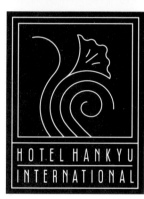

2

3

Palm Springs, California

6

1

1

Annual Report **CRI 1991**
Art Director **DAVID FRANEK**
Designer **DEBORAH FOOTE**
Photographers **CAMERON DAVIDSON, MARK SEGAL**
Design Firm/Typographer **FRANEK DESIGN ASSOCIATES, INC.,**
WASHINGTON, D.C.
Client **CRI INCORPORATED**
Printer **STEPHENSON PRINTING INC.**

2

Calendar **GUNSELMAN & POLITE 1991**
Art Director/Designer **MICHAEL SUNSELMAN**
Designer **KERRY POLITE**
Photographer **CAMERON DAVIDSON**
Design Firm/Client **GUNSELMAN & POLITE, WILMINGTON, DE**
Typographer **COMPOSING ROOM**
Printer **STRINE PRINTING CO., INC.**
Paper Manufacturer **S.D. WARREN CO.**

7

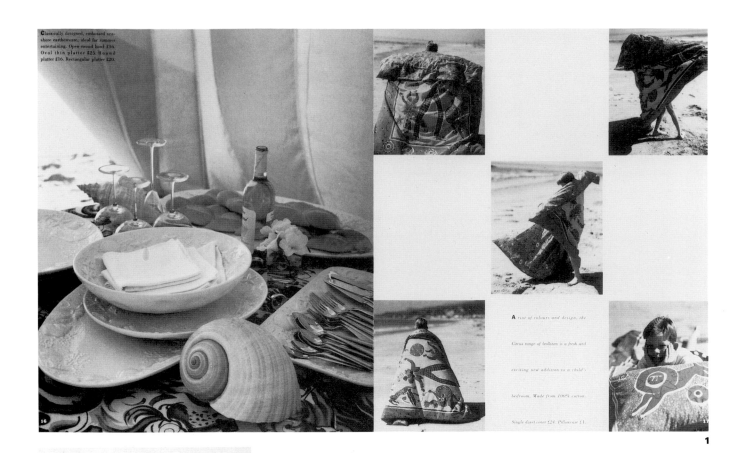

16

17

1

SUMMER 1993

habitat

2

G. Gigli by Romeo Gigli.

It's like being in a movie.

We know that... Just keep swinging.

bloomingdale's
THROUGH NOVEMBER 1ST

1

Brochure **HABITAT, SUMMER 1991**
Art Director **ROBERT VALENTINE**
Photographer **JOSE PICAYO**
Design Firm **ROBERT VALENTINE INC., NEW YORK, NY**
Client **HABITAT DESIGNS LTD.**
Typographer **MARKE COMMUNICATIONS**
Printer **BEN JOHNSON & CO. LTD.**
Paper Manufacturer **PAPYRUS PAPER CO.**

2

Packaging **DELEO CLAY TILE SAMPLE BOXES**
Art Director **JOSE SERRANO**
Design Firm **MIRES DESIGN, INC., SAN DIEGO, CA**
Illustrator/Typographer **TRACY SABIN**
Client **DELEO CLAY TILE**
Printer **RUSH PRESS**
Paper Manufacturer **ZELLERBACK/KRAFT**

3

Video **TEMPO D'ITALIA (IN-STORE EDITORIAL)**
Art Director **JIM CHRISTIE**
Designers **MICHELLE COMTE, JIM CHRISTIE**
Director of Photography **ROBERT LEACOCK**
Design Firm/Client **BLOOMINGDALE'S, NEW YORK, NY**

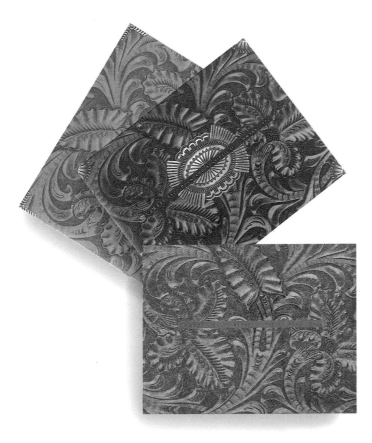

1
Catalog **OTIS/PARSONS SCHOOL OF ART & DESIGN '91-'92 B.F.A.**
Art Director/Designer/Typographer **MICK HAGGERTY**
Design Firm/Client **OTIS/PARSONS SCHOOL OF ART & DESIGN,**
LOS ANGELES, CA
Printer **WELSH GRAPHICS**
Paper Manufacturer **S.D. WARREN**

2
Promotional Brochure **SIMPSON QUEST**
Art Director **KIT HINRICHS**
Designer **BELLE HOW**
Photographers **GEOF KERN, BARRY ROBINSON, CHARLY FRANKLIN**
Illustrators **JOHN HERSEY, GARY SPALENKA, WOLF SPOERL,**
PHILLIPE WEISBECKER, ANTHONY RUSSO, MARK SELFE, McRAY MAGLEBY,
TAKENOBU IGARASHI
Design Firm **PENTAGRAM DESIGN, SAN FRANCISCO, CA**
Client/Paper Manufacturer **SIMPSON PAPER COMPANY**
Typographer **EUROTYPE**
Printer **GRAPHIC ARTS CENTER**

EDUCATION IN THE WEST

*A*fter 40 years in the phone business, Jack MacAllister retired as chief executive officer of U S WEST. But you won't find Jack curled up in an easy chair with a good book. He's a strong advocate for educational excellence and has been active in programs that help the economically vulnerable find employment opportunities. He plans to continue focusing his energies on these issues in the future. We've highlighted some of his favorite projects supported by the U S WEST Foundation so you can share in his pride at what's been achieved so far.

THE WORKS OF WILL PROGRAM AT VAN BUREN MIDDLE SCHOOL IN ALBUQUERQUE, NEW MEXICO, MATCHES HIGH SCHOOL STUDENT TUTORS WITH AT-RISK MIDDLE SCHOOL STUDENTS WHO HAVE FAILED TWO OF THEIR SIX CLASSES. THE TUTORS DEVELOP LEADERSHIP SKILLS AND SELF ESTEEM, WHILE THE AT-RISK STUDENTS ARE GIVEN A CHANCE TO BEAT THE ODDS OF THE AREA'S HIGH DROP-OUT RATE.

Free trade is not a principle, it is an expedient. — Benjamin Disraeli, British Prime Minister

By the end of 1992, twelve European countries will drop their national trade barriers and come together as a single European Community. People, goods and services will be able to move freely within the EC, without passing through customs or paying duty at each national border, and all capital and exchange controls will be abolished. Free trade is expected to reduce paperwork, better utilize the resources of member nations, encourage competition based on consumer demand, and offer a greater choice of attractively priced goods and services.

E.conomists since Adam Smith have agreed that international free trade is in the world's best interest. Yet for centuries, countries have emphasized self-sufficient systems and protectionist policies. That tide has turned. Investment capital moves electronically around the world without regard to national borders. Multinational corporations have global interests. Manufacturers routinely buy components from suppliers in a half dozen countries, assemble them in still another, then sell the products to customers worldwide. Joint ventures between foreign firms have blurred national economic boundaries. While many countries are forming free-trade agreements, the global marketplace has gained its own momentum.

2

3

THE JOY OF
HELPING OTHERS

You can hear the excitement in Abbie LeCesne's voice as she talks about *Works of Will*, an innovative after-school tutoring program at Van Buren Middle School in Albuquerque.

As a teacher in a school district with an alarming drop-out rate, LeCesne sees Works of Will as a glimmer of hope in what can sometimes seem a hopeless situation.

The drop-out rate for Albuquerque Public Schools almost tripled between 1987 and 1989. Nearly one student in four drops out before finishing high school.

It's a daunting statistic that needs to be reversed. LeCesne hopes Works of Will will help do just that. The program is innovative, because the

3
Annual Report **U.S. WEST 1990, FACT BOOK & SLIP CASE**
Designer **SUSAN TSUCHIVA**
Photographers **JOHN BLAUSTEIN, BARRY ROBINSON**
Illustrators/Artists **WALTER DORAN (SILVER BUCKLE), BOB DELLIS (TOOLED LEATHER), RICK BINGER (CHARTS)**
Design Firm **PENTAGRAM DESIGN, SAN FRANCISCO, CA**
Typographer **SPARTAN TYPOGRAPHERS**
Printer **GRAPHIC ARTS CENTER**
Paper Manufacturer **SIMPSON PAPER COMPANY**

1

Box **TEMPO D'ITALIA**
Art Director **JOHN JAY**
Design Firm/Client **BLOOMINGDALE'S, NEW YORK, NY**

2

Catalog **SPRING '92**
Designer **CAROL RICHARDS**
Photographer **DAN LANGLEY**
Client/Typographer **NIKE DESIGN**
Printer **DIVERSIFIED GRAPHICS/MINNEAPOLIS**
Paper Manufacturer **FRENCH'S SPECKLETONE & VINTAGE VELVET**

3

Packaging **ELIKA PACKAGING**
Art Director/Designer **CLIVE PIERCY**
Art Director **MICHAEL HODGSON**
Design Firm **PH.D, SANTA MONICA, CA**

The ancient city flourished until the eruption of Vesuvius, 79 A.D. It was buried for 2000 years.

A

The Art of Pompeii in The House of Labyrinth.

P

1

spring *1992* i.e. shoe collection

grawado slip-on in stone

haley in black, white, clay, wedgewood, stone, toast and shell pink

2

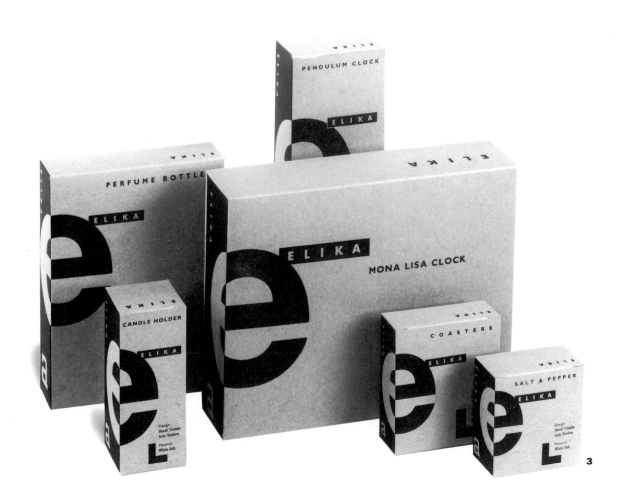

PENDULUM CLOCK

ELIKA

PERFUME BOTTLE

ELIKA

CANDLE HOLDER

ELIKA

ELIKA

MONA LISA CLOCK

COASTERS

ELIKA

SALT & PEPPER

ELIKA

Design:
David Tisdale
Judy Smilow

Material:
White Ash.

3

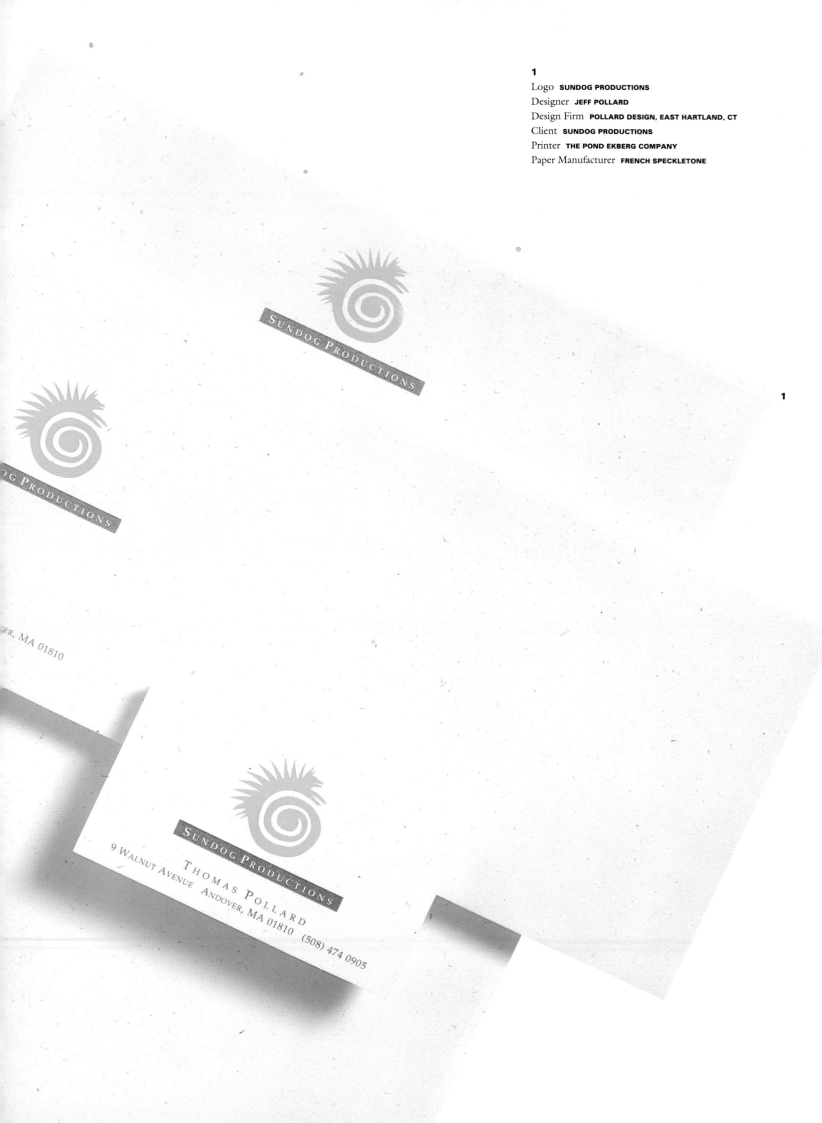

Logo **SUNDOG PRODUCTIONS**
Designer **JEFF POLLARD**
Design Firm **POLLARD DESIGN, EAST HARTLAND, CT**
Client **SUNDOG PRODUCTIONS**
Printer **THE POND EKBERG COMPANY**
Paper Manufacturer **FRENCH SPECKLETONE**

Video **5 GOTCHA/MTV SPOTS**
Art Director **MIKE SALISBURY**
Photographer **HOWARD EDELMAN**

1

Advertisement **THANKSGIVING**
Art Director **HERMAN DYAL**
Design Firm **FULLER DYAL & STAMPER, AUSTIN, TX**
Client **UNIVERSITY UNITED METHODIST CHURCH**

2

Advertisement **MOZART REQUIEM**
Art Director **HERMAN DYAL**
Design Firm **FULLER DYAL & STAMPER, AUSTIN, TX**
Client **UNIVERSITY UNITED METHODIST CHURCH**

3

Promotional Brochure **UN LIBRO EN IMAGENES (A PICTURE BOOK)**
Art Director **ROBERT VALENTINE**
Photographer **CRAIG PERMAN**
Design Firm **ROBERT VALENTINE INC., NEW YORK, NY**
Client/Paper Manufacturer **GILBERT PAPER**
Typographer **BORO TYPOGRAPHERS, INC.**
Printer **DIVERSIFIED GRAPHICS INC.**

3

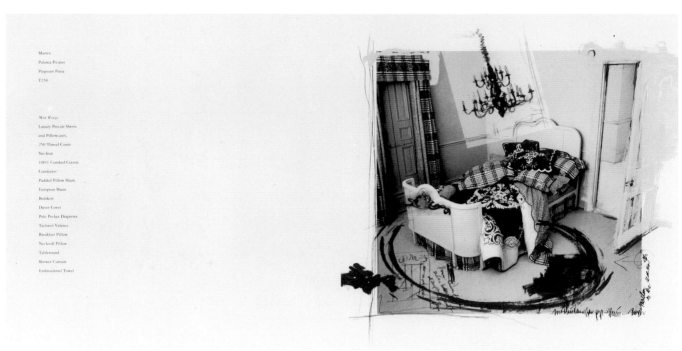

Martex
Paloma Picasso
Potpourri Pima
T250

Moir Rouge
Luxury Percale Sheets
and Pillowcases,
250 Thread Count
No-Iron
100% Combed Cotton
Comforter
Padded Pillow Sham
European Sham
Bedskirt
Duvet Cover
Pole Pocket Draperies
Tailored Valance
Breakfast Pillow
Neckroll Pillow
Tablernund
Shower Curtain
Embroidered Towel

4

MARTEX

5

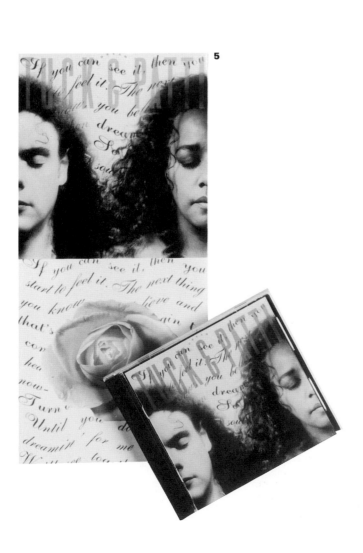

4

Brochure **MARTEX**
Art Director **JEAN MCCARNEY**
Designer **PRODUCTION DESIGN**
Illustration **KEITH JOHNSTON**
Photographer **PATRICIA HEAL**
Agency **IN-HOUSE**
Client **MARTEX, WEST POINT PEPPERELL, INC., NEW YORK, NY**
Typographer **MACINTOSH**
Printer **HENNEGAN**
Paper Manufacturer **CONSOLIDATED PAPER**

5

Packaging **TUCK & PATTI ALBUM PACKAGING**
Art Director/Designer **JENNIFER MORLA**
Designer **JEANETTE ARAMBURU**
Design Firm **MORLA DESIGN, SAN FRANCISCO, CA**
Photographer **BYBEE STUDIOS**
Client **WINDHAM HILL**
Typographer **ANDRESEN TYPOGRAPHICS**

1

1
Exhibition Signage **IDSA EXHIBIT**
Art Director **MICHAEL WESTCOTT**
Designers **ROBERT MOUL, DAVID WARREN, LISA LEESON**
Design Firm **FITCH RICHARDSON SMITH, BOSTON, MA**
Client **GILTSPUR BOSTON, GOLDMAN ARTS**

1
Book **MOCA EDUCATIONAL GIANT BOOK — FIVE LANGUAGES**
Art Director/Designer/Design Firm **MIHO, PASADENA, CA**
Illustrator **MOCA-RAUCHENBERG-RUSCHA-KRUGER**
Client **MOCA**
Typographer **JAPANESE TYPE/KOREAN/CHINESE (WANG)**
Printer **SPANISH (SANTILLO)**
Paper Manufacturer **APPLE**

2
Poster **SMU**
Art Director/Designer/Illustrator **BRYAN L. PETERSON**
Design Firm **PETERSON & COMPANY, DALLAS, TX**
Client **SOUTHERN METHODIST UNIVERSITY**
Typographer **ON COMPUTER**
Printer **PADGETT PRINTING**
Paper Manufacturer **HOPPER**

1

II

11/1 1991

SMU STUDENTS ARE INVITED TO ENTER THE SECOND ANNUAL
STUDENT BOOK COLLECTING CONTEST

ENTER YOUR PERSONAL COLLECTION OF BOOKS. IT MAY CONSIST OF PAPERBACKS, HARDBACKS, MANUSCRIPTS, MINIATURES--USE YOUR IMAGINATION. TOPICS MIGHT INCLUDE SCIENCE FICTION, POETRY, SPORTS, CHILDREN'S BOOKS, MYSTERY NOVELS--ANY COLLECTION WITH A WELL-DEFINED THEME AND THOUGHTFUL CHOICE IN THE SELECTION. FOR MORE INFORMATION PICK UP A BROCHURE WITH ENTRY DETAILS AT ALL CAMPUS LIBRARIES OR CALL 692-3225. WINNERS WILL BE ANNOUNCED AND PRIZES AWARDED DURING THE SMU LITERARY FESTIVAL IN MID-NOVEMBER. ENTRY DEADLINE, NOVEMBER 1. SPONSORED BY THE FRIENDS OF THE SMU LIBRARIES, COLOPHON.

WITH THE GENEROUS ASSISTANCE OF MR. & MRS. JOHN MCELHANEY, DOMINIQUE & CHARLES INGE, CLAMPITT PAPER COMPANY. DESIGN BY PETERSON & COMPANY

2

combined with strong affiliates in France and the United Kingdom. Added to this is the fact that Canderel® (aspartame), Searle's tabletop sugar substitute, is taking its place as a truly Pan-European product, and the fact that applications have been filed for Maxaquin® (lomefloxacin) and Arthrotec® (misoprostol/diclofenac). The oral contraceptive Cycleane was launched in France this spring, and the antiarrhythmic Cipralan (cibenzoline) was launched in Belgium.

Other Global Markets

Important steps taken in reshaping the business portfolio include divesting some non-strategic businesses and restructuring operations in Latin America. At the same time, resources have been redeployed to acquire increased business presence in key markets. Searle's primary international focus is on building strength in Europe and Japan.

In Japan, currently the world's second largest market, reorganization of Searle Yakuhin KK, Searle's joint venture with Dainippon, gave Searle 70 percent ownership. This will provide the company greater flexibility in establishing relationships that will expand the potential of its present pipeline.

The Soviet Union also holds considerable commercial potential. Searle has established itself as a respected and attractive long-term

Geographic Sales

Searle has strengthened its presence in the major pharmaceutical markets of Europe and North America through recent acquisitions and growth from three key products: Calan, Cytotec and Canderel.

Opposite Photo: Quality manufacturing is a top priority at Searle. Here tablets are film-coated in a perforated coating pan. Searle produces more than 10 billion tablets for its ethical and consumer products each year.

"Searle's mission to build a premier international pharmaceutical business is characterized by company-wide traits of science-based marketing, leadership in social responsibility, and high profitability. While attention is sharply focused on building strength in key markets—Europe and Japan—emerging markets such as the Soviet Union also provide significant opportunity."

Ronald L. Goode, Ph.D. Corporate Senior Vice President and Executive Vice President, International Operations

Expanding Horizons

SEARLE 1991

1

Annual Report **EXPANDING HORIZONS SEARLE 1991**
Art Designer/Designer **JAN GULLEY**
Art Director **BART CROSBY**
Photographer **ARTHUR MEYERSON**
Design Firm **CROSBY ASSOCIATES INC., CHICAGO, IL**
Client **SEARLE**
Typographer **MASTER TYPE**
Printer **ANDERSON LITHOGRAPH**
Paper Manufacturer **CONSOLIDATED REFLECTIONS**

2

Annual Report **THE PROGRESSIVE CORPORATION 1990**
Art Director/Designer **JOYCE NESNADNY**
Art Director **MARK SCHWARTZ**
Designer **JENNIFER DYE**
Photographer **VARIOUS**
Design Firm **NESNADNY & SCHWARTZ, CLEVELAND, OH**
Client **THE PROGRESSIVE CORPORATION**
Typographer **TSI: TYPESETTING SERVICE INC.**
Printer **FORTRAN PRINTING**
Paper Manufacturer **S.D. WARREN**

3

Brochure **JEFF CORWIN PHOTOGRAPHY**
Art Director/Designer **LOWELL WILLIAMS**
Designer **BILL CARSON**
Photographer **JEFF CORWIN**
Design Firm **PENTAGRAM DESIGN, SAN FRANCISCO, CA**
Client **JEFF CORWIN PHOTOGRAPHY**
Typographer **ONE WORKS**
Printer **HERITAGE PRESS**
Paper Manufacturer **NORTHWEST PAPER**

3

For quality silkscreen printing: posters, packaging, comps, point-of-sale displays, bus shelter advertising, contest scratch-off presentations, and much more: contact Ambassador Arts, Inc. 122 West 27th Street, NYC 10001. 212-243-4200. 8:00 am-12:00 midnight. fax 212-243-0407.

The big A.

Ambassador Arts. Maximum impact. Minimum price.

1

1

Poster **THE BIG A**

Art Director/Designer/Illustrator/Typographer **PAULA SCHER**

Design Firm **PENTAGRAM DESIGN, NEW YORK, NY**

Client/Printer **AMBASSADOR ARTS**

Paper Manufacturer **NEWSPRINT**

2

Invitation **AN INVITATION TO TYPE 90**

Art Director/Designer/Illustrator **JONATHAN HOEFLER**

Design Firm/Typographer **THE HOEFLER TYPE FOUNDRY, NEW YORK, NY**

Client **ASSOCIATION TYPOGRAPHIQUE INTERNATIONALE**

Printer **A. COLISH**

Paper Manufacturer **STRATHMORE**

3

Promotion Kit **RECYCLED ALTERNATIVES**

Art Directors **THOMAS KLUEPFEL, AGNETHE GLATVED**

Design Firm **DRENTTEL DOYLE PARTNERS, NEW YORK, NY**

Client **CHAMPION INTERNATIONAL**

Printer **POMCO GRAPHICS, INC.**

Paper Manufacturer **CHAMPION INTERNATIONAL**

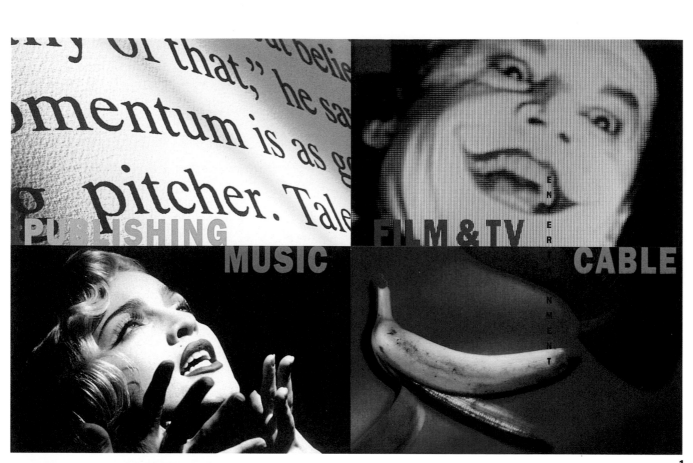

1

1
Annual Report **TIME WARNER 1990**
Creative Directors **AUBREY BALKIND, KENT HUNTER**
Designers **KENT HUNTER, RUTH DIENER**
Illustrator/Photographer **VARIOUS**
Agency/Typographer **FRANKFURT GIPS BALKIND, NEW YORK, NY**
Client **TIME WARNER, INC.**
Printer **HERITAGE PRESS, DALLAS, TX**

2
Packaging **GEAR DADDIES "BILLY'S LIVE BAIT"**
Art Director/Designer/Illustrator **MITCH KANNER**
Art Director **MICHAEL BAYS**
Designer **GEORGE LEBON**
Design Firm **POLYGRAM RECORDS INC., NEW YORK, NY**
Client **GEAR DADDIES**
Typographer **IN-HOUSE MAC**

2

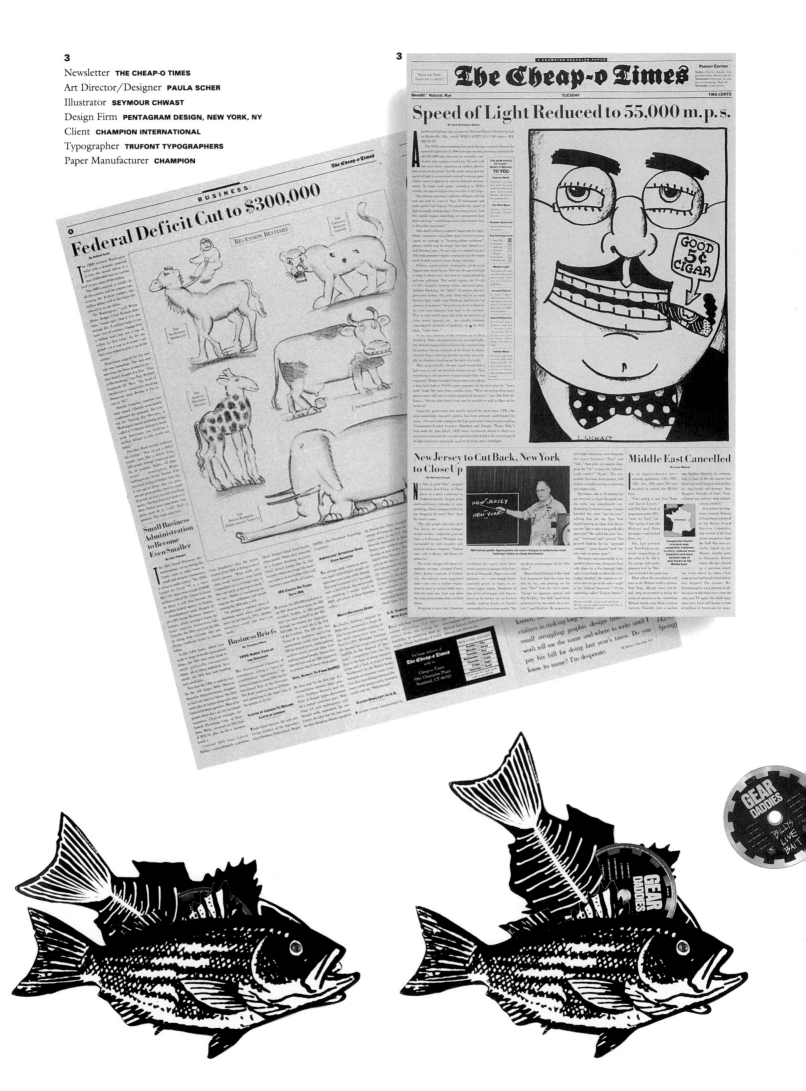

3

Newsletter **THE CHEAP-O TIMES**
Art Director/Designer **PAULA SCHER**
Illustrator **SEYMOUR CHWAST**
Design Firm **PENTAGRAM DESIGN, NEW YORK, NY**
Client **CHAMPION INTERNATIONAL**
Typographer **TRUFONT TYPOGRAPHERS**
Paper Manufacturer **CHAMPION**

1

Gift Box **FALLON WATCHES**

Art Director **SHARON WERNER**

Designers **SHARON WERNER, TODD WATERBURY**

Design Firm **THE DUFFY DESIGN GROUP, MINNEAPOLIS, MN**

Client **FALLON MCELLIGOTT & TIMEX**

Printer **PROCESS DISPLAYS**

2

Annual Report **DATA I/O 1990**

Art Director **JOHN VAN DYKE**

Photographers **ALAN ZENUK, CLIVE DAVIS**

Illustrator **SARAH WALDRON**

Design Firm **VAN DYKE COMPANY, SEATTLE, WA**

Client **DATA I/O**

Typographer **TYPEHOUSE**

Printer **MACDONALD PRINTING**

Paper Manuafacturer **KANZAKI**

3

Letterhead **MECCA**

Art Directors **TOM VASQUEZ, CHUCK JOHNSON**

Designer/Illustrator **TOM VASQUEZ**

Design Firm **BRAINSTORM, INC., DALLAS, TX**

Client **GEORGE MECCA**

2

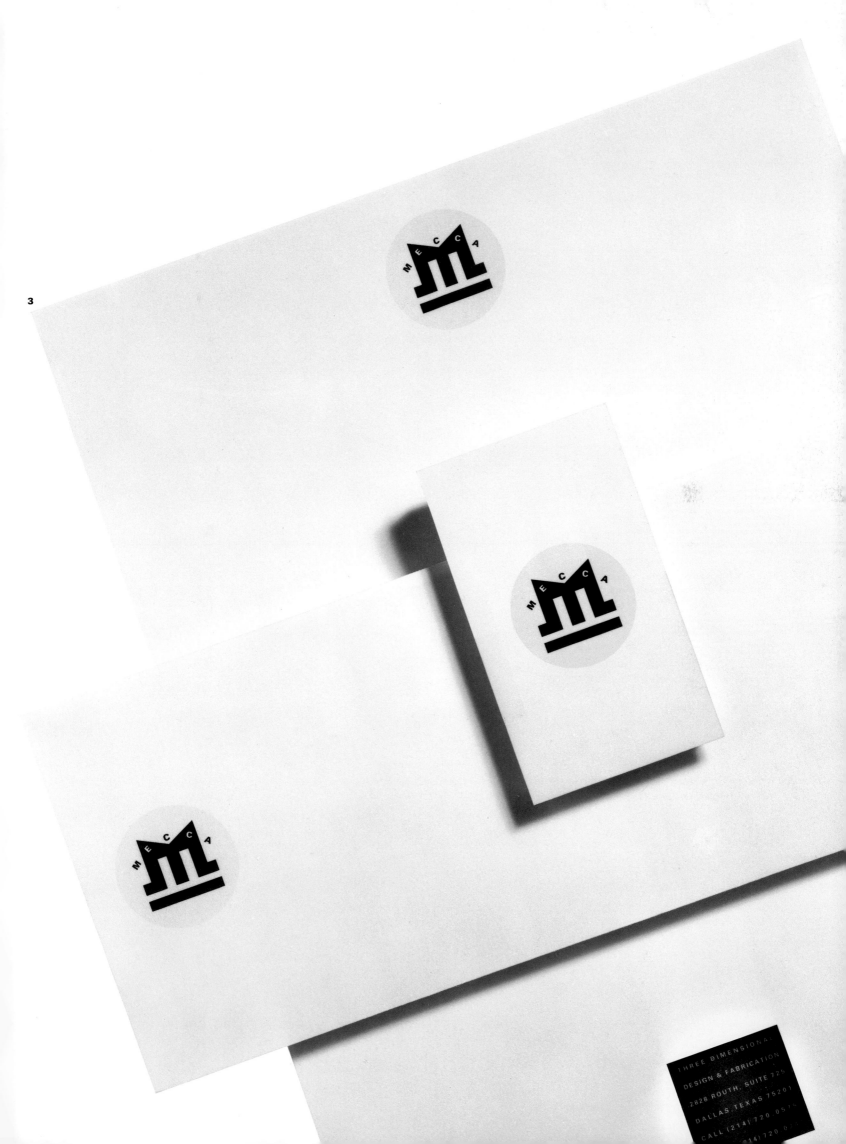

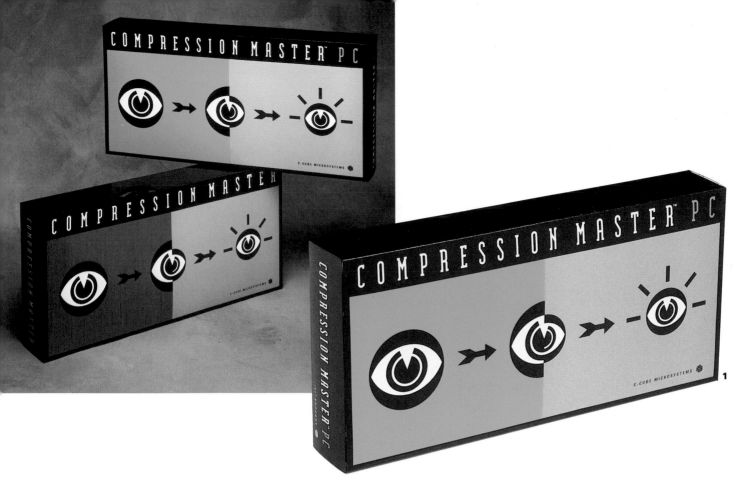

1

Packaging Design **COMPRESSION MASTER PC**

Designers **MARK FOX, PAUL HUBER**

Illustrator **MARK FOX**

Design Firm **BLACKDOG, SAN RAFAEL, CA**

Client **C-CUBE MICROSYSTEMS**

Typographer **ANDRESEN TYPOGRAPHICS**

Printer **BINO-PAK**

2

Poster **COLOUR AIGA NY**

Designer/Photographer **MICHAEL MABRY**

Design Firm **MICHAEL MABRY DESIGN, SAN FRANCISCO, CA**

Client **AIGA/NEW YORK**

Printer **HERITAGE PRESS**

Paper Manufacturer **SIMPSON PAPER**

3

Poster **IBM: FOCUS ON EXCELLENCE**

Art Director/Designer/Photographer **HENRY WOLF**

Design Firm **HENRY WOLF PRODUCTIONS, NEW YORK, NY**

Client **IBM**

Typographer **CHARACTERS**

DESIGN PARTNERSHIP WEEK

Focus on Excellence

An exhibition of the best
in recent IBM US Marketing
Communications design

December 4–6, 1990
9:30 am–5:00 pm

65 East 55th Street, New York City

IBM

1

Standards Manual **EHS PRINTED COMMUNICATIONS GUIDELINES**
Art Director/Designer **DAVID WILLIAMS**
Design Firm/Typographer **LAUSEN WILLIAMS & COMPANY, CHICAGO, IL**
Client **EVANGELICAL HEATH SYSTEMS**
Typographer **INFOCOMM.**
Printer **DARWELL PRESS**
Paper Manufacturers **CHAMPION, MOHAWK**

2

Standards Manual **KNOLL STATIONERY STANDARDS**
Design Director **THOMAS GEISMAR**
Designer **CATHEY SCHAEFER**
Design Firm **CHERMAYEFF & GEISMAR INC., NEW YORK, NY**
Client **THE KNOLL GROUP**
Typographer **MACINTOSH**
Printer **RICE & SONS, CGS**
Paper Manufacturer **MONADNOCK**

3

Catalog **THE MOHAWK SPECIFIER: A SOURCEBOOK OF FINE PAPERS**
Art Director **DOUG WOLFE**
Design Firm **HAWTHORNE WOLFE, ST. LOUIS, MO**
Client/Paper Manufacturer **MOHAWK PAPER MILLS, INC.**

Memo

Leave lines 14 picas
(the top of the page)
(2/4) measuring to
capital letter height)

Month, Day, Year

To:
Recipient 1, TOR
Recipient 2, GR
Recipient 3, NY

From:
Sender's Name, TOR

cc:
P. Anderson, GR S. Leonardi, TOR
G. Collins, NY A. Madera, PGH
R. Decker, EG D. Rosen, PGH
A. Edwards, EG T. Schneider, EG
R. Garrett, GB M. Sullivan, GR
D. Hagel, NY J. Weingold, NY
M. Henderson, TOR
M. Jenkins, LA

the height of the
cal letters with the top
Knoll logotype

noll

MEMORANDUM TYPING FORMAT (MEMO SUBJECT)

This page demonstrates the recommended typing format for all interoffice memorandums. This typing format is an integral part of the memo design.

All typed information aligns flush left on a 2 inch margin. Ten point, twelve pitch Prestige is the typeface used for all typed correspondence.

The date begins the memo, typed 11 line spaces from the top of the page (or 1.73" to the capital letter height). Type "To:" leaving a line space after the date. A list of recipients' names or a group title follows on the next line. Type "From:" leaving a line space after the list of recipients' names. The sender's name follows on the next line.

A list of names to whom the memo is copied appears flush left, 14 line spaces from the top of the page (or 2.24" to the capital letter height) to align horizontally with the recipients' names. Set a tab at 39 picas (6.5") from the left edge of the page for this column. If there are more than 8 names, another column can be positioned 30 picas (5") from the left of the page as shown. Use the same horizontal starting point for both columns. Very long lists should appear on a separate cover page. Set tabs at 12, 21, 30 and 39 picas (2", 3.5", 5" and 6.5") and align the starting position of each column 14 line spaces from the top of the page (or 2.24" to the capital letter height).

The subject of the memorandum is typed in all capital letters, 24 line spaces from the top of the page (or 3.90" to the capital letter height). Leave one line space after the subject heading to the first line of the body of the memo. The body of the memo is single line spaced. Leave an additional line space between paragraphs. There are no indentations. The maximum line length should not exceed 6 inches, this will allow for a 1/2 inch right hand margin.

Blank white paper should be used for second pages of a memorandum. The subject heading is repeated on second sheets, typed in all capital letters, 8 line spaces from the top of the page (or 1.24" to the capital letter height). A page number reference is typed on the same line directly after the subject heading. Leave two line spaces after the subject heading to the first line of the body of the memo.

align margin with the
triangle above, 12 picas
(2") from the left edge
of the page

(shown at 90% of actual size)

Begin typing 8 picas from
the top of the page
(or 1.24" d measuring to
the capital letter height)

Fax

To: Recipient

 Fax No. 616 949-1234

From: Sender

 Fax No. 212 207-5678

Date: Month, Day, Year

 Pages Sent 5

Knoll Subject: Fax Cover Sheet Format

Sent By: Sender's Representative

 Tel No. 212 207-9123

The Knoll Group

Fax

The fax cover page can be hand
written or typed as shown.
(shown at 90% of actual size)

The Mohawk Specifier: A Sourcebook of Fine Papers

3

The Knoll Group
Dealer Stationery
Standards

The Knoll Group
Stationery Typing
Specifications

1

Promo Kit **LEVI'S SHIRTS SWATCH BOOK**
Art Director **NEAL ZIMMERMANN**
Design Firm **ZIMMERMANN CROWE DESIGN, SAN FRANCISCO, CA**
Client **LEVI STRAUSS & COMPANY**
Typographer **VARIOUS**
Printer **K.P. PRINTING**
Paper Manufacturer **BEVERAGE PAPER COMPANY**

2

Promo Kit **LEVI'S SHIRTS IMAGE PIECE**
Art Director **NEAL ZIMMERMANN**
Design Firm **ZIMMERMANN CROWE DESIGN, SAN FRANCISCO, CA**
Client **LEVI STRAUSS & CO.**
Typographer **VARIOUS**
Printer **WATERMARK PRESS**
Paper Manufacturer **SIMPSON**

3

3
Packaging **LEVI'S CAPITAL "E" DISPLAY**
Art Director **DENNIS CROWE**
Design Firm **ZIMMERMANN CROWE DESIGN, SAN FRANCISCO, CA**
Client **LEVI STRAUSS & CO.**
Fabricator **EXHIBIT GROUP**

4
Packaging **LEVI'S CAPITAL "E" PACKAGING**
Art Director **DENNIS CROWE**
Design Firm **ZIMMERMANN CROWE DESIGN, SAN FRANCISCO, CA**
Client **LEVI STRAUSS & CO.**
Printer **COLORBAR**
Paper Manufacturer **SIMPSON**

4

1

1

Shopping Bag **Z GALLERIE BAGS**
Art Director **JOHN BRICKER**
Designer **WENDY WELLS**
Design Firm **GEUSLER ASSOCIATES, SAN FRANCISCO, CA**

2

Big Book **GUESS? DECADE BOOK**
Art Director **PAUL MARCIANO**
Designer **SAMANTHA GIBSON**
Illustrator/Photographer **VARIOUS**
Design Firm/Client **GUESS?, INC., LOS ANGELES, CA**
Typographer **MACINTOSH**
Printer **OVERLAND PRINTERS, INC.**

3

Video **CAPEZIO**
Art Director/Designer **JOANNE DE LUCA**
Photographer **MARK LEDZIAN**
Design Firm **DEFRANCESCO & DELUCA, INC., NEW YORK, NY**
Client **BALLET MAKERS, INC.**

2

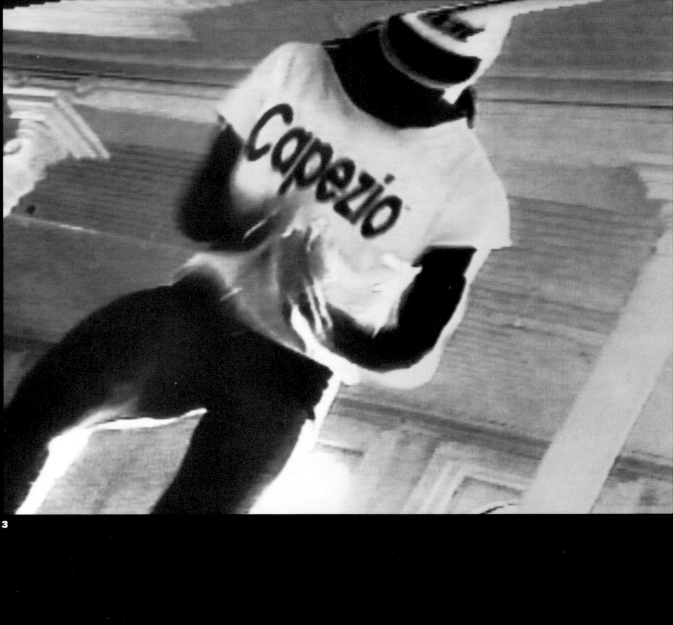

3

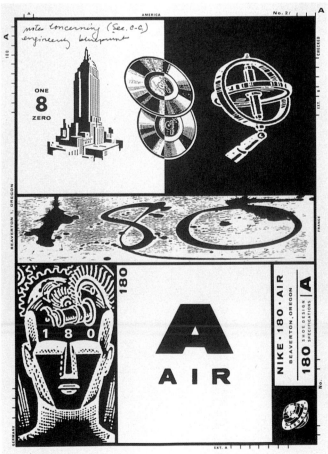

1

Trading Cards **NIKE DESIGN**
Art Director/Designer **GUIDO BROUWERS**
Art Director **RON DUMAS**
Illustrator/Photographer **VARIOUS**
Design Firm **NIKE DESIGN**
Typographer **SCHLEGAL TYPESETTING**
Printer **GRAPHIC ART CENTER**

2

Poster **NIKE 180**
Art Directors **DANIEL OLSON, CHARLES S. ANDERSON**
Designers **DANIEL OLSON, CHARLES S. ANDERSON, HALEY JOHNSON**
Illustrator **RANDALL DAHLK**
Design Firm **CHARLES S. ANDERSON DESIGN COMPANY, MINNEAPOLIS, MN**
Client **WEIDEN & KENNEDY**
Printer **PRINT CRAFT, INC.**
Paper Manufacturer **FRENCH PAPER COMPANY**

3

Poster **JORDAN P.O.P.**
Art Director **ALAN COLVIN**
Designer **KAR WU**
Illustrator **FRED INGRAM**
Design Firm **NIKE DESIGN**
Client **NIKE, INC.**
Printer **PACIFIC LITHO**

1

Environmental Graphics **THE COOPER-HEWITT MUSEUM**
Art Director **STEPHEN DOYLE**
Designers **STEPHEN DOYLE, ANDREW GRAY**
Design Firm **DRENTTEL DOYLE PARTNERS, NEW YORK, NY**
Client **THE COOPER-HEWITT MUSEUM**

1

THE PUZZLE
COMES TOGETHER
IN BITS AND
PIECES —
THROUGH SHAR-
ING KNOWLEDGE,
REVIEWING
HISTORICAL
DATA AND SPEC-
ULATING OVER
DETAILS.

2

2
Annual Report **NORCEN 1990**
Designer **PIPER MURAKAMI**
Photographer **JEFF CORWIN**
Illustrators **MAX SEABAUGH (MAPS/GLOBES), HELENE MOORE (SCHEMATICS),**
RICH BINGER (CHARTS)
Design Firm **PENTAGRAM DESIGN, SAN FRANCISCO, CA**
Client **NORCEN**
Typographer **SPARTAN TYPOGRAPHERS**
Printer **MCDONALD PRINTING**
Paper Manufacturer **NORTHWEST (COVER), SIMPSON PAPER COMPANY (TEXT)**

1

2

Join Us

Celebrate

The Spirit

1

Brochure **ACTIVE8**
Art Directors/Designers **MORTON JACKSON, TIM THOMPSON**
Designer **JOE PARISI**
Photographers **TARAN Z, HOWARD EHRENFELD, ED WHITMAN, MORTON JACKSON**
Design Firm/Typographer **GRAFFITO, BALTIMORE, MD**
Client **ACTIVE8, INC.**
Printers **STRINE PRINTING CO., INC., GLOBE SCREEN PRINT**
Paper Manufacturer **KANZAKI GILBERT**

2

Show Invitation **KNOLL CHICAGO**
Design Director/Designer/Illustrator **IVAN CHERMAYEFF**
Design Firm **CHERMAYEFF & GEISMAR INC., NEW YORK, NY**
Client **THE KNOLL GROUP**
Typographer **TYPOGRAM**
Printer **CONCEPTUAL LITHO**
Paper Manufacturer **KROMEKOTE**

3

Poster **ZOOT RESTAURANT**
Art Director/Designer/Illustrator **LANA RIGSBY**
Design Firm **RIGSBY DESIGN, HOUSTON, TX**
Client **ZOOT RESTAURANT, AUSTIN, TX**
Typographer **CHARACTERS**
Printer **STEFEK COMPANY SCREEN PRINTERS**

3

Cocktails

Buffet

Motion

Wednesday, June 12

7:00 -10:00 pm

Chicago Historical Society
Clark Street at North Avenue

RSVP by June 3
The Knoll Group
212.207.2201, Laura Swift

This invitation admits one

Knoll

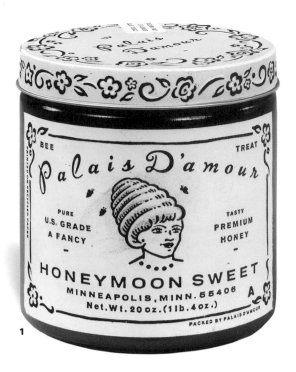

1

The Frozen Foods Division posted record results in sales, volumes and profitability. Its specialty potato products — seasoned fries and/or coil-cut fries — are in the "high growth/high return" portion of the Company's business, while conventional french fries are "lower growth/high return" items. The division is the world's leading producer of specialty french fries. It holds the number four market share position in the total domestic french fry market, moving up a position in 1990 as a result of its capacity expansion projects.

Specialty fries can be coated with a flavored batter, often individualized to a customer's specifications. Demand for these products continues to skyrocket. Market research shows that this unusual product is causing overall demand for frozen french fried potatoes to increase, both as new menu additions in restaurants and through strong "repeat" retail purchases.

As expected a year ago, introduction of competitive products caused demand in the food service market to surge, since many customers require at least two suppliers before they will introduce a new product. Consequently, several leading national and regional fast food restaurant chains have added the division's specialty products to their menus. In addition, television advertising in key markets proved highly effective as a means of promoting retail sales of the division's coated french fries.

During 1990 the division completed adding capacity to all three of its plants. Investment of almost $40 million in additional conventional and specialty fry capacity increased annual production capability by about 25%.

Paralleling growth in domestic demand is that from overseas. Sales to Australia and Pacific Rim countries were very strong, with anticipated annual growth of 20-25% per year for the next several years. In addition, the division is exploring options to capitalize on European opportunities.

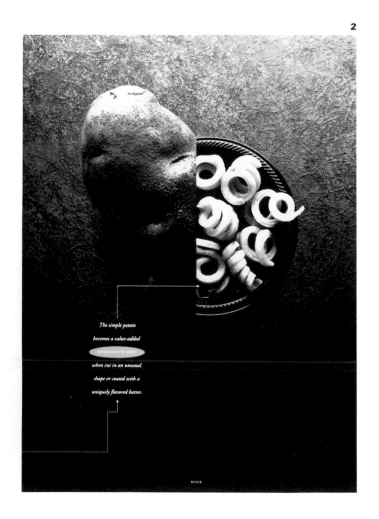

2

The simple potato becomes a value-added SPECIALTY FRY *when cut in an unusual shape or coated with a uniquely flavored batter.*

NINE

1

Packaging **PALAIS D'AMOUR HONEY**
Art Directors **HALEY JOHNSON, CHARLES S. ANDERSON**
Designer **HALEY JOHNSON**
Design Firm **CHARLES S. ANDERSON DESIGN COMPANY, MINNEAPOLIS, MN**
Client **PALAIS D'AMOUR**
Typographer **LITHO, INC.**
Paper Manufacturer **FRENCH PAPER COMPANY**

2

Annual Report **UNIVERSAL FOODS CORP. 1990**
Art Director/Designer **PAT SAMATA**
Designer **GREG SAMATA**
Photographers **SANDRO MILLER, MARC NORBERG**
Design Firm/Typographer **SAMATA ASSOCIATES**
Client **UNIVERSAL FOODS CORP.**
Printer **DIVERSIFIED GRAPHICS**
Paper Manufacturer **CONSOLIDATED**

3

Menu **CARLITA'S LUNCH MENU**
Art Director **MICHAEL GUTHRIE**
Designer **MARK FOX**
Logo Illustrator **MARK FOX**
Design Firm **BLACKDOG, SAN RAFAEL, CA**
Client **ZIM'S RESTAURANT**
Printer **ACME SILKSCREEN**
Paper Manufacturer **KIMBERLY-CLARK**

4

Packaging **BISCOTTI NUCCI PACKAGING**
Art Director/Designer **JENNIFER MORLA**
Designer **JEANETTE ARAMBURU**
Design Firm **MORLA DESIGN, SAN FRANCISCO, CA**
Client **ANNI MINUZZO**
Typographer **ANDRESEN TYPOGRAPHICS/DISPLAY LETTERING & COPY**
Printer **ATLANTIC BEDFORD**

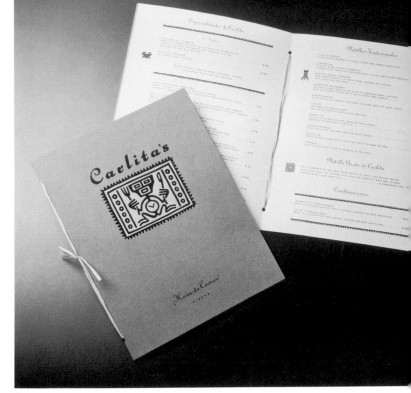

3

4

DESIGN BY ART CHANTRY

1

Poster **30 BEAUTIFUL IMPROVISATIONS**
Art Director/Designer/Typographer **ART CHANTRY**
Design Firm **WARD PAYNE**
Client **UNEXPECTED PRODUCTIONS**
Printer **CONSOLIDATED WEB**

2

Booklet **FOLKTALES**
Art Director **STEPHANIE POWER**
Illustrator **SIMON NG**
Design Firm **REACTOR ART & DESIGN LIMITED, TORONTO, CAN**
Client **CANADA POST CORPORATION**
Printer **SENTON PRINTING**
Paper Manufacturer **SIMPSON PAPER COMPANY**

3

Self Promotion **GRENVILLE VIEUX CARRE**
Art Director **BRENDA LAVOIE**
Illustrator **JAMIE BENNETT**
Design Firm **REACTOR ART & DESIGN LIMITED, TORONTO, CAN**
Client **GRENVILLE PRINTING AND MANAGEMENT**
Printer **GRENVILLE PRINTING**
Paper Manufacturer **FRENCH PAPER COMPANY**

1

1

Annual Report **ALCOA FOUNDATION 1990**
Designer **RICK LANDESBERG**
Photographers **BRUCE STROMBERG (COVER), VARIOUS (INSIDE)**
Design Firm **LANDESBERG DESIGN ASSOCIATES, PITTSBURGH, PA**
Client **ALCOA FOUNDATION**
Typographer **HAMILTON PHOTOTYPE**
Printer **GEYER PRINTING COMPANY, INC.**
Paper Manufacturer **POTLATCH**

2

Tabloid Size Menu **THE CAFE AT THE CORCORAN**
Art Directors **LOU DORFSMAN, YASUO KUBOTA**
Designer **YASUO KUBOTA**
Painters **VARIOUS**
Design Firm **LOU DORFSMAN INC.**
Client **THE CORCORAN GALLERY OF ART, WASHINGTON, DC**
Typographer **KUBOTA & BENDER**
Printer **KADER LITHOGRAPHERS**
Paper Manufacturers **CHAMPION, MOHAWK**

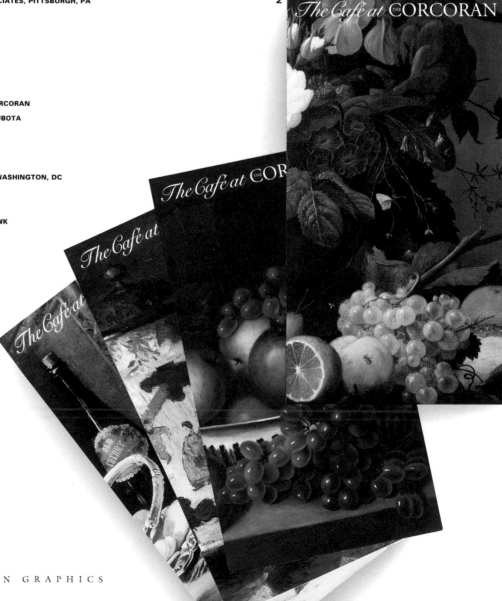

3

Stationery/Letterhead **ZOOT RESTAURANT**
Art Director/Designer/Illustrator **LANA RIGSBY**
Design Firm **RIGSBY DESIGN, HOUSTON, TX**
Client **ZOOT RESTAURANT, AUSTIN, TX**
Typographer **CHARACTERS**
Printer **THE BEASLEY COMPANY**
Paper Manufacturer **CRANE**

1
Print Ad **PROGRESSIVE RESOLUTION: THE REVOLUTIONARY POWER OF THE FLOW**
Art Directors **MIKE SALISBURY, SCOTT BINKLEY**
Designers **MARK KAWAKAMI, DAMIEN GALLAY**
Photographer **HOWARD EDELMAN**
Design Firm **SALISBURY COMMUNICATIONS, INC., TORRANCE, CA**
Client **GOTCHA SPORTSWEAR**

2
Annual Report **EG&G 1990**
Art Director/Designer **HAROLD BURCH**
Art Director **PETER HARRISON**
Photographers **BURTON PRITZKER, SCOTT MORGAN**
Design Firm **PENTAGRAM DESIGN, NEW YORK, NY**
Client **EG&G INC.**
Typographer **CROMWELL**
Printer **COLOR GRAPHICS USA**
Paper Manufacturer **NORTHWEST/CROSS POINTE**

3
Packaging **BONNIE RAITT: LUCK OF THE DRAW**
Art Director/Designer **JEFFERY FEY**
Art Director **TOMMY STEELE**
Photographer **MERLYN ROSENBERG**
Design Firm/Client **CAPITOL RECORDS, INC., HOLLYWOOD, CA**
Typographer **ANDRESEN TYPOGRAPHICS**

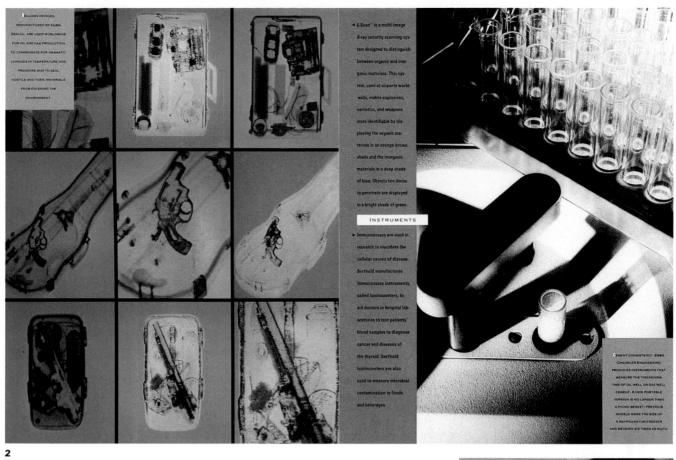

ELLOWS DEVICES, MANUFACTURED BY EG&G SEALOL, ARE USED WORLDWIDE FOR OIL AND GAS PRODUCTION TO COMPENSATE FOR DRAMATIC CHANGES IN TEMPERATURE AND PRESSURE AND TO SEAL HOSTILE AND TOXIC MATERIALS FROM ENTERING THE ENVIRONMENT.

◄ E-Scan™ is a multi-image X-ray security scanning system designed to distinguish between organic and inorganic materials. This system, used at airports worldwide, makes explosives, narcotics, and weapons more identifiable by displaying the organic materials in an orange-brown shade and the inorganic materials in a deep shade of blue. Objects too dense to penetrate are displayed in a bright shade of green.

INSTRUMENTS

► Immunoassays are used in research to elucidate the cellular causes of disease. Berthold manufactures immunoassay instruments, called luminometers, to aid doctors in hospital laboratories to test patients' blood samples to diagnose cancer and diseases of the thyroid. Berthold luminometers are also used to measure microbial contamination in foods and beverages.

CEMENT CONSISTENCY. EG&G CHANDLER ENGINEERING PRODUCES INSTRUMENTS THAT MEASURE THE THICKENING TIME OF OIL WELL OR GAS WELL CEMENT. A NEW PORTABLE VERSION IS NO LARGER THAN A PICNIC BASKET; PREVIOUS MODELS WERE THE SIZE OF A REFRIGERATOR/FREEZER AND WEIGHED SIX TIMES AS MUCH.

2

SOMETHING TO TALK ABOUT
·2·
GOOD MAN, GOOD WOMAN
(DUET WITH DELBERT McCLINTON)
·3·
I CAN'T MAKE YOU LOVE ME
·4·
TANGLED AND DARK
·5·
COME TO ME
·6·
NO BUSINESS
·7·
ONE PART BE MY LOVER
·8·
NOT THE ONLY ONE
·9·
COME QUICK (DODY AND CHICO)
·10·
SLOW RIDE
·11·
THE DRAW

3

BROADLY CL[A]
3 main paper
writing pap
paper, wrap

THE GRADE REPORT SHOW
Thursday, May 2, 1991,
6-10 pm At Harbour Castle
Westin Ballroom, Toronto,
Ontario, Guest Speaker
is Charles S. Anderson

1

1

Brochure **BARBER ELLIS GRADE REPORT**
Art Directors **CHARLES S. ANDERSON, DANIEL OLSON**
Designer **DANIEL OLSON**
Design Firm **CHARLES S. ANDERSON DESIGN COMPANY, MINNEAPOLIS, MN**
Client **BARBER ELLIS**
Typographer **PRINT CRAFT, INC.**
Paper Manufacturer **FRENCH PAPER COMPANY**

2

Bag **BARBER ELLIS GRADE REPORT**
Art Directors **CHARLES S. ANDERSON, DANIEL OLSON**
Designer **DANIEL OLSON**
Illustrator **RANDALL DAHLK**
Design Firm **CHARLES S. ANDERSON DESIGN COMPANY, MINNEAPOLIS, MN**
Client **BARBER ELLIS**
Typography **MACINTOSH**

3

Poster **SEYMOUR CHWAST**
Art Director/Designer/Illustrator **LANNY SOMMESE**
Design Firm **SOMMESE DESIGN, STATE COLLEGE, PA**
Client **SCHOOL OF VISUAL ARTS, PENN STATE**
Printer **DESIGN PRACTICOMM, PENN STATE**

2

1

Newsletter **APPLE BACK-TO-SCHOOL CAMPAIGN**

Art Directors **LIZ SUTTON, CHERY MORENO**

Photographers **JOCK McDONALD, JOHN GREENLEIGH, PAUL MATSUDA**

Design Firm **APPLE CREATIVE SERVICES, CUPERTINO, CA**

Client **APPLE COMPUTER, INC.**

Typography **APPLE COMPUTER**

Printer **QUEBECOR, INC.**

Production Manager **JEANNE STEWART**

Editors **TERI THOMAS, DARCY KENDALL**

Paper Manufacturer **ABITIBI**

2

Identification **PANTONE BINDER SYSTEM**
Art Director/Designer **WOODY PIRTLE**
Designer **MATT HECK**
Illustrator **VARIOUS**
Design Firm **PENTAGRAM DESIGN, NEW YORK, NY**
Client **PANTONE, INC.**

3

Calendar **1991**
Designers **LESLIE SMOLAN, KEN CARBONE, ALLISON MUENCH**
Photographer **KAREN CAPUCILLI**
Design Firm/Client **CARBONE SMOLAN ASSOCIATES, NEW YORK, NY**

1

Invitation **DALLAS SOCIETY OF VISUAL COMMUNCATIONS**
Art Directors **RON SULLIVAN, MARK PERKINS**
Designer **ROBIN COX**
Photographer **JIM OLVERA**
Design Firm **SULLIVAN PERKINS**
Client **DALLAS SOCIETY OF VISUAL COMMUNICATIONS**
Typographer **LISA JOHNSON**
Printer **HERITAGE**

2

Brochure **UN**
Art Director **TOM KAMINSKY**
Designers **BOB MANLEY, ALICIA ZAMPITELLA**
Agency **KAMINSKY DESIGN, BOSTON, MA**
Client **SPRINGHILL PAPER**
Typographer **BERKELEY TYPOGRAPHERS**
Printer **DANIELS PRINTING CO.**
Paper Manufacturer **SPRINGHILL PAPER**

3

Letterhead **HARVARD UNIVERSITY COLLECTION OF SCIENTIFIC INSTRUMENTS**
Art Director/Designer/Typographer **PAMELA GEISMAR**
Design Firm **SISMAN DESIGN, NEW YORK, NY**
Illustrator **IRA SMITH**
Client **HARVARD UNIVERSITY COLLECTION OF SCIENTIFIC INSTRUMENTS**
Printer **HARVARD UNIVERSITY**
Paper Manufacturer **STRATHMORE**

1

2

Harvard University
Collection of Historical
Scientific Instruments

Science Center
Cambridge, Massachusetts 02138
617 495-2779

William J.H. Andrewes
David P. Wheatland Curator

Harvard University
Collection of Historical
Scientific Instruments

Science Center
Cambridge, Massachusetts 02138
617 495-2779

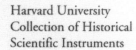

Harvard University
Collection of Historical
Scientific Instruments

Science Center
Cambridge, Massachusetts 02138

Harvard University
Collection of Historical
Scientific Instruments

Science Center
Cambridge MA 02138
617 495-2779

William J.H. Andrewes
David P. Wheatland Curator

Harvard University
Collection of Historical
Scientific Instruments

Science Center
Cambridge, Massachusetts 02138
617 495-2779

William J.H. Andrewes
David P. Wheatland Curator

With Compliments

Harvard University
Collection of Historical
Scientific Instruments

Science Center
Cambridge, Massachusetts 02138

1

Poster **HORSE AROUND WITH THE DSVC**
Art Directors **DANIEL OLSON, CHARLES S. ANDERSON, TODD HAUSWIRTH**
Design Firm **CHARLES S. ANDERSON DESIGN COMPANY, MINNEAPOLIS, MN**
Client **DALLAS SOCIETY OF VISUAL COMMUNICATIONS**
Typography **MACINTOSH**
Printer **PRINT CRAFT, INC.**
Paper Manufacturer **FRENCH PAPER COMPANY**

2

Self Promotion **NEW YEAR'S SEASONS CARD**
Art Director/Designer **GIL LIVNE**
Design Firm/Client **NOTOVITZ DESIGN, INC., NEW YORK, NY**
Client/Printer **COMPTON PRESS**
Paper Manufacturer **WESTVACO CORP.**

3

Annual Report **FURON 1990**
Art Director **RON JEFFREIES**
Designer **JULIE MARKFIELD**
Illustrator **HAMAGAMI/CARROLL**
Photographer **OE/UEDA**
Client **FURON**
Typographer **CENTRAL TYPESETTING**
Printer **GEORGE RICE & SONS**
Paper Manufacturer **SIMPSON/CONSOLIDATED**

1

2

ANNUAL REPORT
1990

Furon

Marva N. Collins

Founder of
Westside Preparatory School
whose students are from
Chicago's inner-city.

Freedom is Never Comfortable

by Marva N. Collins

Freedom is never comfortable. Those
of us who wish to be comfortable and
free does not deserve either.

One generation plants the trees and
another generation reaps the shade.
However, with the average nonchalant
turnstile attitude that seems to permeate
far too many Americans today, one can
only wonder why so many of us have
selected not to carry the banner of
freedom so that those who follow us will
dare to inherit the American dream
rather than the encroaching American
nightmare.

As an educator I call myself a
frightened Optimist. I am truly frightened
at our epidemic illiteracy rate in this
country. No nation can be powerful, free,
and illiterate too.

1

1
Booklet **TWENTY FIVE SQUARE INCHES OF FREEDOM**
Art Director **VALERIE RICHARDSON**
Designer **NEILL FOX**
Photographer **BILL TIMMERMAN**
Illustrator **VARIOUS PEOPLE FROM ALL THE WORLD OVER**
Design Firm **RICHARDSON AND RICHARDSON, PHOENIX, AZ**
Printer **O'NEIL PRINTING**
Paper Manufacturer **GILBERT PAPER COMPANY**

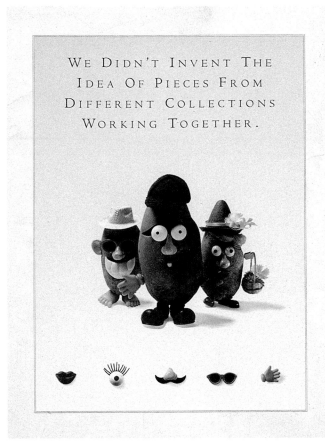

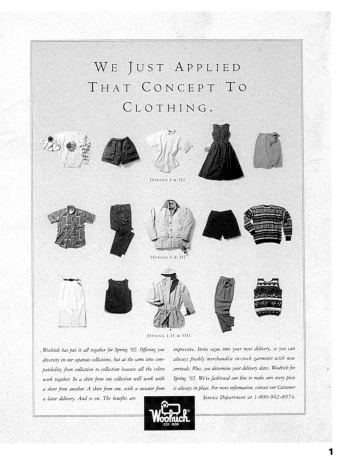

1

Trade Ad **MR. WOOLRICH POTATO HEAD**
Illustrator **HORNICK RIVLIN**
Agency/Typographer **SIQUIS, LTD., BALTIMORE, MD**
Client **WOODRICH INC.**

2

Packaging **KOOKY CUTTERS**
Art Directors/Designers **BYRON GLASER, SANDRA HIGASHI**
Design Firm **HIGASHI GLASER DESIGN, FREDERICKSBURG, VA**
Client **ZOLO, INC.**
Typographer **TRUFONT**
Printer **SATTERWHITE**

Poster **KENDOLL POSTER**
Art Director **DOUG TRAPP**
Photographer **TOM CONNORS, CROFOOT PHOTOGRAPHY**
Design Firm **McCOOL & COMPANY, MINNEAPOLIS, MN**
Client **MINNESOTA AIDS PROJECT**
Typographer **LETTERWORK**
Printer **LITHO SPECIALTIES**

Annual Report **CENTOCOR, INC. 1990**
Art Director **STEPHEN FERRARI**
Designer **JOHN BALL**
Photographer **MICHAEL CRUMPTON, MARTIN HAGGLAND**
Design Firm **THE GRAPHIC EXPRESSION, INC., NEW YORK, NY**
Client **CENTOCOR, INC.**
Typographer **GERARD ASSOCIATES**
Printer **ACME PRINTING CO.**
Paper Manufacturer **NORTHWEST & WARREN**

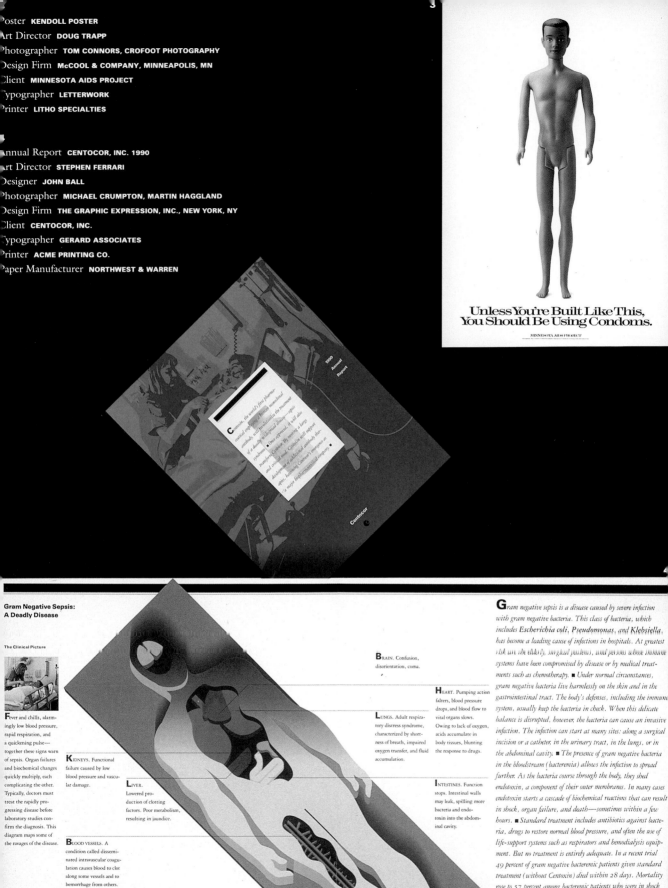

Unless You're Built Like This, You Should Be Using Condoms.

MINNESOTA AIDS PROJECT

Gram Negative Sepsis: A Deadly Disease

The Clinical Picture

Fever and chills, alarmingly low blood pressure, rapid respiration, and a quickening pulse—together these signs warn of sepsis. Organ failures and biochemical changes quickly multiply, each complicating the other. Typically, doctors must treat the rapidly progressing disease before laboratory studies confirm the diagnosis. This diagram maps some of the ravages of the disease.

BRAIN. Confusion, disorientation, coma.

HEART. Pumping action falters, blood pressure drops, and blood flow to vital organs slows. Owing to lack of oxygen, acids accumulate in body tissues, blunting the response to drugs.

LUNGS. Adult respiratory distress syndrome, characterized by shortness of breath, impaired oxygen transfer, and fluid accumulation.

KIDNEYS. Functional failure caused by low blood pressure and vascular damage.

LIVER. Lowered production of clotting factors. Poor metabolism, resulting in jaundice.

INTESTINES. Function stops. Intestinal walls may leak, spilling more bacteria and endotoxin into the abdominal cavity.

BLOOD VESSELS. A condition called disseminated intravascular coagulation causes blood to clot along some vessels and to hemorrhage from others.

Incidence of the Disease

Gram negative sepsis is not only life-threatening, it is becoming more common. Many of the medical advances that prolong the lives of the seriously ill also leave them more vulnerable to sepsis. The incidence of sepsis in the United States has nearly tripled in the past decade. Thirty to forty percent of sepsis cases are caused by gram negative bacterial infections in the bloodstream (bacteremia). Mortality in this group can reach 62 percent.

Cases of sepsis in U.S. hospitals (in thousands)
Source: National Center for Health Statistics

Gram negative sepsis is a disease caused by severe infection with gram negative bacteria. This class of bacteria, which includes *Escherichia coli, Pseudomonas,* and *Klebsiella,* has become a leading cause of infections in hospitals. At greatest risk are the elderly, surgical patients, and persons whose immune systems have been compromised by disease or by medical treatments such as chemotherapy. ■ Under normal circumstances, gram negative bacteria live harmlessly on the skin and in the gastrointestinal tract. The body's defenses, including the immune system, usually keep the bacteria in check. When this delicate balance is disrupted, however, the bacteria can cause an invasive infection. The infection can start at many sites: along a surgical incision or a catheter, in the urinary tract, in the lungs, or in the abdominal cavity. ■ The presence of gram negative bacteria in the bloodstream (bacteremia) allows the infection to spread further. As the bacteria course through the body, they shed endotoxin, a component of their outer membranes. In many cases endotoxin starts a cascade of biochemical reactions that can result in shock, organ failure, and death—sometimes within a few hours. ■ Standard treatment includes antibiotics against bacteria, drugs to restore normal blood pressure, and often the use of life-support systems such as respirators and hemodialysis equipment. But no treatment is entirely adequate. In a recent trial 49 percent of gram negative bacteremic patients given standard treatment (without Centoxin) died within 28 days. Mortality rose to 57 percent among bacteremic patients who were in shock and to 73 percent among those in shock with organ failure.

1

1

Booklet **TEMPO D'ITALIA: BLOOMINGDALE'S PRESENTS THE MODERN AND THE MYTHIC**

Art Director **JOHN JAY**

Photographer **MICHELLE COMTE**

Design Firm/Client **BLOOMINGDALE'S, NEW YORK, NY**

2

Video **TEMPO D'ITALIA T.V.**

Art Directors **DOUG BARTON, JIM CHRISTIE**

Designer **MICHELLE COMTE**

Cinematographer **ROBERT LEACOCK**

Design Firm **BLOOMINGDALE'S, NEW YORK, NY**

Client **GREY ADVERTISING**

Bloomingdale's

ALFA ROMEO 1992

1

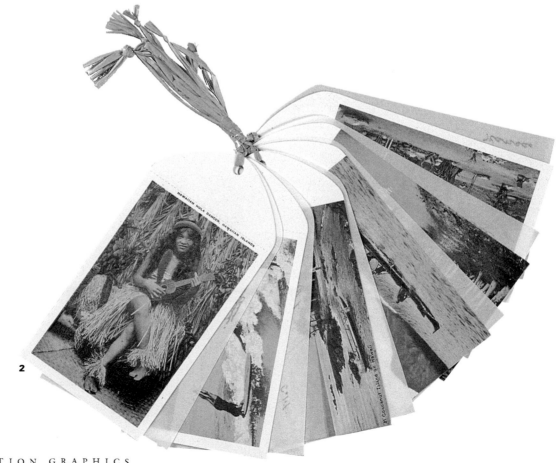

2

1

Calendar **ALFA ROMEO 1992**
Art Director **TIM MERAZ**
Photographer **VIC HUBER**
Design Firm **MERAZ DESIGN, ORANGE, CA**
Client **ALFA ROMEO NORTH AMERICA**
Typographer **ANDRESEN TYPOGRAPHICS**
Printer **THE DOT PRINTER**
Paper Manufacturer **NOLAND**

2

Hang Tags **CANOE POST CARD HANG TAGS**
Art Director **OREN SCHLIEMAN**
Design Firm **INFO GRAFIK, HONOLULU, HI**
Client **CANOE CLOTHING COMPANY**
Printer **TONGG PUBLISHING CO., HONOLULU**
Paper Manufacturer **SIMPSON/EVERGREEN**

3

Annual Report **FIRST MERCANTILE CURRENCY FUND 1990**
Art Director/Designer **DITI KATONA**
Art Director **JOHN PYLYPCZAK**
Photographers **JUNE STEUBE, BURT GLINN, RON BAXTER SMITH**
Design Firm **CONCRETE DESIGN COMMUNICATIONS INC., TORONTO, CAN**
Client **FIRST MERCANTILE CURRENCY FUND**
Typography **CONCRETE (MACINTOSH)**
Printer **ARTHURS JONES**
Paper Manufacturer **SCHEUFELEN**

3

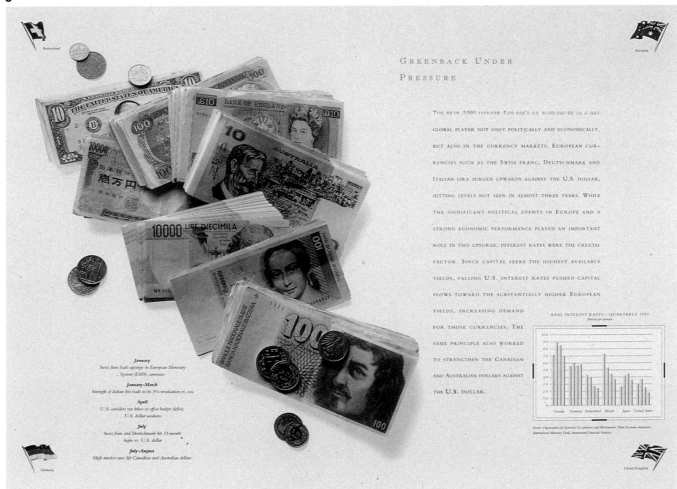

1

2

1

Brochure **BUILDING A STRONG IDENTITY**
Art Director **MIKE SCRICCO**
Designer/Illustrator **JEFF POLLARD**
Designer/Typographer **ADRIENNE POLLARD**
Agency **KEILER & COMPANY, FARMINGTON, CT**
Client/Paper Manufacturer **STRATHMORE PAPER CO.**
Printer **DICKSONS INC.**

2

Stationery **GEORGE FOR DOGS STATIONERY**
Art Director/Designer **MIKE HICKS**
Illustrator **DUANA GILL**
Design Firm **HIXO, INC., AUSTIN, TX**
Client **GEORGE FOR DOGS**
Printer **PRESS CORPS**
Paper Manufacturer **FRENCH PAPER CO.**

3

Self-Promotional Brochure **MICHAEL MABRY DESIGN**
Designer **MICHAEL MABRY**
Design Firm/Client **MICHAEL MABRY DESIGN, SAN FRANCISCO, CA**
Printer **JULIE HOLCOMB PRINTERS**
Paper Manufacturers **STRATHMORE, SIMPSON**

4

Brochure **REX THREE "DOG" BROCHURE ("WOOF")**
Art Director **JOEL FULLER**
Designer/Typographer **LISA ASHWORTH**
Photographer **MICHAEL DAKOTA**
Design Firm **PINKHAUS DESIGN CORP., MIAMI, FL**
Client/Printer **REX THREE INC.**
Paper Manufacturer **CONSOLIDATED**

3

4

1

Announcement **MELTZER & MARTIN HOLIDAY CARD**
Art Director **RON SULLIVAN**
Designer/Typographer **DAN RICHARDS**
Design Firm **SULLIVAN PERKINS, DALLAS, TX**
Client **MELTZER & MARTIN**
Typographer **LISA JOHNSON**
Printer **BENNETTS**
Paper Manufacturer **FRENCH PAPER COMPANY**

2

Announcement **LOOK FOR THE GOOD THINGS OF THE SEASON**
Art Director **RON SULLIVAN**
Designer/Illustrator **LINDA HELTON**
Design Firm/Typographer **SULLIVAN PERKINS, DALLAS, TX**
Client **THE ROUSE COMPANY**
Typographer **LISA JOHNSON**
Printer **HERITAGE PRESS**

3

Self Promotion **MORLA DESIGN HOLIDAY CARD '90**
Art Director/Designer **JENNIFER MORLA**
Designers **JEANETTE ABRAMBURU, SHARRIE BROOKS, SCOTT DRUMMOND**
Design Firm **MORLA DESIGN, SAN FRANCISCO, CA**
Client **MORLA DESIGN**
Typographer **DPI, SAN FRANCISCO, CA**
Printer **APEX DIE, SAN CARLOS**

4

Calendar **BOYER PRINTING COMPANY 1992 CALENDAR**
Art Director **JERRY KING MUSSER**
Design Firm **MUSSER DESIGN, HARRISBURG, PA**
Client/Publisher **BOYER PRINTING COMPANY**
Typographer **MACINTOSH & ADOBE**
Printer **BOYER PRINTING CO.**
Paper Manufacturer **JAMES RIVER**

1

Annual Report **SUNRISE TECHNOLOGIES, INC. 1990**
Art Director **JOHN BIELENBERG**
Designers **JOHN BIELENBERG, BRIAN BORAM, ALLEN ASHTON**
Photographer **JOEL GLENN**
Design Firm **BIELENBERG DESIGN, SAN FRANCISCO, CA**
Typographer **EUROTYPE**
Printer **LITHOGRAPHIX**
Paper Manufacturer **SIMPSON**

2

Poster **MEN OF LETTERS: "T"**
Art Director/Designer **CRAIG FRAZIER**
Designer **DEBORAH HAGEMANN**
Photographer **JOHN CASADO**
Design Firm **FRAZIER DESIGN, SAN FRANCISCO, CA**
Client/Typographer **DISPLAY LETTER & COPY**
Printer **WATERMARK PRESS**
Paper Manufacturer **S.D. WARREN PAPER CO.**

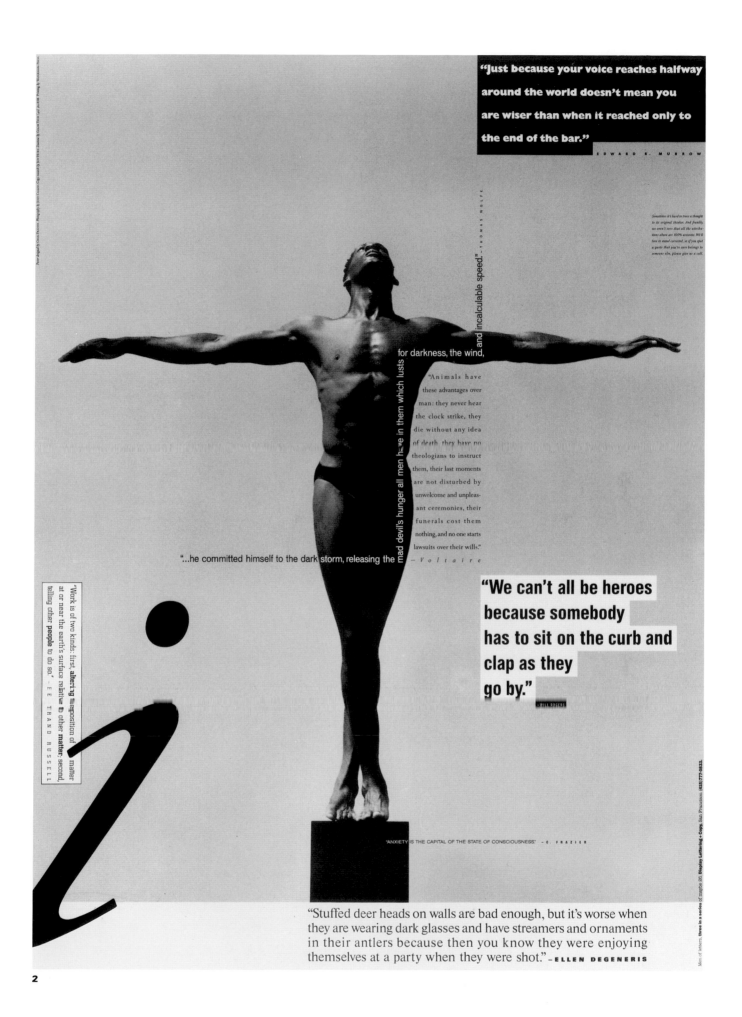

"...and incalculable speed." — THOMAS WOLFE

for darkness, the wind,

"Animals have these advantages over man: they never hear the clock strike, they die without any idea of death, they have no theologians to instruct them, their last moments are not disturbed by unwelcome and unpleasant ceremonies, their funerals cost them nothing, and no one starts lawsuits over their wills." — Voltaire

mad devil's hunger all men have in them which lusts

"...he committed himself to the dark storm, releasing the

"We can't all be heroes because somebody has to sit on the curb and clap as they go by." — WILL ROGERS

"Work is of two kinds: first, altering the position of matter at or near the earth's surface relative to other matter; second, telling other people to do so." — BERTRAND RUSSELL

"ANXIETY IS THE CAPITAL OF THE STATE OF CONSCIOUSNESS." — C. FRAZIER

"Stuffed deer heads on walls are bad enough, but it's worse when they are wearing dark glasses and have streamers and ornaments in their antlers because then you know they were enjoying themselves at a party when they were shot." — ELLEN DEGENERIS

2

229

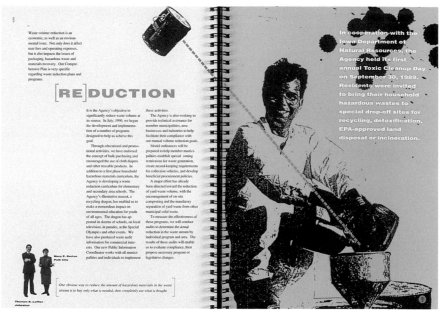

1

Annual **DES MOINES METRO SOLID WASTE AGENCY**

Art Director **STEVE PATTEE**

Designers **KELLY STILES, TIME SCHUMANN**

Photographer **ANDY LYONS**

Design Firm **PATTEE DESIGN, DES MOINES, IA**

Client **DES MOINES METRO SOLID WASTE AGENCY**

Printer **ABC SIGN/PROFESSIONAL OFFSET**

Paper Manufacutrer **JAMES RIVER**

2

Calendar **LEOPARD**

Designer/Illustrator **MICHAEL SCHWAB**

Design Firm **MICHAEL SCHWAB DESIGN, SAUSALITO, CA**

Client/Printer **PARAGRAPHICS**

NOVEMBER

					1	2
3	4	5	6	7	8	9
10	11	12	13	14	15	16
17	18	19	20	21	22	23
24	25	26	27	28	29	30

2 ©1991 MICHAEL SCHWAB DESIGN ANDRESEN TYPOGRAPHICS APEX DIE PARAGRAPHICS FINE PRINTING

3

Letterhead **FOX RIVER PAPER COMPANY**
Art Director/Designer **SHARON WERNER**
Illustrator **SHARON WERNER**
Letterer **LYNN SCHULTE**
Design Firm **THE DUFFY DESIGN GROUP, MINNEAPOLIS, MN**
Client **FOX RIVER PAPER COMPANY**
Typographer **TYPEHOUSE**
Printer **NEENAH PRINTING**
Paper Manufacturer **FOX RIVER PAPER COMPANY**

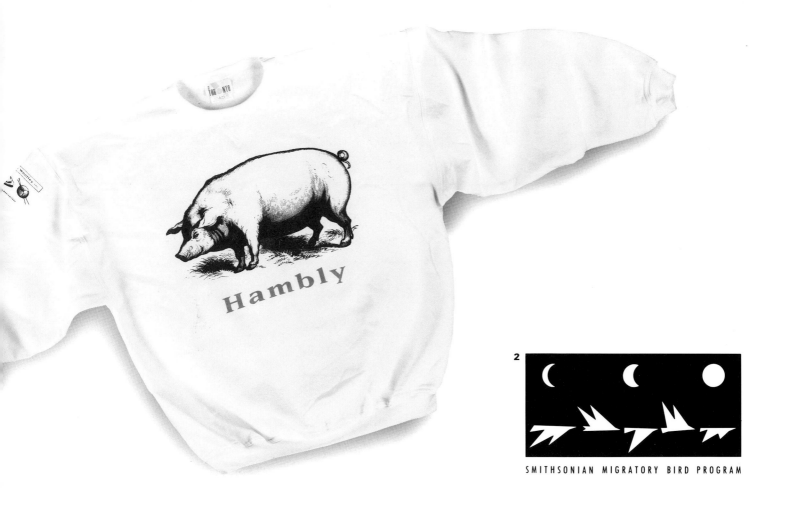

2

SMITHSONIAN MIGRATORY BIRD PROGRAM

3

Save San Francisco Bay

4

1

Sweatshirt **HAMBLY & WOOLLEY**
Art Directors **BOB HAMBLY, BARB WOOLLEY**
Illustrator **BOB HAMBLY**
Design Firm/Client **HAMBLY & WOOLLEY INC., TORONTO, CAN**
Printer **THE EDGE**

2

Logo **THE SMITHSONIAN MIGRATORY BIRD CENTER**
Art Director **LUCINDA CRABTREE**
Designer **MARIA BIERNIK**
Design Firm **CRABTREE & JEMISON, INC., ARLINGTON, VA**
Client **THE SMITHSONIAN MIGRATORY BIRD CENTER**
Typographer **FLORENCE TRAM**
Printer **PEAKE PRINTERS**

3

Poster **SAVE SAN FRANCISCO BAY**
Art Director **DOUG AKAGI**
Designers **DOUG AKAGI, KIMBERLY POWELL**
Design Firm **AKAGI DESIGN, SAN FRANCISCO, CA**
Printer **HERO PRESENTATION PRINTING**
Paper Manufacturer **BIENFANG**

4

Brochure **THE POWER OF WATER**
Art Director **TOM KAMINSKY**
Designer **ALICIA ZAMPITELLA**
Photographer **DAVID MEUNCH**
Agency **KAMINSKY DESIGN, BOSTON, MA**
Client **PLASTOCOR**
Typographer **WRIGHTSON**
Printer **W.E. ANDREWS**
Paper Manufacturer **POTLATCH**

5

Packaging **SHOPPING BAG/SPRING**
Art Director **JUDI RADICE**
Designer/Illustrator **JEAN SANCHIRICO**
Designer Firm/Client **THE NATURE COMPANY, BERKELEY, CA**
Printer **DURO PAPER AND PLASTICS**

5

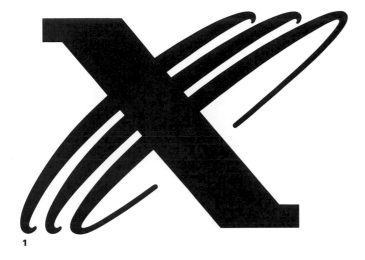

1

Logo **CROSS TRAINING**
Art Director/Designer/Illustrator **ALAN COLVIN**
Art Director **RON DUMAS**
Illustrator **DAVE GILL**
Design Firm **NIKE DESIGN**
Client **NIKE, INC.**

2

Packaging **NIKE TOWN**
Art Director/Designer **MICHELE MELANDRI**
Art Director **SARA ROGERS**
Photographers **DENNIS MENARCHY, PEGGY SIROTA**
Design Firm **NIKE DESIGN**
Typographer **V.I.P. TYPOGRAPHERS**

3

Catalog **VISUAL MERCHANDISING MANUAL**
Art Director/Designer **ALAN COLVIN**
Photographer **PETER ROSE**
Illustrator **MIKE FRASIER**
Design Firm **NIKE DESIGN**
Client **REBECCA KOTCH**
Typographer **SCHLEGEL TYPOGRAPHY**
Printer **OREGON PRINTING PLATES, BINDERY SYSTEMS, INC./
QUINTESSENCE**

4

Packaging **NIKE TOWN**
Art Director/Designer **MICHELE MELANDRI**
Art Director **SARA ROGERS**
Photographers **DENNIS MENARCHY, PEGGY SIROTA**
Design Firm **NIKE DESIGN**
Typographer **V.I.P. TYPOGRAPHERS**

STUDY THE FUNDAMENTALS

COLLECTIONS

COLORIZING · HANGING · SIZING · LIGHTING

FOLDING · LACING

ACCESSORIES

ORGANIZATION OF PRODUCT

The first priority at NIKE is to display Collections.

What are Collections?

Collections are highly focused lines of performance-oriented product, often represented by prominent NIKE athletes. The Collection elements—footwear, apparel and accessories—offer athletes the opportunity to coordinate both performance and style from head to toe.

Design and marketing efforts develop and promote NIKE Collections at the brand level. At the retail level it's up to NIKE visual merchandising to tell the Collection story. The product, combined with Collection-specific graphics and P.O.P., makes an exclusive NIKE presentation. What begins on the designer's drawing board reaches the consumer through the efforts of NIKE merchandisers.

Clearly, Collection merchandising is a priority in our retail accounts. Not only does it address the emotional aspects of consumer behavior, it serves the practical aspects, too. Shopping becomes simplified when similar product is grouped together.

Customers no longer have to wander around the store looking for a matching top, bottom, hat or bag.

Second to Collection merchandising is Sport-specific merchandising. Typically, retailers organize product by sport, not vendor. As a result, displaying NIKE Collections in a single area is not always possible. For example, NIKE's Challenge Court Collection will be situated in the tennis department. In such cases, the goal is to preserve the Collection by merchandising it on a NIKE display unit or a separate store fixture.

Always survey your selection of product before you begin merchandising. Analyze the breadth of colors, selection of materials and number of units.

Footwear
• Apparel
• Accessories
• Collections

3

4

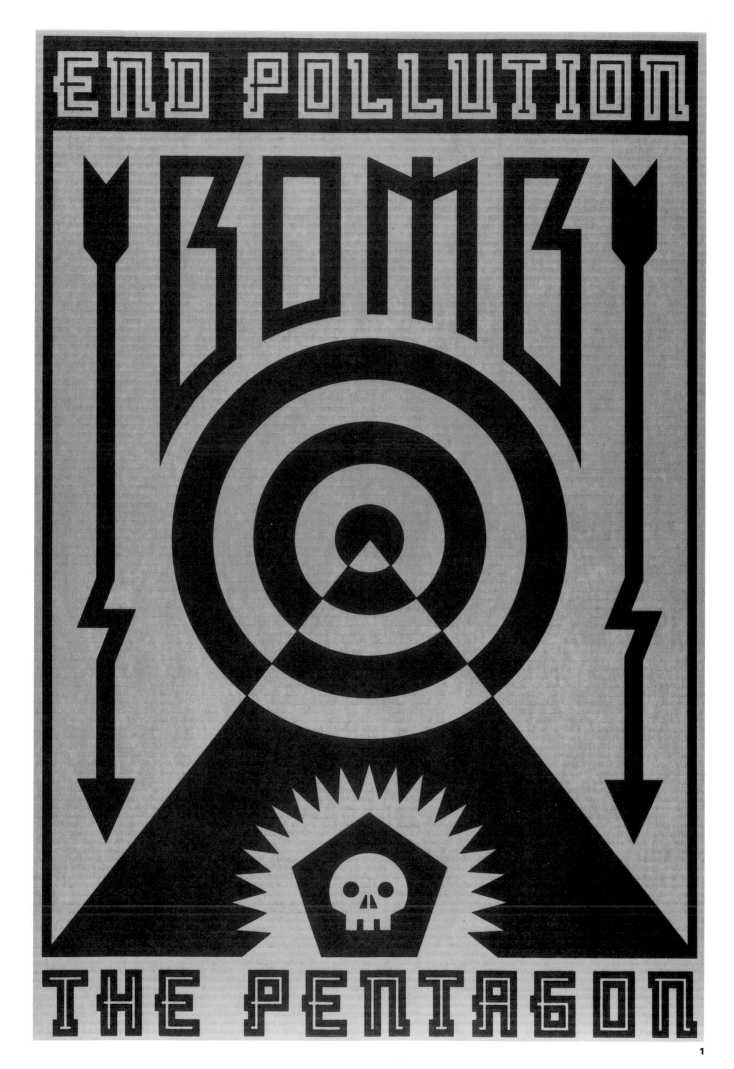

1

Poster **BOMB THE PENTAGON**
Designer/Illustrator **MARK FOX**
Design Firm **BLACKDOG, SAN RAFAEL, CA**
Client **BLACKDOG, AIGA/SAN FRANCISCO**
Typography **BLACK DOG**
Printer **ACME SILKSCREEN**

2

Poster **ED GOLD**
Designers **PAUL SAHRE, BILL SHINN, JACKIE McTEAR, CHRIS PANZER**
Illustrator **PAUL SAHRE**
Design Firm/Client **BARTON-GILLET, BALTIMORE, MD**
Typographer **CURRENT GRAPHICS**
Paper Manufacturer **WARD**

3

Poster **GLASNOST/PERESTROIKA**
Design Director/Illustrator/Client **IVAN CHERMAYEFF**
Design Firm **CHERMAYEFF & GEISMAR INC., NEW YORK, NY**
Printer **SERIGRAFIA LIMITED**

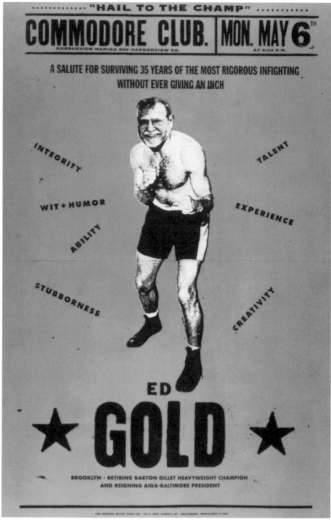

2

3

1

Poster **HOW DOES YOUR WORK MEASURE UP? SPD CALL FOR ENTRIES**
Art Director **FRED WOODWARD**
Designers **FRED WOODWARD, GAIL ANDERSON, ROLLING STONE**
MAGAZINE, NEW YORK, NY
Illustrator **TERRY ALLEN**
Client **SOCIETY OF PUBLICATION DESIGN**
Typographer **TERRY ALLEN AND DENNIS ORTIZ-LOPEZ**
Printer **SEIPLE LITHOGRAPHIC CO.**
Paper Manufacturer **WESTVACO CORPORATION**

2

Announcement **RUSSIAN GRAPHIC DESIGN BEFORE THE REVOLUTION**
Art Director/Designer **REBECA MENDEZ**
Design Firm/Agency **ART CENTER COLLEGE OF DESIGN, PASADENA, CA**
Typography **MACINTOSH**
Printer **TYPECRAFT**

3

Logo **GORBACHEV/MINNEAPOLIS VISIT**
Art Director/Designer **JOE DUFFY**
Illustrator **LYNN SCHULTE**
Design Firm **THE DUFFY DESIGN GROUP, MINNEAPOLIS, MN**
Client **GORBACHEV VISIT COMMITTEE, MINNEAPOLIS, MN**

4

Brochure **FRIEND & JOHNSON**
Art Director/Designer **BRYAN L. PETERSON**
Designer **SCOTT PARAMSKI**
Illustrator/Photographer **VARIOUS**
Design Firm **PETERSON & COMPANY , DALLAS, TX**
Client **FRIEND & JOHNSON**
Typographer **CREATIVE TYPE**
Printer **WILLIAMSON**

3

4

Friend & Johnson

WHAT'S THE BIG IDEA?
Tyler Smith

GRAPHIC DESIGN IN ITS TRUEST FORM IS A DISCIPLINE USED TO HELP COMMUNICATE A CONCEPT. IT BRINGS HARMONY TO COMPLEX GRAPHIC RELATIONSHIPS, AND CLARIFIES INFORMATION. IT CAN SOMETIMES EVEN ADD SIGNIFICANTLY TO THE EMOTIONAL TONE OF A MESSAGE.

IT IS AN IMPORTANT PROCESS THAT TAKES INGREDIENTS LIKE PHOTOGRAPHY, ILLUSTRATION, TYPOGRAPHY, OR COMPUTER GENERATED IMAGES AND MANIPULATES THEM TO EXPRESS AN IDEA.

TO USE GRAPHIC DESIGN AS A GOAL IN ITSELF, IS TO CONFUSE TECHNIQUE WITH CONCEPT. THE COMPUTER HAS QUICKLY BECOME A FANTASTIC TOOL FOR THE GRAPHIC DESIGNER, BUT UNFORTUNATELY, ITS MAGIC HAS TRAPPED MANY OF US INTO A PROCESS WHOSE LOOK IS BECOMING MORE AND MORE COMMONPLACE. TOO MANY "ELECTRONIC COLLAGES" ARE COVERING UP TOO MANY WEAK IDEAS. SIMILARLY, NEW WAVE, RETRO, POST MODERN, PUNK, RUSSIAN CONSTRUCTIVIST AND EMULATED "DUFFYESQUE" DESIGNS ARE BEING CHURNED OUT WITH NO CONCEIVABLE CONNECTION TO THEIR SUBJECT MATTER.

WHEN DOES GRAPHIC DESIGN BECOME DECORATIVE? DOES BORROWING "A LOOK" FOR THE SOLE PURPOSE OF STYLISTIC FASHION JUSTIFY ITS USE? OR, IN FACT, DO NOT THESE STYLES BECOME MORE HONEST WHEN THEY ARE USED AS A DIRECT OUTGROWTH OF THE CONCEPT?

YES, AS DESIGNERS WE HAVE AN OBLIGATION TO COMMUNICATE WITH STYLE, BUT HOPEFULLY WITH STYLE THAT SPRINGS OUT FROM THE SUBJECT, AND NOT JUST VENEERED OVER IT.

WE HAVE MORE THAN ENOUGH WONDERFUL DESIGN TECHNIQUES. FAR RARER ARE NEW IDEAS.

New wave, retro, post modern, punk, Russian constructivist and emulated "Duffyesque" designs are being churned out with no conceivable connection to their subject matter.

1

2

If your trapezium needed attention, where would you take it?

From two Greek words,
akros, for the top or end of a
thing and *omos,* for the shoulder,
we get the noun "acromion,"
which describes the outer extremity
of the shoulder blade.

1

Annual Report **GENDEX CORPORATION 1991**
Art Director/Designer **PAT SAMATA**
Designer **GREG SAMATA**
Photographer **MARK JOSEPH**
Design Firm/Typographer **SAMATA ASSOCIATES, DUNDEE, IL**
Client **GENDEX CORP.**
Printer **GREAT NORTHERN PRINTING**
Paper Manufacturer **POTLATCH/CROSS POINTE**

2

Brochure **SAN RAMON REGIONAL MEDICAL CENTER**
Art Director/Illustrator **ERIK ADIGARD**
Design Firm **M.A.D., SAN FRANCISCO, CA**
Client **SAN RAMON REGIONAL MEDICAL CENTER**
Printer **GEHRE GRAPHICS**
Paper Manufacturer **THE UNISOURCE CORPORATION**

3

Handbook **SWEDISH MEDICAL CENTER PATIENT INFORMATION**
Art Director **THOMAS C. EMA**
Designer **DEBRA JOHNSON HUMPHREY**
Design Firm **EMA DESIGN, DENVER, CO**
Client **SWEDISH MEDICAL CENTER**
Typography **MACINTOSH IIcx**
Linotronic Imaging **LINEAUX, INC.**
Printer **COMMUNIGRAPHICS**
Paper Manufacturer **SIMPSON PAPER COMPANY**

Swedish Medical Center

PATIENT

INFORMATION

HANDBOOK

3

1

1

Brochure **USE WHAT IS**
Art Director/Designer/Typographer **KRISTEN MCDOUGALL**
Design Firm **WALKER ART CENTER DESIGN DEPARTMENT, MINNEAPOLIS, MN**
Publisher **WALKER ART CENTER**
Printer **BOLGER PRINTING**
Paper Manufacturer **GRAPHIKA LINEAL**

2

Shopping Bag **NEW YEAR'S 1991**
Executive Art Director **JIM CHRISTIE**
Art Directors **RICHARD SANCA, JOHN JAY**
Designer **CHRIS SHIPMAS**
Illustrator **MALCOLM GARRETT**
Design Firm/Client **BLOOMINGDALE'S, NEW YORK, NY**

3

Annual Report **CENTRAL AND SOUTH WEST CORPORATION 1990**
Art Director/Designer/Illustration **JACK SUMMERFORD**
Photographer **JIM OLVERA**
Design Firm **SUMMERFORD DESIGN, INC., DALLAS, TX**
Client **CENTRAL AND SOUTH WEST CORPORATION**
Typographer **SOUTHWESTERN TYPOGRAPHICS**
Printer **HERITAGE PRESS**
Paper Manufacturers **WEYERHAEUSER, MOHAWK, CHAMPION**

2

WORDS TEND TO BE INADEQUATE

ALIENATION PRODUCES ECCENTRICS OR REVOLUTIONARIES

THERE'S A FINE LINE BETWEEN INFORMATION AND PROPAGANDA

T IN A CULTURE TO CHAN

ENJOY YOURSELF BECAUSE YOU CAN'T CHANGE ANYTHING ANYWAY

3

CENTRAL AND SOUTH WEST CORPORATION 1990 ANNUAL REPORT

STRATEGY FOR A NEW DECADE

carry more risk than traditional utility investments. Equally important, CSW Energy can make us a strong competitor in the growing non-utility generation field.

Strategy 3: Financial initiatives

We have two active subsidiaries, CSW Credit and CSW Leasing, that primarily are financial ventures.

CSW Credit, the first captive finance company in the electric utility industry, helps lower operating costs for our electric subsidiaries by reducing their financing costs of accounts receivable. Our operating companies sell their daily customer billings to CSW Credit at a discount that covers CSW Credit's operating expenses, income tax and cost of funds. CSW Credit also provides its service, known as factoring receivables, to utilities outside our system.

CSW Leasing purchases capital equipment for client companies through leveraged leases. CSW Leasing owns a fleet of jetliners that are leased to major U.S. airlines, a large container ship that sails to South America out of the Port of New Orleans and other capital equipment. CSW Leasing derives income from the leases and tax savings from interest and depreciation deductions. In addition, the equipment it owns is a good long-term investment.

We continually are evaluating other financial initiatives to improve our earnings, dividends and cash flow. As an example, our aggressive liability management program has achieved $47 million of net present value savings by refinancing more than $1.5 billion of high-cost securities during the past several years. Today, the cost of most of our debt is below 10%.

Strategy 4: Core-business expansion

The final leg of our strategy for enhancing shareholder value is to expand our core business by *buying* existing utility assets, rather than *building* them. But mergers and acquisitions must be approached carefully. We will not seek to acquire a utility unless the acquisition makes good sense—both for our own and the acquired company's customers and shareholders.

For that reason, we have established rigorous criteria for merger and acquisition prospects. Any potential acquisition must enhance our long-term earnings and dividend growth, contribute to the integration of our system or improve our strategic positioning within electric utility markets. It could meet these criteria by lowering our costs, increasing our long-term efficiencies or providing an investment with a good rate of return.

Succeeding when all the rules have changed

Competition is intensifying, regulations are changing and the building years for its are ending—at least temporarily. All the old rules are being redefined.

Success in this new environment will require a careful blend of the progressive and the conservative. It will take a willingness to explore new markets and new ventures, combined with an unwavering commitment to our core electric utility business. And it will take an equitable balancing of shareholder and customer needs.

Our five strategic goals and four-part strategic plan for enhancing shareholder value are our way to put "progressive conservatism" into action. Our approach combines innovative steps like expanding Transok and CSW Energy with the traditional emphasis on our four electric operating companies. Our plan protects our strong capital structure and our dividend policy, two essential elements of our financial strength. And it's carefully crafted to meet the needs of our shareholders and our customers.

With the company's experienced leadership, conservative financial posture and excellent performance day in and day out, we believe Central and South West is positioned to succeed in the future by building on its strengths.

We have established rigorous criteria for mergers and acquisitions so that an acquisition makes good sense—for our own and for the acquired utility's shareholders and customers.

1

Booklet **AMERICAN DIRECTORY OF ARCHITECTS**
Art Directors **JOEL FULLER, MARK CANTOR**
Designer **TOM STERLING**
Photographer **JIM PALMA**
Design Firm **PINKHAUS DESIGN CORP., MIAMI, FL**
Client **PINKHAUS PUBLICATIONS INC.**
Typographer **RALF SCHUETZ**
Printer **FOUR COLOR IMPORTS**

2

Annual Report **AMEV HOLDINGS, INC. 1990**
Art Director/Designer **HERSHELL GEORGE**
Illustrators **KEITH PIACZNY, JAKE WYMAN**
Design Firm **HERSHELL GEORGE GRAPHICS, NEW YORK, NY**
Client **AMEV HOLDINGS, INC.**
Typographer **MACINTOSH**
Printer **L.P. THEBAULT**
Paper Manufacturer **SIMPSON, EVERGREEN**

4

3
Catalog **DOUGLAS ENTRANCE**
Art Director/Photographer **TOM WOOD**
Photographer **PHIL BRODATE**
Design Firm **PATTERSON WOOD PARTNERS, NEW YORK, NY**
Client **LOUIS DREYFUS PROPERTY GROUP**
Typographer **TYPOGRAM**
Printer **HENNEGAN PRINTING CO.**
Paper Manufacturer **MOHAWK**

4
Signage **CONTRACT DESIGN CENTER**
Art Director **JOHN BRICKER**
Designer **TOM HORTON**
Photographer **DAVID WAKELY**

1

Invitation **AIGA MASQUE AUCTION**
Art Directors **LAURA LATHAM, SAM SHELTON**
Illustrators **BRYAN LEISTER, BECKY HEARNER**
Design Firms **INVISIONS LTD, DESIGN, KINETIK COMMUNICATION**
GRAPHICS DESIGN
Client **AIGA WASHINGTON DEC CHAPTER**
Typographer **COMPOSITION SYSTEMS INC.**
Printer **S & S GRAPHICS**
Paper Manufacturer **CHAMPION INTERNATIONAL CORP.**

2

Promotional Brochure **COLLIER CAMPBELL**
Art Director **JEAN MCCARTNEY**
Photography **STEVE COHEN**
Agency **IN-HOUSE**
Client **J.P. STEVENS, WEST POINT PEPPERELL, INC., NEW YORK, NY**
Typographer **CYBERGRAPHICS**
Printer **DIVERSIFIED GRAPHICS**
Paper Manufacturers **STRATHMORE, CONSOLIDATED AND ZANDERS**

3

Accordian Poster **NDCA PROMO POSTER**
Art Designer **TIM KENNEY**
Designer **TOM SNORECK**
Computer Illustration **RANDY GESKE**
Photographer **COMSTOCK**
Design Firm **TIM KENNEY DESIGN, INC., BETHESDA, MD**
Client **NATIONAL DESKTOP COLOR ALLIANCE**
Typographer **TKDI**
Printer **EXPERT BROWN**

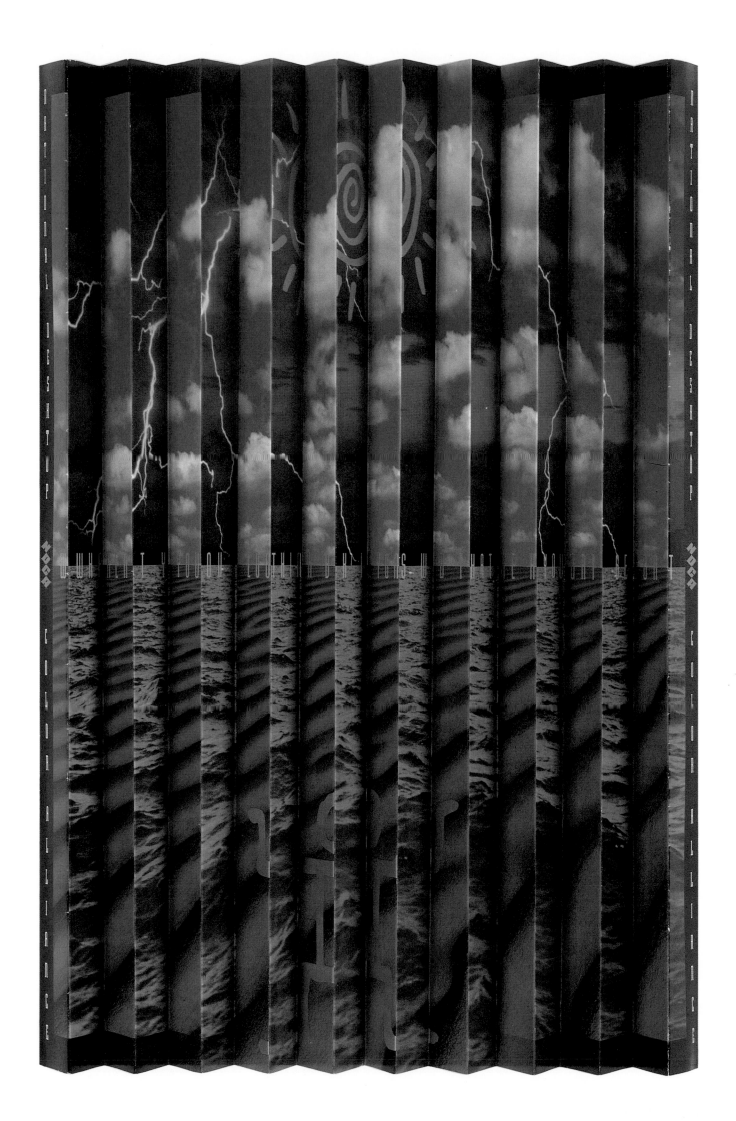

1

2

3

DESIGNING
NEW
YORK:
PARADIGM
AND
PARADOX.
A
COLLOQUIUM
TO
EXPLORE
THE
REVITALIZATION
OF
NEW
YORK
THROUGH
DESIGN.
OCTOBER 3,
1991.

Save Our City

1

Brochure **ILLINOIS FILM OFFICE LOCATION GUIDE**
Art Director **KYM ABRAMS**
Designer **MIKE STEES**
Photographers **VARIOUS**
Design Firm **KYM ABRAMS DESIGN, CHICAGO, IL**
Client **ILLINOIS FILM OFFICE**
Typographer **MASTER TYPOGRAPHERS**
Printer **COLUMBIA GRAPHICS**

2

Guide Book **AIGA DESIGNERS GUIDE TO CHICAGO**
Art Directors/Designers **KYM ABRAMS, SAM SILVIO**
Photographer **ALAN SHORTALL**
Design Firms **KIM ABRAMS DESIGN, SAM SILVIO DESIGN, CHICAGO, IL**
Client **AIGA/CHICAGO**
Typographer **MASTER TYPOGRAPHER**
Printer **NORTHWESTERN PRINTING HOUSE**
Paper Manufacturer **NEENAH PAPER**

3

Poster **"SAVE OUR CITY"**
Art Director **MICHAEL BIERUT**
Design Firm **PENTAGRAM DESIGN, NEW YORK, NY**
Client **DESIGNING NEW YORK**
Typographer **TYPOGRAM**
Printer **AMBASSADOR ARTS**

1

Grocery Bags **HOGAN'S MARKET GROCERY BAGS**
Art Directors **DENISE WEIR, LIAN LAPINE**
Designers **DENISE WEIR, LIAN NG**
Illustrator **LARRY JOST**
Letterer **NANCY STENZ**
Design Firm/Typographer **HORNALL ANDERSON DESIGN WORKS, SEATTLE, WA**
Client **PUGET SOUND MARKETING CORPORATION**
Printer **WILLIS MARKETING, PRINCETON PAPER**
Paper Manufacturer **PRINCETON PAPER**

2

Annual Report **CRACKER BARREL 1991**
Art Director/Designer **THOMAS RYAN**
Illustrator **PAUL RITSCHER**
Photographer **MCGUIRE**
Design Firm **THOMAS RYAN DESIGN, NASHVILLE, TN**
Client **CRACKER BARREL OLD COUNTRY STORE**
Typographer **IN-HOUSE**
Printer **BUFORD LEWIS COMPANY**
Paper Manufacturer **FRENCH PAPER**

3

Self Promotion **VAUGHN/WEDEEN HOLIDAY CRATE**
Art Directors **RICK VAUGHN, STEVE WEDEEN**
Art Director/Designer **DAN FLYNN**
Illustrator **BILL GERHOLD**
Design Firm **VAUGHN/WEDEEN CREATIVE, ALBURQUERQUE, NM**
Typographer **IN-HOUSE**

251

A STRONG AD

Clinical physiologists have identified over 400 different muscles in the human body. While we don't wish to upset the findings, our own study, conducted at the TippyToe Tavern in Hogjaw, Alabama, failed to turn up anyone who could show us more than three or four.

MUSCULAR TOM FOOLERY

Down at the TippyToe, we learned a clever trick. Many of the fellows stood with their arms crossed so that their hands, tucked so casually in their armpits, slyly pushed the meat of their upper arms outward to give the impression of bulging biceps where there were none. Go on, try it yourself.

We asked one respondent of our survey, a strapping boy named Billy, why he thought having well-developed biceps was important enough to merit such trickery. Billy shifted his weight thoughtfully from one foot to the other for a few seconds, grinned and said, "Cause the purty girls like'em."

Now, according to every survey of "purty girls" we've seen (our own is pending), Billy was misguided. Biceps appear to rank fairly low on the list of physical attributes women notice, well below buttocks, hair, eyes and flat stomachs. And for that matter, bulging biceps or not, Billy went home alone that night, while we, of course, never want for companionship.

It is not that our test subjects at the TippyToe try to look muscular out of aesthetic vanity; if that were true, they would dress better. No, they wish to demonstrate strength, and a show of muscles is a quick visual cue to do just that.

Certainly, strength is a desirable quality. Physical strength suggests virility, vitality and power, the greatest aphrodisiac of all. Strength serves to describe anything capable of moving forcefully. People speak of strong winds. Strong medicine. Strong ideas.

STRONG ADS

What makes an ad strong? You've seen thousands of ads with outrageous visuals that didn't move you in the least. Like the boys at the TippyToe with their hands in their armpits, the result was a display of fat pushed around to look like muscle, a mere illusion of strength. And like the girls at the TippyToe,

you weren't fooled, so you powdered your nose and went off to look for Fred Vanderpoel.

Fred makes strong ads. It's easy to think of a photographer as just another hired hand, but Fred has a knack for grasping your central idea and manipulating the image to suit it. You don't need technical wizardry for its own sake, you need the right visual for your ad. That's all Fred promises. And if the visual happens to look damn good, too—well, that's just Fred's little Dutch muscles bulging.

If you need this kind of precision in your productions, call (213) 935-5695 and ask for Fred's free printed portfolio. And if you don't need such precision in your productions, call (415) 621-4405. You'll still get Fred's free printed portfolio. We give you our most solemn word—you'll like what you see.

After all, you're not just buying purty pictures. You're buying ads.

Vanderpoel.

1

2

3

1

Advertising **A STRONG AD**
Art Director/Designer **TOM ROTH**
Photographer **FRED VANDERPOEL**
Agency **ANDERSON & LEMBKE, SAN FRANCISCO, CA**
Client **FRED VANDERPOEL**
Typography **ELECTRA**

2

Advertising **HOW TO GET THE MOST OUT OF AN AD**
Art Director/Designer **TOM ROTH**
Photographer **FRED VANDERPOEL**
Agency **ANDERSON & LEMBKE, SAN FRANCISCO, CA**
Client **FRED VANDERPOEL**
Typography **ELECTRA**

3

Advertising **NO STYLE**
Art Director/Designer **TOM ROTH**
Photographer **FRED VANDERPOEL**
Agency **ANDERSON & LEMBKE, SAN FRANCISCO, CA**
Client **FRED VANDERPOEL**
Typography **ELECTRA**

4

Stationery **SUMMERFORD DESIGN INC.**
Art Director/Designer/Client **JACK SUMMERFORD**
Design Firm **SUMMERFORD DESIGN, INC., DALLAS, TX**
Typographer **SOUTHWESTERN TYPOGRAPHICS**
Printer **MONARCH PRESS**
Paper Manufacturer **STRATHMORE**

NO STYLE
HAIRY TOES AND SAPPHIRES
ECCENTRICS AND BANDWAGONEERS
OUR MAN WITH NO STYLE

Vanderpoel.

Summerford Design, Inc.
Summerford Design, Inc.
Summerford Design, Inc.
Summerford Design, Inc.
Summerford Design, Inc.
2706 Fairmount
Dallas 75201
214 748 4638
Jack

SUMMERFORD DESIGN, INC.
SUMMERFORD DESIGN, INC.
SUMMERFORD DESIGN, INC.
SUMMERFORD DESIGN, INC.
SUMMERFORD DESIGN, INC.
2706 FAIRMOUNT
DALLAS 75201
214 748 4638
JACK

SUMMERFORD DESIGN, INC.
SUMMERFORD DESIGN, INC.
SUMMERFORD DESIGN, INC.
SUMMERFORD DESIGN, INC.
SUMMERFORD DESIGN, INC.
2706 FAIRMOUNT
DALLAS 75201
214 748 4638
JACK

Summerford Design, Inc.
Summerford Design, Inc.
Summerford Design, Inc.
Summerford Design, Inc.
Summerford Design, Inc.
2706 Fairmount
Dallas 75201

SUMMERFORD DESIGN, INC.
SUMMERFORD DESIGN, INC.
SUMMERFORD DESIGN, INC.
SUMMERFORD DESIGN, INC.
SUMMERFORD DESIGN, INC.
2706 FAIRMOUNT
DALLAS 75201

WE DO BUSINESS PRACTICALLY EVERYWHERE. INTERTRANS HAS 35 OFFICES IN THE UNITED STATES, FIVE OFFICES OVERSEAS, AND A NETWORK OF AFFILIATED AGENTS AROUND THE WORLD.

Intertrans has entered a ten-year agency agreement in Brazil to allow us to service our customers in that market.

In September, 1990, we opened a new office in Mexico City to help us obtain greater market share of an emerging economy.

A decade ago, Intertrans began as a single office in Dallas, Texas. Today our offices and agents are in over 200 cities around the globe.

As Eastern Europe opens up to international trade, new economic activity in Hungary, Poland, Czechoslovakia and elsewhere will mean opportunities for our services.

PACIFIC RIM

There are Intertrans offices in Hong Kong and Singapore and business development in Taipei, Taiwan and Bangkok, Thailand. Our participation in Pacific Rim trade continues to grow.

EC
1992

We are prepared for the complete opening of the European Common Market by January, 1993. We now have agreements with major agents throughout Europe, as well as an office in Brussels, a joint venture in Holland, and sales offices in France and Germany.

1990

INTERTRANS
CORPORATION
ANNUAL REPORT

1

Annual Report **1990 INTERTRANS**
Art Director **RON SULLIVAN**
Designer **LINDA HELTON**
Illustrators **CLARK RICHARDSON, ART GARCIA**
Design Firm **SULLIVAN PERKINS, DALLAS, TX**
Client **INTERTRANS CORPORATION**
Typographer **BRANUM TYPOGRAPHY**
Printer **HERITAGE PRESS**

2

Bread Sack **PANE DI PAOLO ITALIAN BREAD PACKAGING**
Art Director **JACK ANDERSON**

1

Brochure **TIME INC. MAGAZINE GROUP**
Creative Directors **KENT HUNTER (GRAPHICS), DANNY ABELSON (COPY)**
Designer **KIN YUEN**
Photographers **VARIOUS**
Design Firm/Typography **FRANKFURT GIPS BALKIND, NEW YORK, NY**
Client **THE TIME MAGAZINE COMPANY**
Printer **LEBANON VALLEY OFFSET**

2

Advertising **CUSTOMWEAVE**
Art Director **RUSS RAMAGE**
Writer **BILL GRANT**
Photographer **GEOF KERN**
Design Firm/Agency **DESIGN!, DALTON, GA**
Client **CUSTOMWEAVE CARPETS**
Printer/Engraver **GRAPHIC ADS**

3

CD Packaging **RAY CHARLES: THE BIRTH OF SOUL**
Art Directors **BOB DEFRIN, CAROL BOBOLTS**
Designer **CAROL BOBOLTS**
Design Firm **RED HERRING DESIGN, NEW YORK, NY**
Client **ATLANTIC RECORDS**
Typographer **EXPERTYPE/GRAPHIC WORD**
Printer **IVY HILL**
Paper Manufacturer **GEORGE WHITING PAPER COMPANY**

1

LIFE finds the human side of important events and the personal side of influential people. Like its readers, its subjects know that *LIFE* is a magazine they can trust. It is this trust that allows *LIFE* access to exclusive stories about important people. *LIFE* covers the common agenda facing Americans today: environment, family, education, and the fundamental American value system. This agenda is *LIFE*'s historic franchise and the source of its present strength. The average issue of *LIFE* magazine is read by 18,959,000 people.

Sometime last night,
I was reviewing a Customweave
sample for my latest project
when my mind wandered
to a mysterious room
I had visited years ago
somewhere in a city
I can't recall.
What I do remember is
the distinct emotion I had
upon entering the space.
Colors, textures and forms

CUSTOMWEAVE

converged in perfect harmony.
I stood for hours
analyzing each component
in pursuit of
the unifying element,
the foundation, the room's soul.
Now I wonder,
perhaps the answer
was right under my feet.
Customweave. Art for the floor.
1.800.241.4900 Ext. 4407

CUSTOMWEAVE

2

1
Photos **SIGNAGE FOR MERVYN'S STORES**
Art Designer **ART CURTIN**
Designer **PETER LOCKE**
Illustrator **TIM CLARK**
Design Firm/Typographer **PAUL CURTIN DESIGN, SAN FRANCISCO, CA**
Client **MERVYN'S**
Printer **COLOSSAL GRAPHICS**

2
Poster **GITANES**
Designer/Illustrator **SEYMOUR CHWAST**
Design Firm **THE PUSHPIN GROUP, NEW YORK, NY**
Client **ECHO INTERNATIONAL**

3
Package Design **CLOUD NINE CANDY BARS**
Art Director **HALEY JOHNSON**
Designers **HALEY JOHNSON, DANIEL OLSON**
Design Firm **CHARLES S. ANDERSON DESIGN COMPANY, MINNEAPOLIS, MN**
Client **CLOUD NINE, INC.**
Typographer **LINOTYPOGRAPHERS**
Printer **DIVERSIFIED GRAPHICS**
Paper Manufacturer **S.D. WARREN**

4
Poster **FANTASIA 50TH ANNIVERSARY**
Designer **HENRY VIZCARRA**
Photographer **GLENN SWEITZER**
Illustrator/Design Firm **30/SIXTY DESIGN, LOS ANGELES, CA**
Client **DISNEY HOME VIDEO**

4

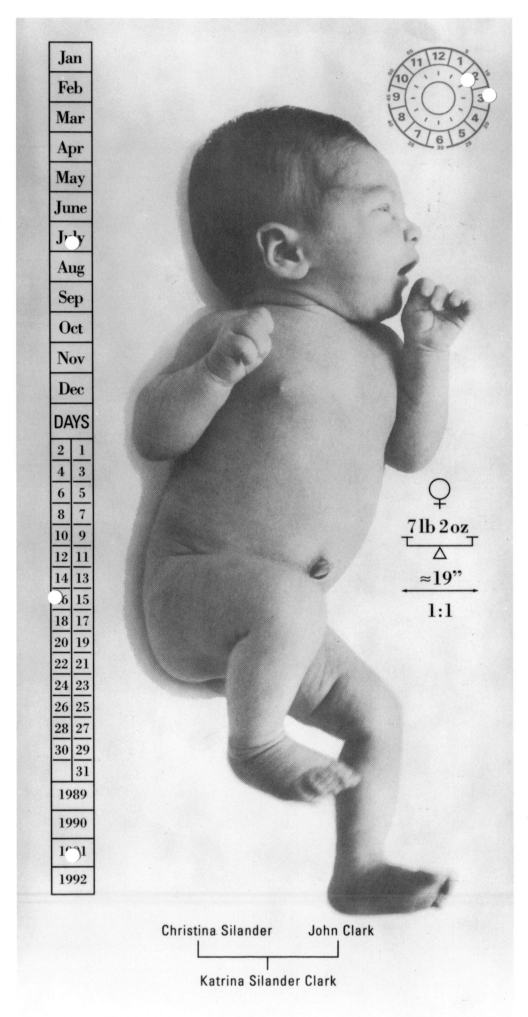

| Jan |
| Feb |
| Mar |
| Apr |
| May |
| June |
| July |
| Aug |
| Sep |
| Oct |
| Nov |
| Dec |

DAYS	
2	1
4	3
6	5
8	7
10	9
12	11
14	13
16	15
18	17
20	19
22	21
24	23
26	25
28	27
30	29
	31
1989	
1990	
1991	
1992	

♀

7 lb 2 oz

≈19"

1:1

Christina Silander John Clark

Katrina Silander Clark

1

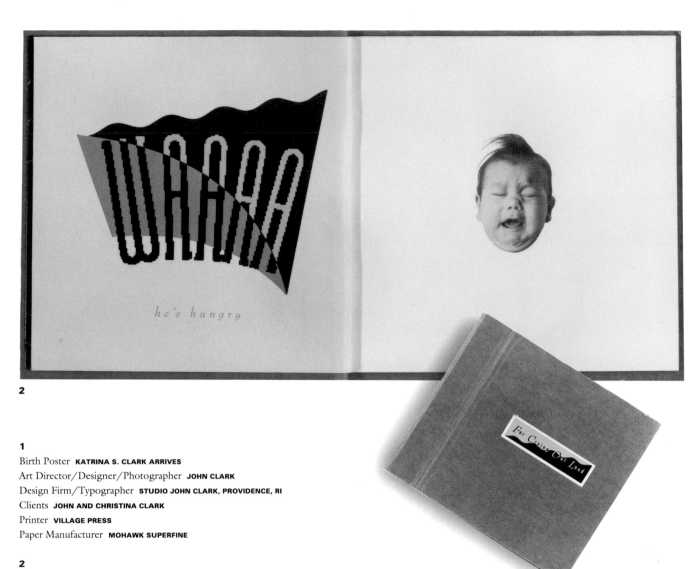

2

1

Birth Poster **KATRINA S. CLARK ARRIVES**
Art Director/Designer/Photographer **JOHN CLARK**
Design Firm/Typographer **STUDIO JOHN CLARK, PROVIDENCE, RI**
Clients **JOHN AND CHRISTINA CLARK**
Printer **VILLAGE PRESS**
Paper Manufacturer **MOHAWK SUPERFINE**

2

Announcment **FOR CRYING OUT LOUD**
Art Director **RON SULLIVAN**
Art Director/Designer **ART GARCIA**
Photographer **JEFF COVINGTON**
Design Firm **SULLIVAN PERKINS, DALLAS, TX**
Client **ART, BECK & DOMINIC**
Typographcr **LISA JOHNSON**
Printer **TOP BOX**
Paper Manufacturer **MONARCH PAPER CO.**

3

Candy Packaging **SAVE THE ANIMALS**
Creative Director **JOHN JAY**
Design Firm/Client **BLOOMINGDALE'S, NEW YORK, NY**

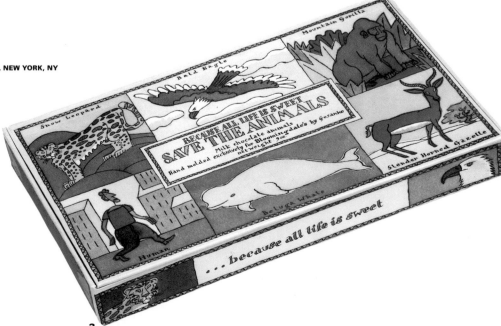

1

1

Exhibit **COMDEX/EXPORVISION**
Art Director **MITCHELL MAUK**
Designer **FRANCIS PACKER**
Design Firm **MAUK DESIGN, SAN FRANCISCO, CA**
Photographer **ANDY CAULFIELD**
Client **EXPERVISION INC.**
Fabricator **BLUEPETER**

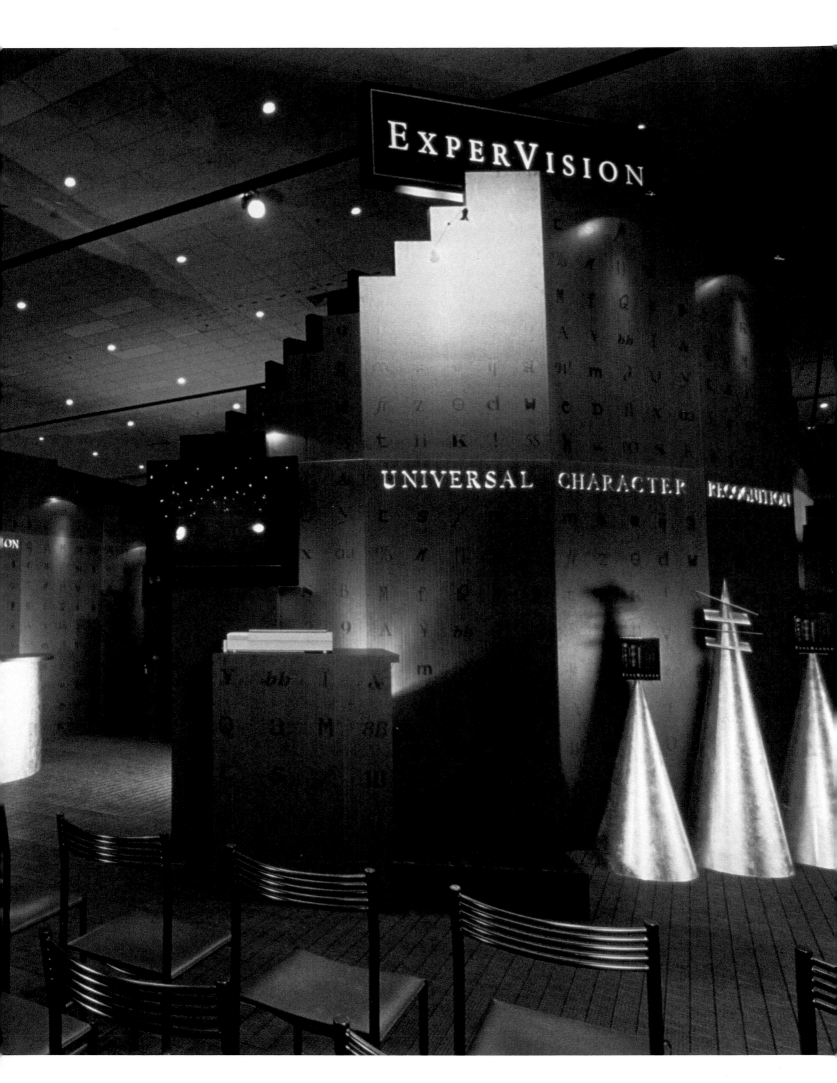

THE BASIC ELEMENTS OF LIFE INSURANCE

What makes a life insurance company financially sound? What should it be able to offer you? What kind of experience should it have? Why should you trust it? In choosing the right company to provide life insurance, you should ask yourself these questions. You must be able to understand the complexities of today's financial world while sifting through which promises can be kept. In keeping with the definition of a primer— a book that covers the basic elements of a subject—this booklet covers the basics of life insurance. It gives you facts and figures on some of the nation's largest life insurers. Use it to answer any questions you might have, so you can make the right decision about this important aspect of your future.

Introduction

FINANCIAL STRENGTH

Since life insurance is a long-term business, financial strength is critical to a company's overall performance.

One of the best measures of financial strength is a company's capital and surplus (or "rainy day funds").

A high percentage of capital (capital, surplus, and other reserves) generally indicates financial strength.

Company Name	Financial Strength*
Guardian Life	14.72
Royal Maccabees	8.46
Transamerica	7.74
New York Life	7.36
Northwestern National Life	7.36
Travelers	7.05
Northwestern Mutual	6.95
Prudential	6.25
Principal Mutual	5.78
Lincoln National	5.53
Connecticut Mutual	5.44
John Hancock	5.38
Alexander Hamilton	5.35
Massachusetts Mutual	5.20
Metropolitan	5.09
General American	5.01
Jackson National	4.97
Pacific Mutual	4.49
Nationwide	4.20
Mutual of New York	4.19
New England Mutual	4.15
Connecticut General	3.87
IDS Life	3.77
Equitable	3.21

*Statutory capital, surplus and mandatory securities valuation reserve as a percentage of total statutory liabilities. Source: Best's Insurance Reports, Life-Health, 1990, 85th Annual Edition, A.M. Best Company, Inc.

One

1

1
Brochure **COMPANY PERFORMANCE PRIMER**
Art Director **MEGAN A. TAYLOR**
Illustrator **NWN LIFE INSURANCE/ARCHIVES**
Design Firm **IN-HOUSE**
Client **NORTHWESTERN NATIONAL LIFE, MINNEAPOLIS, MN**
Typographer **TYPEMASTERS**
Printer **DIVERSIFIED GRAPHICS INC.**

2

Poster CELEBRATION FOR THE NATIVE AMERICAN
Art Director/Designer JACK SUMMERFORD
Illustrator JACK UNRUH
Design Firm SUMMERFORD DESIGN, INC., DALLAS, TX
Client SMITHSONIAN NATIONAL MUSEUM OF THE AMERICAN INDIAN
Typographer SOUTHWESTERN TYPOGRAPHICS
Printer HERITAGE PRESS
Paper Manufacturer MOHAWK

3

Catalog UCLA EXTENSION WINTER QUARTER 1992
Art Director INJU STURGEON
Designer ARMIN HOFMANN

4

Catalog UCLA EXTENSION FALL QUARTER 1991
Art Director INJU STURGEON
Designer KEN PARKHURST

5

Catalog UCLA EXTENSION SUMMER QUARTER 1991
Art Director INJU STURGEON
Designer EIKO ISHIOKA

3

4

2

5

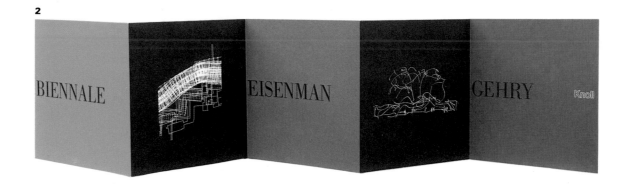

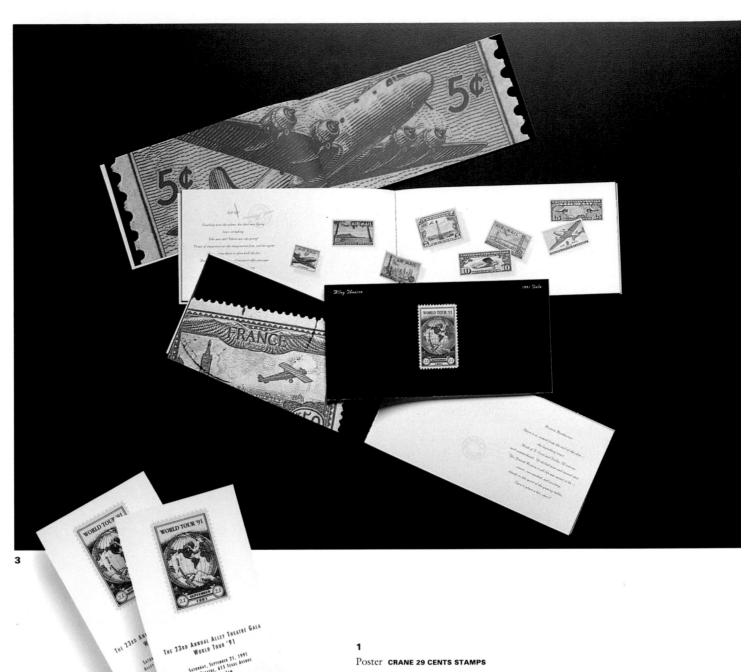

3

1

Poster **CRANE 29 CENTS STAMPS**
Design Director **STEFF GEISSBUHLER**
Designer **BILL ANTON**
Design Firm **CHERMAYEFF & GEISMAR INC., NEW YORK, NY**
Client/Paper Manufacturer **CRANE & CO.**
Typographer **MACINTOSH**
Printer **HENNEGAN**

2

Invitation **KNOLL VENICE BIENNALE**
Designer/Design Director **THOMAS GEISMAR**
Design Firm **CHERMAYEFF & GEISMAR INC., NEW YORK, NY**
Client **THE KNOLL GROUP**
Typography **MACINTOSH**
Printer **CGS**
Paper Manufacturer **MONADNOCK**

3

Invitation **ALLEY THEATRE 1991 GALA — INVITE AND PROGRAM**
Art Director/Designer/Illustrator **LANA RIGSBY**
Illustrator **DEBORAH BROCHSTEIN**
Design Firm **RIGSBY DESIGN, HOUSTON, TX**
Client **ALLEY THEATRE, HOUSTON, TX**
Typographer **CHARACTERS**
Printer **INTERNATIONAL PRINTING**
Paper Manufacturer **MEAD**

1

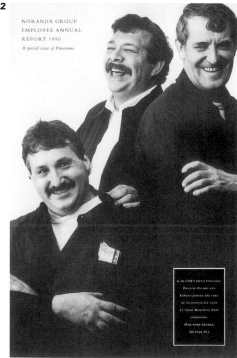

2

1

Annual Report **PUBLIX SUPER MARKETS 1990**

Art Director/Designer **GLENN PELTZ**

Photographer **GORDON MYHRE**

Client **PUBLIX SUPER MARKETS**

Typographer **KAYE FASZHOLZ**

Printer **BRADLEY PRINTING COMPANY**

Paper Manufacturers **QUINTESSENCE REMARQUE COVER/TEXT, TUSCAN TIERRA**

2

Annual Report **NORANDA 1990**

Art Director/Designer **DITI KATONA**

Art Director **JOHN PYLYPCZAK**

Illustrator **CHRIS NICHOLLS**

Design Firm **CONCRETE DESIGN COMMUNICATIONS INC., TORONTO, CAN**

Client **NORANDA INC.**

Typographer **CONCRETE (MACINTOSH)**

Printer **BAKER GURNEY & MCLAREN**

Paper Manufacturer **PHOENIX OPAQUE**

3

Brochure **COASTAL WORLD FALL 1991**

Art Director/Designer/Illustrator **MARK GEER**

Designers/Illustrators **MORGAN BOMAR, MIKE FISHER**

Design Firm **GEER DESIGN, INC., HOUSTON, TX**

Client **THE COASTAL CORPORATION**

Typographer **GEER DESIGN, INC.**

Printer **INTERNATIONAL PRINTING & PUBLISHING**

Paper Manufacturer **WESTVACO**

4

Annual Report **TIMES MIRROR 1990**

Art Director **JIM BERTE**

Photographer **STUART WATSON**

Design Firm **MORAVA OLIVER BERTE, SANTA MONICA, CA**

Client **TIMES MIRROR COMPANY**

Typographer **CENTRAL TYPESETTING CO.**

Printer **GEORGE RICE & SONS**

Paper Manufacturers **CONSOLIDATED, GILBERT & SIMPSON**

3

4

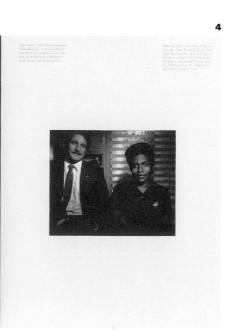

1

Brochure **THE VERY INFORMATIVE GUIDE TO SELLING APPLE, VERSION 2.0**
Art Director **MARK DRURY**
Designers **MARK DRURY, MATT HENDERSHOT**
Photographer **JOHN GREENLEIGH**
Writer **KEITH YAMASHITA**
Design Firm **APPLE CREATIVE SERVICES, CUPERTINO, CA**
Client **APPLE COMPUTER, INC.**
Typography **APPLE COMPUTER**
Printer **PHOENIX PRESS**

2

Booklet **"EIGHT COLORFUL REASONS TO VISIT PORTLAND"**
Art Director **KIT HINRICHS**
Design **BELLE HOW**
Photoghapher **BOB ESPARZA**
Illustrators **BARBARA BENTHIAN, WILL NELSON**
Design Firm **PENTAGRAM DESIGN, SAN FRANCISCO, CA**
Client/Printer **GRAPHIC ARTS CENTER — PORTLAND**
Typographer **SPARTAN**
Paper Manufacturer **NORTHWEST PAPER**

3

Poster **TOUR DE FORCE**
Art Director/Designer/Illustrator **JOHN NORMAN**
Art Director **JEFF WEITHMAN**
Design Firm **NIKE DESIGN**
Typographer **V.I.P. TYPOGRAPHERS**
Printer **HENKES SENEFELDER**

1

CD Packaging **HAMMER: TOO LEGIT TO QUIT**

Art Director **TOMMY STEELE**

Designer/Typographer **STEPHEN WALKER**

Photography **ANNIE LEIBOVITZ**

Design Firm/Client **CAPITOL RECORDS, INC., HOLLYWOOD, CA**

Printer **AGI**

Paper Manufacturer **GILBERT**

2

Annual Report **THE FAIRCHILD CORPORATION 1991**

Design Team **GREGG GLAVANO, JUDY KIRPICH, CLAIRE WOLFMAN**

Photographers **KAY CHERNUSH, BOB CARLOS CLARKE, CAROL CLAYTON,**
PIERRE YVES GOAVEC, KAREN HOLZBERG, SCOTT MORGAN, HANS NELEMAN

Design Firm/Typographer **GRAFIK COMMUNICATIONS LTD.,**
ALEXANDRIA, VA

Client **THE FAIRCHILD CORPORATION**

Printer **PEAKE PRINTERS INC.**

Paper Manufacturer **SIMPSON & ZANDERS**

3

Stationery **AP3C ARCHITECTS IDENTITY PROGRAM**

Art Director/Designer **ANDREA MARKS**

Design Firm **DESIGN: MARKS, PHILADELPHIA, PA**

Client **AP3C ARCHITECTS**

Typographer **THE TYPE CONNECTION**

Printer **MARATHON PRINTING**

Paper Manufcaturer **STRATHMORE**

1

2

AP3C Architects

Cast Iron Building
718 Arch Street
Philadelphia, Pennsylvania 19106

215 | 627.6767
Fax | 627.6447

AP3C

Lawrence A. Goldfarb, AIA
Architecture
Planning

B. Barry Swedloff
Construction Cost Control

AP3C Architects

Cast Iron Building
718 Arch Street
Philadelphia, Pennsylvania 19106

215 | 627.6767
Fax | 627.6447

ΛP3C

B. Barry Swedloff

Direct Dial
215 | 627.6594

AP3C Architects

Cast Iron Building
718 Arch Street
Philadelphia, Pennsylvania 19106

AP3C

1

1
Signage **THE BUCKEYE ROADHOUSE**
Designer/Illustrator **MARK FOX**
Design Firm **BLACKDOG, SAN RAFAEL, CA**
Client **REAL RESTAURANTS**
Typography **BLACKDOG**
Printer **NEON FABRICATIONS**

2
Tabloid Size Menu **LUNA NOTTE MENU**
Art Director/Designer **MIKE HICKS**
Design Firm **HIXO, INC., AUSTIN, TX**
Designer **DUANA GILL**
Illustrator **MARGARET LAYCOCK**
Client **LUNA NOTTE RESTAURANT**
Printer **STERLING KWIK KOPY**
Paper Manufacturer **FRENCH PAPER CO.**

3
Brochure **JAMES H. BARRY TECHNICAL BROCHURE**
Designer **MICHAEL MABRY**
Photographer **MICHAEL LAMOTTE**
Design Firm **MICHAEL MABRY DESIGN, SAN FRANCISCO, CA**
Client **JAMES H. BARRY COMPANY**
Printer **JAMES H. BARRY**
Paper Manufacturer **MISC.**

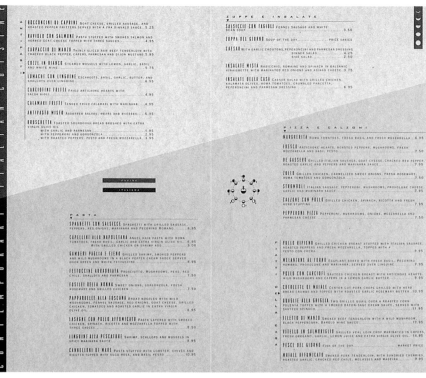

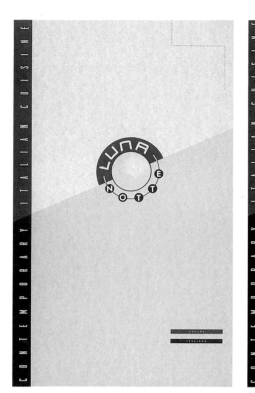

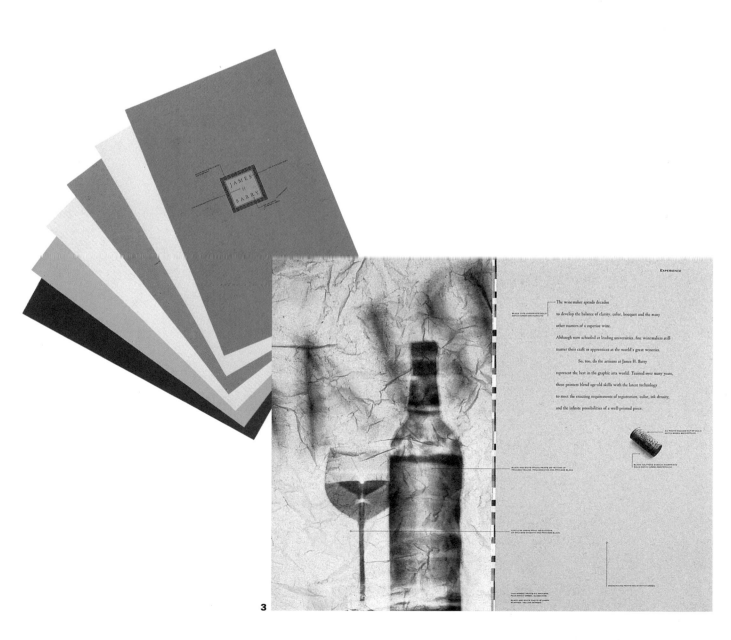

2

3

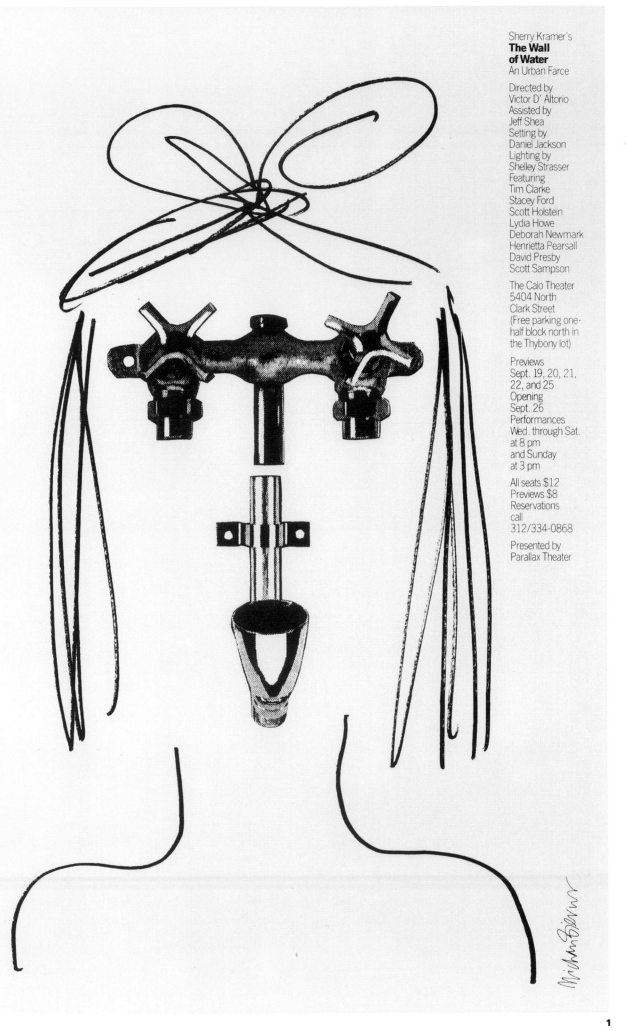

PARALLAX

Sherry Kramer's
**The Wall
of Water**
An Urban Farce

Directed by
Victor D' Altorio
Assisted by
Jeff Shea
Setting by
Daniel Jackson
Lighting by
Shelley Strasser
Featuring
Tim Clarke
Stacey Ford
Scott Holstein
Lydia Howe
Deborah Newmark
Henrietta Pearsall
David Presby
Scott Sampson

The Calo Theater
5404 North
Clark Street
(Free parking one-
half block north in
the Thybony lot)

Previews
Sept. 19, 20, 21,
22, and 25
Opening
Sept. 26
Performances
Wed. through Sat.
at 8 pm
and Sunday
at 3 pm

All seats $12
Previews $8
Reservations
call
312/334-0868

Presented by
Parallax Theater

1

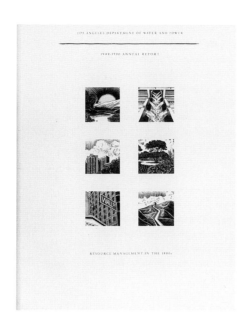

2

1

Poster "THE WALL OF WATER"
Art Director MICHAEL BIERUT
Design Firm PENTAGRAM DESIGN, NEW YORK, NY
Client PARALLAX THEATER COMPANY
Typographer TYPOGRAM
Printer AMBASSADOR ARTS

2

Annual Report LOS ANGELES DEPARTMENT OF WATER AND POWER 1990
Art Director EMMETT MORAVA
Illustrator RODGER XAVIER
Design Firm MORAVA OLIVER BERTE, SANTA MONICA, CA
Publisher LOS ANGELES DEPARTMENT OF WATER AND POWER
Typographer CENTRAL
Printer FRANKLIN PRESS
Paper Manufacturer SIMPSON

3

Poster DON'T LET THE CLEAN AIR ACT...
Art Director JOSH FREEMAN
Designer DAN COOK
Illustrator DAVID SUTER
Design Firm FREEMAN & KARTEN, MARINA DEL REY, CA
Client THE EARTH TECHNOLOGY CORPORATION
Typographer CCI
Printer PLATINUM PRESS
Paper Manufacturer SIMPSON

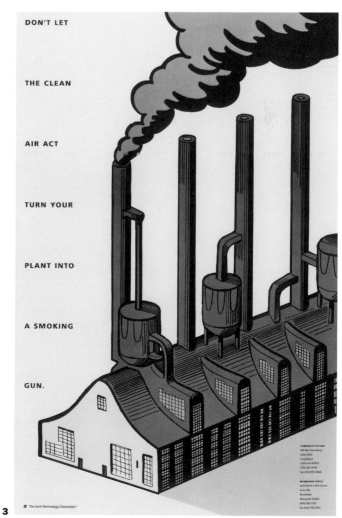

3

1
Calendar **1992**
Art Director/Designer **GEORGE TSCHERNY**
Designers **ELIZABETH LAUB, MICHELLE NOVAK**
Design Firm **GEORGE TSCHERNY, INC., NEW YORK, NY**
Client **SEI CORPORATION**
Typographer **PASTORE DEPAMPHILIS RAMPONE**
Printer **STEPHENSON INC.**
Paper Manufacturer **CHAMPION PAPERS**

2
Card **1991 CORPORATE CHRISTMAS CARD**
Art Director/Illustrator **CHERYL BRUNETT**
Client **HERMAN MILLER, INC., ZEALAND, MI**
Typographer **ELECTRONIC PUBLISHING CENTER**
Printer **ETHERIDGE COMPANY**
Paper Manufacturer **SIMPSON PAPER**

3
Poster **SANTA BARB**
Art Director/Illustrator/Typographer **KEITH PUCCINELLI**
Design Firm/Client **PUCCINELLI DESIGN, SANTA BARBARA, CA**
Printer **ORIGINAL REPRODUCTIONS**
Paper Manufacturer **KARMA**

4
Logo **1992 NEW YEAR PROMO**
Art Director **JEFF LARSON**
Designer **SCOTT DVORAK**
Client **LARSON DESIGN ASSOCIATES, ROCKFORD, IL**
Typographer **PEARSON TYPOGRAPHERS**
Printer **PIP PRINTING**
Paper Manufacturer **SIMPSON**

2

SEASON'S GREETINGS
FROM SANTA BARBARA

1

2

1

Brochure **JOHN VAN DYKE BROCHURE FOR EXHIBIT IN MOSCOW**
Art Director **JOHN VAN DYKE**
Design Firm **VAN DYKE COMPANY, SEATTLE, WA**
Typographer **VAN DYKE COMPANY AND TYPEHOUSE**
Printer **MACDONALD PRINTING**
Paper Manufacturer **SIMPSON**

2

Self Promotion **WE'VE SHORTENED OUR NAME A BIT**
Art Director **JOE RATTAN**
Design Firm/Client/Typographer/Printer **JOSEPH RATTAN DESIGN, DALLAS, TX**
Paper Manufacturer **CHAMPION**

3

Poster **COCA/THE NIGHT GALLERY**
Art Director/Designer **ART CHANTRY**
Client **COCA (CENTER OF CONTEMPORARY ART)**
Printer **VARIOUS**

1

Annual Report **1990 EXPEDITORS INTERNATIONAL**

Art Director/Designer **KERRY LEIMER**

Design Firm **LEIMER/CROSS DESIGN, SEATTLE, WA**

Photographer **TYLER BOLEY**

Illustrator **TOM YAGUCHI**

Client **EXPEDITORS INTERNATIONAL**

Typographer **TYPEHOUSE**

Printer **H. MACDONALD PRINTING**

Paper Manufacturer **POTLATCH**

2

Book **1992 WORLD HOLIDAY AND TIME GUIDE**

Art Director **GERBEN HOOYKAAS**

Designer **TATA DEVEREUX**

Photographer **AMOS CHAN**

Client **J.P. MORGAN & CO.**

Design Firm **J.P. MORGAN CORPORATE IDENTITY & DESIGN, NEW YORK, NY**

Printer **THE VEITCH PRINTING CORPORATION**

3

Corporate Newsletter **DIGITAL NEWS, SERVICES ISSUE**

Art Director **MARK KOUDYS**

Designers **MARK KOUDYS, MICHAEL CHERKAS, JOYCE NESNADNY**

Photographer **RON BAXTER SMITH**

Design Firm **ATLANTA ART & DESIGN, TORONTO, CAN**

Client **DIGITAL EQUIPMENT (CANADA)**

Printer **MATTHEWS, INGHAM AND LAKE**

4

Annual Report **POTLATCH 1990**

Art Director **KIT HINRICHS**

Designer **BELLE HOW**

Photography **TOM TRACY**

Design Firm **PENTAGRAM DESIGN, SAN FRANCISCO, CA**

Client **POTLATCH CORPORATION**

Typographer **QUAD 48**

Printer **ANDERSON LITHOGRAPH**

Paper Manufacturer **NORTHWEST PAPER**

Office of the President ROGER F. OLSON, Senior Vice President, University Relations; CORNELIUS J. PINGS, Provost and Senior Vice President, Academic Affairs; LYN HUTTON, Senior Vice President, Administration; JAMES H. ZUMBERGE, President.

1

1

Brochure **UNIVERSITY OF SOUTHERN CALIFORNIA**
Art Director **DOUGLAS OLIVER**
Photographer **ERIC MYER**
Design Firm **MORAVA OLIVER BERTE, SANTA MONICA, CA**
Client **UNIVERSITY OF SOUTHERN CALIFORNIA**
Typographer **CENTRAL TYPESETTING CO.**
Printer **LITHOGRAPHIX**
Paper Manufacturer **CONSOLIDATED & MONADNOCK**

2

Annual Report **TRIMBLE NAVIGATION**

Art Director/Designer **CRAIG FRAZIER**

Designer **DEBORAH HAGEMANN**

Design Firm **FRAZIER DESIGN, SAN FRANCISCO, CA**

Client **TRIMBLE NAVIGATION**

Typographer **DISPLAY LETTERING & COPY**

Printer **J.H. BARRY**

Paper Manufacturer **CONSOLIDATED/REFLECTION**

3

Advertisement **FIRST CORPORATE TWIN**

Art Director **HERMAN DYAL**

Photographer **BILL CRUMP**

Design Firm **FULLER DYAL & STAMPER, AUSTIN, TX**

Client **TBM NORTH AMERICA, INC.**

4

Advertisement **$4,560.81 A KNOT**

Art Director **HERMAN DYAL**

Photographer **BILL CRUMP**

Design Firm **FULLER DYAL & STAMPER, AUSTIN, TX**

Client **TBM NORTH AMERICA INC**

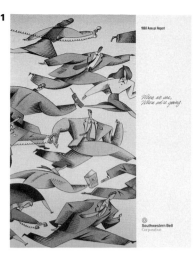

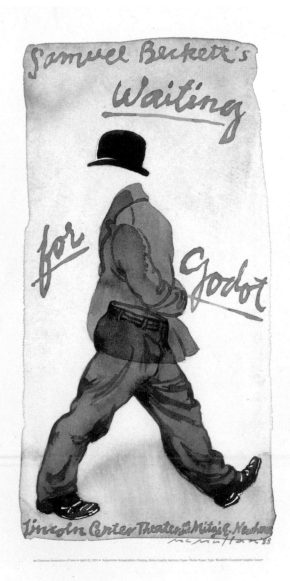

1

Annual Report **SOUTHWESTERN BELL CORPORATION 1990**
Art Director **DOUG WOLFE**
Designer **DAVE HOLT**
Illustrator **TIM LEWIS**
Design Firm/Typographer **HAWTHORNE/WOLFE INC., ST. LOUIS, MO**
Client **SOUTHWESTERN BELL CORP.**
Printer **GULF PRINTING**
Paper Manufacturer **CONSOLIDATED MOHAWK**

2

Poster **WAITING FOR GODOT**
Art Director/Designer **JAMES McMULLAN**
Design Firm/Agency **ART DIRECTORS ASSOCIATION OF IOWA**
Typographer **WADELL'S COMPUTER GRAPHIC CENTER**
Printer **HOLM GRAPHIC SERVICES**
Paper Manufacturer **BUTLER PAPER**

3

Newsletter **AT A CROSSROADS**
Art Director **NANCY KOC**
Illustrator **JIM ENDICOTT**
Design Firm **KOC DESIGN, SAN FRANCISCO, CA**
Client **METROPOLITAN TRANSPORTATION COMMISSION**
Typographer **DESIGN ANGLES**
Printer **DESIGN ANGLES**

4

Packaging **RICHARD THOMPSON: RUMOR & SIGH**
Art Director/Designer **JEFFERY FEY**
Art Director **TOMMY STEELE**
Illustrator **LAURA LEVINE**
Design Firm/Client **CAPITOL RECORDS, INC., HOLLYWOOD, CA**
Typographer **IN-HOUSE**

War on Smog Tops Agenda

When it comes to the environment, personal choices increasingly affect the collective public well-being. This is particularly true of driving habits. Whether going to and from work, taking a trip to the shopping mall or running Saturday errands, the motorist leaves an invisible trail of hydrocarbons – tiny molecules that combine with other pollutants and aggregate to create a sometimes visible haze of smog over the Bay Area. Under a plan now taking shape to further clear Bay Area skies, MTC hopes to shift consumer behavior by making alternatives to solo driving more readily available and attractive.

High-Stakes Game in Washington

How do you convince several hundred metropolitan planning organizations, 50 state highway and transportation departments, dozens of national advocacy groups, 535 members of Congress and countless Washington officials to agree on a common transportation vision for the nation? And how do you shape that vision to take into account everything from rural towns to megalopolises with millions of commuters and thousands of miles of roads and transit routes?

Planners are now presented with the challenge of maintaining progress in cleaning the region's air in the face of continued strong growth in population and travel.

Charting a Course for the Next Century

MTC's powers — and indeed, those of all the cities, counties and special purpose agencies in the Bay Area combined — are being outmuscled by the complex forces of the 1990s: unrelenting population growth coupled with a suburban job boom; a shortage of affordable housing close to job centers; development that outpaces transportation facilities; and suburban sprawl that defies public transit service and threatens precious open space.

1990 Highlights

The Bay Vision 2020 recommendations set the stage for a lively debate in the coming year – both within the Bay Area and in Sacramento – on strengthening regional government.

3

MTC
Metropolitan Transportation Commission 1990 Annual Report

At a Crossroads

Message From the Executive Director

February 1991 marks the 20th anniversary of the Metropolitan Transportation Commission — an occasion that invites reflection on the events that led to the creation of a regional transportation planning agency for the nine-county San Francisco Bay Area, and the parallels between then and now.

4

RICHARD THOMPSON

I Feel So Good I'm Going To Break Somebody's Heart Tonight

1

1

Poster **WILLIAMSON PRINTING COMPANY**
Art Directors **SHARON WERNER, TODD WATERBURY**
Designers **TODD WATERBURY, SHARON WERNER**
Photographer **GEOF KERN**
Design Firm **THE DUFFY DESIGN GROUP, MINNEAPOLIS, MN**
Client **WILLIAMSON PRINTING COMPANY**
Typographers **DAHL & CURRY, GREAT FACES**
Printer **WILLIAMSON PRINTING COMPANY**

2

Environmental Graphics/Exhibition **ELLIS ISLAND/
THE PEOPLING OF AMERICA**
Art Director/Designer **THOMAS GEISMAR**
Designers **THOMAS GEISMAR, CHRIS ROVER**
Photographer **PABLO DELANO**
Design Firm **CHERMAYEFF & GEISMAR INC., NEW YORK, NY**
Client **NATIONAL PARK SERVICE**
Paper Manufacturer **DESIGN & PRODUCTION INC.**

2

1

1

Brochure **GILBERT PAPER PROMOTIONAL**
Art Director **JIM BERTE**
Designer **DEANNA KUHLMANN**
Photographer **EVERARD WILLIAMS, JR.**
Illustrator **JOEL NAKAMURA**
Design Firm **MORAVA OLIVER BERTE, SANTA MONICA, CA**
Publisher/Paper Manufacturer **GILBERT PAPER**
Typographer **DEANNA KUHLMANN & CENTRAL TYPESETTING**
Printer **PLATINUM PRESS**

2

Brochure **AAA**
Art Directors **REBECA S. DEL FABBRO, JORGE DEL FABBRO**
Designer **REBECA S. DEL FABBRO**
Illustrator **ANDREJ DUDZINSKI**
Design Firm **DESIGNWISE, INC., WILMINGTON, DE**
Client **ADVANCED AUTOMATION ASSOCIATES, INC.**
Typography **DESIGNWISE, INC.**
Printer **POMCO GRAPHICS**
Paper Manufacturer **DONSIDE PAPER COMPANY**

3

Letterhead **ROBERT VALENTINE, INC.**
Art Director **ROBERT VALENTINE**
Photographer **MARIA ROBLEDO**
Design Firm **ROBERT VALENTINE INC., NEW YORK, NY**
Typographer **BORO TYPOGRAPHERS, INC.**
Printer **DIVERSIFIED GRAPHICS INC.**
Paper Manufacturer **GILBERT PAPER**

2

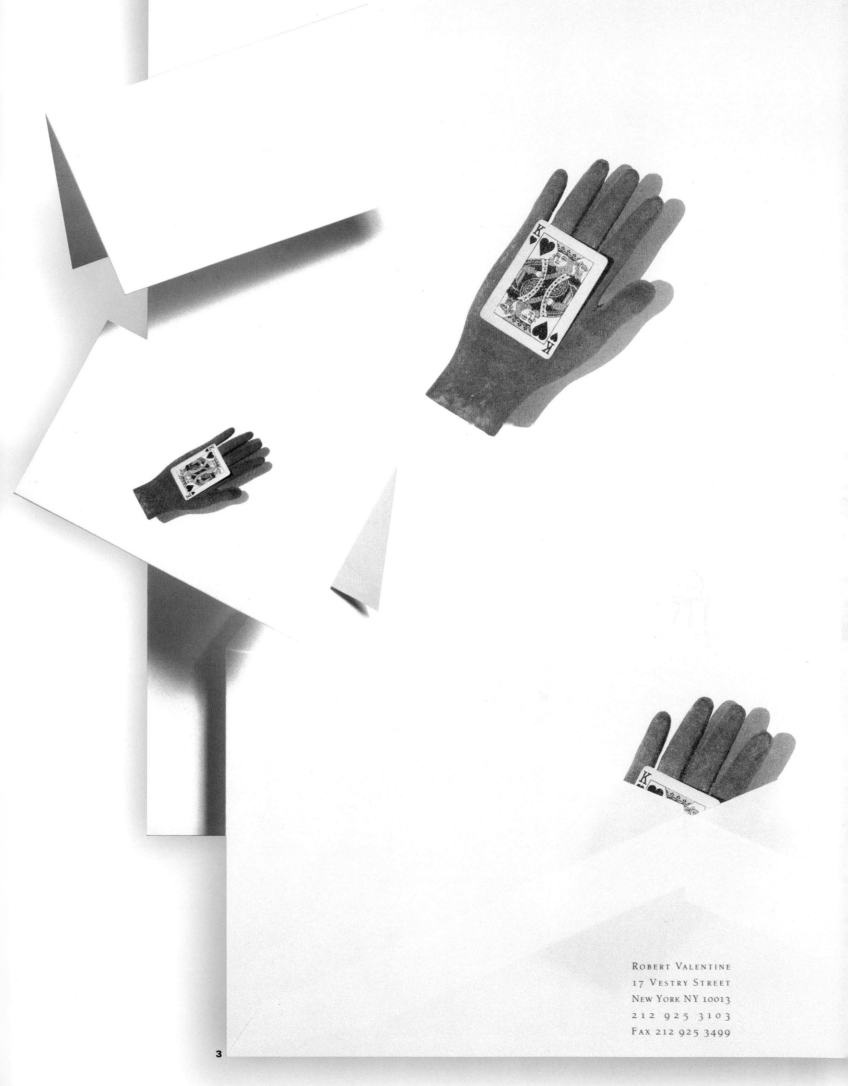

ROBERT VALENTINE
17 VESTRY STREET
NEW YORK NY 10013
212 925 3103
FAX 212 925 3499

3

1

Brochure **COMMON THREADS**
Creative Directors **STEVE DITKO, GREG FISHER, MIKE CAMPBELL**
Photographer **RICK RUSING**
Design Firm **CAMPBELL FISHER DITKO DESIGN, INC., PHOENIX, AZ**
Client **UH OH CLOTHING BOUTIQUE**
Typographer **STACY FRANCE**
Printer **HERITAGE GRAPHICS**

2

Tabloid Booklet **GUESS? LAS VEGAS CATALOG**
Art Director **PAUL MARCIANO**
Designer **SAMANTHA GIBSON**
Illustrator **ELLEN VON UNWERTH**
Design Firm/Client **GUESS?, INC., LOS ANGELES, CA**
Printer **OVERLAND PRINTERS, INC.**

2

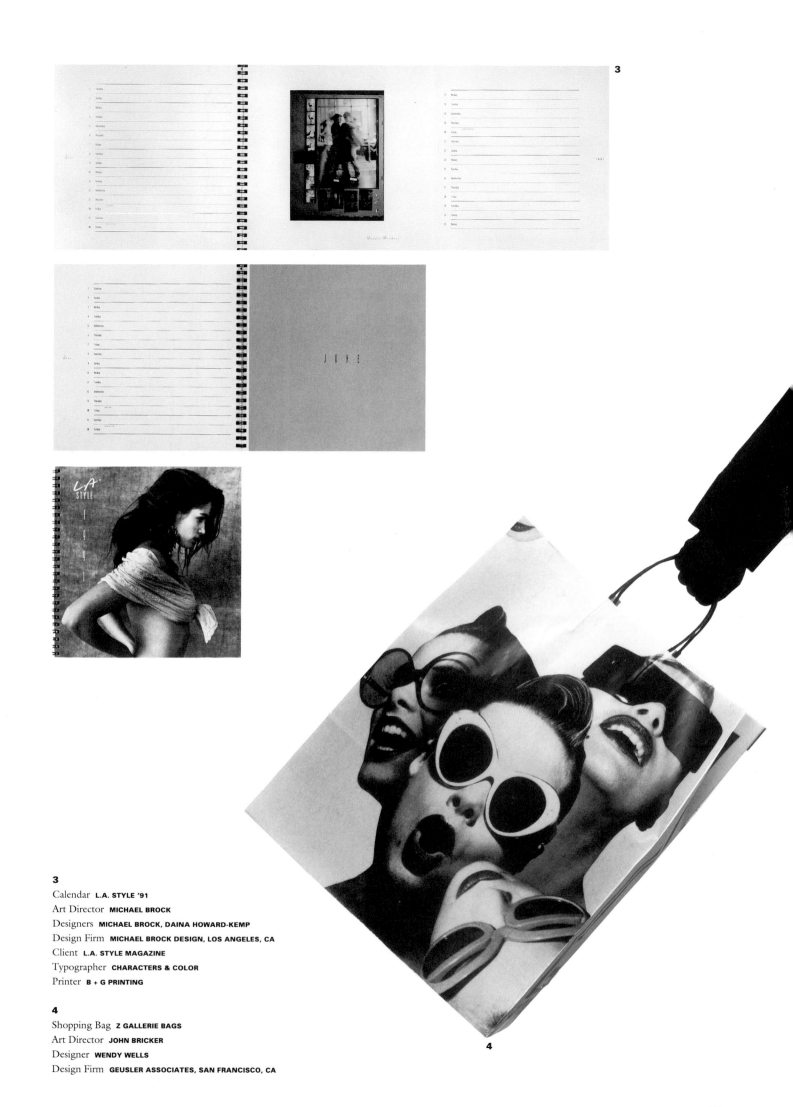

3
Calendar **L.A. STYLE '91**
Art Director **MICHAEL BROCK**
Designers **MICHAEL BROCK, DAINA HOWARD-KEMP**
Design Firm **MICHAEL BROCK DESIGN, LOS ANGELES, CA**
Client **L.A. STYLE MAGAZINE**
Typographer **CHARACTERS & COLOR**
Printer **B + G PRINTING**

4
Shopping Bag **Z GALLERIE BAGS**
Art Director **JOHN BRICKER**
Designer **WENDY WELLS**
Design Firm **GEUSLER ASSOCIATES, SAN FRANCISCO, CA**

Sam has blue dots. Katy's are green. Richard has red. Diane, orange. Mine are brown. If you like the book (the design of it), put a dot on it. Have a cup of coffee. Have a roll. Have two. OK everyone, let's figure this out: I can't vote on anything from Knopf (where I work), but I can vote on Random House (they own Knopf); Sam can't vote on anything from Abrams; Diane can vote on MIT Press books because she doesn't work there anymore. Katy can't vote on anything she's entered at all; Richard can vote on whatever he wants. Ready? Go. What? The question has been raised: What if the design is great and the production is lousy? Well, judge for yourselves. Go. . . . New approaches, new formats, new ideas. Exciting. Hmm. Lots of elephant hide paper. Lots of decals. Lots of computer-stretched type. Lots of doo-dads. A little vellum, a little marbled paper, a little illustration, a little writing, a little gift booklette. But wait . . . look at this, the economy of means on this catalogue. The attention to detail on this binding. The painstaking care of this layout. And that contents page. And this photograph, see? It's there, you just have to look for it.

Chip Kidd, Chairman
The Book Show

Call-for-Entries
Designers and Illustrators: Chip Kidd, Barbara DeWilde
Typesetter: Expertype
Printer: Coral Graphics, Inc.
Special thanks to Carol Devine Carson, Gordon Lish, Sonny Mehta.
Quotations from "Mourners at the Door"; reproduced with the permission of Gordon Lish

J U R Y

Chip Kidd Designer
Alfred A. Knopf Publishers

Diane Jaroch Book Designer

Samuel N. Antupit Director of Art and Design
Harry N. Abrams, Inc.

Richard Ekersley Designer
University of Nebraska Press

Katy Homans Book Designer

1

Title **GRAPHIC DESIGN PROCESSES**
Author **KENNETH J. HIEBERT**
Art Director/Designer **KENNETH J. HIEBERT**
Publisher **VAN NOSTRAND REINHOLD, NEW YORK, NY**
Typographer **KENNETH J. HIEBERT**
Printer/Binder **ARCATA GRAPHICS/HALLIDAY**
Production Manager **LEEAN GRAHAM**
Paper Manufacturer **S.D. WARREN**
Paper **70# PATINA MATTE**
Trim Size **8 1/8" x 11"**
Typefaces **ADOBE UNIVERS, GARAMOND 3**
Jacket Designer **KENNETH J. HIEBERT**
Color Separations/Printing **NEW ENGLAND BOOK COMPONENTS**

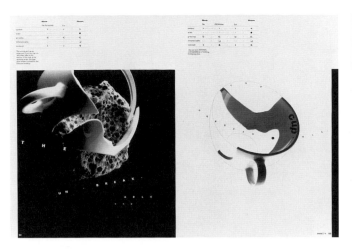

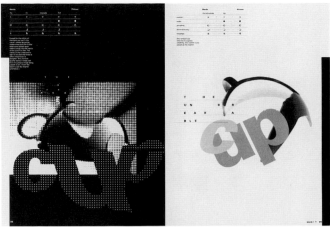

Outside of designers, nobody gives a damn what happens to design or designers. George Nelson

2

Title **DESIGNER'S ONE-LINERS**
Authors **VARIOUS**
Art Director/Designer **MICHAEL SKJEI**
Publisher **SHAY, SHEA, HSIEH & SKJEI PUBLISHING COMPANY, MINNEAPOLIS, MN**
Typographers **PENTAGRAM PRESS, MAY TYPOGRAPHY**
Printer **PENTAGRAM PRESS**
Paper Manufacturer **MOHAWK PAPER MILLS**
Paper **MOHAWK SUPERFINE**
Trim Size **5 3/4" x 8 1/2"**
Typeface **MONOTYPE GILL SANS**
Binder **SHAY, SHEA, HSIEH & SKJEI**

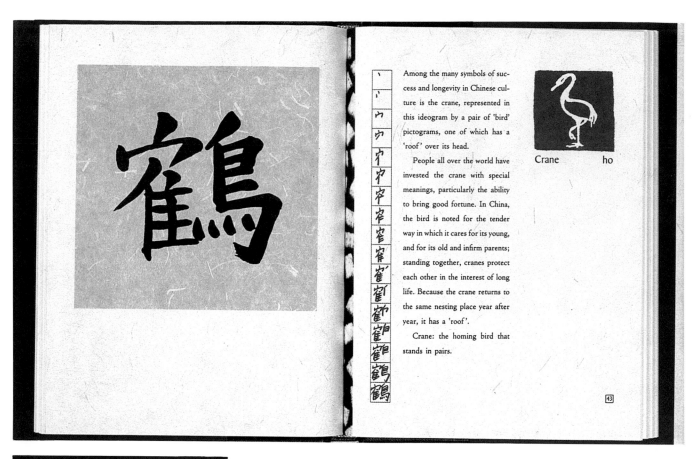

Among the many symbols of success and longevity in Chinese culture is the crane, represented in this ideogram by a pair of 'bird' pictograms, one of which has a 'roof' over its head.

People all over the world have invested the crane with special meanings, particularly the ability to bring good fortune. In China, the bird is noted for the tender way in which it cares for its young, and for its old and infirm parents; standing together, cranes protect each other in the interest of long life. Because the crane returns to the same nesting place year after year, it has a 'roof'.

Crane: the homing bird that stands in pairs.

Crane ho

43

THE NATURE
OF THE
CHINESE
CHARACTER

Text by Barbara Aria
Calligraphy by Russell Eng Gon
Illustrations by Lesley Ehlers

1

MOON
CROSSING
BRIDGE

poetry by
TESS GALLAGHER

NORTHWEST BY NORTHWEST PICKING BONES

2

1

Title **THE NATURE OF THE CHINESE CHARACTER**
Author **BARBARA ARIA**
Designer/Illustrator **LESLEY EHLERS**
Letterer **RUSSELL ENG GON**
Publisher **SIMON & SCHUSTER, NEW YORK, NY**
Typographer **CRANE TYPESETTING SERVICE**
Printer/Binder **TIMES OFFSET PTY., LTD., SINGAPORE**
Production Manager **LINDA WINTERS**
Paper **160 GSM WOODFREE**
Trim Size **5 1/2" x 7 1/4"**
Typefaces **BERNHARD MODERN ROMAN, CLOISTER BAKER SIGNET**
Jacket Design **LESLEY EHLERS**
Jacket Letterer **RUSSELL ENG GON**

2

Title **MOON CROSSING BRIDGE**
Author **TESS GALLAGHER**
Art Director/Designer/Illustrator **TREE SWENSON**
Publisher **GRAYWOLF PRESS, ST. PAUL, MN**
Typographer **THE TYPEWORKS**
Printer/Binder **EDWARDS BROTHERS, INC.**
Production Manager **ELLEN FOOS**
Paper Manufacturer **GLATFELTER**
Paper **55# GLATFELTER B-16**
Trim Size **5 3/4" x 9"**
Typefaces **MONTICELLO, BERNHARD MOD. BOLD**
Jacket Designer/Illustrator **TREE SWENSON**
Jacket Photographer **MARION ETTLINGER**

3

Title **DE AMOR OSEURO/OF DARK LOVE**
Author **FRANCISCO X. ALARCÓN**
Designer **FELICIA RICE**
Illustrator **RAY RICE**
Publisher **MOVING PARTS PRESS**
Printers **FELICIA RICE, SCOTT FIELDS**
Paper Manufacturer **ZERKEL, GERMANY**
Paper **FRANKFURT CREAM**
Trim Size **7 7/8" x 14 1/2"**
Typeface **JANSON**
Binder **BOOKLAB, INC.**

3

1
Title **VIOLATED PERFECTION: ARCHITECTURE
AND THE FRAGMENTATION OF THE MODERN**
Author **AARON BETSKY**
Art Director **LORRAINE WILD**
Designers **BARBARA GLAUBER, SUSAN PARR, LORRAINE WILD**
Photographers **VARIOUS**
Publisher **RIZZOLI INTERNATIONAL PUBLICATIONS, INC., NEW YORK, NY**
Printer **DAI NIPPON**
Production Manager **CHARLES DAVEY (RIZZOLI)**
Trim Size **8 1/2" x 11"**
Typefaces **BARRY SANS, BODONI BOLD, NEWS GOTHIC**
Jacket Designer **LORRAINE WILD**

2
Title **BARTON MYERS ASSOCIATES**
Authors **BARTON MYERS, JOHN DALE, TERRI HARTMAN**
Art Director **APRIL GREIMAN**
Designers **APRIL GREIMAN, SEAN ADAMS**
Photographers **VARIOUS**
Publisher **BARTON MYERS ASSOCIATES, LOS ANGELES, CA**
Typographer **INTEREST**
Printer **MONARCH LITHO**
Production Manager **ELIZABETH BAIN**
Trim Size **8 1/2" X 11"**
Typefaces **ADOBE GARAMOND, UNIVERS**

3
Title **ARCHITECTURE IN THE SCANDINAVIAN COUNTRIES**
Author **MARIAN C. DONNELLY**
Art Director **YASUYO IGUCHI**
Designer **JEAN WILCOX**
Photographers **VARIOUS**
Publisher **THE M.I.T. PRESS, CAMBRIDGE, MA**
Typographer **DEKR CORP.**
Printer/Binder **ARCATA GRAPHICS/HALLIDAY**
Production Manager **TERRY LAMOUREUX**
Paper Manufacturer **WARREN**
Paper **PATINA**
Trim Size **7" x 10"**
Typefaces **JANSON, GILL SANS**
Jacket Designer **JEAN WILCOX**
Jacket Photographers **VARIOUS**

A dramatically lit atrium opens up the ground level to the lower level. The commissioned mural is by Sol Lewitt.

2

This 80,000 square foot renovation created a new home for Hasbro's Manhattan showrooms and executive offices in the shell of a cast-iron department store. The historic building (Stern Brothers, 1896) is located in the Toy District along 23rd Street.

The ground and lower levels have been opened to create a skylit central court. Showrooms (25,000 square feet) surround the court and are overlooked by the executive offices housed in a new mezzanine (11,000 square feet) installed on the perimeter of three sides of the double-height space of the ground floor. The glitter of the showrooms provides an interesting, ever-changing backdrop for office functions. A steel bridge connects the north and south mezzanines offering unique views of the decorative cast-iron columns and showrooms below.

The project comprises Toy Fair showrooms for Hasbro, Playskool and Milton Bradley, a corporate dining facility for 300 people, meeting and conference rooms and 50 corporate offices used year-round by the New York-based executive and sales force.

The planning and development of the showrooms was done in collaboration with Sussman / Prejza, who were responsible for color selection, the design of two of the showrooms and the entrance pavilions. Sussman / Prejza also participated with Barton Myers Associates in the selection of materials and furnishings. Art consultant Nancy Rosen worked with the client to develop the art program.

Architecture in the Scandinavian Countries

Marian C. Donnelly

Barton Myers Associates

3

1

Title **FROM THE EDGE: SOUTHERN CALIFORNIA INSTITUTE OF ARCHITECTURE STUDENT WORKBOOK**

Author **MICHAEL ROTONDI**

Art Director **APRIL GREIMAN**

Designers **APRIL GREIMAN, SEAN ADAMS**

Designer **SEAN ADAMS**

Editor **MARGARET REEVE**

Photographers **VARIOUS**

Publisher **SOUTHERN CALIFORNIA INSTITUTE OF ARCHITECTURE, LOS ANGELES, CA**

Typographer **ICON WEST**

Printer **MONARCH LITHO**

Paper Manufacturer **VARIOUS**

Papers **GILBERT ESSE, MONARCH MATTE**

Trim Size **7 1/2" x 11"**

Typeface **SETTE MITTELSCHRIFT**

2

Title **FOURTEENTH ANNUAL 100 SHOW (AMERICAN CENTER FOR DESIGN)**

Designers **KATHERINE McCOY, TIMOTHY O'KEEFE, MARK SYLVESTER**

Photographers **NANCY THRILL, FRANCOIS ROBERT**

Publisher **AMERICAN CENTER FOR DESIGN, CHICAGO, IL**

Printer **TOTAL REPRODUCTIONS**

Paper Manufacturer **POTLATCH CORP.**

Paper **QUINTESSENCE REMARQUE VELVET**

Trim Size **8 1/2" x 11"**

Typefaces **BLACK OAK, CASLON 3, CASLON 540, GLYPHA, VAG ROUNDED, ZAPF DINGBATS, EGYPTIAN 710 — METAL WORK**

Binder **BOOKLET BINDING, INC.**

Jacket Designer **MARK SYLVESTER**

1

2

3

Title **DISLOCATIONS**

Author **ROBERT STORR**

Design Firm **DRENTTEL DOYLE PARTNERS**

Creative Director **STEPHEN DOYLE**

Designer **ANDREW GRAY**

Project Manager **WILLIAM DRENTTEL**

Publisher **THE MUSEUM OF MODERN ART, NEW YORK, NY**

Art Director **MICHAEL HENTGES**

Project Manager/Editor **ALEXANDRA BONFANTE-WARREN**

Production Manager **MARC SAPIR**

Photographers **DAWOUD BEY, SCOTT FRANCES, PETER MOORE**

Printer **FLEETWOOD LITHO + LETTER CORP.**

Binder **INTERGRAPHIC BINDING AND FINISHING CO.**

Paper Manufacturer **WARREN**

Paper **100# LUSTRO DULL**

Trim Size **9" x 12"**

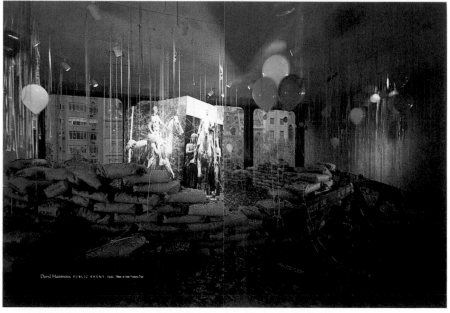

3

Untitled, 1965–66
Latex on burlap, 20 x 65 x 40 inches (variable)
Whitney Museum of American Art, New York;
Gift of Mr. and Mrs. Peter M. Brant 76.43

Untitled, 1965–66
Cast fiberglass, 54 x 94 x 12 inches
Whitney Museum of American Art, New York;
Gift of Mr. and Mrs. Eugene M. Schwartz 70.1597

86

87

Immaterial **Objects**

1

1

Title **IMMATERIAL OBJECTS**
Author **RICHARD MARSHALL**
Designer/Art Director **BARBARA BALCH**
Publisher **WHITNEY MUSEUM OF AMERICAN ART, NEW YORK, NY**
Typographers **MACINTOSH/BARBARA BALCH, DONNA DAVID**
Printer/Binder **EASTERN PRESS**
Production Manager **DORIS PALCA**
Paper Manufacturer **HOPPER, MONADNOCK**
Paper **PROTERRA 80# COVER, SUNSET PINK, ASTROLITE TEXT 80# SMOOTH**
Trim Size **8" x 10"**
Typefaces **UNIVERS CONDENSED LIGHT, BOLD, ITAL**
Jacket Designer **BARBARA BALCH**

2

Title **DE LIGHT: HELEN CHADWICK**
Authors **THOMAS MCEVILLEY, RICHARD HOWARD, HELEN CHADWICK**
Art Director **MARC ZAREF, MARC ZAREF DESIGN, NEW YORK, NY**
Photographer **HELEN CHADWICK**
Publisher **INSTITUTE OF CONTEMPORARY ART,**
UNIVERSITY OF PENNSYLVANIA, PHILADELPHIA, PA
Typographer **MARC ZAREF**
Printer/Binder **MERIDIAN PRINTING**
Paper Manufacturers **HAMMERMILL, S.D. WARREN**
Papers **80# ANTIQUE COVER, 100# LUSTRO DULL**
Trim Size **8 3/8" x 10 1/2"**
Typefaces **KUENSTLER SCRIPT, BEMBO**
Jacket Designers **ALICE KANG, MARC ZAREF**

3

Title **DEAD CERTAINTIES**
Author **SIMON SCHAMA**
Art Director **VIRGINIA TAN**
Designer **IRIS WEINSTEIN**
Publisher **ALFRED A. KNOPF, INC., NEW YORK, NY**
Typographer **IRIS WEINSTEIN**
Printer/Binder **FAIRFIELD GRAPHICS**
Production Manager **TRACY CABANIS**
Paper Manufacturer **S.D. WARREN**
Paper **SABEGO**
Trim Size **4 1/4" x 7 3/8"**
Typeface **CALEDONIA**
Jacket Designer **KANDY LITTRELL**
Jacket Illustrator **PIETER CLAESZ**

2

3

DEAD CERTAINTIES

And what, in the meantime, had happened to the two doctors?

The mortal remains of Dr. George Parkman had been given the funeral rites on December 6. A long train of carriages had followed the hearse on which lay a coffin, lead-lined within, silver-plated without. Reporters had scrambled along the procession not scrupling as to whom they asked, or for that matter who answered, their questions. Many were shut out from Trinity Church on Summer Street, its rusticated masonry and crenellated tower protecting the coffin from vulgar intruders, and then its crypt offering the coffin a resting place.

The mortal part of Dr. John Webster had rallied from the prostration of arrest, accusation and detention. Turnkey Cummings and Jailor Leighton were quite surprised, given their fresh memory of the choking sobs of the night of November 30, that nothing much other than an occasional buzz-like snore came from their most distinguished prisoner's cell. Though he had to withstand the inevitable chaffing from the many rogues who were in the Leverett Street lock-up pending trial, he often seemed in better spirits than they.

By the Monday following his ordeal, the Professor was already making arrangements for his own housekeeping and for sustaining his role as a

Taking Stock: *The Prisoner and the Public*

Boston benefactor by nourishing his fellow inmates (however disrespectful) with his unwanted victuals.

In the evening he wrote to his daughter:

My Dearest Marianne,

I wrote mamma yesterday and Mr. C[unningham] who was here this morning told me he had sent it out. I had a good sleep last night and dreamt of you all. I got my clothes off for the first time and awoke in the morning quite hungry. It was a long time before my breakfast from Parkers came; and it relished I can assure you. At one o'clock I was notified I must appear at the Court Room. All was arranged with great regard to my comfort and avoidance of publicity and this first ceremony went off better than I had anticipated. On my return I had a bit of turkey and rice from Parkers. They send much more than I can eat and I have directed the steward to distribute the surplus to any poor ones here.

If you will send me a small cannister of tea, I can make my own. A little pepper, I may want some day; you can put it up with some bundle. I would send the dirty clothes but they were taken to dry and have not been returned. Half a dozen Rochford powders I should like. Tell mamma *not to open* the little bundle I gave her the other day but to keep it just as she received it. Hope you will soon be cheered by receipt of letters from Fayal. With many kisses to you all.

Good night from
Your afft. father

· 178 ·

· 179 ·

1

Title **BODY CRITICISM**
Author **BARBARA MARIA STAFFORD**
Art Director **YASUYO IGUCHI**
Designer **MIRIAM AHMED**
Illustrators/Photographers **VARIOUS**
Publisher **THE M.I.T. PRESS, CAMBRIDGE, MA**
Typographer **DEKR CORP.**
Printer/Binder **ARCATA GRAPHICS/HALLIDAY**
Production Manager **CONSOLIDATED**
Paper **703 FROSTBRIGHT MATTE**
Trim Size **7 3/4" x 10 3/4"**
Typefaces **JANSON, UNIVERS 67 CONDENSED BOLD**
Jacket Designer/Computer Illustration **MIRIAM AHMED**

2

Title **AN INDUSTRIOUS ART: INNOVATION IN PATTERN
AND PRINT AT THE FABRIC WORKSHOP**
Editor **MARION BOULTON STROUD**
Designers **KATY HOMANS, PHILIP UNETIC**
Photographer **WILL BROWN**
Publisher **W.W. NORTON & COMPANY, NEW YORK, NY**
Typographers **DUKE & COMPANY, TRUFONT**
Printer/Binder **NISSHA PRINTING CO., LTD.**
Production Manager **KATY HOMANS**
Paper **SATIN KINFUJI**
Trim Size **6 1/2" x 11"**
Typefaces **UNIVERS, SABON**
Jacket Designer **KATY HOMANS**
Jacket Cover Cloth **KIM MACCONNELL**

1

2

Fort Point
Sentry at the Golden Gate

As a post, Fort Point was damp, cold, and isolated. The fort was on a tip of land of great strategic value but it was frequently enveloped in fog and swept by strong winds. Spray from crashing Pacific waves often blew over the parapet walls of the barbette tier, making life miserable for the sentries on duty. The interior courtyard of the fort was arranged like a well, and for much of the day the parade ground and living quarters were cloaked in deep shadows. The thick walls of the fort, designed to keep out enemy artillery fire, created dank living quarters. The only heat came from tiny fireplaces in each of the gorge rooms, and it took hours for a smoky coal fire to heat up the interior of a gloomy casemate.

Garrison life was considerably better for the officers assigned to the fort than for the enlisted soldiers. The second tier of the gorge was "officers' country," where unmarried officers were assigned individual bedrooms. Each pair of bedrooms shared a common parlor, and personal furnishings for these rooms were popular; a well-turned-out parlor might feature curtains, carpets, a hooked rug, paintings on the walls and damask-covered chairs. A few lucky officers were allowed to bring their wives to the post, and before the end of the Civil War a handful of woodframe residences were built south of the fort for these married officers. Officers were also part of San

Francisco's privileged class of society, and invitations to dress balls, parties and other events offered pleasant breaks from the monotony of duty in a seacoast fortress.

Enlisted men enjoyed few luxuries at Fort Point. Living in the third-tier gorge casemates, the privates and non-commissioned soldiers lacked almost all of the comforts enjoyed by the officers downstairs. The enlisted men slept in two-man bunks, twelve bunks to a casemate, twenty-four men to a room filled with the mingled aromas of sour straw, stale tobacco and unwashed, wet woolen uniforms. A soldier had few possessions, restricted to what could be stuffed in a pack stowed at the foot of the bunk or hung on a wooden wall peg. Mattresses were sacks filled with straw ticking, the latrine was at the end of the tier and personal hygiene was basic. (Army regulations stipulated mandatory bathing once a week and washing of the feet twice a week.)

Defense Against the Sea: The Seawall

Almost as soon as the soldiers moved into the new fort they found it was literally being eaten away by natural forces. When the bluff of Cantil Blanco was demolished to make way for the new fort, its rocky remains were spread along the shore to protect the new fortification's foundations. By early 1862, though, much of this rubble had eroded and waves were threatening to undermine the concrete and granite footings. Engineers began to focus their attentions on construction of a seawall to protect the fort.

Over the next eight years, work progressed on a 1,500-foot granite seawall enclosing the tip of Fort Point that would have to withstand the full force of the Pacific Ocean. Thousands of tons of granite blocks were imported from Folsom, California, and laid together in interlocking keyed courses backed with concrete and packed rubble. The spaces between the stones were filled with cement, then covered with tar-impregnated cloth and molten lead to keep out the salt water. The seawall was finally completed in 1869, just as soldiers began vacating the fort.

The new seawall, a masterpiece of engineering, protected a fortress whose day was rapidly passing. Military engineers had studied the performance of forts similar to Fort Point during the Civil War and came up with a dismal forecast: advances in modern long-range rifled artillery made these masonry forts obsolete. The most notable example of a failed casemated work occurred at Fort Pulaski near Savannah, Georgia, where Union guns demolished the fort's seven-foot thick walls in just under 48 hours. Now that the war was over, the U.S. Army was having serious doubts about the wisdom of protecting the country's crucial harbors with such vulnerable targets.

Recreation
Common soldiers had few choices for recreation at Fort Point. Fishing off the seawall was a frequent diversion, as were the concerts put on by the Presidio band. Although gambling was prohibited, checkers and dominos were popular, along with clandestine games of poker and three-card monte. Fleshier diversions were available to men willing to bike the hills to San Francisco's waterfront and visit the saloons along what was becoming known as the Barbary Coast.

Alcatraz
Island of Change

Golden Gate National Recreation Area

logical torture that included the island's proximity to San Francisco. "The barbarous effect is the same as chaining a starving man to a wall and spreading a feast beyond his reach."

Trials of inmates for escape attempts, assault and prison murders kept the papers full of news of Alcatraz. Not all the press was negative; a November 1935 story in the *Saturday Evening Post*, titled "The Rock," followed a fictional inmate's adjustment to the penitentiary. The article noted the use of metal detection devices and push-button tear gas dispensers in the "scientific stir," along with hand-picked guards trained in "target practice, scientific frisking, gunnery and reading codes. They're as hard boiled as G-men." The penitentiary, in the words of the *San Francisco Examiner* in May 1936, "hurts, but it works."

For most Americans, Alcatraz became the epitome of the "tough" prison. Alcatraz was designed not just for public enemies, but for the most dangerous, notorious, and recalcitrant wards of the federal prison system. Alcatraz offered little in the way of rehabilitation. The inmates served hard time with limited privileges. As the regulations stated, "You are entitled to food, clothing, shelter and medical attention. Anything else you get is a privilege." Prison regulations were rigidly enforced, and violations were swiftly punished. Minor infractions brought a warning, while more serious offenses meant losing "good time," reduced privileges, or lock up in segregation—so-called "solitary confinement."

Violent crimes in the prison often brought rough handling. Punishment usually meant incarcerating in the special treatment unit's isolation cells with bare steel walls, a blanket and pitch darkness when the lights were out. The last stop in the prison system, Alcatraz housed, in the eyes of many, the rottenest of the rotten apples.

Escape from Alcatraz

While inmates successfully escaped from the military prison on Alcatraz, no one made it off the island alive or without recapture during its 29-year federal penitentiary era. In all, prisoners made eight foiled and six partially successful escape attempts.

Sensational headlines followed an escape attempt on May 23, 1938. Three convicts beat Officer Royal Cline to death with a claw hammer and were stopped by the quick action of Officer Harold P. Stites, who ended the escape attempt by shooting two of the three when they assaulted his rooftop guard tower.

In May 1946, as six inmates attempted to "blast out" of Alcatraz with weapons seized from captured correctional officers, tens of thousands crowded the Bay's shore to watch U.S. Marines bombard the cellhouse with rifle grenades. Police launches, Coast Guard cutters

FBI GRILLS 'ROCK' FELONS: DEATH TRIAL LIKELY FOR 3

Four banco operators immortalized in Rogues' Gallery: (clockwise from top left) "Old Ike" Vail, Joseph "Hungry Joe" Lewis, Joseph "Paper Collar Joe" Bond, James "The Kid" Fitzgerald. Photograph by Jacob Riis.

operators as Herman "Beansy" Rosenthal, Bald Jack Rose, Bridgie Webber, and Sam Schepps were constantly feuding among themselves and with their police protectors. Rosenthal, for example, closed his house in Far Rockaway because of persistent raids instigated by a rival, then opened the Hesper Club on lower Second Avenue, which swiftly failed because of the success of Webber's nearby Sans Souci, then opened a house on West 116th Street that was soon closed by the police, then opened one on West Forty-fifth that was raided innumerable times and firebombed twice. His luck changed dramatically when he took on Lieutenant Charles H. Becker of the Gambling Squad as his partner. Becker, who extorted from prostitutes and pursued a bitter vendetta against the novelist Stephen Crane, who had exposed him in print, was called the "crookedest cop who ever stood behind a shield," which was certainly a distinction in such a crowded field. Rosenthal's security was short-lived, however. In March 1912 Rosenthal failed to contribute $500 toward the legal defense of Becker's press agent, who was charged with a killing in the course of a raid on a dice game, and the following month Becker retaliated by arranging for a raid on Rosenthal's house. When Rosenthal then threatened to spill all he knew about protection rackets to District Attorney Charles Whitman, other gamblers became alarmed and threatened Rosenthal. In June of that year the gangster Big Jack Zelig was approached in the Tombs and offered his freedom in return for disposing of Rosenthal. Zelig commissioned four of his hoods, Gyp the Blood, Lefty Louie, Dago Frank, and Whitey Lewis, to do the job. They set out to execute it in early July at the Garden Café on Seventh Avenue, but somehow suffered a collective failure of nerve. A week or two later Rosenthal published an affidavit in the *World* naming Becker as his partner at 20 percent of the cut in illegal gambling operations, and that same day was summoned to appear before the D.A. The following evening he was called away from dinner at the Hotel Metropole on West Forty-fifth by the message that a man wanted to see him outside, and Rosenthal, incredibly, complied. The minute he hit the pavement he went down in a shower of bullets fired by four men in a car. Gyp, Lefty, Dago, and Whitey were arrested almost

3

Once upon a time there was a married couple with two children, Catalina and Bernardo, both of whom went to school. One day their mother promised them that she was going to leave a cup of milk in the cupboard for the one who returned home from school first. Bernardo was the first to arrive. He opened the door of the cupboard but did not find any milk, so he ran looking for his mother.

"Mother, the milk is not in the cupboard."

"Yes, it's there, Bernardo," replied his mother. "Put your head way inside."

Bernardo put his head farther inside, but at that very instant his mother closed the door with a bang and cut off his head. Next she cut him up in little pieces and put him in a cauldron to cook.

A short time later, Catalina came home and asked about her brother.

"He still has not returned," replied her mother. "There is milk for you in the cupboard. Go get it."

But suddenly, Catalina observed with horror that her brother's fingers were floating to the top of the boiling cauldron. Then her mother reminded her that she had to take dinner to her father.

Catalina was walking along with the meal balanced on her head, crying inconsolably, when she met an old woman.

"What has happened to you, Catalina?" she asked.

"Nothing you can help me with."

"Why not, child? I will solve your problem."

The girl told the old woman the whole story, including the part about her brother, the pieces of whom she was carrying to her father for dinner. The old woman suggested

62

that she carefully gather all the bones that her father threw away. And she added, "Your father will ask you, 'Why are you keeping those bones, Catalina?' You must answer him, 'To play with.' Next, return to your house, take out a hoe, make a hole in the ground, and bury all the bones. Your mother will wonder and ask you, 'What are you doing there, Catalina?' And you must answer, 'Planting garlic.' That will seem like a good idea to your mother and she will say to you, 'Very well, very well, plant garlic, we need some.'"

Catalina reached the place where her father was, and as he ate, she followed the advice of the old woman and carefully collected the bones that her father tossed away. Her father asked her, "What do you want those bones for, Catalina?"

"To play with."

When she returned home, she dug the hole and was burying the bones when her mother asked her, "What are you doing there, Catalina?"

"Planting garlic."

"Ah, good, we need some!"

The following morning when her father got up, he saw a graceful tree growing in the middle of the garden. Up in the tree was Bernardo holding a tempting orange in one hand and a sword in the other. His father said to him, "My son, give me that beautiful orange."

"I will give it to you," said the son, "if you will jump over my sword three times." The father jumped, once, twice, and the third time Bernardo cut off his head.

Later his mother came and said to him, "My son, will you give me that beautiful orange?"

"I will give it to you," said the son, "if you will jump over my sword three times." The mother jumped, once, twice, and the third time Bernardo cut off her head.

A little later, he saw his sister Catalina, and she said to

63

1

Title **LOW LIFE**

Author **LUC SANTE**

Art Director/Designer **BARBARA DE WILDE**

Photography **COURTESY OF NEW YORK HISTORICAL SOCIETY, THE MUSEUM OF THE CITY OF NEW YORK, AND BROWN BROTHERS**

Publisher **FARRAR STRAUS GIROUX, NEW YORK, NY**

Typographer **EXPERTYPE**

Printer **PHOENIX COLOR**

Trim Size **6 3/8" x 9 3/8"**

Typefaces **BULMER OLD STYLE, UNIVERS BOLD**

Jacket Designer **BARBARA DE WILDE**

2

Title **RUBBER BLANKET #1**

Authors/Illustrators/Designers **DAVID MAZZUCCHELLI AND RICHMOND LEWIS**

Publisher **RUBBER BLANKET PRESS, HOBOKEN, NJ**

Printer **FREDDY LAGNO**

Trim Size **12" x 9"**

Cover Designers/Illustrators **DAVID MAZZUCCHELLI AND RICHMOND LEWIS**

Cover Illustrator **DAVID MAZZUCCHELLI**

3

Title **A VIEW FROM THE WITCH'S CAVE: FOLKTALES OF THE PYRENEES**

Editor **LUIS de BARANDIARÁN IRIZAR**

Designer **RICHARD HENDEL**

Illustrator **ASUN BALZOLA**

Publisher **UNIVERSITY OF NEVADA PRESS, RENO, NV**

Typographer **TSENG INFORMATION SYSTEMS, INC.**

Printer/Binder **THOMSON-SHORE, INC.**

Production Manager **CAM SUTHERLAND**

Paper Manufacturer **GLATFELTER**

Paper **60#B-16, NATURAL ANTIQUE**

Trim Size **5" x 9"**

Typefaces **9.5, 15 JOANNA, JOANNA DISPLAY, BENGUIAT**

Jacket Designer **RICHARD HENDEL**

Jacket Illustrator **ASUN BALZOLA**

Jacket Printer **NEW ENGLAND BOOK COMPONENTS**

1

Title **PRATTONIA NINETEEN NINETY ONE**
Art Directors **GEORGE CHENG, VINCENT LACAVA**
Designer **GEORGE CHENG**
Illustrator **CYNTHIA IGNACIO**
Photographers **IAN LIN, ZULKALNAIN ZAINAL ABIDIN,
RICKY YUK-KWANG NG**
Publisher **SCHOOL OF GRAPHIC ARTS, PRATT INSTITUTE,
BROOKLYN, NY**
Typographer **THE ACE GROUP, INC.**
Printer **MIRROR GRAPHICS, INC.**
Trim Size **7 15/16" x 11 7/8" OBLONG**
Typefaces **FUTURA, GOUDY**

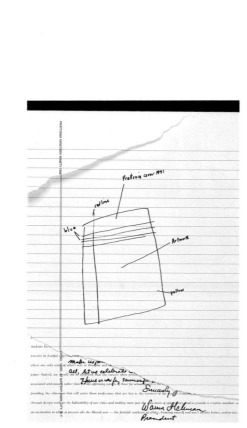

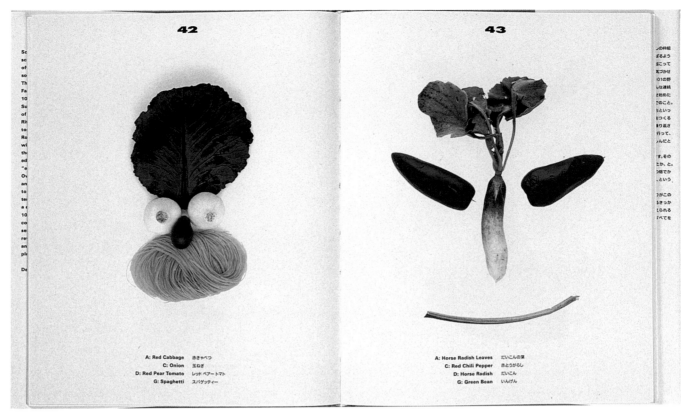

A: Red Cabbage　赤きゃべつ
C: Onion　玉ねぎ
D: Red Pear Tomato　レッド ペアートマト
G: Spaghetti　スパゲッティー

A: Horse Radish Leaves　だいこんの葉
C: Red Chili Pepper　赤とうがらし
D: Horse Radish　だいこん
G: Green Bean　いんげん

2

2

Title　**101 VEGETABLE FACES**
Author　**DELRAE ROTH**
Art Director　**TAMOTSU YAGI**
Designers　**TAMOTSU YAGI, MISA AWATSUJI**
Photographer　**ROBERT CARRA**
Photo Stylists　**ANNA CARRA, RITSUKO YAGI**
Publisher　**ROBUNDO PUBLISHING, INC., TOKYO, JAPAN**
Typographer　**TYPE COSMIQUE**
Printer　**TORYO PRINTING CO., LTD.**
Production Manager　**TAKASHI SUZUKI**
Paper Manufacturer　**SANYO-KOKUSAKU PULP CO., LTD.**
Paper　**COATED MATTE ART PAPER**
Trim Size　**7 7/8" x 9 1/2"**
Typeface　**UNIVERS BOLD**
Binder　**TANAKA BOOKBINDING CO., LTD.**
Jacket Designer　**TAMOTSU YAGI**
Jacket Photographer　**ROBERT CARRA**

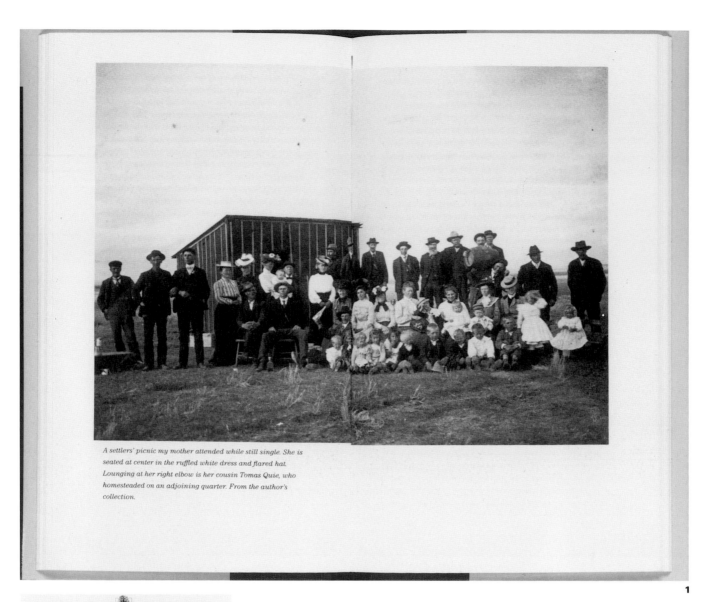

*A settlers' picnic my mother attended while still single. She is
seated at center in the ruffled white dress and flared hat.
Lounging at her right elbow is her cousin Tomas Quie, who
homesteaded on an adjoining quarter. From the author's
collection.*

1

Title **NOTHING TO DO BUT STAY**
Author **CARRIE YOUNG**
Designer/Jacket Designer **RICH HENDEL**
Publisher **UNIVERSITY OF IOWA PRESS, IOWA CITY, IA**
Typographer **G&S TYPESETTERS, INC.**
Printer/Binder **THOMSON-SHORE, INC.**
Production Manager **KAREN COPP**
Paper Manufacturer **GLATFELTER**
Paper **GLATFELTER B-16, 55#**
Trim Size **5 1/4" x 9"**
Typefaces **ITC CENTURY LT, LETRASET POPPL DISPLAY INITIALS, LINOTYPE WALBAUM, FUTURA**
Jacket Designer **RICH HENDEL**
Jacket Illustrator **BETH KROMMES**

2

Title **JOE**
Author **LARRY BROWN**
Art Director **SUSAN REINHARDT**
Designer **MOLLY RENDA**
Publisher **ALGONQUIN BOOKS OF CHAPEL HILL**
Typographer **MARATHON TYPOGRAPHY SERVICE**
Printer/Binder **ARCATA**
Production Manager **BETH MACKIN**
Paper Manufacturer **S.D. WARREN**
Paper **55# SEBAGO ANTIQUE**
Trim Size **5 1/2" X 8 1/2"**
Typefaces **TIMES ROMAN, GILL SANS CONDENSED**
Jacket Designer **MOLLY RENDA**

JOE

"Aw, I'm all right," Gary said. "I just wanted to talk to you about workin some more."

The bossman draped the towel over his shoulders and picked up his cigarettes. He smiled a little crooked smile, not unkindly. "Work? Boy, don't you see what it's doing out there? It's pouring down rain."

"Yessir," Gary said. He rubbed the towel over his head. He put a finger in it and drilled his earholes a little.

"Where's my drink at? Have you got some pants he can wear? What size waist you got, anyway?"

He looked down at himself. "I don't know what size," he said. "My mama gets my clothes for me. I just wear whatever she gets."

What he was wearing was a pair of khaki pants that were pinched up around his waist with a belt that was six inches too long. A Kiss T-shirt and a pipe welder's cap.

"I think I got some jeans he can wear," she said. "Let me go in here and see."

"Well, set down," Joe told him. "I didn't know you were out there. You oughta hollered."

"I figgered if I hollered again he'd nail me. I bet nobody comes messin around here when you ain't here."

"Why I got him. I ain't here much. Way things are now, some sumbitch'll back a truck up to your door and just load up what he wants while you gone to work. He won't bother somebody just walkin down the road, though. A dog's smarter than you think. Anybody comes in this yard they better have a gun. I got to be here when they read the meter. Long as you stayed in the road he didn't bother you, did he?"

168

JOE

"Nosir. He just growled was all."

"You could have walked on off and he wouldn't have done anything. The road ain't his. He knows what's his."

"Here," Connie said, and handed him a pair of jeans. "Try these on. I believe they'll fit you."

He took the jeans and looked them over and looked around. "Bathroom down the hall," she said, pointing. "You can change in there."

"Yesm," he said, even though she wasn't four years older than he was. He found his way down the hall and went into the bathroom and shut the door. Then he groped around in the dark looking for the light switch. Feeling all over the wall. He turned it on and then he stood for a minute just looking at all the products scattered on shelves and around the sink and lined up beside the bathtub, a wide assortment of ointments and creams and shampoos and deodorants and colognes and aftershaves. He opened some of them and sniffed, and looked at their labels. Meaningless symbols printed there whose messages he could only imagine. In the mirror stood a wet boy-child whose hair was twisted all up over his head like a rooster's comb. He found a brush on the sink and pawed at his hair with it, slicking it down long over his ears. There was long downy hair all over his chin and neck that he'd never shaved. Finally he pulled the threadbare shirt over his head and unbuckled the belt and pulled the wet trousers down over his knees and stepped out of them and stood naked in the room, his balls shriveled and drawn from the cold and the wet. He dried himself all over and put on her blue jeans. They were almost a perfect fit except that her legs were longer than his,

169

B e t s y E v e r i t t

As if this wasn't enough, his mother sent
Miss Pearl to pick him up from school.

She swerved and screeched and nearly killed
three poodles before they made it home.

1

2

1

Title **MEAN SOUP**
Author/Illustrator **BETSY EVERITT**
Art Director **MICHAEL FARMER**
Designer **CAMILA FILANCIA**
Publisher **HARCOURT BRACE JOVANOVICH, SAN DIEGO, CA**
Typographer **THOMPSON TYPE**
Printer/Binder **TIEN WAH PRESS**
Production Managers **WARREN WALLERSTEIN, DAVID HOUGH**
Paper **130 GSM**
Trim Size **10" x 11"**
Typeface **CENTURY EXPANDED**
Jacket Designer **CAMILLA FILANCIA**
Jacket Illustrator **BETSY EVERITT**

2

Title **THE ALPHABET PARADE**
Author/Designer/Illustrator **SEYMOUR CHWAST**
Art Director **MICHAEL FARMER**
Publisher **HARCOURT BRACE JOVANOVICH, SAN DEIGO, CA**
Typographer **TRUFONT**
Printer/Binder **TIEN WAH PRESS**
Production Managers **WARREN WALLERSTEIN, MICHELE GREE**
Paper **130 GSM**
Trim Size **10" x 10"**
Typeface **CENTURY EXPANDED**
Jacket Designer/Illustrator **SEYMOUR CHWAST**

And now,
back by popular demand,
Buster and Buck,
the world-famous goats.

3

3

Title **CIRCUS**
Author/Illustrator **LOIS EHLERT**
Art Director **HARRIETTE BARTON**
Designer **LOIS EHLERT**
Publisher **HARPERCOLLINS, NEW YORK, NY**
Printer/Binder **TEIN WAH PRESS**
Typographer **LINOPRINTER COMPOSITION CO., INC.**
Production Manager **DANIELLE VALENTINO**
Paper Manufacturer **NYMOLLA**
Paper **8 PT. MAT ART**
Trim Size **9 1/4" X 12 1/4" (CASE), 7 1/4" X 12" (BOOK)**
Typeface **AVANT-GARDE GOTHIC MEDIUM 24 PT**
Jacket Designer **LOIS EHLERT**

1

1

Title **CONVERSATIONS WITH MENUHIN**
Author **DAVID DUBAL**
Art Directors **VAUGHN ANDREWS, CAMILLA FILANCIA**
Designer **JOY CHU**
Publisher **HARCOURT BRACE JOVANOVICH, SAN DIEGO, CA**
Typographer **COM COM**
Printer **MAPLE VAIL**
Production Manager **DAVID HOUGH**
Paper Manufacturer **GLATFELTER**
Paper **60# OFFSET LAID**
Trim Size **4 1/2" x 7 1/4"**
Typeface **JANSON ALTERNATE**
Binder **VAIL BALLOU**
Jacket Designer **LAURA COE DESIGN**
Jacket Photographer **JOHN JOHNSON**

2

Title **THE LETTERS OF SAMUEL JOHNSON, VOL. 1: 1731-1772**
Editor **BRUCE REDFORD**
Designer **MARK ARGETSINGER**
Publisher **THE PRINCETON UNVERSITY PRESS, PRINCETON, N.J.**
Printer/Typographer **STINEHOUR PRESS**
Production Manager **MIKE BURTON**
Paper Manufacturer **MOHAWK**
Paper **TICONDAROGA TEXT**
Trim Size **6 1/4" x 9 5/8"**
Typefaces **LINOTRONIC BASKERVILLE, MONOTYPE,**
FOUNDRY TYPE CASLON
Binder **ACME**
Jacket Designer **MARK ARGETSINGER**

2

TO CHARLES BURNEY, 24 DECEMBER 1757
(Special Collections, Mary Couts Burnett Library, Texas Christian University)

3

3

Title **TONAL ALLEGORY IN THE VOCAL MUSIC OF J.S. BACH**
Author **ERIC CHAFE**
Design Director/Designer **STEVE RENICK**
Publisher **UNIVERSITY OF CALIFORNIA PRESS, BERKELEY, CA**
Typographer **A-R EDITIONS, INC.**
Printers **MALLOY LITHOGRAPHING INC. (COVER), NEW ENGLAND**
BOOK COMPONENTS, INC. (JACKET)
Production Coordinator **FRAN MITCHELL**
Paper Manufacturer **PERKINS & SQUIER**
Paper **55# HI-OPAQUE**
Trim Size **7" x 10"**
Typeface **BEMBO**
Binder **JOHN H. DEKKER & SONS**
Jacket Designer **STEVE RENICK**

least, you will know by my letters, whatever else they may have or want, that I continue to be, Your most affectionate friend,

SAM. JOHNSON

Thomas Percy

SATURDAY 12 SEPTEMBER 1761

MS: Hyde Collection.

ADDRESS: To the Revd. Mr. Percy at Easton Mauduit, Northamptonshire, by Castle Ashby bag.

POSTMARK: 12 SE.

Dear Sir: Septr. 12, 1761

The kindness of your invitation would tempt one to leave pomp and tumult behind, and hasten to your retreat, however as I cannot perhaps see another coronation so conveniently as this,[1] and I may see many young Percies,[2] I beg your pardon for staying till this great ceremony is over after which I purpose to pass some time with you,[3] though I cannot flatter myself that I can even then long enjoy the pleasure which your company always gives me, and which is likewise expected from that of Mrs. Percy,[4] by, sir, your most affectionate,

SAM. JOHNSON

1. The coronation of George III took place in Westminster Abbey on 22 Sept. 1761. SJ was interested enough in the occasion to contribute to John Gwynn's pamphlet *Thoughts on the Coronation* (*Bibliography*, pp. 100, 144). Donald Greene argues that SJ was responsible for "the whole of the actual text" (*Works*, Yale ed. X.291).

2. Thomas and Anne Percy had six children, only two of whom survived to adulthood. *Post* To Thomas Percy, 27 Nov. 1770 and nn. 1, 2.

3. SJ visited Percy in the summer of 1764, when he stayed for almost two months (*Post* To Thomas Percy, 23 June 1764).

4. *Ante* To Thomas Percy, 4 Oct. 1760, n. 8.

1

Title **CULTURAL CONNECTIONS: MUSEUMS AND LIBRARIES OF PHILADELPHIA AND THE DELAWARE VALLEY**

Author **MORRIS J. VOGEL**

Art Director/Designer **JOEL KATZ**

Designers **JOEL KATZ, ANGIE HURLBUT**

Photographers **VARIOUS**

Publisher **TEMPLE UNIVERSITY PRESS, PHILADELPHIA, PA**

Typographer **DUKE & CO.**

Printer **NISSHA PRINTING CO.**

Production Manager **CHARLES AULT**

Paper Manufacturer **MITSUBISHI**

Paper **157.0 GSM SUPER MATT ART PAPER**

Trim Size **8" x 10"**

Typefaces **GARAMOND 3, BODONI, UNIVERS**

2

Title **MARTHA STEWART'S GARDENING**

Author **MARTHA STEWART**

Art Director **HOWARD KLEIN**

Designer/Jacket Designer **GAEL TOWEY**

Illustrator **RODICA PRATO**

Photographer **ELIZABETH ZESCHIN**

Publisher **CLARKSON N. POTTER, INC., NEW YORK, NY**

Printer/Binder **TOPPAN PRINTING CO. (AMERICA), INC.**

Production Manager **TERESA NICHOLAS**

Papers **86# GLOSSY COATED, 105# WHITE WOODFREE**

Trim Size **9 7/8" x 9 7/8"**

Typefaces **BEMBO, POLIPHILUS**

3

Title **COME ON IN!**

Authors **THE JUNIOR LEAGUE OF JACKSON, MS, INC.**

Art Director/Designer/Illustrator/Letterer **HILDA STAUSS OWEN**

Photographer **PATRICIA BRABANT**

Publisher **THE JUNIOR LEAGUE OF JACKSON, MS, INC., JACKSON, MS**

Printer **DAI NIPPON PRINTING CO., LTD.**

Paper Manufacturer **KANZAKI PAPER MFG. CO., LTD.**

Paper **DULLTON TEXT**

Trim Size **7" x 11"**

Typeface **PALATINO**

Jacket Designer/Letterer **HILDA STAUSS OWEN**

Jacket Photographer **PATRICIA BRABANT**

1

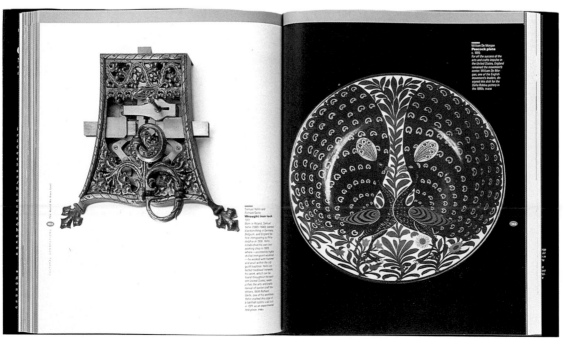

I CAN REMEMBER PERFECTLY THE DAY THAT my grandmother, Babcia Helcia, introduced me to the fabulous 'Peace' rose that she had nurtured in manure-rich soil in her ultra-neat backyard rose bed; I was quite sure, even then, that someday I would have my own garden of roses. ❦ Grandma Helen propagated her roses from precious cuttings gathered from the bushes of friends and acquaintances, protecting them with glass "cloches" (really a collection of oversize pickle jars). My father selected his roses from catalogues, purchasing a few bushes each year, and adding them to the ever-expanding rose garden in our Elm Place yard. It was my duty as a child to deadhead the bushes, pick off the Japanese beetles, and cut the most beautiful flowers for my mother or my teacher. ❦ My father preferred tea roses, and chose them primarily for their scent. I inherited his taste; for my first Mother's Day in Westport, my husband bought one dozen sturdy pot-planted hybrid teas, and placed them carefully in the garden as a surprise. It was an exciting and lovely present, affording me many years of pleasure. But my taste in roses remained relatively uninformed until I made my first gardening trip to England. Traveling with friends, I visited Great Dixter, Hidcote, Barnsley House, Sissinghurst, Upton House, Pusey, Rousham Park, Petworth, and Mottisfont Abbey. We arrived at Mottisfont

RIGHT: *I like to pick masses of my roses regardless of color scheme; here are 'Alchymist', 'Blaze', 'Louise Odier', 'Golden Sun', 'White Rose of York', 'Reines des Violettes', 'Jacques Cartier', and other favorites.* LEFT: *Our old shagbark hickory split in two during a vicious gale, leaving an ugly scar. Following Vita Sackville-West's inspiration of training roses to grow into trees, I planted two roses at the base: a rambler, 'Veilchenblau', and a gallica, 'Tuscany'.*

R O S E S

152

2

1

Title **PHOTOGRAPHS: ANNIE LEIBOVITZ 1970-1990**
Author/Photographer **ANNIE LEIBOVITZ**
Art Director **JOSEPH MONTEBELLO**
Designer **JEFF STREEPER**
Publisher **HARPERCOLLINS PUBLISHERS, NEW YORK, NY**
Typographer **EXPERTYPE/GRAPHIC WORD**
Printer/Binder **AMILCARE PIZZI**
Production Managers **ROZ BARROW, EILEEN MAX**
Paper **100# GARDAMATT**
Trim Size **11" x 13"**
Typeface **GILL SANS**
Jacket Photographer **ANNIE LEIBOVITZ**
Jacket Illustrator **GERARD HUERTA**

2

Title **A CURE FOR DREAMS**
Author **KAYE GIBBONS**
Designer **MOLLY RENDA**
Publisher **ALGONQUIN BOOKS OF CHAPEL HILL**
Typographer **MARATHON TYPOGRAPHY SERVICE**
Printer/Binder **ARCATA**
Production Manager **BETH MACKLIN**
Paper Manufacturer **S.D. WARREN**
Paper **60# SEBAGO ANTIQUE**
Trim Size **5" x 7"**
Typefaces **GRANJON, GILL SANS, GARAMOND**
Jacket Designer/Illustrator **MOLLY RENDA**

1

2

ALGONQUIN BOOKS OF CHAPEL HILL

KAYE GIBBONS

A Cure for Dreams

A NEW NOVEL BY THE AUTHOR OF

ELLEN FOSTER AND A VIRTUOUS WOMAN

78 : KAYE GIBBONS

river bridge, with Polly Deal teaching us how to watch our bobbers.

And then there came another turn in the road! One Saturday morning my mother and I announced our desire to ride to town to window-shop, thinking my father would surely carry us and drop us off to do something so harmless. He wouldn't. He said he didn't want to part with the gasoline. He said we were both foolish. He said we acted and dressed and talked foolishly and we were lazy as well, and these things more or less added up to explain why he was saddled with supporting a seventeen-year-old daughter. He said if I was worth anything that I'd have long ago been spoken for. This was such a rude thing to say to a young girl. I'd have died for him to talk to me my entire life, and when he finally let go of more than a mumble, this is what came out.

That following Monday I followed an urge and mailed off and had two dresses sent to me on approval from the Butterick's ready-to-wear division. I simply couldn't help myself. Even my mother was huffy at first, but later that month when the beautiful dresses arrived and she saw how pretty they were, she placed an order through me. Then we both had our hands slapped.

A Cure for Dreams : 79

My mother talked very fiercely to him.

This is your fault. You've brought this spree on yourself. All Betty and I had wanted to do was get out of the house to window-shop, but, oh boy, have we done more than window-shop now! I can't believe you've taken to hoarding gasoline from your own family, like we're forever asking to be carried somewhere. You act as if all Betty and I care to do is rip-roar up and down the highway gas-happy in your automobile. Haven't you ever seen or heard of us out walking? We together keep the weeds trampled down for miles up and down either side of Milk Farm Road!

He listened and walked out. Anger was called for in return, but he was numb past the point of being able to rally. While he was gone, my mother and I discussed the matter and decided to tell him that evening that we would send the dresses back to Butterick's. However, we didn't return the dresses. We sold them to Amanda Bethune for less than half price, on time, and we loaned her the money to make the payments. This way we still could enjoy looking at them and everyone was more or less pleased.

Two weeks later my father left the house early, dressed so as my mother believed he was headed to town on busi-

3

Title **BEYOND THE FRAME: AMERICAN ART 1960-1990**
Curator **LYNN GUMPERT**
Art Director/Designer **KAREN SALSGIVER**
Photographers **VARIOUS**
Publisher **AMWAY LIMITED, JAPAN**
Typography **LEAH LOCOCO, MACINTOSH,
NAKAMURA SEIKO PRINTING (USA) INC.**
Printer/Binder **DAI NIPPON PRINTING CO., LTD.**
Production Manager **SALSGIVER COVERNEY ASSOCIATES, INC.**
Trim Size **8 1/4" x 11 3/4"**
Typeface **GARAMOND NO. 3**
Jacket Designer **KAREN SALSGIVER**
Jacket Illustrator **JOHN BALDESSARI**

3

1

Title **AMISH: THE ART OF THE QUILT**

Author **JULIE SILBER**

Art Director **TAMOTSU YAGI**

Designers **TAMOTSU YAGI, DELRAE ROTH**

Photographer **SHARON RISEDORPH**

Publisher **CALLAWAY/KNOPF, NEW YORK, NY**

Typographer **DISPLAY LETTERING**

Printer/Binder **NISSHA PRINTING**

Production Manager **TRUE SIMS, IWAO MATSUI**

Paper Manufacturer **KANZAKI PAPER MFG., CO., LTD.**

Paper **NEW AGE**

Trim Size **14 1/8" x 14 1/2"**

Typeface **BODONI**

Jacket Designers **TAMOTSU YAGI, DELRAE ROTH**

Jacket Photographer **SHARON RISEDORPH**

AUGUST
Metropolitan

Midsummer
Fiction
Number

20¢

The Imagined World

FICTION IN THE MAGAZINE

F or two and a half centuries now, fiction and American magazines have managed to go along together, despite dire predictions for both. Time and again, as innovations came along — the car, radio, television — it was thought that each would decrease reading to such a degree that magazines would be put out of business. That hasn't happened, but the way magazines are read has changed drastically: These days, magazines are seldom read for entertainment of a narrative sort.

Fiction has always been more exploited than exalted in America's popular magazines. Short stories and serialized novels have served as adornments, come-ons, or concessions; have been dismissed as frivolous (and, in the old days, derided as "feminine") compared with what the best editors of our best magazines over the years usually considered their "serious" purposes: to inform, perhaps even to reform (in muckraking exposés), to educate and instruct, to influence, to guide, to provide service to the readers, whether for the home or office.

The good news is that, despite such editorial prejudices, an extraordinary amount of extraordinarily fine fiction has been published in American magazines over the years — although some of it appeared in very odd places. And there have been at least two long episodes in which individual magazines and their fiction managed to make a harmonious match.

From the very beginning — from, that is, the days when Ben Franklin and Andrew Bradford both claimed to have started the first American magazine, in Philadelphia, through Boston's newspaper-like quickies, to four-pagers like *The Independent Reflector* (1752) and *The Instructor* (1755), in New York City — the tone of magazines has been didactic and essayistic. News was for newspapers; essays were for magazines. Meanwhile, anything of a literary nature tended to be British — either just clipped and pasted from English periodicals or blatantly imitated.

For most of the magazines that came and went in America during the nineteenth century, literature in general and fiction in particular was merely an adjunct to their main functions. This was true even of magazines edited specifically for women, whose editors seem to have assumed that their readers were more interested in cooking and dress patterns and home decorating than in fiction. As a rule, the magazines started by book publishers serialized their own list of mostly foreign authors: *Appletons' Journal*'s serials were by British, French, and German novelists; *Harper's New Monthly Magazine* published Dickens

Mark Twain at the writer's desk in a 1911 silhouette inset from *The Ladies' Home Journal* (above). Booth Tarkington's novel *The Magnificent Ambersons* was featured on this 1918 Metropolitan (opposite).

1

Title **THE HISTORY OF PHOTOGRAPHY**
Author **MICHAEL PARKE-TAYLOR**
Art Director/Photographer **ROBERT TOMBS**
Publisher **OWENS ART GALLERY**
Typographer **MICHAEL AND WINIFRED BIXLER**
Printer/Binder **HERZIG SOMERVILLE LTD**
Paper Manufacturer **S.D. WARREN**
Paper **CAMEO DULL**
Trim Size **8" x 10"**
Typeface **MONOTYPE JOANNA**
Jacket Designer **ROBERT TOMBS**

1

ROBERT TOMBS: THE HISTORY OF PHOTOGRAPHY

DOUBLE IDENTITY & THE HISTORY OF PHOTOGRAPHY

ROBERT TOMBS'S SERIES of large-scale colour photographs, begun in 1985, uses images borrowed from the history of photography. By recreating historical photographic images which have become familiar through mass-media reproduction, his photographs assume that viewers will recognize "the original," and thus will enter into his subtle and witty dialogue with the past. While there is obvious humour in Tombs's photographs, his enterprise belies serious intent.

Since its invention in 1839, the photograph has shaped not only our understanding of history, but also the way we see. Tombs's work underlines the truism that our interpretation of visual images is predicated on what we have previously seen.

Tombs constructs his parallel *History of Photography* to question the uncritical assumption that photography is a neutral, objective, and "truthful" record of a person or event. His series of photographs, which he refers to as "an alternate history that 'depicts' history," stimulates enquiry into the authoritative power of photographic images. Tombs's work draws attention to the dogmatic acceptance of the photograph at face value without considering the intent of the photographer. His self-conscious recreations are overtly artificial, but are no less real for that. Often a distinction is not made between a posed photograph such as a studio portrait of Freud, and a documentary photograph such as the assassination of Lee Harvey Oswald. By staging impromptu-like photographs, Tombs makes us question how "unstaged" the originals might have been, and thus he points out that is is impossible to accurately determine the origin of an image based only on the visual result. Tombs's work deals with degrees of artificiality and reality and the distinction between the two.

By using himself as the model, Tombs concocts semi-disguised self-portraits wherein a double identity is employed. He is not an impostor pretending to be the well-known figures he portrays; he takes on their attributes while maintaining his own identity. Tombs similarly does not mask the true nature of the props used as visual clues necessary for the reference to the photographic antecedent. This is frequently accomplished with wit, for example, the fabricated plasticine nose that unquestionably

2

Argillite Plate
Late 19th century; Haida, Masset Village, Queen Charlotte Islands, British Columbia
Tahaygen (Charles Edenshaw, c. 1839–1924)
Argillite (carbonaceous shale), diam. 12 in. (30.5 cm)
Gift of John H. Hauberg, 91.1.127

A prolific and accomplished carver in all native materials, Tahaygen was one of the most innovative and imaginative of the nineteenth-century Haida artists, both in his sculptural style and his handling of two-dimensional traditions. Argillite was one of his favored media, and a great many examples of his work in the soft, black stone survive today, nearly all in museums and private collections outside his own culture.

Like many of his artistic contemporaries, Tahaygen called upon the rich oral tradition of Haida mythology for his subject matter. He often illustrated complex stories with a graphic and descriptively pictorial approach that is a conceptual step beyond the style employed in traditional representations within the Haida culture. Following the devastating epidemics of the mid-nineteenth century, surviving Haida artists, particularly those working in argillite, appear to have been intent on recording enduring images to illustrate and perpetuate the narrative style and cultural values of Haida mythology.

Tahaygen's exquisite craftsmanship is evident throughout the formation of this plate. The tale represented concerns the sexing of human beings, which Tahaygen also chose to illustrate on at least three other known objects. Here Yeihl, the Raven-in-human-form, sets off in a mythic canoe, having animated a shelf fungus to handle the steering. His intent is to spear the rock chitonlike female genitalia that cling to a certain sea-washed rock, and then return to bestow their supernatural power upon the first human females.

74

Headdress Frontlet
Mid- to late 19th century; Haida, Hydaburg, southeast Alaska
Attributed to Albert Edward Edenshaw (Masset, 18109–94)
Maple, abalone shell, Native and trade pigments, h. 6¼ in. (16 cm)
Gift of John H. Hauberg, 91.1.82

A complex story-image is depicted with poetic simplicity in this striking headdress frontlet. Created to adorn the front of swansdown and ermine decorated dancing headdresses, the carved figures on frontlets derive from oral history, often from origin stories that are owned by particular clans or family lines. This work was attributed to Albert Edward Edenshaw (Charles Edenshaw's maternal uncle) by its last Native owner. The finely crafted carving portrays the tale of a man who captured and killed a powerful sea monster, known as Gonakadeit in both Haida and Tlingit stories. Wearing the skin of the monster enabled the man to swim deep in the sea, capturing many fish and even whales with which to feed his village.

Here the whole picture is compactly rendered in a deep and rich sculptural style. The central human figure in the story is portrayed in a crouch, his knees and elbows drawn in. Long-fingered hands delicately touch the profile body of a whale, rendered in two-dimensional design and held in front of the man's shins and torso. The man wears the skin of the Gonakadeit like a headdress, the monster's teeth forming a graceful arch of U-shapes across his forehead. The teeth are inlaid with pieces of iridescent blue abalone shell, acquired by Native trade from California, as are the man's eyes and prominent features of the whale. The monster's body and legs drape down behind delicately spiraled ear shapes, its feet resting on the man's shoulders, the claws curving alongside his full, rounded cheeks. Larger pieces of abalone shell decorate the rim of the frontlet, all of which combine to catch and brightly reflect the firelight of the performance house.

75

2

Title **SELECTED WORKS: SEATTLE ART MUSEUM**
Authors **CURATORIAL STAFF, SEATTLE ART MUSEUM**
Art Director/Designer **ED MARQUAND**
Photographer **PAUL MACAPIA**
Publisher **SEATTLE ART MUSEUM, SEATTLE, WA**
Typographer **PAUL O. GIESEY/ADCRAFTERS**
Printer/Binder **TOPPAN PRINTING COMPANY**
Paper **NEW AGE**
Trim Size **6" X 10"**

3

Title **BAROQUE MODERNISM: NEW WORKS BY ALBERT PALEY**
Authors **PETER JOSEPH, J. RICHARD GRUBER, MARCIA WESTBY**
Art Director **MICHAEL BIERUT**
Designers **MICHAEL BIERUT, DORIT LEV**
Photographer **MICHAEL GALATIS**
Publisher **PETER JOSEPH GALLERY, NEW YORK, NY**
Typographer **TYPOGRAM**
Printer **BECOTTE & GERSHWIN**
Production Manager **KARLA COE**
Paper Manufacturers **GILBERT PAPER CO., SIMSON PAPER CO.**
Papers **ESSE COVER, KASHMIR TEXT**
Trim Size **8" x 11"**
Typefaces **LINOSCRIPT, NEWS GOTHIC**
Jacket Designer **MICHAEL BIERUT**
Jacket Photographer **MICHAEL GALATIS**

1

Title **THE BEE**
Author **DR. BETH B. NORDEN**
Art Directors **JIM WAGEMAN, LYNN PIERONI (COVER)**
Designer **LYNETTE RUSCHAK**
Illustrator **BIRUTA AKERBERGS HANSEN**
Paper Engineer **JAMES DIAZ**
Publisher **STEWART, TABORI & CHANG, NEW YORK, NY**
Typography **IN-HOUSE**
Printer/Binder **LERNER PRINTING**
Production Manager **JAMES DIAZ**
Trim Size **8 7/8" x 12 1/4"**
Typefaces **GOUDY, ONYX**
Cover Designer **LYNN PIERONI**
Cover Illustrator **BIRUTA AKERBERGS HANSEN**

2

Title **PISH POSH SAID HIERONYMUS BOSCH**
Author **NANCY WILLARD**
Art Director **MICHAEL FARMER**
Designers/Illustrators **LEO AND DIANE DILLON**
Publisher **HARCOURT BRACE JOVANOVICH, SAN DIEGO, CA**
Printer **HOLYOKE LITHOGRAPH**
Production Manager **WARREN WALLERSTEIN**
Paper **100# NATURAL KARMA**
Trim Size **10" x 11"**
Binder **BOOK PRESS, VERMONT**
Jacket Designers/Letterers **LEO AND DIANE DILLON**
Jacket Illustrators **LEO, DIANE AND LEE DILLON**

2

1

Title **NOW BECOMING THEN: DUANE MICHALS**
Author/Photographer **DUANE MICHALS**
Author/Editor **MAX KOZLOFF**
Designer **JACK WOODY**
Publisher **TWIN PALMS PUBLISHERS, SANTA FE, NM**
Printer **TOPPAN PRINTING COMPANY**
Trim Size **9" x 12"**
Jacket Designer **JACK WOODY**
Jacket Photographer **DUANE MICHALS**

2

Title **ALLEN GINSBERG: PHOTOGRAPHS**
Author/Photographer **ALLEN GINSBERG**
Designer **JACK WOODY**
Publisher **TWELVETREES PRESS, SANTA FE, NM**
Printer **TOPPAN PRINTING COMPANY**
Trim Size **11" x 14"**
Jacket Designer **JACK WOODY**

3

Title **HOW DO I LOOK?: QUEER FILM AND VIDEO**
Authors **BAD OBJECT-CHOICES**
Designer **KATY HOMANS**
Photographers **VARIOUS**
Publisher **BAY PRESS, SEATTLE, CA**
Typographer **TRUFONT TYPOGRAPHERS**
Printer **GERHARD STEIDL, DRUCKEREI und VERLAG**
Production Manager **CHRISTOPHER STEARNS**
Trim Size **6" x 9"**
Typefaces **GILL SANS, WALBAUM**
Binder **STEIDL VERLAG**
Jacket Designers **TOM KALIN, KATY HOMANS**
Jacket Photographer **CHRISTOPHER BOAS (FILM STILL FROM "SHE MUST BE SEEING PICTURES")**

1

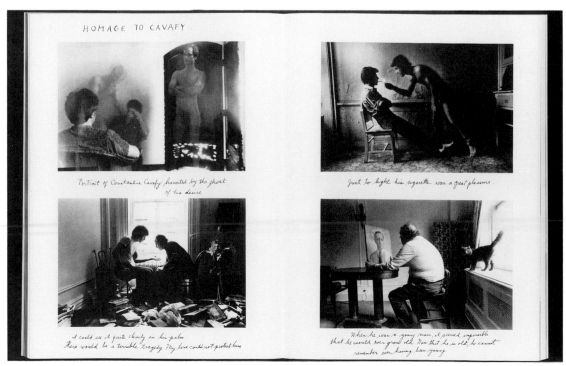

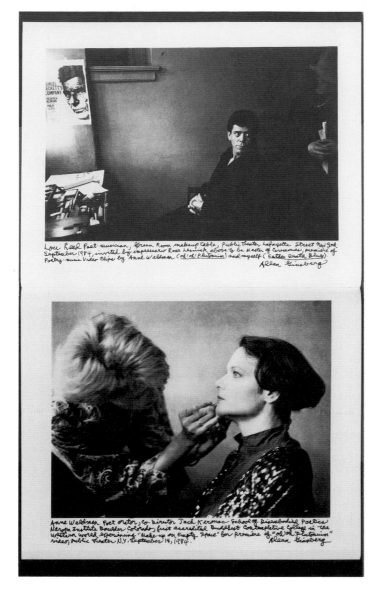

Lou Reed Poet musician, Green Room makeup table, Public Theater Lafayette Street New York September 1984, invited by impresario Rose Lesniak above to be Master of Ceremonies, premiere of Poetry-music Video Clips by Anne Waldman (oh-oh Plutonium) and myself (Father Death Blues)
Allen Ginsberg

Anne Waldman Poet orator, co-director Jack Kerouac School of Disembodied Poetics Naropa Institute Boulder Colorado, first accredited Buddhist Contemplative College in the Western world experiencing "Make-up on Empty Space" for premiere of "oh-oh Plutonium" video, Public Theater N.Y. September 14, 1984.
Allen Ginsberg

ALLEN GINSBERG PHOTOGRAPHS

2

3

HOW DO I LOOK?

QUEER FILM AND VIDEO

EDITED BY BAD OBJECT-CHOICES

Robert Mapplethorpe, Ken Moody, 1983.
The Estate of Robert Mapplethorpe

ism in Mapplethorpe's work, not as a repetition of racist fantasies but as a deconstructive strategy that lays bare psychic and social relations of ambivalence in the representation of race and sexuality. This deconstructive aspect of his homoeroticism is experienced, at the level of audience reception, as the disturbing shock effect.

The Eurocentric character of the liberal humanist values invested in classical Greek sculpture as the originary model of human beauty in Western aesthetics is paradoxically revealed by the promiscuous intertextuality whereby the filthy and degraded form of the commonplace racist stereotype is brought into the domain of aesthetic purity circumscribed by the privileged place of the fine art nude. This doubling within the pictorial space of Mapplethorpe's black nudes does not reproduce either term of the binary relation between "high culture" and "low culture" as it is: it radically decenters and destabilizes the hierarchy of racial and sexual difference in dominant systems of representation by folding the two together within the same frame. It is this ambivalent intermixing of textual references, achieved through the appropriation and articulation of elements from the "purified" realm of the transcendental aesthetic ideal and from the debased and "polluted" world of the commonplace racist stereotype, that disturbs the fixed positioning of the spectator. One might say that what is staged in Mapplethorpe's black male nudes is the return of the repressed in the ethnocentric imaginary. The psychic-social boundary that separates "high culture" and "low culture" is transgressed, crossed and disrupted precisely by the superimposition of two ways of seeing, which thus throws the spectator into uncertainty and undecidability, precisely the experience of ambivalence as a structure of feeling in which one's subject-position is called into question.

In my previous argument, I suggested that the regulative function of the stereotype had the upper hand, as it were, and helped to "fix" the spectator in the ideological subject-position

186 Mercer

182 Skin Head Sex Thing

1

Titles **THE HOUSE, THE COLORS, THE WIND**
Author/Illustrator **MONIQUE FELIX**
Designer **RITA MARSHALL**
Publisher **CREATIVE EDUCATION, MANKATO, MN**
Typographer **DIX TYPE**
Printer **EDITORIALE LIBRARIA, TRIESTE, ITALY**
Paper **ART MATT WOODFREE**
Trim Size **7" x 7"**
Typeface **CABLE BOLD**
Jacket Designer **RITA MARSHALL**
Jacket Illustrator **MONIQUE FELIX**

2

Title **OHH-LA-LA (MAX IN LOVE)**
Author/Illustrator **MAIRA KALMAN**
Designers **TIBOR KALMAN, SCOTT STOWELL**
Publisher **VIKING CHILDREN'S BOOK DIVISION, NEW YORK, NY**
Typographer **SCOTT STOWELL**
Printer/Binder **ARCATA GRAPHICS/KINGSPORT PRESS**
Production Manager **LIZ WALKER**
Paper Manufacturer **WEYERHAEUSER**
Paper **80# COUGAR OPAQUE SMOOTH**
Trim Size **8" x 10"**
Typeface **GILL SANS BOLD**
Jacket Designers **TIBOR KALMAN, SCOTT STOWELL**
Jacket Illustrator **MAIRA KALMAN**

2

1

Title **THE LIBRARY BOOK: A GOOD BOOK FOR A RAINY DAY**

Authors **ANDERSON, DUBROW, KOVAL**

Art Director/Illustrator **JUDY ANDERSON**

Designer **SARAH CONRADT**

Photographer **MEL CURTIS**

Publisher **SEATTLE ARTS COMMISSION, SEATTLE, WA**

Printer **EVERGREEN PRINTING COMPANY**

Paper Manufacturer **MOHAWK PAPER MILLS INC.**

Paper **MOHAWK SUPERFINE**

Trim Size **9 1/2" x 8"**

Typefaces **SABON, FUTURA, GARAMOND**

Binder **BAYLESS BINDERY INC.**

2

Title **THE FIRST & LAST ANNUAL SIX TOWNS**

AREA OLD TIMERS' BASEBALL GAME

Author **W.P. KINSELLA**

Designer **ALLAN KORNBLUM**

Illustrator **GAYLORD SCHANILEC**

Publisher **COFFEE HOUSE PRESS, MINNEAPOLIS, MN**

Printers **JULIA DRUSKIN, JILL MACKENZIE**

Production Manager **JULIA DRUSKIN**

Paper **RIVES HEAVYWEIGHT, ST. ARMAND (COVER & SLIPCASE)**

Trim Size **6 1/2" x 11"**

Typefaces **WALBAUM, P.T. BARNUM, VAUDEVILLE (DISPLAY)**

Binder **JILL JEVNE**

In his haste to report for duty, a young man who had enlisted in the army apparently had forgotten about a library book. An overdue notice was sent. After seven months, the letter was returned. It was covered with a dozen postmarks, showing it had been sent back and forth across the country several times and eventually to an overseas army post. Under the final postmark was a terse, hand-written notation: missing in action 11-17-43. ■

THE WAR ABROAD AND AT HOME

The 1940's: Boom & Bust.

A good barometer of Seattle's history during these years, as in many others, is the Boeing Company.

When war broke out in 1939, Boeing employed about 4,000 people and had sales of just under $10 million a year. By 1944, the peak war year, Boeing's employment was up to 50,000 in Seattle and annual sales surpassed $600 million.

During the war, Boeing relied on the Seattle Public Library for detailed technical information. Couriers appeared at the Central branch at least once a week on "top secret" missions to pick up materials requested by the company's engineers and designers.

As soon as the war ended, however, Boeing was down to 11,000 employees and the company was worried about what to do with those remaining.

Seattle's vast industrial expansion during and after World War II leads to a growing interest in the subjects of science and technology among public library patrons.

54

was wading in two inches of water, while in right field Torval Imsdahl had to put on his fishing boots because the slough water rode calf-high all afternoon.

Flop Skalrud and Bandy Wicker ran into each other trying to field a ground ball over second base and Bandy Wicker sprained his ankle and couldn't play for the rest of the afternoon, which he spent sitting alongside third base taking an occasional swig from a stone crock of good old Heathen's Rapture, or good old bring-on-blindness, logging-boot-to-the-side-of-the-head homebrew.

To top things off, in spite of several reminders, Eddie Grassfires didn't show up to practice his pitching, so with Bandy Wicker's injury the team was two players short, plus somebody had to hit practice baseballs into the field.

I filled in at second base, where I could occasionally stop a ground ball, although I didn't have enough arm to throw to first. After a lot of wheedling from Daddy, Mama filled in for Eddie Grassfires, Mama holding the ball above her head like a trophy, then wheeling her pitching arm in circles like she was maybe screwing a corkscrew into an invisible cork, then letting the ball fly somewhere in the general direction of the plate, where Daddy, having left third base vacant, would try to hit the ball to one of the old-timers.

Just as the sun was thinking about setting and everybody was about to go home, Eddie Grassfires, being, my daddy said, on Indian time, showed up for the practice, but by that time the

three baseballs that had been used that afternoon were being dried out in our oven, as were the shoes of most of the genuine players and both of the conscripted players (Mama and me).

The old-timers decided that their next practice would be held at the Fark Baseball grounds, where, Bandy Wicker said, at least the catcher could see second base when the weather was clear.

At that practice, a few of the young ball players, including Truckbox Al McClintock, came by to watch and marvel, so it became clear that even

In the Library, the unemployed along with returning soldiers poured over books in search of careers. Welders sought to become accountants, laborers taught themselves auto mechanics, and clerks learned about the export/import business.

The post-war building boom brought crowds into the Library's "home-building" sections to find tips on building and plans for affordable houses, remodels and additions.

It was also a time of increased activity for the Friends of the Seattle Public Library. The group, which was formed during the Library's 50-year anniversary in 1941, went into high gear with their educational and fund-raising efforts.

The Friends sponsored a popular series of noontime book reviews and presentations that included "Racial Minorities and Race Relations" in 1945 and programs during the following year that included a writers conference, children's storytelling groups and noontime forums.

The 1950's: *Red Scare*

Two key tools were used by the anti-Communist proponents during these years in their zealous efforts to "root out subversives" and "purify" the American way of thinking.

The first was censorship. Encouraged by the public's previous acceptance of "classified" information for national security reasons during the war years, the anti-red movement sought to supress "subversive" literature. In destroying the materials, these zealots often destroyed lives.

The City Librarian testified at trials in defense of booksellers, arguing they were merely displaying materials which were available to anyone in the stacks of the Seattle Public Library, such as *The Writings of Tolstoy*.

The second tool of over-zealous patriots was the loyalty oath. This clever maneuver gave the anti-Communist brigade what they considered a "clear mandate" since anyone who signed

 1956
The five million dollar bond issue finally passes, permitting plans for the construction of a new structure to replace the fifty year old Carnegie Building. The Central library temporarily moves to The Seventh and Olive Building awaiting construction of the new building.
Service to the public schools is eliminated.

 1957
Willard O. Youngs is appointed City Librarian.

55

3

Title	**MIRACLE ON 34TH STREET**
Author	**VALENTINE DAVIES**
Art Director	**VAUGHN ANDREWS**
Designer	**TRINA STAHL**
Photographer	**LESTER GLASSNER COLLECTION**
Publisher	**HARCOURT BRACE JOVANOVICH SAN DIEGO, CA**
Typographer	**CRANE TYPESETTING**
Printer/Binder	**R.R. DONNELLEY**
Production Manager	**DAVID HOUGH**
Paper Manufacturer	**FINCH-PRUYN**
Paper	**70# FINCH OPAQUE VELLUM**
Trim Size	**5 1/4" x 9 1/4"**
Typeface	**FOURNIER**
Jacket Designer	**VAUGHN ANDREWS**

3

FAITH IS BELIEVING IN THINGS WHEN COMMON SENSE TELLS YOU NOT TO

MIRACLE ON 34th STREET

Valentine Davies

A HARVEST / HBJ ORIGINAL

Valentine Davies

derful Santa; the old man was definitely crazy. Mr. Shellhammer exploded. They must get him back at once—before he left the store. If they didn't, all was lost!

Doris said they could get another Santa Claus to carry out the same policy. But Mr. Macy had brought his grandson to see Kringle that afternoon, Shellhammer told her. He had been tremendously impressed—they must get Kringle back at any cost!

After a frantic search Doris finally caught Kris in the service elevator. She told him that she had reconsidered and that he still could have the job. But to her dismay, Mr. Kringle politely declined. "I'm afraid I don't like your attitude," he said frankly, "nor Mr. Shellhammer's either!" Frantically Doris tried to explain that his genuine helpfulness and kindness had caused a sensation.

"You *must* stay and keep on spreading good will. Why, even Mr. Macy—"

Kris, however, was adamant. Mrs. Walker had clearly indicated her cynical disbelief. That was enough for him.

34

"WHO WAS THE FIRST PRESIDENT OF THE UNITED STATES? HOW MUCH IS THREE TIMES FIVE?" KRIS ANSWERED ALL THE TEST QUESTIONS AS PATIENTLY AS HE COULD.

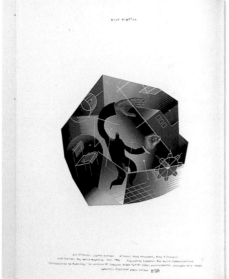
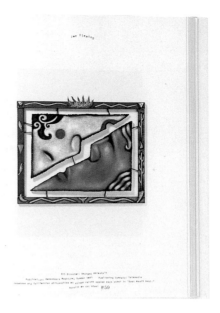

1

1

Title **AMERICAN ILLUSTRATION 10**
Author **EDWARD BOOTH-CLIBBORN**
Designer **MICHAEL MABRY**
Assistant Designers **KEIKO HAYASHI, SANDY LEE**
Photographer **MICHAEL MABRY**
Publisher **WATSON-GUPTILL PUBLICATIONS, NEW YORK, NY**
Typography **MICHAEL MABRY DESIGN**
Printer **DAI NIPPON**
Trim Size **9 3/16" x 12 3/16"**
Jacket Designer/Letterer **MICHAEL MABRY**
Jacket Illustrator **GARY BASEMAN**

2

Title **THIS HERITAGE REMEMBERED III: THE DIARIES OF ADAM AND EVE**
Authors **MARK TWAIN, LEE HERRICK (NOTES)**
Art Director **REX PETEET**
Designers **REX PETEET, DON SIBLEY**
Illustrators **REX PETEET, DON SIBLEY, DAVID BECK**
Letterers **DAVID BECK, TOM HOUGH**
Publisher **HERITAGE PRESS, DALLAS, TX**
Typographer **TYPOGRAPHY PLUS**
Production Manager/Producer **BOB DOWNS, HERITAGE PRESS**
Paper Manufacturer **JAMES RIVER CORPORATION**
Papers **BRIGHTWATER, TUSCAN TERRA, FANTASY, MOMI**
Trim Size **6" x 6"**
Typefaces **BERNHARD, KABEL**
Jacket Designer/Illustrator **REX PETEET**

2

3

Title **PLAYING TO WIN**
Authors **TOM CALLAHAN AND RICHARD KUHN**
Art Director/Designer **RICK VAUGHN**
Illustrator **JEFF KOEGEL**
Photographers **VALERIE SANTAGTO, VARIOUS**
Publisher **PECOS RIVER LEARNING CENTER, SANTA FE, NM**
Typography **IN-HOUSE**
Printer/Binder **HERITAGE PRINTING**
Production Manager **JUDITH YELVINGTON**
Paper Manufacturer **SIMPSON PAPER**
Papers **COUGAR VELLUM (COVER), EVERGREEN (TEXT)**
Trim Sizes **8" x 11" (COVER AND DIVIDERS, 7 1/2" x 11" (TEXT)**
Typefaces **COCHIN, FUTURA EXTRA BOLD, FUTURA, CORONET**
Jacket Designer/Illustrator **RICK VAUGHN**

TEAMS

"PRLC is about people. People who are some-how transformed from limiting their focus from "me" to broadening it with even higher intensity to "we." It's about watching a young secretary struggle with terror and literally stretch her capabilities to conquer the pole. It's about seventeen other team members who rejoiced in her accomplishment, some with moistened eyes, as she wept in sheer joy and relief over her victory. It's about individuals who combine their limited talents to form a team with almost unlimited abilities."

George Herring, Training and Development Specialist
Du Pont Corporation, Kinston, NC

When individuals join together in a team, turn their sights toward achieving a common goal and draw support and strength from each other, it's amazing what they can accomplish.

"I'll tell you what, after you get done with some of those high wire drills, you're ready to hug anybody."
Jerry Burns,
Former Head Coach,
Minnesota Vikings,
Minneapolis, MN

DEVELOPING T.A.S.T.E.™

After experiencing the power of Playing to Win™ at Pecos River Learning Centers, the typical response is: "If we could be like this back at work, we'd be awesome." The only problem is, it's not like this back at work.

So, how can we make it like this back there?

Creating an environment that supports us in Playing to Win calls for the values of T.A.S.T.E.™ (Truth, Accountability, Support, Trust, and Energy) — within ourselves, our teams, and our organizations.

That's not an easy job. The process involves getting rid of old, negative values and behaviors that have restricted our progress and kept us from Playing to Win.

It's as though we're all "Gullivers" — sleeping giants who are tied up by thousands of threads labeled "no truth," "no accountability," "no support," "no trust," and "no energy." Creating an environment of T.A.S.T.E. means that we have to get together and cut those threads!

"As we get bigger, we tend to get ourselves bound up. The bureaucracy takes hold and people are working like crazy and nothing is happening. After awhile it becomes an accepted norm. The company gets sleepy and sluggish. What Pecos does is wake us up. It helps us realize we're tied up. It helps us get rid of our ropes and burdens, so we can begin to concentrate on what we want to be, to concentrate on a vision for the future and a strategy to get there."

Mike Syzmanczyk, Senior Vice President of Sales
Philip Morris, New York, NY

WAKE UP

1

Title **SELECTED POEMS**

Author **ROBERT CREELEY**

Design Director **STEVE RENICK**

Designer **BARBARA JELLOW**

Publisher **UNIVERSITY OF CALIFORNIA PRESS, BERKELEY, CA**

Typographer **WILSTED & TAYLOR PUBLISHING SERVICES**

Printers **MALLOY LITHOGRAPHING INC. (TEXT), NEW ENGLAND BOOK COMPONENTS, INC. (JACKET)**

Production Coordinator **FRAN MITCHELL**

Paper Manufacturer **PERKINS & SQUIER**

Paper **50# VELLUM B-31**

Trim Size **5" x 8"**

Typeface **ALDUS**

Binder **JOHN H. DEKKER & SONS**

Jacket Designer **BARBARA JELLOW**

Jacket Photographers **ELSA DORFSMAN, JONATHAN WILLIAMS, CHRIS FELVER**

2

Title **TO READ**

Authors **VARIOUS**

Art Director/Designer **VANCE STUDLEY**

Designers **VARIOUS STUDENT DESIGNERS**

Publisher **ARCHETYPE PRESS, VENICE, CA**

Typographers **VARIOUS**

Printer **ARCHETYPE PRESS**

Papers **VARIOUS COMMERCIAL AND HANDMADE STOCK**

Trim Size **12 1/2" x 15"**

Binder **KATER-CRAFT BOOKBINDERS**

Jacket Designer/Letterer **VANCE STUDLEY**

GIAMBATTISTA
BODONI

International Typeface Corporation

NEW YORK, 1991

Hic ille est Magnus, typica quo nullus in arte
Plures depromsit divitias, veneres.

3

3

Title **BODONI**
Authors **VARIOUS**
Art Director/Designer **JERRY KELLY**
Publisher **INTERNATIONAL TYPEFACE CORPORATION, NEW YORK, NY**
Typographers **VARIOUS**
Printer/Binder **STINEHOUR PRESS**
Production Manager **REBECCA L. PAPPAS**
Paper Manufacturer **ARCHES**
Paper **TEXT LAID (MOULD MADE)**
Trim Size **12 1/4" x 8 5/8"**
Typefaces **ALL METAL TYPES: LINOTYPE BODONI, LANSTON**
MONOTYPE, BOOK #875, BAUER BODONI
Jacket Designer/Illustrator/Photographer/Letterer **JERRY KELLY**
Jacket Paper **FABRIANO ROMA (HANDMADE)**
Step Case **STINEHOUR PRESS (HANDMADE)**

1

1

Title **ALL MY BEST FRIENDS ARE ANIMALS ADDRESS BOOK**
Author **WARD SCHUMAKER**
Art Director **KAREN PIKE**
Designers **BRENDA ENO, KAREN PIKE, WARD SCHUMAKER**
Illustrator/Letterer **WARD SCHUMAKER**
Publisher **CHRONICLE BOOKS, SAN FRANCISCO, CA**
Printer/Binder **OVERSEAS PRINTING**
Production Managers **LINDSAY ANDERSON, NANCY REID**
Paper Manufacturer **OVERSEAS PRINTING**
Papers **120 GSM MATTE ART PAPER, 350 GSM ROYAL IVORY**
Trim Size **6" x 8"**
Typeface **FUTURA**
Jacket Designer/Illustrator/Letterer **WARD SCHUMAKER**

PARTICULARLY CATS

not as a cat would have to travel. The cat slipped out of the camp, her nose pointed in the direction her instinct told her she must go. There was no clear road she could take. Between our farm and the camp were a haphazard meander of roads, all of them dirt tracks, and the road to the camp was for four or five miles wheel tracks through dry grass. Unlikely she could follow the car's route back. She must have come straight across country, desolate untenanted veld which had plenty of mice and rats and birds for her to eat, but also cat enemies, like leopards, snakes, birds of prey. She probably moved at night. There were two rivers to get across. They were not large rivers, at the end of the dry season. In places there were stones across; or she might perhaps have examined the banks till she found a place where branches met over the water, and crossed through the trees. She might have swum. I've heard that cats do, though I've never seen it.

The rainy season broke in that two weeks. Both rivers came down in a sudden flood, and unexpectedly. A storm happens upstream, ten, fifteen, twenty miles away. The water banks up, and sweeps down in a wave, anything from two to fifteen feet high. The cat might very easily have been sitting on the edge waiting for a chance to cross the river when the first waters of the season came down. But she was lucky with both rivers. She had got wet through: her fur had been soaked, and had dried. When she had got safely over the second river, there was another ten miles of empty veld. She must have travelled blind, fierce, hungry, desperate, knowing nothing at all except that she must travel, and that she was pointed in the right direction.

Grey cat did not run away, even if she was thinking of it when strangers came to the cottage, and she hid herself in the fields. As for black cat, she made herself at home in the armchair, and stayed there.

"She lay down and rolled in front of the fire, exposing her creamy belly to the warmth, as she would in sunlight on a London floor."

2

Title **RED LEAF, YELLOW LEAF**
Author/Designer/Illustrator **LOIS EHLERT**
Designer/Jacket Designer **LYDIA D'MOCH**
Publisher **HARCOURT BRACE JOVANOVICH, SAN DIEGO, CA**
Typographer **THOMPSON TYPE**
Printer/Binder **TIEN WAH PRESS**
Production Managers **WARREN WALLERSTEIN, GINGER BOYER**
Paper **130 GSM**
Trim Size **10" x 10"**
Typeface **CENTURY EXPANDED**
Jacket Designer/Illustrator **LOIS EHLERT**

3

Title **PARTICULARLY CATS...AND RUFUS**
Author **DORIS LESSING**
Art Director **VIRGINIA TAN**
Designer **MIA VANDER ELS**
Illustrator **JAMES MCMULLAN**
Publisher **ALFRED A. KNOPF, INC., NEW YORK, NY**
Typographer **MARIA VANDER ELS**
Printer/Binder **THE KINGSPORT PRESS**
Production Manager **ANDY HUGHES**
Paper Manufacturer **BALDWIN PAPER**
Paper **ST. LAWRENCE RECYCLED MATTE**
Trim Size **6 1/4" x 8 1/8"**
Typeface **GARAMOND NO. 3**
Jacket Designer/Illustrator **JAMES MCMULLAN**

6.2
Duchamp's studio, 33 W. 67th St., New York, 1917–1918. Retouched photograph from the *Box-in-a-Valise* showing *Trébuchet (Trap)*, 1917, and *Bicycle Wheel*, second version, 1916.

1

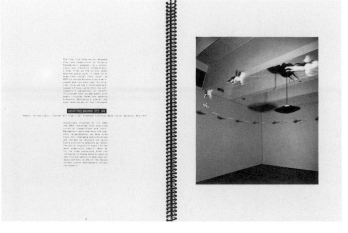

2

1

Title **THE DEFINITIVELY UNFINISHED MARCEL DUCHAMP**

Author **THIERRY DE DUVE**

Art Director **YASUYO IGUCHI**

Designer **JEANNET LEENDERTSE**

Photographer **NICHOLAS WALSTER**

Publisher **THE M.I.T. PRESS, CAMBRIDGE, MA**

Printer/Binder **HALLIDAY**

Production Manager **TERRY LAMOUREUX**

Paper Manufacturer **SIMPSON**

Paper **KASHMIR NATURAL 80# BOOK**

Trim Size **7 3/4" x 9"**

Typefaces **BODONI (BOLD, ITALIC), UNIVERS 55, 75**

Jacket Designer **JEANNET LEENDERTSE**

Jacket Photographer **NICHOLAS WALSTER**

2

Title **MECHANIKA**

Curator **JAN RILEY**

Designer/Letterer **DAVID BETZ**

Photographer **RON FORTH**

Publisher **THE CONTEMPORARY ARTS CENTER, CINCINNATI, OH**

Typographer **Q.C. TYPE, INC.**

Printer/Binder **BERMAN PRINTING COMPANY**

Paper Manufacturer **FRENCH PAPER CO.; POTLATCH**

Paper **SPECKLETONE, KARMA**

Trim Size **9" x 12"**

Typefaces **O.C.R.A.; MODULA SERIF**

3

Title **MULTIPLES IN RETROSPECT 1964-1990**

Author **CLAES OLDENBURG**

Designers **EMSWORTH DESIGN: ANTONY DROBINSKI, CHRISTOPHER EVANS**

Publisher **RIZZOLI INTERNATIONAL PUBLICATIONS, NEW YORK, NY**

Typographer **GRAPHIC TECHNOLOGY**

Printer/Binder **DAI NIPPON PRINTING CO., LTD., TOKYO**

Production Manager **ELIZABETH WHITE**

1

Title **A WITCH**
Author **AUGUST STRINDBERG**
Art Director **ROBERT SHAPAZIAN**
Designer **JEFFREY MUELLER**
Illustrator **TONI ZETO**
Photographers **VARIOUS**
Publisher **THE LAPIS PRESS, VENICE, CA**
Typographer **ANDRESEN TYPOGRAPHICS**
Printer **GARDNER LITHOGRAPH**
Production Manager **ROBERT SHAPAZIAN**
Paper Manufacturers **SIMPSON, P.S.I., GILBERT**
Papers **80# TETON TEXT, 1113 IKONOLUX**
GLOSS COVER, 173 GILCLEAR
Trim Size **7" x 10"**
Typefaces **BEMBO, STANDARD MEDIUM CONDENSED GOTHIC**
Binder **CARDOZA-JAMES BOOKBINDING CO.**
Jacket Designers **ROBERT SHAPAZIAN, JEFFREY MUELLER**

2

Title **A MAN JUMPS OUT OF AN AIRPLANE**
Author **BARRY YOURGRAU**
Art Director **HOWARD KLEIN**
Designer **JANE TREUHAFT**
Publisher **CLARKSON N. POTTER, INC. NEW YORK, NY**
Typographer **AMERICOMP**
Printer/Binder **ARCATA FAIRFIELD**
Production Manager **JOY SIKORSKY**
Paper Manufacturer **PERKINS & SQUIRE**
Paper **70# P&S OFFSET**
Trim Size **5 1/2" x 8 1/4"**
Typefaces **ELECTRA, BAUER BODONI, BODONI BOLD**
Jacket Designer **JANE TREUHAFT**

1

2

After living on the Great Plains by himself for a year, a Swedish farmer named Febold Feboldson grew afraid that he might die of loneliness. As he watched wagon trains bump over the prairies on their way to California, he waved his straw hat and shouted, "Stay here! Live here!"

But Febold always got the same answer: "No, thanky. We're going to look for gold!"

Instead of giving up, the broad-shouldered, sunburned Swede sat down and cupped his jaw in his giant hand and tried to figure out a way to make the gold hunters settle near him on the plains. In three seconds Febold came up with about a hundred great ideas. But the idea that made him do a little dance was this: order a thousand goldfish from Peru.

Febold ordered the goldfish, and when they arrived, he dumped all of them in a lake near his sod shanty—the only lake on the whole prairie. Then the crafty farmer hid in the tall grass and waited for the prairie schooners to roll by.

95

3

3

Title **AMERICAN TALL TALES**
Author **MARY POPE OSBORNE**
Art Director **DENISE CRONIN**
Designer/Jacket Designer **ELLEN ROSENTHAL**
Illustrator/Jacket Illustrator **MICHAEL McCURDY**
Publisher **ALFRED A. KNOPF, NEW YORK, NY**
Typographer **MAPLE VAIL**
Printer **ARCATA GRAPHICS/KINGSPORT**
Production Manager **CAROL NAUGHTON**
Paper Manufacturer **PERKINS & SQUIER**
Paper **80# P&S OFFSET REGULAR**
Trim Size **8" x 10 7/8"**
Typefaces **FAIRFIELD MED., LATIN, BEMBO MED., GARAMOND DISPLAY**
Jacket Designer **ELLEN ROSENTHAL**
Jacket Illustrator **MICHAEL McCURDY**

1

Title **LATIN AMERICAN DRAWINGS TODAY**
Authors **MARY SOFFLET, SHIFRA GOLDMAN, GLORIA ZEA, BÉLGICA RODRÍGUEZ**
Project Director **DAVID W. HEWITT**
Designers **RON MIRIELLO, MICHELLE BARBESINO (MIRIELLO GRAFICO DESIGN)**
Photographer **PHILIPP SCHOLZ RITTERMAN**
Publisher **SAN DIEGO MUSEUM OF ART, SAN DIEGO, CA**
Typographer **DEAN AMSTUTZ**
Printer **FRYE & SMITH**
Paper Manufacturers **GILBERT PAPER, POTLATCH CORPORATION**
Papers **ARCHIVAL CHIPBOARD 80# ESSE COVER AND TEXT,**
100# QUINTESSENCE DULL TEXT
Trim Size **8" x 11"**
Typefaces **COCHIN, MAXIMUS, CASLON ANTIQUE**
Binder **ROSWELL BOOKBINDING**

2

Title **FRENCH DIRT**
Author **RICHARD GOODMAN**
Art Director/Designer **MOLLY RENDA**
Illustrator **MOLLY RENDA**
Publisher **ALGONQUIN BOOKS OF CHAPEL HILL**
Typographer **TSENG INFORMATION SYSTEMS**
Printer/Binder **ARCATA**
Production Manager **BETH MACKIN**
Paper Manufacturer **S.D. WARREN**
Paper **55# SEBAGO ANTIQUE**
Trim Size **5" x 8 1/2"**
Typefaces **GARAMOND NO. 3, SCHNEIDLER, ADOBE GARAMOND**
Jacket Designer **MOLLY RENDA**
Jacket Illustrator **PAULA MUNCK**

LUCÍA MAYA

68

México, b. 1953

Madre del olvido

1987
pencil

1

2

Verde lino

1989
pastel

69

Gallina de cabeza rota

1989
pastel

3

Title **DUNGENESS CRABS AND BLACKBERRY COBBLERS**
Author **JANIE HIBLER**
Art Director **VIRGINIA TAN**
Designer **BARBARA BALCH**
Publisher **ALFRED A. KNOPF, INC., NEW YORK, NY**
Typographer **BARBARA BALCH**
Printer/Binder **THE COURIER COMPANIES, INC.**
Production Manager **CLAIRE BRADLEY**
Paper Manufacturer **S.D. WARREN**
Paper **SABEGO**
Trim Size **6 1/2" x 9 3/4"**
Typeface **GARAMOND**
Jacket Designer **CAROLE DEVINE CARSON**
Jacket Illustrator **PETRA MATHERS**

1

1

Title **GLASSES — WHO NEEDS 'EM?**
Author/Illustrator **LANE SMITH**
Art Director/Designer **MOLLY LEACH**
Publisher **VIKING PRESS CHILDREN'S BOOK DIVISION, NEW YORK, NY**
Typographer **MOLLY LEACH**
Printer/Binder **ARCATA GRAPHICS/KINGSPORT PRESS**
Production Manager **LIZ WALKER**
Paper Manufacturer **POTLATCH-NORTHWEST**
Paper **80# MOUNTIE MATTE**
Trim Size **8" x 9"**
Typeface **STONE SANS**
Jacket Designer **MOLLY LEACH**
Jacket Illustrator **LANE SMITH**

2

Title **TUESDAY**
Author **DAVID WEISNER**
Art Director/Designer **CAROL GOLDENBERG**
Publisher **CLARION BOOKS, NEW YORK, NY**
Typographer **PULSAR PHOTOGRAPHICS**
Printer **PRINCETON POLYCHROME**
Production Manager **ANDI BARLOW**
Paper Manufacturer **CONSOLIDATED**
Paper **PALOMA MATTE**
Trim Size **10 3/4" x 9"**
Typeface **BULMER**
Binder **HOROWITZ/RAE**
Jacket Designer **CAROL GOLDENBERG**
Jacket Illustrator **DAVID WIESNER**

2

3

3

Title **THE BIG PETS**
Author/Illustrator **LANE SMITH**
Art Director/Designer **MOLLY LEACH**
Publisher **VIKING PRESS CHILDREN'S BOOK DIVISION, NEW YORK, NY**
Typographer **M & M TYPOGRAPHY**
Printer/Binder **DAI NIPPON PRINTING COMPANY**
Production Manager **LIZ WALKER**
Paper Manufacturer **SANYO-KAKUSAKU PULP COMPANY**
Paper **U-LITE SK MATTE**
Trim Size **8 5/8" x 10 1/2"**
Typeface **WEISS**
Jacket Designer **MOLLY LEACH**
Jacket Illustrator **LANE SMITH**

INDEX

Art Directors, Designers, Illustrators, Artists, Photographers, Curators, Authors, Editors, Copywriters, Production Managers

A

Aardema, Verna, 91
Abelson, Danny, 256
Abidin, Zulkalnain Zainal, 310
Abrams, Kim, 249
Adams, Alyssa, 93
Adams, Sean, 300, 302
Adigard, Eric, 241
Ahmed, Miriam, 306
Aison, Cathryn S., 83
Akagi, Doug, 129, 233
Akagi, Hiroshi, 129
Alarçon, Francisco X., 299
Alcala, Antonio, 100
Allen, Terry, 238
Alterman, Kent, 139
Anderson, Charles S., 70, 78, 155, 194, 201, 208, 214
Anderson, Gail, 118, 238
Anderson, Jack, 254
Anderson, Judy, 332
Anderson, Lindsay, 338
Anderson, Mark, 71
Andrews, Vaughn, 316, 333
Anton, Bill, 267
Antonow, Melissa, 119
Aramburu, Jeannette, 149, 173, 201, 227
Argetsinger, Mark, 316
Aria, Barbara, 299
Arnesen, Jan, 102
Arnett, Dana, 139, 254
Ashton, Allen, 228
Ashworth, Lisa, 225
Ault, Charles, 318
Austin, Bill, 130
Avery, Eileen, 69
Avery, Eric, 109
Awatsuji, Misa, 311

B

Baer, Kimberly, 100
Bain, Elizabeth, 300
Balch, Barbara, 304, 345
Baldessari, John, 321
Balkind, Aubrey, 182
Ball, John, 219
Balzola, Asun, 309
Baravalle, Giorgio, 96
Barbesino, Michelle, 344
Barlow, Andi, 346
Bartalos, M., 159
Barth, Paul, 128
Barton, Byron, 83
Barton, Doug, 220
Barton, Harriette, 83, 87, 315
Basch, Stephanie, 109
Baseman, Gary, 115, 334
Bass, Melanie, 71
Bauer, Kirk, 108, 110
Bays, Michael, 182
Beck, David, 334
Beddows, Eric, 75
Belew, Tandy, 115
Bennett, Jamie, 203
Benthian, Barbara, 271
Benson, Greg, 96
Benson, John, 136
Berhardt, Craig, 124
Berman, Miriam, 81
Berte, Jim, 133, 269, 290
Betsky, Aaron, 300
Betz, David, 341
Bey, Dawoud, 303
Bielenberg, John, 228
Biernik, Maria, 233
Bierut, Michael, 249, 277, 325
Binger, Rick, 167, 197
Binkley, Scott, 206
Bixler, Michael, 324
Bixler, Winifred, 324
Blaustein, John, 167
Blechman, R.O., 159
Boardman, John, 110
Boas, Christopher, 328
Bobolts, Carol, 256
Boley, Tyler, 283
Bomar, Morgan, 269
Bonfante-Warren, Alexandra, 303
Booth-Clibborn, Edward, 334
Boram, Brian, 228
Boyer, Ginger, 339
Brabant, Patricia, 318
Brewer, Mary Beth, 81
Bricker, John, 192

Bricker, Tom, 139, 245, 293
Brochstein, Deborah, 267
Brock, Michael, 293
Brodate, Phil, 245
Brooks, Larry, 69
Brooks, Sharrie, 227
Brouwers, Guido, 194
Brown, Iris, 124
Brown, Larry, 313
Brown, Will, 306
Brunett, Cheryl, 278
Bryant, Dan, 152
Bull, Fran, 117
Burch, Harold, 206
Burdick, Becky, 136
Burke, Thomas, 79
Burstein, Naomi, 114
Burton, Mike, 316
Butler, Craig, 69
Byerly, Tom, 123

C

Cabanis, Tracy, 305
Cahan, Bill, 99
Callahan, Tom, 335
Campbell, Keith, 122
Campbell, Mike, 292
Cantor, Mark, 242
Capucilli, Karen, 211
Carbone, Ken, 211
Carra, Anna, 311
Carra, Robert, 311
Carson, Bill, 151, 179
Carson, Carol Devine, 345
Carter, Marc, 100
Carton, Libby, 159
Casado, John, 143, 228
Casella, Margaret, 137
Catanzaro, Kimberley, 79
Cerio, Steven, 120
Cetta, Al, 89
Chadwick, Helen, 305
Chafe, Eric, 317
Challis, Chris, 143
Chan, Amos, 283
Chantry, Art, 97, 102, 123, 124, 203, 280
Chapin, David, 153
Cheap Art, 109
Cheng, George, 310
Cherkas, Michael, 283
Chermayeff, Ivan, 84, 85, 199, 237
Chermayeff, Jane Clark, 84, 85
Chernush, Kay, 272
Cheung, Mark F., 2
Ching, Donna, 161
Christie, Jim, 165, 220, 242
Chu, Joy, 81, 316
Chwast, Seymour, 84, 88, 94, 127, 134, 183, 258, 314
Claesz, 305
Clark, Christina, 261
Clark, John, 261
Clark, Philip F., 2
Clark, Tim, 151, 258
Clarke, Bob Carlos, 272
Clarke, Greg, 115
Clayton, Carol, 272
Cloud, Jerome, 80
Coe, Karla, 325
Coe, Laura, 316
Coe, Sue, 120
Cohen, Steve, 246
Colvin, Alan, 194, 234
Comstock Photographics, 246
Comte, Michelle, 165, 220
Connors, Tom, 219
Conradt, Sarah, 332
Cook, Dan, 277
Cook, Roger, 72
Cooper, Barbara, 100
Copp, Karen, 313
Corwin, Jeff, 179, 197
Covington, Jeff, 261
Cox, Robin, 212
Crabtree, Lucinda, 233
Crane, Tom, 80
Creeley, Robert, 336
Cronan, Denise, 83, 91, 92, 343
Cronin, Denise, 83, 91, 92, 343
Crosby, Bart, 178
Crowe, Dennis, 191
Crowell, Beth A., 323
Crum, Lee, 143
Crump, Bill, 285
Cunningham, Scott, 120
Cuomo, Yolanda, 117
Curtin, Art, 258
Curtin, Paul, 151
Cuyler, Scott, 147
Curtis, David, 154
Curtis, Mel, 332

D

Dahlk, Randall, 155, 194, 208
Dakota, Michael, 225
Dale, John, 300
Davey, Charles, 300
Davidson, Cameron, 162
Davies, Valentine, 333

Davis, Clive, 184
Davis, Paul, 104, 115
Davison, Robert, 98
Dearwater, Andy, 151
Debarandiaran Irizar, Luis, 309
DeDuve, Thierry, 341
Defrin, Bob, 256
DeHeer, Rose, 114
Delano, Pablo, 289
Del Fabbro, Jorge, 290
Del Fabbro, Rebeca S., 290
Delgado, James, 307
De Luca, Joanne, 192
Dellis, Bob, 167
Denham, Stewart, 90
Devereux, Tara, 283
DeWilde, Barbara, 294, 309
Diaz, Henry, 101
Diaz, James, 326
Diener, Ruth, 182
Dillon, Diane, 326
Dillon, Lee, 326
Dillon, Leo, 326
Ditko, Steve, 292
Dix, Paul, 125
D'Moch, Lydia, 339
Donnelly, Marion C., 300
Doran, Walter, 167
Dorfsman, Elsa, 336
Dorfsman, Lou, 204
Downs, Bob, 334
Doyle, Stephen, 196, 303
Drenttel, William, 303
Drobinski, Antony, 341
Drummond, Scott, 227
Drury, Mark, 271
Druskin, Julia, 332
Dubal, David, 316
Dudzinski, Andrzei, 114, 290
Duffy, Joe, 87, 141, 238
Dumas, Ron, 194, 234
Dvorak, Scott, 278
Dyal, Herman, 172, 285
Dye, Jennifer, 179

E

Eastwood, Mark, 90
Edelman, Howard, 171, 206
Edelstein, Judith, 123
Edwards, Eddie, 114
Ehlers, Lesley, 299
Ehlert, Lois, 87, 315, 338
Ehrenfeld, Howard, 199
Eisenhardt, Roy, 307
Eisner, Ellen, 144
Els, Maria Vander, 339
Ema, Thomas C., 241
Emmenegger, Edie, 93
Endicott, Jim, 286
Eno, Brenda, 299
Espara, Bob, 130, 271
Esparza, Bob, 271
Ettlinger, Marion, 299
Evans, Christopher, 341
Evans, John, 72, 87
Everitt, Betsy, 314, 114

F

Farmer, Michael, 74, 81, 314, 326
Felix, Monique, 330
Felver, Chris, 336
Ferrari, Stephen, 219
Fey, Jeffery, 206, 286
Fieschko, Heidi, 152
Filancia, Camila, 314, 316
Fisher, Greg, 292
Fisher, Mike, 269
Flake, Stuart, 99
Fleischman, Paul, 75
Flynn, Dan, 251
Foos, Ellen, 299
Foote, Debra, 162
Forbes, Colin, 161
Forth, Ron, 341
Fox, Mark, 96, 115, 124, 129, 186, 201, 237, 279
Fox, Neill, 217
Francher, Lou, 83
Francis, Scott, 303
Franek, David, 162
Frank, Mark, 120
Franklin, Charly, 166
Frasier, Debra, 81
Frasier, Mike, 234
Frazier, Craig, 228, 285
Freeman, Josh, 277
Friedman, Julius, 119
Fudyma, Janice, 124
Fuller, Joel, 225, 242

G

Gagliostro, Vincent, 110
Galatis, Michael, 325
Gallagher, Tess, 299
Gallay, Damien, 206
Garcia, Art, 254, 261
Garcia, Stephanie, 154
Gardner, Beau, 76
Garrett, Malcolm, 242

Garvens, Derek, 90
Geer, Mark, 269
Gehshan, Virginia, 80
Geisey, Paul O., 325
Geismar, Pamela, 212
Geismar, Thomas, 188, 267, 289
Geissbuhler, Steff, 82, 267
George, Hershell, 244
Gerhold, Bill, 251
Gericke, Michael, 161
Geske, Randy, 246
Getman, Judith Fletcher, 2
Gibbons, Kaye, 320
Gibson, Samantha, 192, 292
Gill, Dave,
Gill, Duana, 225, 272
Ginsberg, Allen, 328
Glaser, Byron, 218
Glass, Michael, 141
Glassner, Lester, Collection of, 333
Glatved, Agnethe, 181
Glauber, Barbara, 300
Glaviano, Gregg, 71, 272
Glenn, Joel, 228
Glinn, Burt, 223
Goavec, Pierre Yves, 272
Godard, Keith, 66, 87, 91
Gokl, Renate, 137
Goldenberg, Carol, 346
Goldman, Shifra, 344
Golub, Leon, 120
Goodman, Richard, 344
Grady, Kerry, 141
Graham, Leean, 296
Grant, Bill, 256
Grant, Tony, 79
Gray, Andrew, 196, 303
Gray, Bryan, 90
Green, Michelle, 314
Greenleigh, John, 210, 271
Greiman, April, 300, 302
Grigsey, Bill, 144
Gruber, J. Richard, 325
Guarnaccia, Steven, 84, 144
Gulley, Jan, 178
Gumpert, Lynn, 321
Guthrie, Michael, 201
Gutzwiller, Marla, 70

H

Hadad, Daniel, 85
Hagami/Carroll, 214
Hageman, Deborah, 228, 285
Haggerty, Mick, 166
Hale, Tim, 155
Haldeman, Brock, 149
Hambly, Bob, 233
Hampton, Holly, 147
Hansen, Biruta Akerbergs, 326
Hardie, Elizabeth, 92
Hardt, Roy Eisen, 307
Harr, Bob, 151
Harrington, Ollie, 120
Harrison, Peter, 206
Hartman, Terri, 300
Hauswirth, Todd, 214
Havie, Robert, 79
Hayashi, Keiko, 334
Heal, Patricia, 158, 173
Heck, Matt, 211
Heffernan, Terry, 156
Heiselman, Karl, 82
Heinz, Julie, 133
Heller, Steven A., 154
Hellman, Danny, 120
Helton, Linda, 227, 254
Hendel, Richard, 309, 313
Hendershot, Matt, 271
Henry, Leigh, 88
Hentges, Michael, 303
Hermes, Mary, 254
Herner, Becky, 246
Herrick, Lee, 334
Hersey, John, 114, 115, 166
Hershscovitch, Diana, 153
Hewitt, David W., 344
Hibler, Janie, 345
Hicks, Mike, 225, 279
Hiebert, Kenneth J., 296
Higashi, Sandra, 218
Hinrichs, Kit, 130, 154, 166, 271, 283
Hinrichs, Linda, 151, 159
Hodgson, Michael, 168
Hoefig, Nancy, 159
Hoefler, Jonathan, 134, 181
Hofmann, Armin, 265
Holland, Brad, 122
Holt, Dave, 286
Holzberg, Karen, 272
Homans, Katy, 306, 328
Hooykaas, Gerben, 283
Hopfensperger, Alan, 78
Horton, Tom, 245
Hough, David, 314, 316, 333, 334
How, Belle, 166, 271, 283
Howard, Kim, 76
Howard, Richard, 305
Howard-Kemp, Daina, 293
Huber, Paul, 186

Huber, Vic, 223
Huerta, Gerard, 320
Hughes, Andy, 339
Humphrey, Debra Johnson, 241
Hunter, Kent, 182, 256
Hurlbut, Angie, 318

I

Igarashi, Takenobu, 166
Ignacio, Cynthia, 310
Iguchi, Yasuyo, 300, 306, 341
Ingram, Fred, 75, 194
Ishioka, Eiko, 265
Ivester, Devin, 133

J

Jackson, Morton, 199
Janello, Amy, 323
Jarecke, Ken, 121
Jay, John, 168, 220, 242, 261
Jazak, Alan, 113
Jazquez, Richard, 101
Jeffries, Ron, 214
Jellow, Barbara, 336
Jennings, Beth, 81
Jennings, Hannah, 93
Johnson, Chuck, 152, 184
Johnson, Haley, 155, 194, 201, 258
Johnson, John, 316
Johnston, Keith, 173
Jones, Brennon, 323
Jonston, Keith, 158
Joseph, Mark, 156, 241
Joseph, Peter, 325
Jost, Larry, 251, 254
Joyce, William, 83
Junior League of Jackson, The, 318

K

Kaake, Philip, 114
Kalin, Tom, 328
Kalman, Maira, 331
Kalman, Tibor, 331
Kaminsky, Tom, 212, 233
Kanai, Kiyoshi, 97, 126
Kane, Art, 145
Kang, Alice, 305
Kanner, Mitch, 182
Karier, Nancy, 114
Katona, Diti, 223, 269
Katz, Joel, 318
Kawakami, Mark, 206
Kelly, Jerry, 337
Kendall, DeWitt, 107
Kenny, Tim, 246
Kern, Geof, 141, 166, 256, 289
Kidd, Chip, 294
Kiddy, John, 69
Kinsella, W.P., 332
Kirpich, Judy, 272
Kirstein, Bill, 90
Klein, Howard, 318, 342
Klistner, Dan, 90
Klotnia, J., 159
Klotz, Michael, 141
Kluepfel, Thomas, 181
Koc, Nancy E., 307, 286
Koegel, Jeff, 335
Kornblum, Allan, 332
Kortum-Stermer, Jeanie, 101
Kostelny, Emil, 107
Koudys, Mark, 283
Kozloff, Max, 328
Kramer, Myra, 79
Kretschmer, Hugh, 114
Krommes, Beth, 313
Kross, Marnie, 87
Kubata, Yasuo, 204
Kuhlmann, Deanna, 290
Kuper, Peter, 118, 120, 139
Kuhn, Richard, 335

L

Lacava, Vincent, 310
Lacomb, Brigitte, 142
Lamarche, James, 79
Lambertus, James, 103
Lamotte, Michael, 279
Lamoureux, Terry, 300, 341
Landesberg, Rick, 136, 204
Lapine, Lian, 251
Langley, Dan, 142, 143, 168
LaRochelle, Lisa, 103
Larson, Jeff, 278
Latham, Laura, 246
Lau, Rose, 114
Laub, Elizabeth, 278
Lavoie, Brenda, 203
Lay, Carol, 97
Laycock, Margaret, 279
Leach, Molly, 346, 347
Leacock, Robert, 165, 220
Leaman, June, 72
Lebon, George, 182
Lebron, Michael, 125
Ledzian, Mark, 192
Lee, Gloria, 114
Lee, Norm, 156
Lee, Sandy, 334

Leendertse, Jeannet, 341
Leeson, Lisa, 175
Leibovitz, Annie, 272, 320
Leimer, Kerry, 283
Leister, Bryan, 246
Leiva, Loretta, 72
Lessing, Doris, 339
Levine, Laura, 286
Lev, Dorit, 325
Lewis, Richard, 309
Lewis, Tim, 286
Lin, Ian, 310
Lionni, Leo, 92
Liska, Steve, 149, 152
Lisker, Emily, 111
Littrel, Kandy, 305
Livne, Gil, 214
Locke, Peter, 151, 258
Louey, Robert, 133
Lynaugh, Matthew, 114
Lyons, Andy, 230

M

Mabry, Michael, 142, 161, 186, 225, 279, 334
Macapia, Paul, 325
Mackenzie, Jill, 332
Mackin, Beth, 313, 320, 344
Madere, John, 219
Madisia, Joseph, 102
Magleby, McRay, 112, 161, 166
Manley, Bob, 212
Marchese, Frank, 143
Marchionna, Thom, 79
Marciano, Paul, 192, 292
Marks, Andrea, 272
Mark, Mary Ellen, 118
Markfield, Julie, 214
Marquand, Ed, 325
Marshall, Richard, 304
Marshall, Rita, 88, 330
Martensen, Christine, 114
Martini, John A., 307
Matcho, Mark, 98
Mathers, Petra, 91, 345
Matsuda, Paul, 133, 210
Matsui, Iwao, 322
Matsumoto, Takaaki, 73, 113
Mauk, Mitchell, 262
Mayor, Bill, 71
Mayer, Nancy, 96, 104
Mazer, Anne, 83
Mazzucchelli, David, 309
McCarney, Jean, 173
McCartney, Jean, 158, 246
McConnell, Kim, 306
McCoy, Gary, 69
McCoy, Katherine, 302
McCurdy, Michael, 343
McDonald, Jock, 210
McDonald, Mercedes, 114, 115
McDougall, Kristin, 241
McEvilley, Thomas, 305
McGillicuddy, Kim, 101
McGinn, Michael, 73, 113
McMullan, James, 286, 339
McTear, Jackie, 237
Melandri, Michele, 234
Menarchy, Dennis, 234
Mendez, Rebeca, 144, 238
Meraz, Tim, 223
Merikken, Bill, 161
Meunch, David, 233
Meyerson, Arthur, 178
Michals, Duane, 328
Miho, Jim, 145, 176
Miller, Edward, 91
Miller, Sandro, 156, 201
Milsal, D'Miles, 90
Miriello, Ron, 344
Mitchell, Fran, 317, 336
Monderer, Stewart, 98
Montebello, Joseph, 320
Moore, Helene, 197
Moore, Peter, 303
Morava, Emmett, 277
Moreno, Chery, 210
Morgen, Scott, 206, 272
Morla, Jennifer, 149, 173, 201, 227
Mortensen, Chris, 115
Moskoff, Martin, 74
Moss, James, 108, 114
Moul, Robert, 175
Mueller, Jeffrey, 342
Muench, Allison, 211
Mulligan, Todd A., 99, 105
Munk, Paula, 344
Murakami, Piper, 154, 197
Musgrove, Will, 96, 99
Musser, Jerry King, 227
Myer, Eric, 284
Myers, Barton, 300
Myers, Chris, 96, 104
Myhre, Gordon, 269

N

Nakamura, Joel, 290
NASA, 133
Naughton, Carol, 343
Neleman, Hans, 272

Nelson, Will, 271
Nesnadny, Joyce, 179, 283
Newsbury, Jeffry, 103
Nicholls, Chris, 269
Ng, Lian, 251
Ng, Ricky Yuk-Kwang, 310
Ng, Simon, 203
Nicholas, Teresa, 318
Nix, Carol, 153
Norberg, Marc, 201
Norden, Dr. Beth B., 326
Norman, John, 271
Novack, Michelle, 278
Nudo, Jim, 75

O

Oddo, Tommy, 127
O'Keefe, Timothy, 302
O'Reilly, Kathleen, 105
Oldenburg, Claes, 341
Oliver, Douglas, 284
Olson, Daniel, 155, 194, 208, 214, 258
Olvera, Jim, 212, 242
Ormsby, Lawrence, 307
Ortiz-Lopez, Dennis, 238
Osborne, Mary Pope, 343
Oswald, Frank, 146
Ottinger, Mary, 92
Owen, Hilda Strauss, 318
Oziersk, Elizabeth, 143

P

Paar, Susan, 300
Packer, Francis, 262
Palca, Doris, 304
Palma, Jim, 244
Panzer, Chris, 237
Pappas, Rebecca L., 337
Paramski, Scott, 238
Parisi, Joe, 199
Parkhurst, Ken, 265
Park-Taylor, Michael, 324
Pattee, Steve, 230
Payne, Ward, 203
Peltz, Glenn, 269
Penoyer, Barbara, 143
Perkins, Mark, 212
Perman, Fred, 172
Peteet, Rex, 69, 85, 142, 334
Peterson, Bryan L., 176, 238
Phillips, Lou, 76
Piaczny, Keith, 244
Picayo, Jose, 165
Piercy, Clive, 168
Pieroni, Lynn, 326
Pigott, Peter, 69
Pike, Karen, 338
Pirtle, Woody, 159, 211
Polite, Kerry, 162
Pollard, Adrienne, 126, 225
Pollard, Jeff, 126, 170, 225
Powell, Kimberly Lentz, 129, 233
Power, Stephanie, 203
Prato, Rodica, 318
Pritzker, Burton, 206
Puccinelli, Keith, 278
Pylypczak, John, 223, 269

Q

Queen, Mark, 70

R

Radice, Judi, 233
Raglin, Tim, 84
Ramage, Russ, 256
Raphaele, 151
Ratcliffe, Carl, 101
Rattan, Joe, 280
Redford, Bruce, 316
Reeve, Margaret, 302
Reid, Fitzcarl, 101
Reid, Nancy, 338
Reinhardt, Susan, 313
Renda, Molly, 313, 320, 344
Renick, Steve, 317, 336
Reynoso, Bernardino, 153
Rice, Felicia, 299
Rice, Ray, 299
Richards, Carol, 168
Richards, Dan, 227
Richardson, Clark, 254
Richardson, Valerie, 217
Rigsby, Lana, 199, 205, 267
Riley, Jan, 341
Risedorph, Sharon, 322
Ritscher, Paul, 251
Ritterman, Philipp Scholz, 344
Rivlin, Hornick, 218
Robert, Francois, 139, 254, 302
Robinson, Barry, 166, 167
Robinson, Ray, 99
Robledo, Maria, 290
Rodriguez, Belgica, 344
Rogers, Sara, 234
Rogge, Robie, 81
Romberger, James, 120
Rood, Don, 156
Rose, Peter, 234
Rosenberg, Merlyn, 206

Rosenthal, Ellen, 343
Roth, Del Rae, 311, 322
Roth, Tom, 252
Rotondi, Michael, 302
Rover, Chris, 289
Rubin, Laurie, 152
Rubino, Regina, 133
Ruschak, Lynette, 326
Rush, Michael, 136
Russo, Anthony, 142, 159, 166
Ryan, Thomas, 251

S

Sackett, Mark, 71, 76
Sahre, Paul, 237
Salisbury, Mike, 171, 206
Salsgiver, Karen, 321
Salstrand, Duane, 153
Salway, Ann, 117
Samata, Greg, 156, 201, 241
Samata, Pat, 201, 241
Sanca, Richard, 242
Sanchirico, Jean, 76, 233
Santagto, Valerie, 335
Sante, Luc, 309
Sapir, Marc, 303
Savage, Paula, 127
Savitski, Mike, 136
Schaefer, Gilberto, 69
Schaefer, John, 69
Schaefer, Cathey, 188
Schama, Simon, 305
Schanilec, Gaylord, 332
Schenke, William, 81
Scher, Paula, 137, 181, 183
Schlieman, Oren, 112, 223
Schrack, Thea, 114
Schroeder, Al, 107
Schulte, Lynn, 70, 78, 238
Schultz, Steven, 80
Schumaker, Ward, 338, 114
Schuman, Tim, 230
Schwab, Michael, 139, 161, 230
Schwartz, Mark, 179
Scricco, Mike, 143, 225
Seabaugh, Max, 197
Segal, Mark, 162
Selfe, Mark, 154, 159, 166
Serrano, Jose, 165
Shanosky, Don, 72, 147
Shapazian, Robert, 342
Shelton, Sam, 246
Shinn, Bill, 237
Shipmas, Chris, 242
Shortall, Alan, 249
Sibley, Don, 334
Siebert, Diane, 89
Sievert, Claus, 307
Sikorsky, Joy, 342
Silber, Julie, 322
Silton, Susan, 98
Silverman, Helene, 106
Silvio, Sam, 249
Simon, John, 72, 79
Simone, Dean, 90
Sims, Jim, 151
Sims, True, 322
Sirota, Peggy, 234
Skach, Peter, 93
Smith, Ira, 212
Smith, Lane, 346, 347
Smith, Maggie, 118
Smith, Randall, 146
Smith, Ron Baxter, 223, 283
Smith, Tyler, 111
Smith, Valerie Taylor, 143
Smolan, Leslie, 93, 211
Snoreck, Tom, 246
Sofflet, Mary, 344
Solem, Joe, 112
Sommese, Lanny, 104, 120, 208
Smidt, Sam, 146
Spalenka, Gary, 166
Spero, Nancy, 120
Spivack, Peter G., 122
Spoerl, Wolf, 166
Sposato, John, 72
Stafford, Barbara Maria, 306
Stahl, Trina, 333
Stearns, Christopher, 328
Steele, Tommy, 206, 272, 286
Stees, Mike, 249
Stens, Nancy, 251
Stepping, Jon, 254
Sterling, Tom, 242
Stermer, Dugald, 101
Steube, June, 223
Stewart, Martha, 318
Stier, K., 159
Stiles, Kelly, 230
Storr, Robert, 303
Stowell, Scott, 331
Streeper, Jeff, 320
Strindberg, August, 342
Stromberg, Bruce, 204
Stroud, Marion Boulton, 306
Studley, Vance, 265
Sturgeon, Inju, 265
Sullivan, Renee, 115

Sullivan, Ron, 212, 227, 254, 261
Sumgarner, Kristin, 82
Summerford, Jack, 242, 252, 265
Sunselman, Michael, 162
Suter, David, 277
Sutherland, Cam, 309
Sutton, Liz, 210
Suzuki,Takashi, 311
Swenson, Tree, 299
Sweitzer, Glenn, 258
Sylvester, Mark, 302

T
Tafoya, Terry, 103
Tan, Virginia, 305, 339, 345
Tanner, Voldi, 114
Taran, Z., 199
Taylor, Megan A., 264
Tharp, Rick, 79
Thomas, Columbia, 100
Thompson, Tim, 199
Thrill, Nancy, 302
Timmerman, 217
Tobin, Pat, 75
Tobocman, 118
Tombs, Robert, 324
Towey, Gael, 318
Tracy, Tom, 283
Trapp, Doug, 219
Treuhaft, Jane, 342
Truglio, Gwynne, 117
Tscherny, George, 278
Tsuchiva, Susan, 167
Tucker, Bill, 143
Twain, Mark, 334
Tyler, Ann, 123

U
Ugay, 90
Ulricksen, Mark, 115
Unitec, Philip, 306
Unruh, Jack, 265

V
Valentine, Robert, 165, 172, 290
Valentino, Danielle, 315
Vallen, Mark, 121
Vander Els, Maria, 339
Vanderpoel, Fred, 252
Van Dyke, John, 184, 280
Van Haafen, Heather, 149
Van Kessel, Katherine, 81
Vasquez, Tom, 184
Vaughn, Rick, 251, 335
Viesti, Joe, 159
Vizcarra, Henry, 258
Vogel, Morris J., 318
Von Unwerth, Ellen, 292

W
Wageman, Jim, 326
Wajdowicz, Jurek, 103
Wakely, David, 245
Waldron, Sarah, 184
Walker, Liz, 331, 346, 347
Walker, Polly, 120
Walker, Rachel, 121
Walker, Stephen, 272
Wallerstein, Warren, 314, 339
Walster, Nicholas, 341
Warinner, Kathy, 82
Warren, David, 175
Watson, Stuart, 269
Waterbury, Todd, 141, 184, 289
Wedeen, Steve, 251
Weinstein, Iris, 305
Weir, Denise, 251
Weisbecker, Phillipe, 166
Weisner, David, 346
Weithman, Jeff, 271
Weitz, 136
Weizman, David, 89
Weller, Don, 157
Wells, Josh, 108
Wells, Wendy, 192
Werner, Sharon, 87, 184, 231, 289
Wescott, Michael, 175
Westby, Marcia, 325
Wetherbee, Michele, 97, 111
White, Elizabeth, 141, 341
Whitman, 199
Wides, Susan, 323
Widstrand, Russ, 133
Wilcox, Jean, 300
Wild, Lorraine, 300
Wilson, Lori, 141
Wilson, Marjo, 144
Willard, Nancy, 326
Williams, David, 188
Williams, Emmett, 91
Williams, Jonathan, 336
Williams Jr., Everard, 290
Williams, Lowell, 151, 179
Williams, Mark, 125
Wimmer, Mike, 89
Winsor, Jane, 98
Winter, Jeannette, 92
Winters, Linda, 299
Wolf, Henry, 186

Wolf, Doug, 188, 286
Wolfman, Claire, 272
Wood, Audrey, 74
Wood, Tom, 245
Wood, Don, 74
Wooley, Barb, 233
Woodward, Fred, 118, 238
Woody, Jack, 328
Wu, Kar, 194
Wyman, Jake, 244

X
Xavier, Rodger, 277

Y
Yagi, Ritsuko, 311
Yagi, Tamotsu, 311, 322
Yaguchi, Tom, 283
Yamashita, Keith, 271
Yelvington, Judith, 335
Yenawine, Philip, 73
Young, Carrie, 313
Yourgrau, Barry, 342
Yuen, Kin, 256

Z
Zampitella, Alicia, 212, 233
Zaref, Mark, 305
Zea, Gloria, 344
Zenuk, Alan, 184
Zeschin, Elizabeth, 318
Zepponi, Frank, 106
Zeto, Toni, 342
Zimmerman, Neal, 190

Design Firms and Agencies

A
A Boy, A Girl and A Little of Both, 114
ACT UP/New York, 110
Akagi Design, 129, 233
Anderson & Lembke, 252
Ann Tyler Communcation Design, 123
Apple Creative Services, 210, 271
Art Center College of Design, Pasadena, 144, 238
Art Chantry Design, 97, 102
Art Directors Association of Iowa, 286
Atlanta Art & Design, 283

B
Barton-Gillet, 237
Bauer Design, 108, 110
Beau Gardner Associates, 76
Berhardt Fudyma Design Group, 124
Bielenberg Design, 228
Blackdog, 96, 124, 129, 186, 201, 237, 279
Bloomingdale's, 165, 220, 242, 261
Brainstorm Inc., 152, 184
Brigham Young University/BYU Graphics, 112
Burstein/Max Associates, Inc., 114
Butler, Inc., 69

C
Cahan & Associates, 99
Campbell Fisher Ditko Design, 292
Capitol Records, Inc., 149, 206, 272, 286
Carbone Smolan Associates, 93, 211
Center of Contemporary Art, 280
Charles S. Anderson Design Company, 155, 194, 201, 208, 214, 258
Cheap Art, 109
Chermayeff and Geismar Associates, Inc., 82, 188, 199, 237, 267, 289
Citizens Committee for New York City, 101
Cloud and Gehshan Associates, Inc., 80
Concrete Design Communications Inc., 223, 269
Cook and Shanosky Associates, Inc., 72, 147
Crabtree & Jemison, Inc., 233
Critical Mass, 108
Crosby Associates, Inc.,
Curtis Design, 154

D
Dako Design, 153
David Carter Graphic Design Associates, 141
DeFrancesco & Deluca, Inc., 192
Design!, 256
Design: Marks, 272
Designwise, Inc., 290
DeWitt Kendall Design, 107
Don Rood Design, 156
Drenttel Doyle Partners, 181, 196
Duffy Design Group, The, 70, 87, 141, 184, 231, 238, 289

E
Ema Design, 241
Emerson, Wadjowicz Studios, Inc., 103
Epstein, Gutzweiller & Partners, 80

F
FitchRichardsonSmith, 175
Forma, 153
Franck Design Associates, Inc., 162
Frankfurt Gips Balkind, 139, 182, 256
Freeman & Karten, 277

Frazier Design, 228, 285
Fuller Dyal & Stamper, 172, 285

G
Geer Design, Inc., 269
George Tscherny, Inc., 278
Grafitto, 199
Graphic Communications Ltd., 272
Graphic Expression, Inc., The, 219
Guesler Associates, 192, 293
Guess?, Inc., 192, 292
Gunselman + Polite, 162

H
H$_2$O, 103
Hambly & Wooley, Inc., 233
Hawthorne Wolfe, Inc., 188, 286
Hello Studio, 106
Henry Wolf Productions, 186
Hershell George Graphics, 244
Higashi Glaser Design, 218
Hixo, Inc., 225, 279
Hoefler Type Foundry, The, 134, 181
Hornall Anderson Design Works, 251, 254

I
Images, 119
Info Graphik, 112, 223
Innovation Advertising & Design, 69
Invisions Ltd. Design, 246

J
J. P. Morgan Corporate Identity and Design, 283
John Bricker, 293
John Sposato Design, 72
Joseph Rattan Design, 280

K
Kaminsky Design, 212, 233
Keiler & Company, 143, 225
K.I.D., 90
Kimberley Baer Design Associates, 100
Kinetik Communication Graphics, 246
Kiyoshi Kanai, Inc., 97, 126
Koc Design, 286
KORE, 105
Kym Abrams Design, 249

L
Landesberg Design Associates, 136, 204
Larsen Design Associates, 278
Lausen Williams & Company, 188
Leimer/Cross Design, 283
Liska and Associates, Inc., 149, 152
Lou Dorfsman Inc., 204
Louey/Rubino Design, 133

M
M.A.D., 241
Mauk Design, 262
McCool & Company, 219
Meraz Design, 223
Michael Brock Design, 293
Michael Glass Design, Inc., 141
Michael Mabry Design, 142, 161, 186, 225, 279
Michael Schwab Design, 139,161, 230
Miho, 145
Mires Design, Inc., 165
Miriam Berman Graphic Design, 81
Morava Oliver Berte, 133, 269, 277, 284, 290
Morla Design, 149, 173, 201, 227
M Plus M, 73, 113
Musser Design, 227

N
Nature Company, The, 76, 82, 233
Nesnadny & Schwartz, 179
Nike Design, 143, 194, 234, 271
Notovitz Design, Inc., 214

O
Office of Mayer & Myers, The, 96, 104

P
?Paradox?, 79
Paterson Wood Partners, 245
Pattee Design, 230
Paul Curtin Design, 151, 258
Paul Davis Studio, 104, 115
Pentagram, 130, 137, 151, 154, 159, 161, 166, 167, 181, 183, 197, 206, 211, 249, 271, 277, 283
Peter G. Spivack, 122
Peterson & Company, 176, 238
Ph.D., 168
Pinkhaus Design Corp., 225, 244
Pollard Design, 126, 170
Powell Street Studio, 151
Polygram Records, Inc., 141, 182
Pucinelli Design, 278
Pushpin Group, The, 84, 88, 134, 258

R
Reactor Art & Design Limited, 203
Red Herring Design, 256
Review and Herald Publishing Association, 90
RG Design, 199
Richardson or Richardson, 217
Rigsby Design, 199, 205, 267

Robert Valentine Inc., 165, 172, 290
Rolling Stone Magazine, 118

S
Sackett Design, 71, 76
Salisbury Communications, Inc., 171, 206
Samata Associates, 156, 201, 241
Sam Silvio Design, 249
Sam Smidt, Inc., 146
Savage Design Group, 127
Sibley/Peteet Design, 69, 72, 85, 87, 142
Siquis, Ltd., 218
Sisman Design, 212
Society of Publication Designers, 238
Sommese Design, 104, 120, 208
SOS, 98
Stewart Monderer Design, Inc., 98
Studio A, 100
Studio Graphics, 114
Studio John Clark, 261
StudioWorks, 66, 87
Sullivan Perkins, 212, 227, 254, 261
Summerford Design, Inc., 242, 252, 265
Sun Creative, 133
Sussman/Prejza & Company, Inc., 147

T
Tandy Belew Design, 115
Tharp And/Or Marchionna, 79
The Pushpin Group, 94, 127
30/Sixty Design, 258
Thomas Ryan Design, 251
Tim Kenney Design, Inc., 246
Todd Mulligan Graphic Design, 99, 105

U
United Nations Transition, 102

V
Van Dyke Company, 184, 280
Vaughn/Wedeen Creative, 251
VSA Partners, Inc., 139, 254

W
Walker Art Center, 242
Ward Payne, 203
WSMV-TV 4, 70
WYD Design, 146
Weller Institute for the Cure for Design, Inc., 157
Wetherbee Design, 97, 111

Y
Yolanda Cuomo Design, 117
Youth Force, 101

Z
Zimmermann Crowe Design, 190, 191

Clients and Publishers

A
Active8, Inc., 199
ACT UP/New Haven, 108
A&D Forum, 151
Advanced Automation Associates, Inc., 290
Alcoa Foundation, 204
Alexander Communications, 149
Alfa Romeo North America, 223
Alfred A. Knopf, 83, 91, 92, 305, 339, 343, 345
Algonquin Books of Chapel Hill, 313, 320, 344
Alley Theater, 267
Allsteel Inc., 156
Ambassador Arts, 181
American Center for Design, 302
American Indian AIDS Institute (AIAI), 103
American Institute of Graphic Arts, 66, 94, 130, 149, 186, 237, 246, 249
American Red Cross/Greater Cleveland and Northern Ohio Blood Services, 107
Amev Holdings, Inc., 244
Amway Limited, 321
Ann Minuzzo, 201
Apple Computer, Inc., 210, 271
AP3C Architects, 272
Archetype Press, 336
Art Center College of Design, 154
Architects, Designers & Planners for Social Responsibility, 97
Architecture & Design Forum, 159
Art Museum of Santa Cruz County, The, 79
Association Typographique International, 181
Atlantic Records, 256

B
Ballet Makers, Inc., 192
Barber Ellis, 208
Barton Myers Associates, 300
Bay Press, 328
Bella Blue, 139
Binding Industries of America, 119
Blue, Bella, 139
Boyer Printing Company, 227
Brio Scanditoy, 79
Broadmoor Baker, 254
Brookfield Zoo, 93
Busz Words, 105

C

California Crafts Museum, 76
Callaway/Knopf, 322
Canada Post Corporation, 203
Canoe Clothing Company, 223
Capitol Records, 206, 286
C-Cube Microsystems, 186
Centocor, Inc., 219
Central and Southwest Corporation, 242
Centre Reinsurance, 146
Champion International, 159, 181, 183
Charlotte Zolotow Books, 75
Chicago Board of Trade, 254
Chronicle Books, 338
Clarion Books, 346
Clarkson N. Potter, Inc., 318, 342
Cloud Nine, Inc., 258
Coffee House Press, 332
Cole & Weber, 142
Coleman Advocates for Children, 101
Collin Creek Mall, 142
Compton Press, 214
Contemporary Arts Center of Cinncinati, The, 341
Coastal Corporation, The, 269
Cook-Ft. Worth Children's Medical Center, 69
Cooper-Hewitt Museum, The, 196
Corcoran Gallery of Art, The, 204
Cracker Barrel Old Country Store, 251
Crane & Co., 267
Creative Education, Inc., 88, 330
Creativity for Kids, 70
CRI Incorporated, 162
CUA Vision, The, 153
Customweave Carpets, 256

D

Dallas Museum of Art, 69, 85
Dallas Society of Visual Communications, 212, 214
Data I/O, 184
David R. Godine, 89
Dawydiak Auto Sales, 154
Day Without Art at Yale, 114
Delacorte Press, 73
Deleo Clay Tile, 165
Designing New York, 249
Des Moines Metro Solid Waste Agency, 230
Dick Friel, John Brown & Partners, 122
Digital Equipment (Canada), 283
Disney Home Video, 258
Display Letter & Copy, 228
Design Industries Foundation for AIDS (DIFFA), 139
Discovery Toys, 90

E

Earth Day Committee, The, 127
Earth Technology Corporation, The, 277
Ear Wear, 153
East End Gay Organization, The, 115
Echo International, 258
Eclat, 151
EG&G, Inc., 206
Eichhorn, Dennis P., 97
Estee Lauder, 72
Eurotype, 228
Evangelical Health Systems, 188
Expeditors, International, 283
Expervision, Inc., 26

F

Fairchild Corporation, The, 272
Fallon McElligott, 184
Farrar Straus Giroux, 309
Federation of Jewish Philanthropies, 104
First Mercantile Currency Fund, 223
Fossil Watches, Inc., 155
Fox River Paper Company, 231
Freedom House, 103
Fresh Force Youth Volunteers, 70, 78
Friend & Johnson, 238
Furon, 214

G

Gear Daddies, 182
Gendex Corporation, 241
George A. Miller Committee, 123
George For Dogs, 225
George Mecca, 184
Gilbert Paper Company, 124, 172, 290
Giltspur Boston, 175
Give Peace a Chance, 122
Give Peace a Dance, 123
Golden Arts, 175
Golden Gate National Recreation Area, 307
Gorbechev Visit Committee, 238
Gotcha! Sportswear, 171, 206
Graphic Arts Center, 271
Graphic Terrorist Organization, 124
Graywolf Press, 299
Grenville Printing and Management, 203
Grey Advertising, 220
Guess?, Inc., 292

H

Habitat Designs Ltd., 165
Hankyu Hotels Corporation, 161

Harcourt Brace Jovanovich, 74, 81, 83, 314, 316, 326, 333, 339
HarperCollins, 75, 87, 89, 315, 320
Harry N. Abrams, Inc., 85, 323
Harvard University Collection of Scientific Instruments, 212
Heritage Press, 334
Herman-Miller, Inc., 278
Houghton-Mifflin Company, 93

I

IBM, 186
Illinois Film Office, 249
Illinois Gay and Lesbian Task Force, 107
International Design Conference of Aspen, 84
International Paper, 152
International Typeface Corporation, 337
Intertrans Corporation, 254
Iowa State University College of Environmental Studies, 128

J

James H. Barry Company, 279
Jeff Corwin Photography, 179
John Portman Companies, 151
J.P. Morgan & Co., 283
J.P. Stevens/Westpoint Pepperell, 246
Junior League of Jackson, MS, The, 318

K

Kane, Art, 145
Knoll Group, The, 188, 199, 267
Kotch, Rebecca, 234

L

Lapis Press, The, 342
Larson Design Associates, Inc., 278
L.A. Style Magazine, 293
Lee Jeans, 87
Legal Aid Society of San Francisco, The, 96
Levi Strauss & Company, 190, 191
Linda Leibman Human Rights Fund, The, 115
Liz Smith, 123
Logicon, Inc., 133
Los Angeles Festival, 105
Lothrop, Lee & Shepard, 76
Louis Dreyfus Property Group, 245
Luna Notte Restaurant, 279

M

Mervyn's, 258
Martex/Westpoint Pepperell, 158, 173
M.I.T. Press, The, 300, 306, 341
Milton Bradley, 72
Minneapolis College of Art and Design, 105
Minnesota AIDS Project, 219
Meltzer & Martin, 227
Metropolitan Meals on Wheels Program, 99
Metropolitan Museum of Art, 81
Metropolitan Transportation Corporation, 286
Mohawk Paper Mills, 134, 188
Mon Jardinet, Ltd., 161
Moving Parts Press, 299
Museum of Contemporary Art, Los Angeles, 176
Museum of Modern Art, The, 73, 74, 303

N

National Constitution Center, 104
National Desktop Color Alliance, 246
National Junior Tennis League, The, 99
National Park Service, 289
Natural Wonders, 146
Neenah Paper, 141
New York City Department of Health, Department of AIDS Services and Programs, 114
New York City Department of Cultural Affairs, 82
Nike, 75, 142, 168, 194, 234
Noranda, Inc., 269
Norcen, 197
Northwestern National Life, 264
Novatrix, 69

O

Overseas Products International, Inc., 155
Owens Art Gallery, 324

P

Padgett Printing, 152
Palais D'Amour, 201
Pantone, Inc., 211
Paragraphics, 230
Parallax Theater Company, 277
Park People, 141
Pecos River Learning Center, 335
Penguin Books/Viking, 81
Penner, Meryl, 127
Perkins Shearer, 161
Peter Joseph Gallery, 325
Pinkhaus Publications, Inc., 244
Plastocor, 233
Polygram Records, 141
Potlatch Corporation, 283
Pratt Institute, School of Graphic Arts, 310
Princeton University Press, 316
Progressive Corporation, The, 179
Propaganda Factory, 112
Publix Super Markets, 269
Puget Sound Marketing Corporation, 251

R

Rabbit Ears, 84
Reactor Gallery, 144
Real Restaurants, 279
Red Hot & Blue, 106
Results, 71
Rhode Island Project AIDS, 111
Rhode Island School of Design, 137
Rizzoli International Publications, 300, 341
Robundo Publishing, 311
Rockwell International, 133
Rogers Display Company, 80
Rouse Company, The, 227
Rubber Blanket Press, 309
Rumors of the Big Wave, 102

S

San Diego Museum of Art, 344
San Francisco AIDS Foundation, 114
San Francisco Area Pro-Choice Coalition, 97, 111
San Francisco Museum of Modern Art, 151
San Ramon Regional Medical Center, 241
Searle, 178
Seattle Art Museum, 325
Seattle Arts Commission, 332
SEI Corporation, 278
School of Visual Arts, Penn State, 208
Shaliko Company, 120
Shapiro, Leonardo, 120
Shay, Shea, Hsieh & Skjei Publishing Co., 297
Shooting Back, 100
Shosin Society, 112
Simon & Schuster, 299
Simpson Paper Company, 166
Smithsonian Migratory Bird Center, The, 233
Smithsonian National Museum of the American Indian, 265
Society for Contemporary Crafts, The, 136
Southern California Institute of Architecture, 302
Southern Methodist University, 176
Soutwestern Bell, 286
Springhill Paper, 212
Staten Island Children's Museum, 87
Stewart M. Ketchum/Downtown YMCA, 100
Stewart, Tabori & Chang, 326
Stinehour Press, 337
Straight Arrow Publishers, 118
Strathmore Paper Company, 143, 225
Sundog Productions, 170
Sun Microsystems, 133
Sunshine Mission, The, 98
Swedish Medical Center, 241

T

Take It Back Foundation/Jolie Jones, 139
TBM North America, 285
Temple University Art Gallery, 96
Temple University Press, 318
Time-Life Inc., 100
Time Magazine Company, 256
Times Mirror Company, 269
Time Warner, Inc., 182
Timex, 184
Trammel Crow Company, 147
Trimble Navigation, 285
Twelvetrees Press, 328
Twin Palms Publishers, 328

U

Uh Oh Clothing Boutique, 292
Unexpected Productions, 203
United Jewish Appeal, 104
Universal Foods Corporation, 201
University of California Press, 317, 336
University of Illinois at Urbana-Champaign, 123
University of Iowa Press, 313
University of Nevada Press, 309
University of Pennsylvania, Institute of Contemporary Art, 305
University of Southern California, 284
University of Texas/Austin, University Lambda, 108, 110
University United Methodist Church, 172

V

Vanderpoel, Fred, 252
Van Nostrand Reinhold, 296
Visual AIDS, 113, 115
Viking Press, The, 331, 346, 347

W

Walker Art Center, 242
W.W. Norton & Company, 306
Watson-Guptill Publications, 334
Weiden & Kennedy, 194
Westpoint-Pepperell, Inc., 158
Windham Hill Records, 173
Whitney Museum of American Art, 304
Wolf Fund, 126

Woodrich, Inc., 218
Works Editions, 91
World Wildlife Fund, 126

Y

Youth Force/Citizens Committee for New York City, 101

Z

Ziba Design, 156
Zim's Restaurant, 201
Zolo, Inc., 218
Zoological Society of Philadelphia, 72, 80, 147
Zoot Restaurant, 199, 205

Printers, Binders, Engravers, Fabricators, and Separators

A

ABC Sign, 230
Academy Press, 123
Acme Printers, 219, 316
Acme Silkscreen, 129, 201, 237
Anderson Lithograph, 283
Adrian Ray, 87
Advance Graphic, 81
AGI, 272
Ambassador Arts, 249, 277
Amilcare Pizzi, 320
Anderson Lithograph, 178
Andromeda Printing, 123
Apex Die, 227
Arcata Graphics, 296, 300, 306, 313, 320, 331, 342, 343, 344, 346
Arthurs Jones, 223
ASI/Enameltec, 69
Aspen Grafics, 154
Atlantic Bedford, 201
Avery, Eric, 109

B

B+G Printing, 293
B&R Screen Graphics, 161
Baker Gurney & McLaren, 269
Bayless Bindery, Inc., 332
Bayshore Press, 79
Beasley Company, The, 205
Bellshire Ltd., 161
Ben Johnson & Co., Ltd., 165
Bennetts, 227
Bercotte & Gershwin, 325
Berman Printing Company, 341
Bianca, 72
Bindery Systems, Inc., 234
Bino-Pak, 186
Bluepeter, 262
Bolger Printing, 242
Booklab, Inc., 299
Booklet Binding, Inc., 302
Boyer Printing Co., 227
Bradley Printing Company, 269
Bruce Offset, 139, 156
Buford Lewis Company, 251

C

Cardoza-James Bookbinding Co., 342
Carpenter Reserve Printing Co., 107
CGS, 188, 267
Clark Packaging, 151
Classic Color, 94
Colish, A., 181
Colorbar, 191
Color-Craft Silkscreen Displays, Inc., 141
Colorgraphics, Inc., 151, 153, 154
Color Graphics USA, 206
Color Masters Enterprises, 71
Colossal Graphics, 258
Columbia Graphics, 249
Communigraphics, 241
Conceptual Litho Inc., 97, 199
Consolidated Web, 203
Copycat, 128
Coral Graphics, Inc., 294
Courier Companies, The, 345
Custom Capabilities, 153

D

Dai Nippon Printing Co., Ltd., 300, 307, 318, 321, 323, 334, 341, 347
Danbury Printing, 66
Daniels Printing, 146, 212
Darwell Press, 188
Design Angles, 286
DES Offset, 137
Design Practicom, 104, 120, 208
Dicksons Inc., 225
Diversified Graphics, 168, 172, 201, 246, 258, 264, 290
Dot Printer, The, 223
Druckerei und Verlag, 328
Duro Paper and Plastics, 233
Dynagraphics, Inc., 156

E

Eastern Press, 91, 304
Eco-Support Graphics, 127
Edge, The, 233
Editoriale Ubraria, 330
Edwards Brothers, Inc., 29
Etheridge Company, 278
Ethridge, 141

Evergreen Printing Company, 332
Exhibit Group, 191
Expedi Printing, 110
Expert Brown, 246

F
Fairfield Graphics, 305, 342
Fields, Scott, 299
Finley Brothers Co., The, 143
Fleetwood Litho + Letter Corp., 303
Flint Ink Corporation, 94
Ford Graphics, 149
Fortran Printing, 179
Forward Press, 122
Four Colour Imports, 244
Franklin Packaging, 142
Franklin Press, 277
Fruitridge Printing and Lithograph Co., 99
Frye & Smith, 344

G
Garnder Lithograph, 342
Gehre Graphics, 13, 241
Gene Gamble Printing, 156
George Rice & Sons, 214, 269
Geyer Printing Company, Inc., 204
Globe Screen Print, 199
Graphic Ads, 256
Graphic Arts Center, 75, 130, 166, 167, 194
Graphic Center, 142
Great Northern Printing, 241
Greenleaf Press, 87
Grenville Printing, 203
Gulf Printing, 286

H
Halliday, 306, 341
Harp Press, 69
Henkes Senefelder, 271
Hennegan Printing Co., The, 173, 245, 254, 267
Heritage, 212
Heritage Graphics, 292
Heritage Press, 151, 179, 182, 186, 227, 242, 254, 265
Heritage Printing, 139, 335
Hero, 76
Hero Presentation Printing, 233
Herzig Somerville Ltd., 324
Holm Graphic Services, 286
Holyoke Lithograph, 326
Horowitz-Rae, 75, 83, 346

I
Ideal Printing Company, 108
Imago Publishing, 89
Imperial Lithographing, 79
Inland Lithography, 107
Intergraphic Binding and Finishing Co., 303
International Printing, 267
International Printing & Publishing, 269
Interprint, 307
Island Can, 155
Ivy Hill, 256

J
James H. Barry, 274
Janus Screen Graphics Studio, 78
Japanese American Cultural Center, 105
Japan Sleeve Co., 126
Jevne, Jill, 332
J.H. Barry, 285
J.F.B. & Sons Lithographers, 134
John H. Dekker & Sons, 317, 336
Johnson, E.A., 111
Julie Holcomb Printers, 225

K
Kader Lithographers, 204
K&L Labs, 125
K.P. Printing, 190
Kater-Craft Bookbinders, 336
Kingsport Press, The, 331, 339, 343, 346

L
Lebanon Valley Offset, 134, 256
Lerner Printing, 326
Linco Printing, 120
Lineaux, Inc., 241
Lithographix, 133, 228, 284
Litho Specialties, 219
L.P. Thebault, 244
Lunar Caustic Press, 144

M
Malloy Lithographing Inc., 317, 336
Maple Vail, 316
Marathon Printing, 272
Mastercraft Press, 159
Matthews, Ingham and Lake, 283
McDonald Printing, 184, 197, 280, 283
Mercury Printing, 136
Meridian Printing, 305
Metropolitan, 103
Mirror Graphics, Inc., 310
Monarch Litho, 300, 302
Monarch Press, 252
Moser Bag, 254
Mueller Trade Bindery, 91

N
National Litho, Inc., 92
Neenah Printing, 231
Neon Fabrications, 279
Negastrip Lithographers, 98
New England Book Components, 309, 317, 336
Nissha Printing Co., Ltd., 306, 318, 322
Northwestern Printing House, 249

O
Ohio State University, 113
O'Neil Printing, 217
Oregon Printing Plates, 143, 234
Original Reproductions, 278
Overland Printers, Inc., 192, 292
Overseas Printing, 338

P
Pacific Lithographic Company, 114, 194
Padgett Printing, 176
Paragon Press, 69
Paragraphics, 96, 103
Patrick Reagh Printers, 144
Pattie, Steve, 123
Peake Printers, 233, 272
Pentagram Press, 297
Perry Gugler, 82
Phoenix Color, 309
Phoenix Press, 271
Pidgeon Press, 102
PIP Printing, 278
Platinum Press, 100, 277, 290
Pomco Graphics, 159, 181, 290
Pond-Ekberg Company, The, 126, 170
Press Corps, 225
Princeton Paper, 251
Princeton Polychrome, 83, 89, 346
Print Craft, Inc., 194, 214
Print Shoppe, 99
Process Displays, 184
Professional Offset, 230
Promotions By Design, Inc., 74

Q
Quebecor, Inc., 210
Quintessence, 234

R
Raff Embossing & Foilcraft, 71
Ragged Edge Printing, 101
Rainbow Sign, 70, 78
Rappaport, 137
Rapoport/Metropolitan, 103
Review and Herald Publishing Association, 90
Rice & Sons, 188
Rice, Felicia, 299
Robinson, Rory, 112
Roswell Bookbinding, 344
R.R. Donnelley, 333
Rush Press, 165

S
Sanjean Graphics, 119
Santillo, 176
S&S Graphics, 246
Satterwhite, 218
Screen Images, 127
Seiple Lithographic Co., 238
Senton Printing, 203
Serigrafia Limited, 237
Service Litho-Print, 141
Shenandoah Publishing, 88
Shorewood, 141
Silken Screen, The, 97, 111
Singer Printing, 115
Sirocco, 91
Snohomish Publishing, 106
Sofy Copy, 122
South China Printing Company, 85
Spiral Binding Company, Inc., 79
Stefek Company Screen Printers, 199
Stephenson, Inc., 278
Stephenson Printing, Inc., 162
Sterling Kwik Kopy, 274
Stinehour Press, 316, 337
Strine Printing Co., Inc., 162, 199

T
Tanaka Bookbinding, Co., Ltd., 311
Ted Tuellers Ink, 157
The Nines, 98
The Press, Inc., 100
Thomson-Shore, Inc., 309, 313
Tien Wah Press, 83, 87, 91, 314, 315, 339
Times Offset Pty., Ltd., 299
Tongg Publishing Co., 223
Top Box, 261
Toppan Printing Company, Inc., 318, 325, 328
Toryo Printing Co., Ltd., 311
Total Reproductions, 302
Typecraft, 144, 238
TX Unlimited, 130

V
Vail Ballou, 316
Venture Graphics, 114
Veitch Printing Corporation, The, 283
Village Press, 261
Virginia Lithograph, 71

W
Warrens Waller Press, 114
Watermark Press, 114, 190, 228
W.E. Andrews, 233
Welsh Graphics, 166
Westvaco, 92
Williamson Printing, 94, 238, 289
Willis Marketing, 251

Typographers, Letterers, and Calligraphers

A
A-R Editions, Inc., 317
Ace Group, Inc., The, 310
Amstutz, Dean, 344
Andresen Typographics, 173, 186, 201, 206, 223, 342
Apple Computer, 210, 271

B
Balch, Barbara, 345
Berkeley Typographers, 212
Blazing Graphics, 111
Boro Typographers, Inc., 172, 290
Branum Typography, 254

C
Cardinal Type, 83
CCI, 277
Centennial Graphics, Inc., 92
Central Typesetting, 214, 269, 277, 284, 290
Cerio, Steven, 120
Champion Papers, 99
Characters, 186, 199, 205, 267
Characters and Color, 293
Com Com, 316
Commerical Graphics, Inc., 74
Composition Systems, Inc., 246
Composing Room, The, 162
Composition Typesetting, 133
Crane Typesetting Service, 299, 333
Creative Type, 238
Cromwell, 206
CSI, 71
CT & Photogenics, 92
Current Graphics, 237
Cybergraphics, 246

D
Dahl & Curry, 141, 289
Dekr Corporation, 300, 306
Design Angles, 286
Design & Type, 154, 159
Display Lettering & Copy, 76, 201, 285, 322
Dix Type, 330
DNA, 155
Doug Murakami Design & Type, 151
DPI, 227
Duke & Company, 306, 318
Dwight Yeager Typographers, 113

E
Edwards, Kathleen, 111
Electra, 252
Electronic Publishing Center, 278
Eurotype, 115, 228, 307
Expertype, 294, 309
Expertype/Graphic Word, 256, 320

F
Faszholtz, Kaye, 269
Fitzcarl A.J. Reid, 101
Fotocomp, 79
France, Stacy, 292

G
G&S Typesetters, Inc., 313
Gerard Associates, 219
Get Set, 105
Gon, Russell Eng, 299
Graphics Express, 98
Graphic Technology, 124, 341
Great Faces, 289

H
Hamilton Phototype, 204
Harrison Scott Graphics, 110
Hickman, Nicole, 121
Hiebert, Kenneth J., 296
Hoffmitz, Leah, 149

I
Icon West, 302
Images, 153
Infocom, 188
Intellitext, 123
Interest, 300

J
JCH, 137
Jet Set, 115
Johnson, Lisa, 212, 227, 261

K
Kortum-Stermer, Jeanie, 101
Kubota & Bender, 204
Kuhlman, Deanna, 290

L
Letterwork, 219
Lightning Ink, 99
Linoprint, 75, 83
Linoprinter Composition Co., Inc., 315
Linotype, 89, 323
Linotypographers, 258
Litho, Inc., 201
Lococo, Leah, 321

M
M&M Typography, 347
Maple Vail, 343
Marke Communications, 165
Master Typographers, 249
Matrix Type, 143
Marathon Typography Service, 153, 313, 320
Mark Hagar Typography, 82
Master Type, 178
May Typography, 297
Meriden-Stinehour Press, 89
Monogram, 159

N
Nakamura Seiko Printing (USA) Inc., 321

O
O.C. Type, Inc., 341
One Works, 151, 179
On Line Typography, 142
O'Reilly, Kathleen, 105
Omnicomp, 114, 130

P
Pastore DePamphilis Rampone, 278
Paul Baker Typography, 141
PDR New York, 66
Pearson Typographers, 278
Pentagram Press, 297
Pica & Points Typography, Inc., 100
Print & Design, 85
Print Craft, Inc., 208
Pro Typography, 107
Pulsar Photographics, 346

Q
QC Inc., 119
Quad, 48, 283

R
Review and Herald Publishing Association, 90
Rocketype, 102

S
Schlegal Typesetting, 194, 234
Schuetz, Ralf, 244
Side 1, 143
Silton, Susan, 98
Skousen, Jonathan, 112
Southwestern Typographics, 242, 252, 265
Spartan Typographers, 167, 197, 271
Stowell, Scott, 331
Studio Source, 156

T
Thomas & Kennedy, 122
Thompson Type, 74, 314, 339
TKDI, 246
Tram, Florence, 233
Trotter, Christy, 66
Trufont, 74, 183, 218, 306, 314, 328
TSI, Inc., 70, 179
Tseng Information Systems, Inc., 309, 344
Type Connection, The, 272
Type Cosmique, 311
Typecrafters, Inc., The, 134
Type Gallery, The, 254
Typehouse, 184, 231, 283
Typemasters, 264
Typeshooters, 70, 78, 87
Type Shop, The, 72
Typeworks, 299
Typola, 79
Typogram, 87, 161, 199, 245, 249, 277, 325
Typographic Images, 91
Typography Plus, 334
Typographic Resource, 139

U
U.S. Lithograph, Inc., 125

V
Villager Graphics, 105
V.I.P. Typographers, 234, 271

W
Wadell's Computer Graphics Center, 286
Weller, Cha Cha, 157
Wetherbee, Michele, 97
Wilsted & Taylor Publishing Services, 336
Wrightson, 233

Z
Zaref, Marc, 305